THE STAR WARS™ BOOK

THE STAR WARS BOOK

PROJECT EDITOR
Matt Jones

PROJECT ART EDITOR
Jon Hall

EDITORS
Emma Grange, Vicky Armstrong,
Kathryn Hill

DESIGNERS
Stefan Georgiou, David McDonald,
Mark Penfound

INFOGRAPHIC ILLUSTRATORS
Stefan Georgiou, Mark Penfound,
Jon Hall

PRODUCTION EDITOR
Marc Staples

SENIOR PRODUCTION CONTROLLER
Louise Minihane

MANAGING EDITOR
Sarah Harland

DESIGN MANAGER
Vicky Short

PUBLISHER
Julie Ferris

ART DIRECTOR
Lisa Lanzarini

PUBLISHING DIRECTOR
Mark Searle

FOR LUCASFILM

SENIOR EDITOR
Brett Rector

CREATIVE DIRECTOR
OF PUBLISHING
Michael Siglain

ART DIRECTOR
Troy Alders

STORY GROUP
James Waugh, Pablo Hidalgo,
Leland Chee, Kelsey Sharpe,
Matt Martin, Emily Shkoukani

ASSET MANAGEMENT
Shahana Alam, Chris Argyropoulos,
Nicole LaCoursiere, Gabrielle Levenson,
Bryce Pinkos, Erik Sanchez,
Sarah Williams

DK would like to thank Chelsea Alon at
Disney; Michael Siglain, Brett Rector,
and Robert Simpson at Lucasfilm
Publishing; Simon Beecroft for his
assistance with the synopsis; Pamela
Afram and David Fentiman for editorial
assistance; Megan Douglass
for proofreading; and Vanessa Bird
for creating the index.

First American Edition, 2020
Published in the United States
by DK Publishing
1450 Broadway, Suite 801,
New York, NY 10018

© & ™ 2020 Lucasfilm Ltd.

Page design copyright © 2020 Dorling
Kindersley Limited
DK, a Division of Penguin Random
House LLC
20 21 22 23 24 10 9 8 7 6 5 4 3 2
006–316454–Oct/2020

Published in Great Britain by Dorling
Kindersley Limited

A catalog record for this book
is available from the Library of Congress.
ISBN 978-1-4654-9790-1

DK books are available at special
discounts when purchased
in bulk for sales promotions, premiums,
fund-raising, or educational use. For
details, contact: DK Publishing Special
Markets, 1450 Broadway, Suite 801,
New York, NY 10018
SpecialSales@dk.com

Printed and bound in China

For the curious

www.dk.com

CONTRIBUTORS

PABLO HIDALGO, AUTHOR

A lifelong fan and recognized expert on the depth and history of the saga, Pablo Hidalgo has been a full-time *Star Wars* authority at Lucasfilm for over 20 years. He has written many authoritative *Star Wars* reference books, including Visual Dictionaries or Guides for the films *The Force Awakens*, *The Last Jedi*, *The Rise of Skywalker*, *Rogue One*, and *Solo: A Star Wars Story*. He is currently a Senior Creative Executive at Lucasfilm, helping to develop new movies, TV series, published works, and location-based experiences. He lives in San Francisco.

COLE HORTON, AUTHOR

Cole Horton is the author or coauthor of a dozen *Star Wars* books, including *Star Wars: Absolutely Everything You Need to Know* and *Star Wars Galaxy's Edge: A Traveler's Guide to Batuu*. He has contributed to StarWars.com, Marvel.com, and *run*Disney. As a Brand Manager and Consumer Researcher, he's worked on a number of video games including *Star Wars: Galaxy of Heroes*, *Star Wars Battlefront II*, and *Star Wars Jedi: Fallen Order*.

DAN ZEHR, AUTHOR

Dan Zehr is the Host and Brand Director of the *Star Wars* podcast Coffee With Kenobi. He is a Feature Blog Contributor for StarWars.com, as well as a writer for IGN, and is a prominent expert in *Star Wars* fandom. Dan is also a prolific high school educator, who teaches Literature and Composition, and has a Master's Degree in Teaching and Learning. His work combining *Star Wars* and education garnered him a role in the Target *Rogue One Star Wars* commercial. He resides in Illinois with his wife and three boys.

CONTENTS

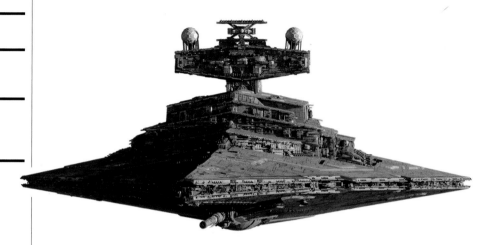

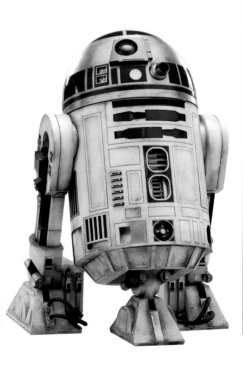

THE FORCE

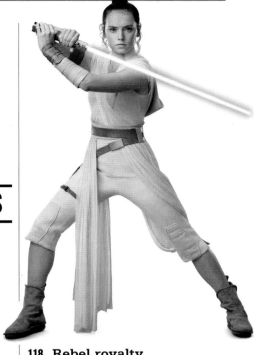

THE SKYWALKERS

GALACTIC GOVERNMENTS AND THEIR DISSIDENTS

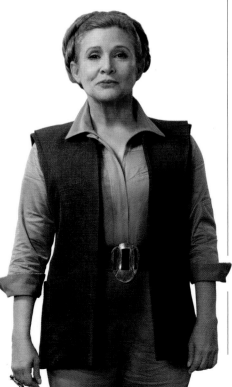

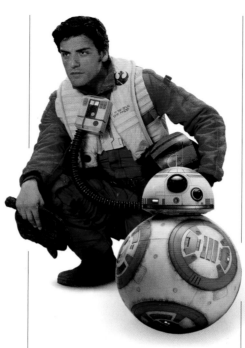
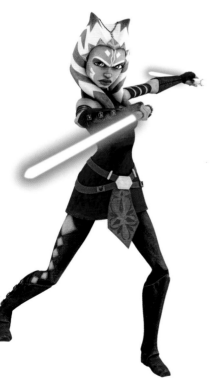

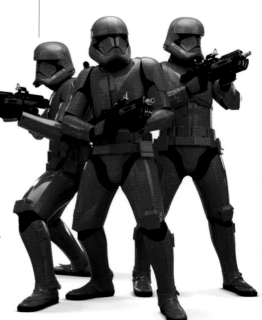

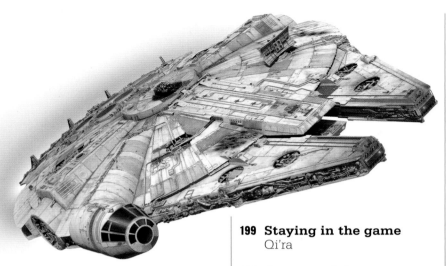

GALACTIC DENIZENS

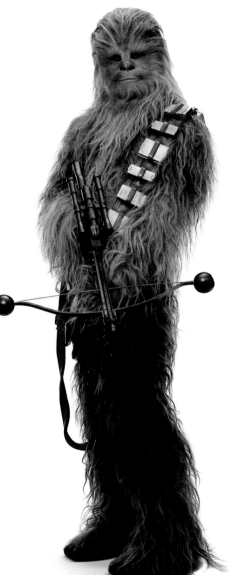

INTRODU

CTION

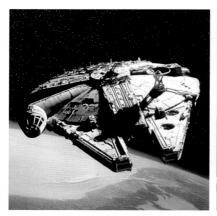
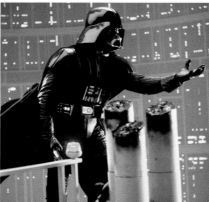
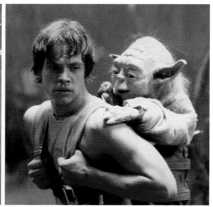

When *Star Wars* premiered in movie theaters on May 25, 1977, no one—not even its creator, George Lucas—could have predicted the success it would become. Now more than 40 years later, *Star Wars* has grown into a global phenomenon that transcends generations, borders, and mediums. What started as just one movie became three trilogies of films. It leapt from the screen onto the pages of books and comics, spawned both animated and live action television and web series, and inspired video games and theme parks. Collectively they form a vast galaxy, rich in ever-expanding lore, unforgettable characters, and interconnected stories. Whether you are a newcomer or a life-long fan, within this book you'll explore many of the themes that make *Star Wars* so enduringly popular.

Every story has a beginning

The first film—known at the time simply as *Star Wars*—was subsequently renamed *Star Wars*: Episode IV *A New Hope*. It introduced the world to a story of struggle at both a galactic scale and on a personal level.

Drawing inspiration from human history, it pitted a brave Rebellion against an evil Empire. This epic confrontation intertwined with the personal trials and tribulations of the iconic heroes, Luke Skywalker, Princess Leia, and Han Solo. Together, they challenged the ruthless Darth Vader and his merciless army of stormtroopers. It threw audiences into a faraway galaxy filled with remarkable aliens, fanciful technology, and exotic planets.

The California filmmaker George Lucas was seeking to reinvent the

I wanted to take ancient mythological motifs and update them—I wanted to have something totally free and fun, the way I remembered space fantasy.

George Lucas

classic genre of space opera. Influenced by adventure stories and the Flash Gordon comics of the 1930s, Lucas infused his space fantasy with psychological and mythological motifs. Lucas drew from his appreciation of samurai films, westerns, and military history to create something that was wholly unique and stood out from its contemporaries. Science fiction of the 1970s was a reflection of the real world. Cynical and grim, the films were full of anti-heroes and terrible disasters. In contrast, *Star Wars'* message was hopeful, setting itself apart from many films of the era. This swashbuckling adventure showed that good could triumph over evil, and individuals have the power to change the fate of their galaxy.

When *Star Wars* premiered in 32 US movie theaters in May of 1977, it was an instant commercial success and one of the first blockbuster films. "May the Force be with you" worked its way into everyday vocabulary, and its stars, Mark Hamill, Carrie Fisher, and Harrison Ford, became household names. Being the highest grossing movie of all time at that point ensured that the first *Star Wars* film wouldn't be the last.

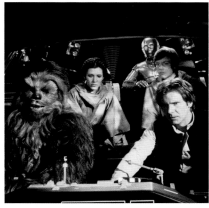
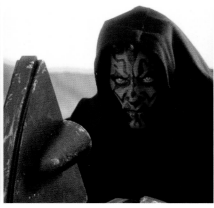
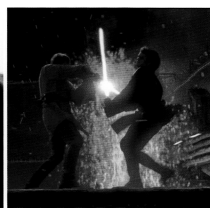

The sequel, *Star Wars*: Episode V *The Empire Strikes Back* (1980), introduced audiences to new worlds and shocked them with the revelation that Darth Vader was, in fact, Luke Skywalker's father. It delved deeper into the Force, a mysterious energy that permeates the fictional galaxy. Determined to retain control of the world he had created, Lucas personally financed the big-budget sequel. Increased external creative input and a set count almost twice the size of *A New Hope* made *The Empire Strikes Back* significantly larger and more costly to produce. But it was a gamble that paid off in spades—the film achieved critical and commercial success. Three years later, in 1983, the saga continued with the release of *Star Wars*: Episode VI *Return of the Jedi*, which saw the epic climax of the struggle between the Rebellion and the Empire. It was the final chapter of the Original Trilogy, and left audiences waiting 16 years for the next film installment.

Movie magic

Star Wars didn't just reinvent a genre; it changed the way movies are made. To bring his vision to life, George Lucas needed visual effects unlike any that had come before,

requiring the invention of new technology. That task fell to his new special effects company, Industrial Light & Magic.

A young team of mavericks were tasked with creating the film's revolutionary visual effects, including the construction of a motion-controlled camera system that was vital in creating the film's dynamic starship shots and dogfights. Model makers painstakingly crafted vehicles and space stations with amazing detail, using classic techniques on a massive scale. The result was a film unlike any seen before, leaving audiences astonished and laying the foundations for the decades of innovation that followed.

ILM was at the forefront of bringing increasingly advanced digital capabilities to the entertainment industry. Lucas and his team pioneered previsualization technologies that gave filmmakers the ability to craft their movies before cameras even started rolling. They used computer animation to bring characters and creatures to life—a feat that would have been impossible with practical effects alone. More than 40 years after its founding, ILM continues to push the boundaries of storytelling, creating

> I had never experienced special effects that were so real.
> **Steven Spielberg**

award-winning visual effects and pioneering innovations that wow audiences to this day.

The universe expands

Star Wars was not only a revolutionary film; it practically invented the licensed merchandise industry that we know today. Audiences couldn't get enough of *Star Wars*, but thanks to thoughtful merchandising, they were able to take home a bit of the world's most famous galaxy. Action figures were among the many products introduced, helping kids and adults alike recreate their favorite scenes from the movie at home. The success of the merchandise fueled future *Star Wars* projects and »

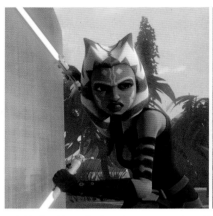

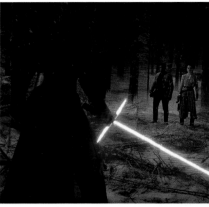

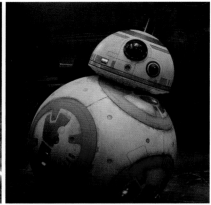

allowed George Lucas to remain independent from the major Hollywood studios.

Before the first film even reached movie theaters, Lucas' screenplay was adapted into a *Star Wars* novel, and Marvel published a line of comics featuring characters and storylines from the film. Hundreds of novels and comics have followed, allowing fans to explore a wider galaxy with new people, creatures, places, and events. In the years that followed, audiences could actively explore the galaxy thanks to the many video and tabletop games available. All of these additional storytelling mediums helped fans stay connected to the galaxy even when films were few and far between.

Return of the Force

After a sixteen-year hiatus from *Star Wars* films, George Lucas kicked off a new triumvirate of prequels to the Original Trilogy. *Star Wars*: Episode I *The Phantom Menace* explored the origins of Obi-Wan Kenobi, and revealed how the Republic, mentioned in *A New Hope*, became the Empire. Episode II *Attack of the Clones* and Episode III *Revenge of the Sith* focused on the continuing unrest throughout the galaxy, and followed Anakin Skywalker on his journey from podracing prodigy to eventually turning his back on the light side of the Force and becoming Darth Vader. But these films still left plenty of untold war stories, leading to the development of *Star Wars: The Clone Wars* (2008-2020). With its high production value and a

Connected stories

Star Wars is recognized for its adoption of a single continuous storyline. Creator George Lucas always considered Episodes I-VI and the series *The Clone Wars* to be the official lore. The Expanded Universe of books, comics, and games created between 1977 and 2013 now fall under the "Legends" banner, distinguishing them from the stories that followed. While a rich source of inspiration, the events found within them are considered to be outside of the authentic timeline. As Lucasfilm ramped up for a new era of production in 2012, all media except the movies and *The Clone Wars* TV series came under the Legends banner. Since 2014, the stories told across mediums are added to the official *Star Wars* mythology, forming one connected plotline in a shared galaxy. Lucasfilm custodians ensure that the films, animated series, books, comics, games, and even emerging mediums—such as virtual reality and the theme parks—share the same galaxy coherently.

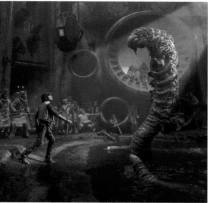

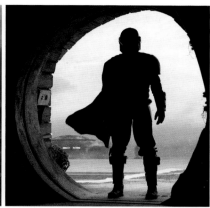

willingness to explore a variety of themes, the animated series gave viewers a look into the human side of the war while providing new insights into the power of the Force.

New generation of heroes

After more than 40 years leading the company he founded, in 2012 George Lucas announced his retirement and that *Star Wars* would become part of The Walt Disney Company. With long-time producer Kathleen Kennedy now at the helm of Lucasfilm, *Star Wars* expanded more than it ever had before. Production began on a new trilogy, beginning with Episode VII *The Force Awakens* (2015), followed by Episode VIII *The Last Jedi* (2017), and Episode IX *The Rise of Skywalker* (2019). These new films saw classic characters pass the torch to a new generation of heroes: Rey, Finn, and Poe. New villains, including General Hux, Kylo Ren, and Supreme Leader Snoke also arose, aiming to thwart the Resistance.

For the first time, Lucasfilm also branched out into stand-alone *Star Wars* projects. *Rogue One* (2016) brought to life the Rebel mission to steal the Death Star plans, an event first mentioned in *A New Hope*

I felt there were a lot more *Star Wars* stories left to tell. I was eager to start telling some of them through animation.
George Lucas

in 1977. *Solo* (2018) explored the origins of Han Solo and his copilot, Chewbacca, as they make their famed Kessel Run, also referenced in the original film. The first live action TV series, *The Mandalorian*, premiered in 2019. Telling the story of an enigmatic bounty hunter and his ward—a baby of Yoda's species known simply as "the Child"—both characters immediately became fan favorites.

Lucasfilm also continued to make animated series, introducing fans to new characters and further expanding the galaxy. *Star Wars: Rebels* (2014-2018) took place after the fall of the Jedi Order. It followed a group of rebels that formed an early incarnation of the Rebel Alliance. *Star Wars: Resistance* (2018-2020) gave insights into events leading up to *The Force Awakens*, including the growing power of the First Order.

How to use this book

The Star Wars Book provides an in-depth look at the most important themes that weave through the ongoing *Star Wars* saga. You'll find insights into the key characters, their relationships, and their motivations while developing an understanding of the galaxy's many factions and governments.

To illustrate how things fit together, timelines and topic boxes provide greater detail. The dating system adopted in the timelines indicates how many standard years before or after *Star Wars: Episode IV A New Hope* an event occurs in the galaxy, denoted by BSW4 or ASW4.

The Star Wars Book guides new fans through the most important elements of the galaxy, illustrating how characters and events connect. For longtime fans, it offers a new perspective on the franchise they know and love, and a few surprises not found anywhere else. ■

THE
GALAXY

As stunning as it is dangerous, the galaxy plays host to millions of star systems and planets filled with innumerable alien species, amazing technologies, and mysterious powers. It is the backdrop for great heroes to rise, sinister villains to reign, and for the wars they wage to decide the fate of trillions who live in this colossal expanse of known space.

FAR, FAR' AWAY....

THE GALAXY

HOLOCRON FILE

NAME
The Galaxy

SIZE
100,000 light years in diameter

KNOWN FOR
The Force, a mystical energy field created by all living things

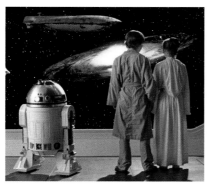

The galaxy The Rebel Alliance hides on the edge of the galaxy, planning its next move against the Empire.

For most beings, the galaxy's scale is hard to truly comprehend. Estimates suggest it holds 400 billion stars and more than 3.2 million habitable star systems. The galaxy is home to millions of unique sentient species and untold forms of flora and fauna. A single system can contain dozens of planets, even more moons, and any number of celestial bodies.

Travel across these great distances was once constrained by the limits of a being's endurance, but the advent of faster than light hypertravel effectively opened up the entire galaxy to anyone with access to a starship with a hyperdrive. What were once uncrossable distances could now be traversed in moments, leading to an explosion of trade, culture, and the spread of interstellar politics.

While great Republics and powerful Empires attempt to bring order to the galaxy, none can ever truly control it entirely. Even the largest governments in galactic history rule over but a portion of the myriad star systems. New discoveries are made with each new cycle of political upheaval, as explorers risk their lives to uncover the secrets of the galaxy.

The known galaxy is divided up into multiple regions, each with its own unique character and history. At the very center is the Deep Core, a hazardous, densely packed region of stars circling an ancient black hole. Radiating out from the Deep Core lie more regions, including the affluent Core Worlds, stable Colonies, remote Outer Rim, and eventually the largely uncharted Unknown Regions that extend to Wild Space. Each region has many solar systems that in turn are home to multiple planets. Conventionally, numerous star systems are collected to form a sector, areas of the galaxy mapped together though not necessarily organized politically or culturally.

All star systems have a set of coordinates, allowing them to be plotted by a ship's navicomputer. The most complete archive of them is found in the Jedi Temple **»**

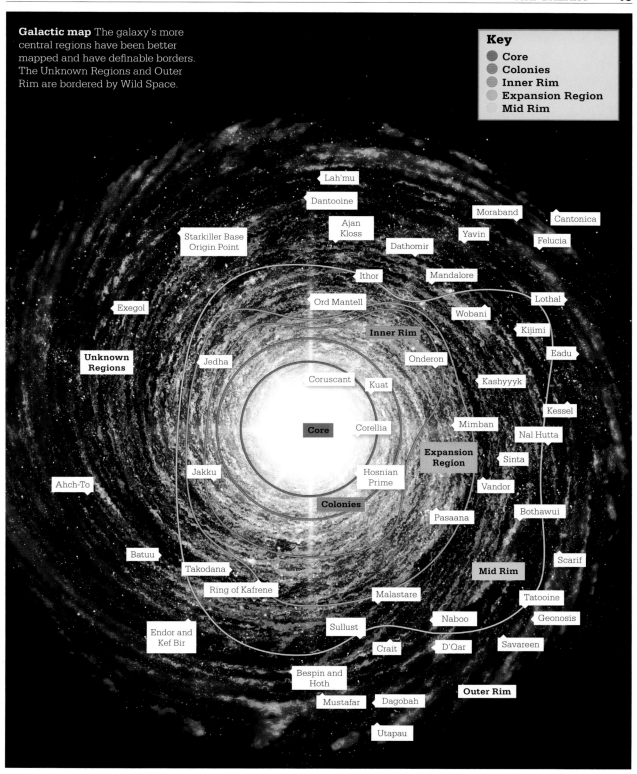

Galactic map The galaxy's more central regions have been better mapped and have definable borders. The Unknown Regions and Outer Rim are bordered by Wild Space.

Key
- Core
- Colonies
- Inner Rim
- Expansion Region
- Mid Rim

Lah'mu
Dantooine
Ajan Kloss
Dathomir
Moraband
Cantonica
Yavin
Felucia
Starkiller Base Origin Point
Ithor
Mandalore
Ord Mantell
Lothal
Wobani
Inner Rim
Kijimi
Exegol
Eadu
Unknown Regions
Jedha
Onderon
Kashyyyk
Coruscant
Kuat
Kessel
Core
Corellia
Mimban
Nal Hutta
Expansion Region
Sinta
Jakku
Vandor
Hosnian Prime
Bothawui
Ahch-To
Colonies
Pasaana
Mid Rim
Batuu
Scarif
Takodana
Malastare
Tatooine
Ring of Kafrene
Geonosis
Naboo
Endor and Kef Bir
Sullust
Savareen
Crait
D'Qar
Bespin and Hoth
Outer Rim
Mustafar
Dagobah
Utapau

Senator Palpatine is elected as Supreme Chancellor, but few know he is secretly the Sith Lord, Darth Sidious, who plots to destroy the Galactic Republic from within.

Palpatine makes himself Galactic Emperor and wipes out the Jedi Order. He makes Anakin Skywalker his apprentice, Darth Vader. Both are unaware that Skywalker's infant children, Luke and Leia, are hiding in the galaxy.

After a team known as Rogue One steals the technical readouts to the Death Star, Jedi hopeful Luke Skywalker destroys the battle station.

PHANTOM MENACE
32 BSW4

EMPIRE DECLARED
19 BSW4

BATTLE OF YAVIN
0 SW4

22 BSW4
CLONE WARS

2 BSW4
ALLIED REBELS

3 ASW4
BATTLE OF HOTH

Under the sway of Sidious, Count Dooku encourages thousands of star systems to leave the Galactic Republic. This Separatist Crisis explodes into the Clone Wars.

Fractured rebel cells unite to form the Alliance to Restore the Republic. Leia Organa, Princess of Alderaan, is among its leaders.

The Rebel Alliance narrowly escapes the Imperial fleet.

Library on Coruscant, kept under the watchful eye of generations of Jedi historians.

Traffic across the galaxy is most heavily concentrated along the many trade routes, the paths through space that have been arduously mapped by explorers and are clear of most hazards. Planets along these routes benefit economically and politically, using their status and reputation on these vital lanes to wield outsized influence over galactic affairs. The trade routes can also bring unwanted attention, as legitimate corporations or illegal syndicates jockey for control over the spacelanes, particularly where strong central governments are not concerned.

The Core Worlds

Home to some of the wealthiest and most prestigious systems, the Core Worlds sit near the center of the galaxy and also at the center of galactic politics. Various Core Worlds have been the seat of the prevailing government, as the Galactic Republic, Galactic Empire, and New Republic all seat their capitals on one of the Core planets.

The prosperity enjoyed by those in the Core becomes a source of tension between those in the Core and those who live in farther reaches of the galaxy. Core Worlders gain a reputation for arrogance and selfishness as those beyond the Core begin to see them as privileged. Common critiques of the Galactic Republic include that it

disproportionately favors the Core Worlds and its politicians ignore the safety, well-being, and needs of those in other regions.

A visit to Coruscant reveals why many see the Core as privileged. The capital planet of both the Republic and later the Empire, the entire planet is a city where level upon level has built up over the ages. The tallest skyscrapers sit more than 5,000 levels above the planet's natural surface. Those that live among them enjoy a comfortable and luxurious life for which Coruscant is famous. The magnificent Senate Rotunda and the towering Jedi Grand Temple reside on the highest levels, where their inhabitants sit comfortably in their well-appointed headquarters

Palpatine's plan to ensnare the Alliance backfires, seemingly leading to his death at the Battle of Endor.

Luke Skywalker's attempt to train a new generation of Jedi fails when his nephew, Ben, falls to the dark side and takes the name Kylo Ren.

The First Order uses its Starkiller superweapon to obliterate the New Republic capital. The Resistance wins a victory against the station, but stands alone against the First Order fleet. Led by a Jedi hopeful named Rey, a new generation of heroes rises to face Kylo Ren's might.

EMPEROR FALLS
4 ASW4

JEDI FALL
28 ASW4

STARKILLER INCIDENT
34 ASW4

5 ASW4
BATTLE OF JAKKU

29 ASW4
RESISTANCE

35 ASW4
BATTLE OF EXEGOL

The Imperial fleet is defeated by the newly-founded New Republic; remnants of the Empire retreat to the Unknown Regions.

Predicting the rise of the First Order, Leia Organa forms the Resistance to fight back when the New Republic refuses to take action.

Palpatine is revealed as the real master behind the First Order's rise. A ragtag fleet rallies to the aid of Rey and the Resistance, extinguishing the Sith Lord and his followers.

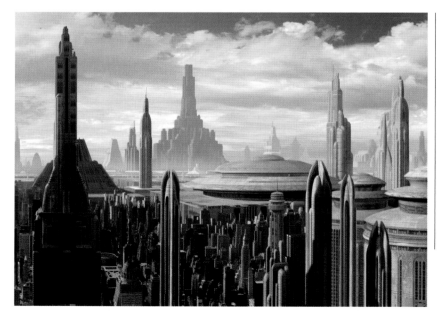

but far from those they profess to serve and protect.

One doesn't have to look far to find the disparity, as all of the wealth found on the upper levels is contrasted by the hardships found on levels below. Down there, citizens might live their whole lives without seeing natural sunlight in a notoriously crime-ridden underworld. While other worlds, like Nal Hutta and its moon Nar Shaddaa, are legendary criminal havens, the galaxy's great injustices are perhaps best illustrated by Coruscant. The powerful citizens live completely aloof of those suffering below. »

City world Unlike most planets, Coruscant's entire surface is covered by one sprawling mega city and is rife with pollution and overpopulation.

Turbulent world Mustafar was once a forested world, teeming with life, until a tragedy devastated the planet.

Core Worlds like Alderaan and Chandrila also share in the prosperity, but unlike Coruscant, retain their natural beauty. These systems gain fame for their cultural influence, serving as tastemakers in the arts. They produce an outsized share of political leaders in the waning days of the Republic as well, their leaders being strong advocates for galactic peace like that they have enjoyed from their safe region of the galaxy. The Core's manufacturing prowess is notable, too, with the shipyards of Corellia and Kuat being among the finest the galaxy has to offer.

Colonies and Mid Rim
Lying outside the core is a sector known as the Colonies, a region that long ago was colonized by the Core Worlds but today is so wealthy and prosperous that it is hard to tell them apart. Situated along the major trade routes, worlds like Fondor serve as important manufacturing hubs while planets like Castell and Cato Neimoidia are major centers of commerce. The latter is the headquarters of the Trade Federation which oversees its massive business interests from this centrally-located region.

The Colonies lead to the Inner Rim and Expansion Region, two parts of the galaxy that enjoy relative security and prosperity despite their modest distance from the Core. Further rimward lies the Mid Rim, the home of planets including Naboo, Kashyyyk, and Takodana. Though once considered out of the way worlds, Naboo and Kashyyyk are significant locations in the final days of the Republic. Many other Mid Rim worlds are the site of fighting during the Galactic Civil War as Rebels stage insurrections against Imperial forces who are stretched more thinly than the fleets protecting the Coreward regions.

Outer Rim
Far from the stability of the Core, the Outer Rim is a vast region known for its many lawless, lightly populated, and primitive frontier worlds. As the largest region, it is also known for its diversity of planets and peoples. Far from the oversight of powerful galactic governments, outlaws, bounty hunters, mercenaries, and smugglers operate here with relative impunity, as Republic and Imperial laws mean very little so far from those who might enforce them. To fill the power vacuum, local gangsters and warlords establish their own rule. In this lawless place, danger is ever present but opportunity is plentiful.

Much of the Outer Rim is controlled by the Hutts, powerful gangsters who become wealthy by controlling the spacelanes and exploiting local economies. Other criminal syndicates, such as the Pykes, Black Sun, and Crimson Dawn operate their own illicit empires from Outer Rim worlds, often profiting from the trade of highly illegal spice.

Despite its remote location, the Outer Rim plays host to many of the galaxy's most significant events. During the age of the Republic, tensions between Outer Rim systems and the Core boil over into the Separatist movement, and this area of space plays host to much of the fighting during the ensuing Clone Wars as the Republic attempts to regain control of the systems that left. Late in the war, the Republic mounts a final push to force the Separatists to surrender.

During the Empire's rule, many Outer Rim planets assume they are inconsequential enough to avoid Imperial attention, but learn that the Emperor's quest for power and resources extends to their homeworlds as well. To wrangle this vast territory, the Emperor installs one of his most trusted enforcers, Grand Moff Tarkin. The Rebel Alliance chooses remote Outer Rim worlds for its secret bases, using the sheer number of planets to its

I've flown from one side of this galaxy to the other. I've seen a lot of strange stuff...
Han Solo

advantage as it attempts to avoid detection. The Alliance's headquarters on Yavin 4 and Hoth become the center of some of the Galactic Civil War's most momentous confrontations. Similarly, the Empire constructs the Death Star battle stations at secret Outer Rim worlds where the odds are against their discovery.

Following the ascension of the First Order, Outer Rim planets are among the first to face subjugation by the new invaders. Like its Rebel predecessors, the Resistance hides on remote worlds like D'Qar, Crait, and Ajan Kloss.

The Outer Rim is known for its many harsh worlds, including the volcanic planets of Nevarro, Sullust, and Mustafar, the latter being rich in dark side energies, making it the ideal site for Darth Vader's castle. Moraband and Dathomir, also strongly connected to the Force, rarely see visitors in part due to their remote location and in part because of their connections to the dark side. Among the least desirable locations to visit is Kessel, a world made famous for its brutal spice-mining operations.

The world of Batuu lies on the edge of the Outer Rim and is a popular stop for those traveling further into Wild Space. Smugglers, gamblers, explorers, and travelers alike find refuge in Black Spire Outpost, the planet's most populous town. Chandrila Star Lines operates luxury cruises in this region, bringing travelers from other regions out to the edges of the galaxy on expedition journeys that promise both comfort and adventure.

Unknown Regions

While the Outer Rim is considered remote by most, it at least has the advantage of being thoroughly explored. The Unknown Regions have received only the most rudimentary mapping and most of its star systems remain a mystery. This region produces many legends, including tales of colossal spacefaring monsters. Whether they truly exist is hard to determine, as traveling into the Unknown Regions often requires navigating one of the region's many nebulae. Cyclones and electrical super storms tear apart ships that venture too closely. As the Empire crumbles, portions of

its fleets go into hiding in the Unknown Regions, using the anomalies like the Vulpinus Nebula to hide for decades. On Exegol, Darth Sidious and his Acolytes use this ancient Sith stronghold to rebuild his power and construct a terrible new fleet far from the prying eyes of the New Republic.

Wild Space

Wild Space lives up to its name, as this unmapped, irregularly explored region lies at the furthest extremes of the galaxy. Those claiming to have visited Wild Space are as likely to be spinning a tall tale as they are telling the truth, given that most consider a trip into this part of the galaxy unnecessary at best and suicidal at worst. Only the most adventurous or desperate venture into this unknown, which is home to a number of planets including the mythical homeworld of the Lasat, Lira San, and the mysterious planet of Mortis. The Galactic Empire makes some attempts to survey parts of Wild Space, but what it finds there is but one of Palpatine's many secrets. ∎

Exceptional abodes

While planets are the most commonly populated celestial bodies, the galaxy is also host to a number of other inhabitable locales—including moons, the occasional asteroid colony, and fabricated structures. The Ring of Kafrene, a trading post in the Thand sector of the Expansion Region, is built between two malformed planetoids in the midst of an asteroid belt. The towering city bridges the two rocks together, creating a maze of streets and alleyways clogged with traders, travelers, and miners.

In the Outer Rim, the colony of Polis Massa sits on an asteroid left by the mysterious destruction of a planet by the same name. This hidden base is the birthplace of Padmé Amidala's children, Luke and Leia. The Haxion Brood, a criminal syndicate led by Sorc Tormo, makes its base on Ordo Eris, a planetoid from the cataclysm. On the watery planet of Castilon, the aptly named *Colossus* serves as a refueling and trading platform. This city-sized starship provides shelter and civilization where otherwise none would exist.

SCIENCE AND TECHNOL

OGY

Behind every great adventure and important event lies marvelous technology that aids heroes and villains alike. Some innovations, such as interstellar starships or hyperdrives, seek to advance galactic culture. Others serve to tear it down in the never-ending race to harness unimaginable power. For better or worse, these are the most notable scientific and technological advancements.

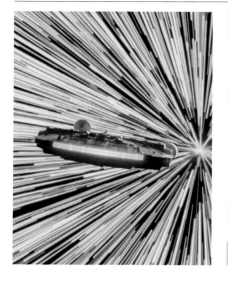

JUMP TO LIGHTSPEED
HYPERSPACE

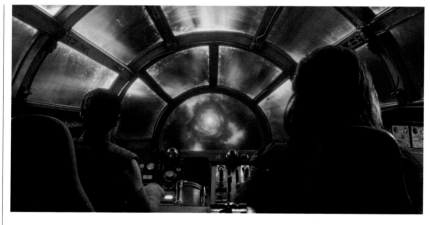

HOLOCRON FILE

NAME
Hypertravel

DESCRIPTION
Crossing space through the alternate dimension of hyperspace

NOTABLE TECHNOLOGIES
Hyperdrive; navicomputer; hyperfuel

Comprising billions of habitable systems, the galaxy is full of wondrous things to discover. With many regions, territories, and trade routes, crossing the entire galaxy would require more than a lifetime if not for the ability to travel faster than lightspeed. Thankfully for galactic travelers, hyperdrives allow ships to cross unimaginable distances in mere moments, hours, or days.

Ships equipped with a hyperdrive use a coaxium-coated reaction chamber that, upon being energized, propels the ship into an alternate dimension. During the Galactic Civil War, the rapid expansion of the Imperial starfleet and its attempt to control the material makes coaxium hyperfuel an exceedingly rare substance.

Upon entering hyperspace, passengers see the galaxy swirling past them in a hypnotic array of light. While the jump to lightspeed involves some turbulence, traveling through hyperspace is generally smooth enough to allow captains to relax with only minimal oversight of critical systems.

In battle, the most common use of hypertravel is to and from the battlefield, but there are rare cases of lightspeed jumps being used offensively. Launching a ship at

Buckle up A mesmerizing blue light fills the cockpit of the *Millennium Falcon* as it travels through hyperspace.

a target is a risky, suicidal strategy that some consider to be a result of luck as much as it is skill. After Vice-Admiral Holdo uses the tactic to destroy the First Order's Star Dreadnought *Supremacy*, it becomes known as the "Holdo Maneuver."

Pesky purrgil
The exact history of hypertravel has been lost to time, but the existence of the spacefaring purrgil might provide a clue as to the inspiration for the earliest travelers. These

enormous whalelike creatures consume the gas Clouzon-36, inhaling enough of the substance to enable them to jump to lightspeed. They travel in pods, jumping from system to system, often creating hazards for other space travelers. Pilots learn to hate the purrgil and the danger they pose to ships.

Dangers of hypertravel

Even with modern technology, traveling through hyperspace is a complex undertaking. It requires a carefully calculated route with a series of precise coordinates. Some ships rely on droids with limited preprogrammed jumps, while more advanced navicomputers provide almost infinite options by individually mapping each potential route. Unmapped jumps are incredibly risky maneuvers as the galaxy is full of hazards. Incorrect calculations risk launching the ship into asteroid belts, black holes, dust clouds, gravity fields, supernovas, electrical fields, imploded stars, pods of purrgil, or even the debris field known to smugglers as the Graveyard of Alderaan. Due to these dangers, a ship's "speed" is often calculated in parsecs, a unit of

distance. Han Solo famously claims the *Millennium Falcon* has made the Kessel Run in less than 12 parsecs. The fastest ships not only have

Purrgil pods These mysterious creatures traverse the galaxy, but their intentions remain unknown.

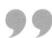

Sir, I noticed earlier the hyperdrive motivator has been damaged. It's impossible to go to lightspeed!

C-3PO

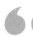

powerful engines, but use navicomputers that efficiently plot the shortest path around the many obstacles. The shorter the path, the faster the ship can travel.

Mapping the spacelanes

Previously explored routes for safe travel are known as hyperspace lanes. These routes link worlds along established paths, becoming strategically vital during times of peace and war. During the Clone Wars, many battles rage for control of these spacelanes. As new hyperspace lanes are established, worlds that were once popular stop-offs along older routes begin to see a decline in traffic. Batuu is one such place, but the advent of hyperlanes draws most legitimate traffic elsewhere, making the planet a haven for those who wish to go unnoticed.

Hyperspace routes open up a new era of prosperity, allowing trade between distant worlds and enabling species to colonize planets far from their native systems. Efficient hypertravel facilitates the rise of central governments like the Republic, allowing member worlds to engage in galaxy-wide politics. ∎

Sublight engines

For travel slower than the speed of light, most vessels rely on sublight engines. Whether using power from reactors or solar arrays, the engines convert that energy into thrust to propel the ship forward. Many engine designs use thrust rings to accelerate and direct the energy appropriately.

Ion engines are frequently adopted in starship design for their efficiency and compact size. This type of engine is so notable that the TIE fighter is

named for its engine arrangement —the Twin Ion Engine.

Powering sublight engines requires fuel, of which there are many forms. Rhydonium is a particularly volatile substance, but its explosive properties make it especially effective in starship propulsion. Some exotic designs allow for sublight travel even without a traditional engine, including Count Dooku's *Punworcca 116*-class sloop which unfurls a solar energy-collecting sail to enable it to fly without the need for fuel.

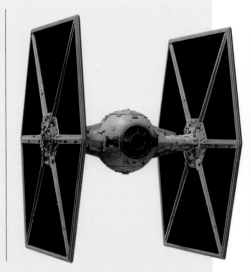

AMAZING AUTOMATONS
DROIDS

HOLOCRON FILE

NAME
Droids

DESCRIPTION
**Mechanical beings with
artificial intelligence**

MANUFACTURED BY
**Droidsmiths and
droid factories**

It is easy to dismiss droids as little more than mechanical servants, especially because most of them go about their work with little notice and even less recognition. Yet, a single droid can change its master's life for the better, and millions of droids can change the course of galactic history. Their intelligence might be artificial, but their impact is very real. From working droids fueling galactic industry to battle droids tipping the balance of power, there is a droid for every need.

Technical droids

Droids are ideal for repetitive, physically difficult, or highly technical tasks. While they aren't a complete substitute for organic beings' expertise, astromech droids are as close as one can get to a droid that can do it all. Housed within their metal bodies are tools for a variety of tasks, from starfighter repair to computer interaction. R-series droids are a best seller, with many interchangeable parts that the owner can customize for their unique needs. They prove to be as helpful on Outer Rim homesteads as they are in the droid socket of a starfighter.

While R-series models are still widely used in the time of the New Republic, modern BB-series units represent the latest in astromech technology. Trading treads and legs for

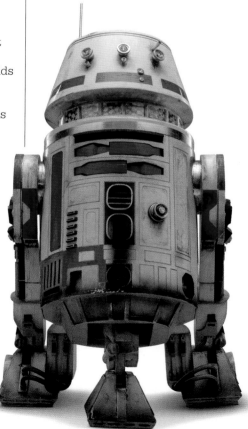

Astromech droid Rebel and Resistance technicians refurbish decades-old astromechs, mixing and matching components to keep the rugged droids operational.

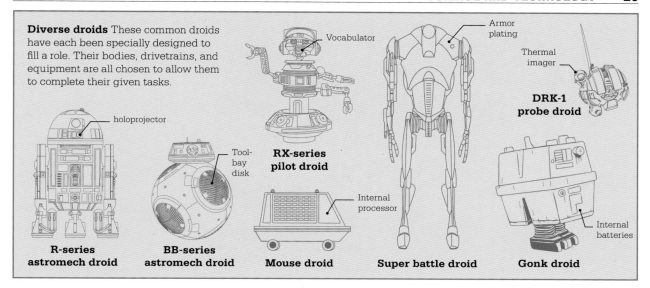

Diverse droids These common droids have each been specially designed to fill a role. Their bodies, drivetrains, and equipment are all chosen to allow them to complete their given tasks.

Vocabulator — RX-series pilot droid

holoprojector — R-series astromech droid

Tool-bay disk — BB-series astromech droid

Internal processor — Mouse droid

Armor plating — Super battle droid

Thermal imager — DRK-1 probe droid

Internal batteries — Gonk droid

a spherical body, the BB-unit features state-of-the-art gyroscopic propulsion systems. The tool-bay discs allow for rapid customization of its many attachments. Aside from their technical abilities, astromechs are prized companions that develop unique personalities if they are not subjected to frequent memory wipes—a sadly common occurrence across the galaxy.

Astromechs are able to carry out a variety of tasks, but other droids are built for a specific purpose. EG-series droids, or Gonk droids, are like walking batteries; they power other equipment and are a common site in starship hangars and work sites. They work alongside WED Treadwell droids, whose multiple arms offer precise manipulation for sonic welding and repair work. Their stalklike bodies have a low center of gravity and slow-moving treads that provide a stable base for these exacting tasks.

With so many individuals to serve, medical droids are in use across the galaxy. Their memory banks allow them to understand the unique physiologies of their diverse patients, and their mechanical precision is an advantage during surgery. Medical droids save the life of Darth Vader after his battle with Obi-Wan Kenobi on Mustafar. Working as a team, FX- and 2-1B series droids mitigate his burn damage while replacing his limbs with cybernetic alternatives.

Droid assistants

Where other droids put function before sophistication, protocol droids are designed to be relatable companions for their masters. Protocol droid designs imitate humanoid features, and their vocabulators allow for full speech. »

> I am a droid, I am always right.
> **TX-20**

Explorer droid BD-1, an old ally of Jedi Eno Cordova, accompanies Cal Kestis on his mission to save the Jedi Order.

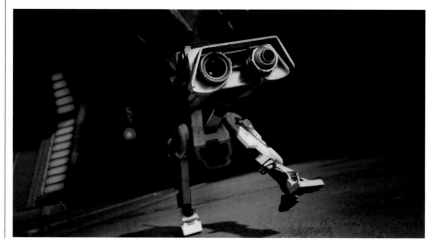

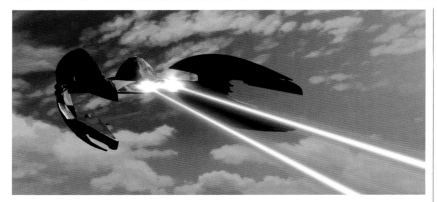

Their memories house millions of unique customs and alien languages, making them ideal assistants to politicians or those in service industries.

Pilot droids help captains and officers with the complicated task of starship command, sometimes even eliminating the need for a biological pilot entirely. The ability to interface directly with the ship allows a droid pilot to calmly navigate more hazardous routes than a living pilot might do alone.

Droids at war
Many associate war droids with those units that fight in the Clone Wars. Even before the conflict, the Trade Federation enlists battalions of droids to settle disputes and protect its valuable cargoes. Just as living soldiers learn to adapt, battlefield experience leads to

> Droids are not good or bad. They are neutral reflections of those who imprint them.
> **Kuiil**

upgrades in the Trade Federation's droid army. Early models rely on a central computer to control the entire army, but when that system is exposed during the Battle of Naboo, the Federation installs independent processing units in subsequent models. These B1 battle droids form the backbone of the Separatist army, augmented by more menacing variants. The Separatists build droids for every theater of war, including the underwater aqua droid models featuring built-in propellers. Droid starfighters fill the skies, such as the *Vulture*-class droid starfighter capable of launching discord missiles containing dozens of tiny buzz droids. If the starfighter is unable to shoot the enemy down with its cannons, the buzz droids will tear it apart piece by piece.

The Empire primarily relies on living soldiers, but retains some droids for specific tasks. KX-series security droids act as enforcers guarding key Imperial installations. Courier droids, often R-series astromechs, carry vital information that is too sensitive to be transmitted electronically. As Imperial buildings and starships grow to enormous size, MSE

ME-8D9 A loyal protocol droid who works for Maz Kanata, ME-8D9 is thousands of years old. Some believe that she used to work for the Jedi Order.

Vulture droid With built-in droid intelligence, Trade Federation starfighters fly without the need for a living pilot. On the ground, they can transform into small walkers.

"mouse" droids are employed to lead troops through the perplexing maze of corridors. When the Empire falls, the New Republic's demilitarization efforts lead it to adopt security droids to fill roles once performed by living guards. Some vessels, including interstellar prison ships, are entirely automated by the government.

Bounty hunting droids
Bounty hunting droids approach their trade with machinelike efficiency, providing a potentially lifesaving alternative to living hunters when tracking down high-risk suspects. For decades, bounty droids from the IG family of models serve as private security or freelance members of the Bounty Hunters Guild, the bounty hunter's regulatory body. Though there are

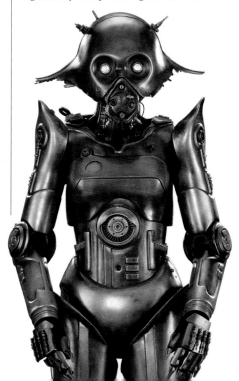

differences between models, these droids are easily identifiable by their cylindrical, sensor-laden heads. They are agile enough to outshoot most living beings and are physically tougher than organics.

Bounty hunter droids make ideal business partners, as their internal toolsets can apply healing bacta sprays or lift heavy objects. But like many droids, they struggle with ambiguity and have a slavish regard for the rules. This can make them ill-suited for the more complicated intricacies of the bounty hunting profession. Their programming forbids them from being captured, and if apprehension appears imminent, they will engage their self-destruct protocols.

Anti-droid sentiment

Despite droids improving the lives of billions of people, some still hold deep resentment toward them. While the reasons for such distrust are wide-ranging, many blame droids for the destruction and suffering of the Clone Wars. Memories of droid invasions linger in the minds of survivors, who swear off the use of droids entirely.

After General Grievous' ravaging of his homeworld during the Separatist crisis, survivor Ralakili establishes a droid fighting ring on Vandor, dedicating his life to watching droids destroy each other. Over time, the emotional scars fade and the galaxy grows more accepting, but droids rarely receive the same respect given to living beings.

Reprogramming

While droids will carry out their primary functions unquestionably,

Fighting rings Modified beyond their original purpose, gladiator droids have no choice but to battle for the entertainment of others.

their allegiance is not permanent. Through careful reprogramming, the former Imperial droid K-2SO comes to aid the Alliance, and the former bounty droid IG-11 gives up his ruthless ways to serve as a nanny droid. These unlikely allies both sacrifice themselves in order to protect their newfound masters. ■

Droid rights

In most parts of the galaxy, droids are viewed as property—much like any other piece of technology. As property, droids have few legal rights and fair treatment is at the discretion of their masters. Unjust handling raises questions of droid rights, a cause taken up by some droids and living beings alike. Though in the minority, they contend that memory wipes and restraining bolts should be outlawed. They stand up to physical torture and droid fighting rings as a form of entertainment.

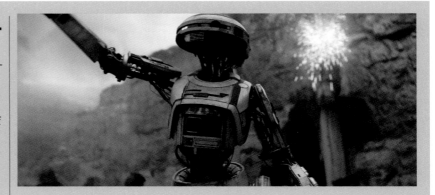

One vocal proponent of the droid rights movement is L3-37, the copilot of Lando Calrissian's ship, the *Millennium Falcon*. L3's outspoken stance often gets them both in trouble, but on their

ill-fated mission to Kessel it proves to be her downfall. She inspires a droid uprising among the worker droids in the Spice Mines, but is destroyed fighting for what she believes in.

SMALL ARMS
BLASTERS

HOLOCRON FILE

NAME
Blasters

DESCRIPTION
Handheld energy weapons

MANUFACTURERS
**BlasTech Industries;
Merr-Sonn Munitions;
WESTAR (among others)**

T he most common weapon in the galaxy is the blaster. Favored by militaries, gangsters, rogues, and royals alike, blasters provide dependable firepower for just about any application. The concept of firing projectiles has been around since ancient times, and in some societies guns that fire physical projectiles are still in use. Thousands of years before the Galactic Civil War, these projectile weapons gave way to energy blasters that are easier to reload and more effective than the ancient weapons. No matter their specialized purpose, the basic function is largely the same. Using an energy source, often a cartridge filled with energized gas, a blaster propels a glowing particle beam at high speed. Depending on the gas and design of the blaster, different color bolts are possible. Red is the most common, but green, blue, and yellow are potential variants. Blaster bolts form a finite blast, setting them apart from lasers which emit a steady stream of energy. As such, lasers are typically reserved for stationary, crew-mounted, or vehicle-mounted

Energy beams Blast size and power are the main differences between a blaster and a cannon; lasers function differently.

weapons where a laser can be reliably aimed on target for a time.

Blasters are found in almost every imaginable configuration to match the myriad mission profiles or unique physiology of the user. Blaster pistols are compact variants that trade firepower and capacity for excellent mobility. Hip-holstered pistols provide handy protection and are favored by Han Solo, who is famous for carrying a heavily modified DL-44. Some users favor concealability in their pistols, such as Queen Amidala's short-barreled ELG-3A stored in the arm of her royal throne on Naboo.

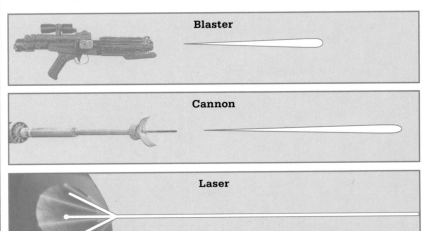

Set for stun

For situations where lethal force is not required, many blasters have a stun setting that modifies the output from a deadly blaster bolt to an incapacitating blast. These stun attacks are easily distinguished from traditional blaster bolts by their distinct sound and blue rings. The stun is strong enough to temporarily knock most humanoids unconscious, while not causing lasting physical damage. It's a useful tool for taking captives or capturing bounties alive, as effects generally only last for a period of a few minutes, long enough to detain the target permanently.

Leia Organa has been on both ends of a stun blast: once being taken prisoner by stormtroopers on *Tantive IV* prior to her interrogation by Darth Vader; and another during her time leading the Resistance when she stuns Captain Dameron after his attempted mutiny against Vice Admiral Holdo.

Hokey religions and ancient weapons are no match for a good blaster at your side, kid.

Han Solo

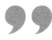

Stylish shooting Lando Calrissian's customized SE-14r pistol reflects his refined tastes.

Heavy weapons

With longer barrels and a heavier frame, blaster rifles sacrifice some maneuverability, but pack more of a punch than a pistol. During the Clone Wars, Republic troops most commonly shoulder blasters from the DC-15 family, offering troops shorter carbine variants as well as long-barreled rifles. They face off against B1 battle droids equipped with E-5 blaster rifles or the integrated weapons systems built into droidekas or B2 super battle droids. The B2's blasters are supplemented with wrist-mounted homing rockets, projectile weapons that gain infamy among the clone troops who face them.

Heavy blasters provide serious firepower for individual soldiers by offering higher rates of fire than smaller models. Often used by specially trained Imperial stormtroopers, the DLT-19 and RT-97C are just two models found in Imperial armories. Rebel shock trooper Cara Dune is known to prefer these more serious weapons in a firefight. Among the most powerful blasters, the E-Web heavy repeating blaster cannon is a crew-served platform that can mow down personnel and equipment alike.

Arms manufacture

No matter the model or war, the production of blasters is big business. During the Galactic Civil War, BlasTech Industries supplies the Imperial military with its most successful small arm in company history: the E-11 blaster rifle. It expands its manufacturing operations to meet the increasing demand, establishing new factories on expansion worlds such as Lothal.

After the fall of the Empire, treaty restrictions prevent weapons manufacturers from supplying arms to the First Order. This edict leads BlasTech and its rival Merr-Sonn Munitions to form a joint venture: Sonn-Blas Corporation. Operating from the Unknown Regions, this new entity ensures that both companies profit from the First Order's rise by manufacturing and supplying most of its weaponry. ∎

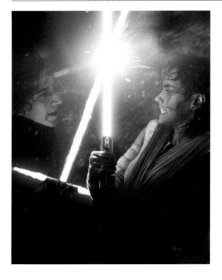

ELEGANT WEAPON
LIGHTSABER

HOLOCRON FILE

NAME
Lightsaber

DESCRIPTION
Energy melee weapon

NOTABLE WIELDERS
Jedi and Sith

This weapon is your life.
Obi-Wan Kenobi

A lightsaber is more than a sword; it is a reflection of the Force user who wields it. The most enduring symbol of the Jedi Order and its eternal enemies the Sith, the lightsaber is a unique weapon that can be used for attack and also serves to shield others from danger. Throughout time, laser swords win wars, topple Republics, and help bring down Empires. They are surprisingly simple in their construction, yet full of complex history and mysterious ritual.

The lightsaber's pure energy blade can cut through almost any solid material and is best blocked by the energy of another saber. The electrostaff, an energized polearm, is among the few weapons that can withstand its strike. Sabers work underwater, in the vacuum of space, and—unlike blasters—do not require the user to reload it in the heat of battle. While a lightsaber can be used by anyone, in the hands of a Force wielder it lives up to its full potential.

Lightsabers come in a variety of colors, sizes, and styles. Determined by the kyber crystal inside, most Jedi sabers are green or blue,

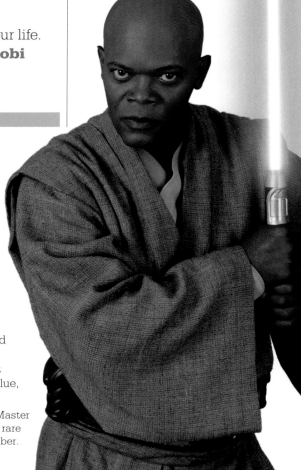

Purple power Jedi Master Mace Windu wields a rare purple-colored lightsaber.

Kyber crystals

At the heart of any lightsaber is the kyber crystal, a naturally occurring Force-attuned stone that focuses and amplifies energy. The crystal is said to choose its user, creating a deep connection between it and the one who finds it. Upon its discovery, the crystal takes its color.

In the time of the Jedi Order, younglings traveled to the planet Ilum in search of their first kyber crystal. Upon entering the icy caves there, each youngling faces a personal trial testing their determination and ultimately revealing to them their unique crystal. In the years after the fall of the Order, Jedi hopefuls must find crystals in other sacred places, or take up the lightsabers of Jedi past.

During this dark period, those who continue to believe in the Force recognize the spiritual value of kyber crystals. The Empire desecrates sacred sites and ravages Ilum in search of the crystals for its own nefarious purposes.

but on rare occasions can be purple. Yellow is typically the color found in the sabers of the Jedi Temple Guards and in some circumstances, other colors have appeared. Dark side users' blades are mostly red, a biproduct of corrupting the crystal with the dark side in a process called "bleeding." If a crystal is spared from its corruption, it transforms into a brilliant white, as they are in former Jedi Ahsoka Tano's sabers.

Design and build

Most lightsaber blades extend to approximately 91 cm (36 in). Master Yoda's saber is shorter than average, matching his small stature. A lightsaber's hilt is a unique creation of each handler, gathering materials of all types. The general construction of each saber is the same, including an end cap, a grip sleeve, a switch to ignite the blade, and an emitter that projects the blade itself. The final design is often a reflection of its user. Count Dooku's lightsaber is notably refined, its curved hilt designed to give him precise control to match his fluid fighting style. Mace Windu's purple-bladed saber

is both sleek and exact, with its sharp vertical lines balanced by an electrum-plated alloy finish. Though most wielders use just a single blade, some, like Ahsoka Tano or Asajj Ventress, carry two. Others, including Darth Maul, Jaro Tapal, and Pong Krell use hilts with two opposing blades, forming a staff-like saber. Kylo Ren's saber harks back to ancient designs with its primary blade augmented by smaller cross guard blades. His cracked kyber crystal creates an unstable, ominous blade.

Lightsaber wielders spend countless hours honing their skills. For the Jedi, training begins when they are younglings. Practice sabers are used to teach the basics until the students take part in a ritual called the Gathering when they enter the sacred Crystal Cave on Ilum to find a kyber crystal that matches their Force presence. For generations, the ancient droid Huyang has overseen the creation of nearly every Jedi saber, helping each student choose the right materials and assemble the parts. ∎

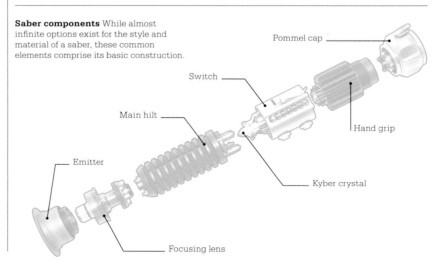

Saber components While almost infinite options exist for the style and material of a saber, these common elements comprise its basic construction.

Pommel cap

Switch

Main hilt

Hand grip

Emitter

Kyber crystal

Focusing lens

PROTECT AND DEFEND
SHIELDS

HOLOCRON FILE

NAME
Shields

DESCRIPTION
Energy fields to protect beings and things

TYPES
Deflector shields; plasma shields; ray shields; particle shields

Not all energy technologies are turned into weapons. In fact, some serve the opposite purpose, acting as shields to defend the lives of their users. Energy shields give pacifists and combatants alike a chance to survive the barrage of offensive weaponry they might face by either deflecting energy blasts or absorbing energy altogether. Some form nearly impenetrable barriers, while others allow objects to pass through if moving at the optimal speed and trajectory.

The smallest shields provide personal protection for humanoid-sized users. Some Mandalorian gauntlets feature energy bucklers, portable shields no more than 50 cm (20 in) in circumference that provide protection from blaster shots.

Droideka destroyer droids have a fierce battlefield reputation thanks to their heavy armament and shield generators that project a spherical barrier around the entire unit. During the Clone Wars, opposing troops learn that the energy shield will allow slow-moving objects to pass through, meaning a well-placed thermal detonator can roll inside the shield perimeter and explode at the droids' feet.

Shields of many types are found on Naboo where native plasma is harvested and turned into a variety

Angle the deflector shields while I charge up the main guns!
Han Solo

of Gungan technologies. The Gungan Grand Army employs personal shields for its front-line infantry and larger animal-mounted generators that encapsulate the entire ground force. Their preference for shields is no coincidence: it's a reflection of the Gungans' longstanding need to shield themselves from outsiders.

Starship shields

The most common application of shield technology is on starships. Capital ships employ powerful shield generators to surround the entirety of the vessel, giving the vessel more resilience against broadside barrages from enemy battleships and deterring all but the most foolhardy starfighter attacks. Imperial Star Destroyers feature two deflector shield generators sitting prominently atop their command towers. Rebel starpilot training encourages focused fire on these points. Should the domes be destroyed, the entire ship is exposed. The bravest fighter pilots learn that small ships can fly inside the shield's protective barrier, meaning that if they can get close enough, they can bypass the shield entirely. The Resistance flagship,

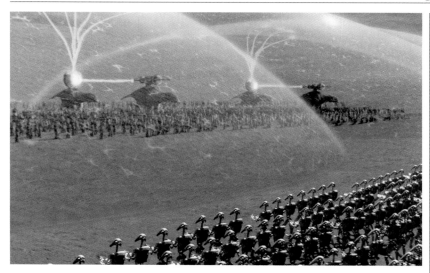

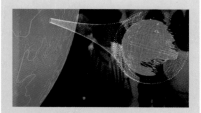

Attack on Endor

While the Empire constructs the first Death Star in secret, its discovery and destruction teaches the Imperials to better protect the station that follows. The Empire constructs a new Death Star in orbit of the Forest Moon of Endor, positioning the station just outside the moon's atmosphere. Its low orbit falls within range of a ground-based shield projector, housed in a sizable facility below. The SLD-26 planetary shield generator envelops the entire station in a powerful barrier, preventing rebel attack while the station is under construction.

If the Alliance has any hope of destroying the station, it must first sabotage the shield. Its approach to defeating this mechanical marvel is decidedly low tech: it will simply infiltrate and install explosives inside the shield generator. With the help of the Ewoks, the shield comes down and the station is subsequently destroyed.

the *Raddus*, is outfitted with experimental deflector shields that can withstand massive damage when correctly angled against incoming fire, without which the Resistance might not have survived its flight from the First Order.

The *Millennium Falcon* is equipped with military grade shield generators, including one model for the bow and a different type for the stern. These augment the salvaged armor plating applied to critical areas of the hull, allowing Han Solo to escape more than one situation where he is outgunned. Solo's fellow rebels use shield technology in their fighters to conserve their valuable ships and pilots, providing them with protection the Empire generally doesn't afford its own fighter pilots.

Stationary and planetary shields

Stationary shield generators vary in size depending on their purpose: ranging from just a few meters wide to models that could surround an entire sector of a planet.

War beasts Teams of fambaas carry Gungan energy shield generators into battle on Naboo's Great Grass Plains.

When Chancellor Palpatine makes public appearances during the Clone Wars, a shield is erected to protect him from assassination attempts. The Separatists use shields, defending their droid troops with large generators at the Battle of Christophsis and the Second Battle of Geonosis, among others.

During the Galactic Civil War, the Empire guards the entire planet of Scarif with a planetary shield, hoping to shelter the valuable archive there from infiltration. Though it doesn't protect the full planet, the Rebel Alliance repurposes Imperial shield generator technology to prevent orbital bombardments of its base on Hoth.

Personal protection Gungan infantry use handheld energy shields to protect against blaster fire and weapons in battle.

Later, the First Order uses a planetary shield to inhibit access to Starkiller Base. Yet even with shields that cover an entire planet, no barrier is ever truly impenetrable. In nearly all cases, and with a little ingenuity, the opposing side finds a way to circumnavigate, deactivate, or destroy such shields. ∎

DEFYING GRAVITY
TRACTOR BEAMS AND REPULSORS

HOLOCRON FILE

NAME
Tractor beams and repulsors

DESCRIPTION
Technological manipulation of gravity

MANUFACTURERS
Aratech Repulsor Company; SoroSuub Corporation; Rothana Heavy Engineering (among others)

Gravity is a powerful natural force, but through advances in technology it can be overcome or even exploited. Tractor beams and repulsorlifts are separate—but fundamentally related—technologies, as each is designed to defy gravity in some way. Repulsors push against gravity's force, while tractor beams act to pull an object closer, each becoming a vital tool in military use, galactic trade, travel, and daily life.

Repulsors
Repulsorlifts power speeders, starships, and even smaller objects like sleds or chairs allowing them to float or fly through the air. Modern repulsorlift technology is exceedingly efficient and able to be fitted into relatively small chassis. Some objects, such as carbonite blocks or storage crates, have repulsors built into their frames, allowing them to be pushed with ease as they hover just above the ground. Repulsor sleds assist in the movement of objects lacking their own lifts and are a common

Child care Bounty hunter Din Djarin discovers a Force-sensitive surprise in a repulsor-powered baby carrier.

sight in factories or hangars where individuals must rearrange heavy equipment. In domestic situations, repulsorlift chairs provide mobility for those with physical impairments. Repulsor-equipped baby carriers afford a smooth ride for younglings while helping parents keep their children close at hand.

While the designs of airspeeders, landspeeders, speeder bikes, and swoops can vary widely, they all rely on the same technology to operate. Repulsor units arranged in a cluster, matrix, or array keep the vehicle floating at nearly all times. At high speeds, repulsorlifts create significant heat requiring a cooling matrix or exhaust manifold

We're caught in a tractor beam. It's pulling us in.
Han Solo

Jetpacks

For individuals who prefer ultimate mobility without the need for a speeder, jetpacks give the power of flight to anyone brave enough to try it. The Republic trains special jetpack troopers to fight against battle droids, and Imperial jumptroopers continue the tradition well into the Galactic Civil War. The jetpacks, worn on each soldier's back, contain limited fuel to propel the soldier into the air, enabling them to bound over obstacles or rain fire down upon their target.

Mandalorian warriors are known for using jetpacks, a technology they call the Rising Phoenix. Training in how to use these jetpacks is accompanied by countless hours of drills. Fully mastering this equipment makes a Mandalorian soldier even more deadly than normal, adding speed, verticality, and agility to their already impressive arsenal.

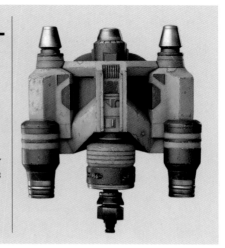

to prevent the unit from overheating. Many speeders come equipped with static discharge vanes to prevent the buildup of dangerous energy as the vehicle moves through the environment.

Tractor beams

By using artificial gravitational forces, tractor beams can take hold of, and control, an object. They are most commonly affixed on starships where they can be aimed at other vessels. It takes one or more tractor beam projectors to effectively take hold of the object, where they can then push or pull that object as desired. If sufficiently powered, the invisible beams can create an attraction so strong that the object cannot get away under its own power.

Pilots and industrial workers are frequent users of tractor beams, manipulating cargo, or gathering up material from relative safety. Military applications are common as well—controlling a vessel is sometimes more desirable than disabling or destroying it.

As the Galactic Empire seeks to take a figurative grip on the galaxy, tractor beams make it a reality. Imperial Star Destroyers feature powerful tractor beam arrays on the bow of the ship, used in the pursuit of other vessels. Princess Leia Organa's *Tantive IV* is captured in such a fashion as she flees with the first Death Star plans just prior to the Battle of Yavin. Once her ship's main reactor is deactivated, the Imperials tow it into the main hangar for boarding by their troops. For star systems where piracy is a concern, the Imperial Navy employs *Cantwell*-class cruisers: starships designed around three powerful tractor beam projectors. Suspicious ships or vessels that don't comply with Imperial instruction are towed into the cruiser's hangar for closer inspection. The Death Star battle stations are dotted with a number of tractor beams. Ships that pass too closely are pulled in, and rarely can a vessel escape under its own power unless the tractor beam generators are shut down from within the Death Star. ∎

Speeding scavenger Rey's speeder is her own unique creation, fashioned out of scavenged parts.

SPACE TRAVELERS
STARSHIPS

HOLOCRON FILE

NAME
Starships

DESCRIPTION
Spacefaring vessels

MANUFACTURERS
Corellian Engineering Corporation; Kuat Drive Yards; Incom Corporation; Sienar Fleet Systems; Koensayr Manufacturing (among others)

The explosion of galactic interplanetary travel creates the need for spacefaring vessels of all types. Trade calls for freighters and civilian transports of various sizes. Protecting such vessels and their homeworlds falls to military craft, ranging from tiny starfighters with room for just a single pilot, to giant capital ships that can accommodate upward of 40,000 passengers and crew.

Freighters

While military vessels vie for control of the stars, most space traffic is made up of far more modest civilian vessels. Transport pilots and smugglers ferry goods in countless freighters, and none is more famous than the *Millennium Falcon*. The Corellian YT-1300 light freighter changes hands often during its operational life, most notably as Lando Calrissian's sporting vessel before it passes to Han Solo. Calrissian's modifications favor style as much as performance, a design

choice not shared by Solo. Han's numerous (and sometimes illegal) upgrades push the limits of the freighter, making it ideal for getting out of trouble during many ill-advised smuggling jobs. Solo transforms the already speedy ship into one of the fastest in the galaxy, growing his—and its—reputation during many feats and missions for the Rebel Alliance.

Multi-crew vessels from capital ships to freighters often carry escape pods for use in emergency.

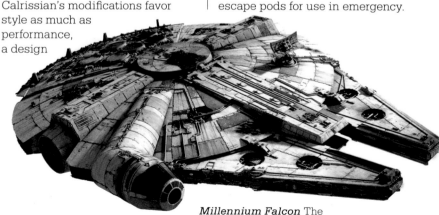

Millennium Falcon The hard-worn exterior of Solo's ship is the result of frequent trouble.

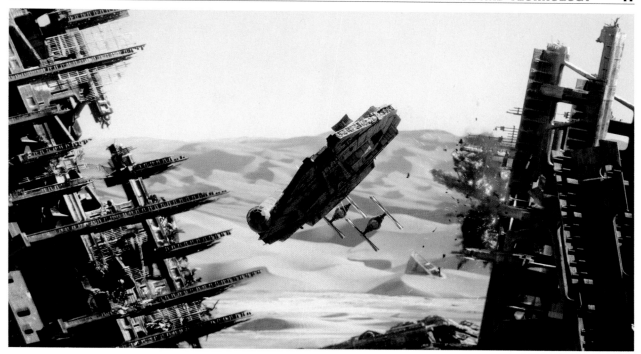

Jakku flight Better armed than most freighters, the *Millennium Falcon* makes another escape from TIE fighters.

The smallest hold just a single being, but most can fit two or more passengers. Once launched, the pod carries its passengers to nearby inhabitable planets or, if a safe landing location is not accessible, offers enough life support to allow for a rescue by another vessel.

Manufacture and evolution

Starships are built in dockyards and factories galaxy-wide, though some builders achieve greater commercial acclaim than others. Kuat-Entralla Engineering emerges to covertly build the First Order's Star Destroyers, Siege Dreadnoughts, and the Sith Eternal's *Xyston*-class Star Destroyer. This new entity works in secret to build the vessels and send supplies to Exegol.

The planet of Corellia is famed for both its shipyards and the

difficult life led by those who work them. It is a notoriously undesirable place, and shipbuilding is an arduous trade for those who toil in the docks. Perhaps it is for this reason that some of the best starpilots in the galaxy come from Corellia, as not only are they familiar with starships from a young age, but they also have plenty of motivation to leave the planet.

You've never heard of the *Millennium Falcon*? It's the ship that made the Kessel Run in less than 12 parsecs.
Han Solo

The orbital shipyards like the Kuat Drive Yards are so large that they form a ring around the entire planet. Colonists flock to places like the Nadiri Dockyards in the Bormea sector in search of work, causing tensions with the homeworlders. Though the shipbuilding process remains largely the same, the ships themselves evolve with the introduction of new models and improved technology.

In the age of the Republic, buyers look for style and elegance in their starships, but as the reign of the Empire takes hold, with it comes new sensibilities. Craftsmanship gives way to practicality. Sleek curves decline in favor of harsh uniformity. The Empire isn't interested in aesthetics or technological advancements when mass production and sheer size will do. In the decades after the Empire's end, many of these features live on in their First Order successors, though the technology within improves significantly. »

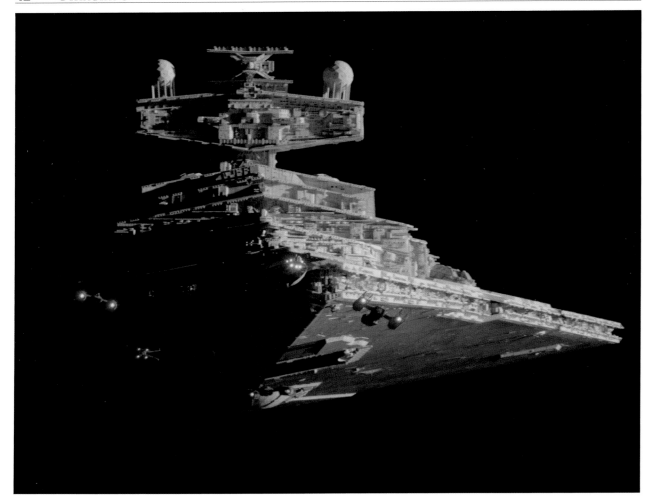

Vader's flagship At the Battle of Scarif, Darth Vader's Star Destroyer, the *Devastator*, arrives to face the rebel fleet.

Ten thousand?
We could almost buy our
own ship for that!
Luke Skywalker

Most battles are won not so much by the actions of admirals in flagships, but by the bravery of the starfighter pilots they command. Fighter pilots sit at the controls of small ships, often the sole occupant of the vessel, flying in ships that seem fragile by comparison to larger vessels. A starfighter pilot's fate lies in their own hands, for it is by their own flying and shooting that they live or die.

Imperial pilots are put in the most precarious circumstances. The TIE fighters they pilot offer great speed and respectable firepower, but give no protection in the form of shields. They are manufactured in the millions by Sienar Fleet Systems, which develops multiple variants for virtually every military application. From destructive bombers to the aptly named "brute" brandishing heavy cannons, the TIE design constantly evolves.

The Rebel Alliance lacks similar production capabilities leading it to source fighters wherever it can. The Y-wing dates back to the Clone Wars, but proves to have surprising relevance long after the Empire falls. The most enduring fighter in rebel hands is the X-wing. An evolution of the earlier Z-95 Headhunter, the X-wing is an all-around performer.

The T-65B X-wing is the backbone of the Rebel Alliance and personal favorite of Luke Skywalker. The Jedi keeps his ship—named Red Five—until long after the war. Successive models build upon its impressive capabilities, leading the New Republic to adopt the T-70 and T-85 models for its defense fleets. The T-70, considered outdated by the time Leia Organa forms the Resistance, is the mainstay fighter of her fledgling fleet. More than 30 years after the last war ended, the next conflict sees X-wings face TIE fighters once again in battles that make heroes out of brave pilots.

Capital ships

Among the largest vessels in the galaxy are capital ships, generally the most impressive and important ships in the military fleet. The Star Destroyer is the most representative example, with its modern roots dating back to the Republic's *Venator*-class ships. While a capable warship that made many officers into heroes, it is phased out by the Empire in favor of larger *Imperial*-class Star Destroyers to better project Imperial power across the stars. Each vessel boasts more than 40,000 passengers and its heavy weapons allow for orbital

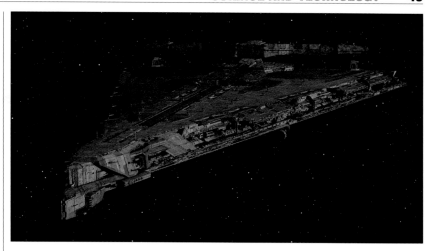

Heavy weapon The First Order's Dreadnought *Fulminatrix* has more firepower than a dozen Star Destroyers.

bombardment of ground targets. Attacking one is considered a suicide mission, so the presence of a single destroyer is often enough to keep a planet in line. They outclass virtually every contemporary, including the Rebel Alliance's Mon Calamari cruisers.

These larger ships house internal landing bays to launch smaller vessels, including dozens of starfighters. The First Order builds upon the Star Destroyer's legacy with its *Resurgent*-class vessels,

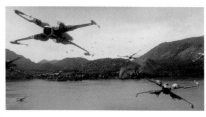

Nimble fighters The Resistance uses surplus T-70 X-wings in its battle against the latest First Order TIE fighters.

an impressive upgrade in virtually all respects. But even the *Resurgent* pales in comparison to the warship the *Mandator IV*-class Siege Dreadnought—a colossal platform that lays waste to cities and fleets. ∎

Spaceports

Dotting the outskirts of the tiniest towns or towering among the most sprawling metropolises, spaceports offer a valuable service to captains in search of safe harbor. Here they can dock their starships for repairing, refueling, or just laying low in a safe spot. More populous cities operate under traffic controllers who assign landing pads, while more isolated ports are self-governed. Imperial crackdowns lead to strict checkpoints on worlds like Corellia where agents must approve every being who comes and goes from this strategic manufacturing center.

The local cantina, Bounty Hunters Guild representatives, and pilots for hire are never far from the local spaceport, making it a center of life for many citizens and entrepreneurs who seek business opportunities in adjacent industries.

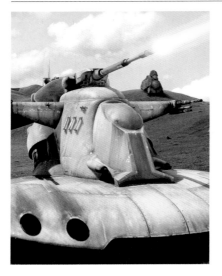

TERRESTRIAL
TRANSPORTATION
PLANETARY VEHICLES

HOLOCRON FILE

NAME
Speeders and walkers

DESCRIPTION
**Low altitude and
atmospheric transportation**

HAZARDS
**Object collision; hijacking;
mid-flight repulsor
malfunction**

Crossing the vast expanse of planets or traveling through any of the galaxy's bustling cities often requires the use of vehicles classified as speeders.

Found in many home garages, landspeeders are an economical form of transportation for rural and urban dwellers alike. Luke Skywalker finds some semblance of freedom in his youth at the controls of an X-34 landspeeder. Even this older model could crisscross Tatooine deserts at speeds of up to 250 km (155 miles) per hour.

For those looking for speed—and maybe a little danger—speeder bikes and swoops provide increased performance and maneuverability at the expense of cargo capacity. The Aratech 74-Z is a popular model during the Clone Wars and beyond. Imperial troops employ them regularly for scouting operations under the control of specially outfitted scout troopers. The 74-Z's forward-mounted blaster cannon is an effective armament against ground troops when used in hit-and-run strikes. Moving at such rapid speeds on a lightly armored vehicle leaves the rider quite exposed; one wrong move could lead to serious injury or, most likely, death.

The Cloud-Riders led by Enfys Nest rely on more powerful and dangerous swoop bikes, a type of vehicle that gains infamy for its popularity among outlaws. Their repulsorlifts can achieve greater altitude than landspeeders, making them more practical for traveling over rocky terrain.

Airspeeders are specially designed for higher altitude atmospheric flight. They fill the skies of the city-planet Coruscant, where the wealthy owners zip through the skies

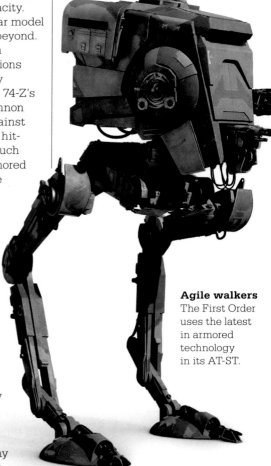

Agile walkers
The First Order uses the latest in armored technology in its AT-ST.

Animal transports

In some harsh environments and backwater worlds, living creatures prove to be more dependable or economical than machines. Despite being low-tech, some animals can even outperform technology. On Tatooine alone, the dewback, bantha, eopie, ronto, jerba, and etobi are among the animals used as pack beasts and for transportation.

If properly trained, blurrgs can serve as mounts and are valued on planets like Ryloth for their steady demeanor in the heat of battle. The Twi'lek freedom fighters take great pride in their creatures, thinking so highly of them that they consider the blurrg superior to Republic All Terrain Recon Transport (AT-RT) walkers. Another creature used in battle is the orbak, a horselike quadruped from the moon Kef Bir tamed by Jannah and her tribe. They take part in the Battle of Exegol, bravely mounting a charge against armored Sith troopers.

in a chaotic array of traffic lanes. Here, where most citizens never even see the highest levels, owning a personal speeder is a status symbol beyond the imagination of most of the population.

Armored vehicles

Walkers and tanks bolster infantry forces in ground combat, using powerful cannons and hardened armor to lay siege to entrenched defenders. The Confederacy of Independent Systems employs a number of droid battle tanks, including the Trade Federation's Armored Assault Tank (AAT).

The AAT's standard armaments are fearsome, tearing through ground troops with a heavy cannon, antipersonnel lasers, and projectile launchers. It can face off against the Republic's all terrain walkers, including the six-legged All Terrain Tactical Enforcer (AT-TE). These walkers are the predecessors of Imperial models, evolving into even more hulking behemoths than the Republic commands.

The All Terrain Armored Transport (AT-AT) stands upon four towering legs, firing down on enemies with multiple cannons. It can double as a troop carrier,

ferrying infantry inside its blast-resistant hull. Two-legged walkers provide even more flexibility, bringing intermediary firepower in a smaller package. The bipedal All Terrain Scout Transport (AT-ST) requires just two crew, but can wipe out whole companies of infantry.

The First Order carries forward the armored tradition, building its own AT-ST, AT-AT, and the even more imposing All Terrain Mega-Caliber 6 (AT-M6). Its walkers are upgraded with the latest technology, but share developmental DNA with the walkers of the Republic some 50 years earlier. ■

Luxury models Residents of the casino world Canto Bight display their wealth with some of the most expensive speeders credits can buy.

Ever since the XP-38 came out, they just aren't in demand.
Luke Skywalker after selling his XP-34

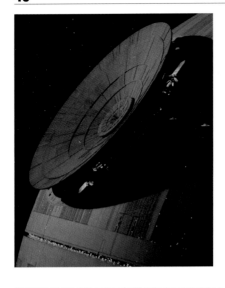

ULTIMATE POWER
SUPERWEAPONS

HOLOCRON FILE

NAME
Superweapons

DESCRIPTION
Weapons of mass destruction

AIM
Military victory through unprecedented power

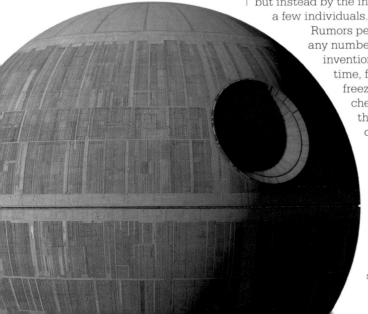

In the never-ending arms race for control of the galaxy, some choose to develop ever more powerful superweapons that outclass anything else on the battlefield. These technological terrors are a display of vision, might, and often hubris. They're the result of believing that great power will lead to complete control. Yet in almost all circumstances, they turn out to be great failures. Ironically, these costly weapons are undone not by rival technological marvels, but instead by the ingenuity of a few individuals.

Rumors persist of any number of terrible inventions throughout time, from interstellar freeze rays to chemical weapons that turn organics into stone. What is certain is that

some mega weapons are indeed real. One of the earliest known examples is the great engine designed by the Sith Lord Darth Momin. This weapon has the ability to destroy an entire city, a great feat in its time. It is part of the Sith's superweapon tradition, as more than a thousand years later, Darth Sidious lays out plans for terrible devices of his own.

The Death Star Orbital Battle Station is to be the Empire's ultimate weapon. Its development begins before the Clone Wars when the Geonosians create the schematics for a moon-sized battle station. A theoretical platform at

Super-sized
At 160 km (99 miles) in diameter, the Death Star is the size of a small moon.

This station is now the ultimate power in the universe. I suggest we use it.
Admiral Motti

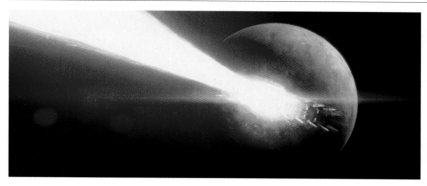

Fierce machine Starkiller Base, located on Illum, fires its kyber-powered weapon across the galaxy.

that point, the plans are entrusted to Darth Tyranus so that his master can begin construction after the fall of the Republic. While it requires a massive diversion of resources, assembly of the station itself is relatively straightforward. The station's many delays are caused by its problematic main weapon, which proves to be a research and development nightmare.

Under the leadership of Director Orson Krennic, Imperial scientists aim to harness the power and amplification of kyber crystals to create a laser that is powerful enough to destroy a planet. The practical application of this theory causes years of delays until Galen Erso solves the technical challenges. Once completed, the Death Star's weapon lives up to expectations and its most devastating test destroys the planet of Alderaan entirely.

Deep within the station lies a fatal flaw which is seized upon by the Rebel Alliance. They destroy the station with a targeted starfighter assault. While some in the Empire see this failure as a reason to change doctrine, the Emperor remains committed. Undeterred by history and to the dismay of some in his high command, he begins construction of a second Death Star.

The Empire takes steps to ensure the Death Star II is better protected than its predecessor. Its reactor flaws are rectified and the station is enveloped in a defensive shield throughout its rushed construction. Before it can be completed, Palpatine attempts to use his precious station to lure the Rebellion into a trap, but his scheme fails. The second battle station suffers the same fate as the first.

Starkiller Base

The scientific principles that power the Death Star are applied on an even more terrifying scale with the construction of Starkiller Base. There, the First Order converts the planet of Ilum into a superweapon, harnessing the planet's kyber-rich core to support a weapon that could fire across the galaxy. Charging the laser requires the energy of a nearby sun, which is consumed entirely to power each blast. The First Order destroys the entire Hosnian system (and with it the New Republic fleet) before the Resistance can infiltrate and obliterate the station.

Emperor Palpatine's return to the galactic stage brings another superweapon threat. His Sith Eternal fleet of *Xyston*-class Star Destroyers threatens to deploy across the galaxy armed with precision superlaser cannons. These would have decimated thousands of planets had it not been for the arrival of a Resistance-led fleet. ■

Mega ships

Naval warfare evolves with the advent of ever more impressive capital ships, harnessing unprecedented size and firepower to dominate space battles. The Separatist Alliance constructs the *Malevolence*, a warship armed with mega-ion cannons that can disable an entire Republic battle group in a single blast.

Having scaled up its Star Destroyers, the Empire continues to push the size of its fleet with the *Executor*-class Star Dreadnoughts. These Super Star Destroyers stretch more than 12 times longer than the standard *Imperial*-class and serve as flagships for the highest-ranking Imperials. Darth Vader and Emperor Palpatine each take one as their command ship.

Supreme Leader Snoke oversees the First Order from his own megaship, the *Supremacy*. The vessel is so large that it serves not only as a command center and battleship, but also as a mobile manufacturing center to further arm the First Order's expansion.

MASS PRODUCTION

CLONING

HOLOCRON FILE

NAME
Cloning

DESCRIPTION
Genetic duplication of an organism into one or more identical copies

NOTABLE EXAMPLES
Clone Army of the Republic

The field of genetics yields many great discoveries over time, but few are more important than the discovery of cloning. While practiced elsewhere, it is the Kaminoans who are best known for turning the science into big business. Using the DNA of bounty hunter Jango Fett, they grow millions of clone soldiers for the Republic. Each clone is physically identical to the donor, but the Kaminoans alter some aspects of their DNA to make them more docile.

Though the Kaminoans have nearly perfected the art, cloning humans is not a perfect science. The occasional genetic or physical defect is possible, leading to both wanted and unwanted specimens. One genetic sample can create millions of copies, but they do not last forever. The host sample degrades over time, requiring the donor to remain available for replacement samples or a new host to be adopted.

During the Clone Wars, the DNA record of Jango Fett is considered a military asset of the highest importance. The Separatists stage an elaborate attack on Kamino in an attempt to stop the production of new clones. The destruction of the clone DNA room would bring production to a halt, but the

Clones can think creatively. You will find that they are immensely superior to droids.
Prime Minister Lama Su

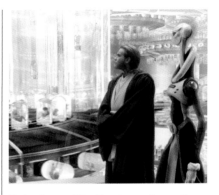

Baby boom The Kaminoan Lama Su shows Obi-Wan Kenobi the growing clones, among the finest ever created.

Republic soldiers consider Kamino their home and give their all to defend it. Their bravery ensures that cloning will continue, at least for the time being.

After the fall of the Republic, new recruits take the place of clones in the Imperial army, but Emperor Palpatine remains interested in cloning for his own sinister reasons. Rumors spread of Imperial attempts to create clones of unique species. After his body is destroyed aboard the Death Star II, Emperor Palpatine transfers his consciousness to a cloned body of himself that is in wait on the hidden Sith world Exegol. ■

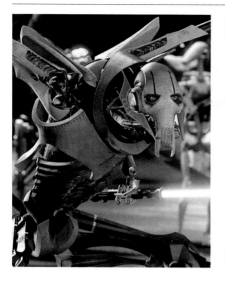

AUGMENTED ABILITIES
CYBERNETICS

I submit to no one. I chose them.
General Grievous

Organic beings have long sought new ways to improve themselves. With the advent of cybernetic enhancements, the opportunities to upgrade one's natural abilities are nearly limitless. While simple cybernetic limb replacements are common after accidents, some take the enhancements much further, choosing to augment their bodies to the extreme.

The droid General Grievous, born a Kaleesh, is an example of a being who chooses to undergo almost a complete replacement of their body. His transformation occurs over an extended period, with each enhancement adding to the last until only his vital organs remain. Grievous sees his new cybernetic limbs, body, and facemask as improvements necessary to achieve his ultimate goal of being the galaxy's greatest warrior. He takes frequent damage in battle, requiring a lair of replacement parts to maintain his new body.

While Grievous is looking for physical enhancements, others use cybernetics to improve their cognitive ability. Members of the Imperial Information Office adopt BioTech Industries headgear to improve their efficiency, though the powerful units have been known to cause memory loss and erratic behavior. In some cases, the computer overruns the mind of its wearer, rendering them nearly emotionless.

Not all cybernetically enhanced individuals consent to these additions. The fugitive Dr. Cornelius Evazan earns the death sentence on 12 systems for crimes including illegal cybernetic surgeries. Evazan creates a host of cyberslaves called the Decraniated, individuals whose brains and upper cranium are entirely replaced by cybernetic equipment. These obedient cyborgs work as servants for unscrupulous, affluent masters such as the criminal syndicate Crimson Dawn. ∎

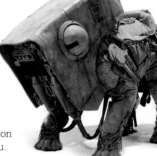

Luggabeast
Cyborg beasts of burden discover and transport scrap on the planet Jakku.

THE
FORCE

The mystical energy field known as the Force surrounds the galaxy, binding all living things together. It is enigmatic to some, fascinating to others, and mythological to much of the galaxy. The greatest mysteries of the Force continue to challenge, elude, and confound those that study it, whether they align themselves with its light or dark side.

THE FORCE IS WITH YOU

THE FORCE

The Force is a mystical, mysterious energy field that has been around for billions of years and is created by all living things. Life creates it and makes it grow while it connects and binds the galaxy together. All parts of life exist in and through it, and all parts of life are infused with it. It is both organic and spiritual in nature, and is paradoxical to scholars, mystics, and even the Jedi. The Force has a will of its own, but can also be guided by the user.

No one is sure when the galaxy first became aware of the Force, and while much is known, there is even

Testing midi-chlorians The Jedi can assess how many midi-chlorians a subject possesses. Anakin Skywalker's count of 20,000 is off the chart.

more knowledge undiscovered. These mysteries have been studied, explored, and hypothesized upon for millennia. Someone strong in the Force can harness its spiritual energy to use powers and abilities far beyond those of normal individuals. The Force is a powerful ally, able to be tapped into by the Jedi, the Sith, and other Force-sensitive beings. However, the Force does not belong to any specific group, even though some are much more connected to it than others.

The cosmic Force and the living Force

There are two aspects to the Force: the cosmic Force and the living Force. They work together

Force vergences

Across the galaxy, there are numerous worlds that possess Force vergences. At these locations, Force sensitives may have stronger interactions with the Force.

Ahch-To
Site of the first
Jedi temple

Dagobah
Location of the
Cave of Evil

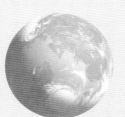

Dathomir
Home of the
Nightsisters

Exegol
Sith world
from antiquity

Force planet
Homeworld of
midi-chlorians

Ilum
A sacred Jedi world
possessing many
kyber crystals

Lothal
An Outer Rim world
home to an ancient
Jedi temple

Malachor
Home of a Sith temple
and a powerful
weapon

Moraband
Homeworld of the
ancient Sith

Mortis
Ethereal realm
occupied by powerful
Force users

Mustafar
Lava world strong
with the dark side

> Luminous beings are we.
> Not this crude matter.
>
> **Yoda**

in harmony, creating a beautiful, delicate balance of the organic and the spiritual. Living beings generate the living Force, which then powers the wellspring that is the cosmic Force. It is a wonderous type of cosmic symbiosis. The cosmic Force has a will of its own and is what connects Force-sensitives to midi-chlorians, binding everything together.

Belief in this aspect of the Force was not as widespread among the Jedi. However, Jedi »

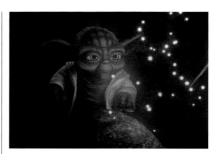

One with the Force Qui-Gon Jinn is the first Jedi known to retain his identity after death through the Force. He contacts Yoda on Dagobah.

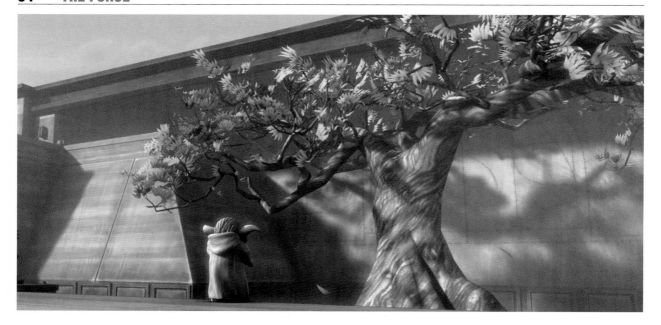

Sacred tree Uneti trees are incredibly rare in the galaxy. The specimen at the Jedi Temple has been growing for generations.

Master Qui-Gon Jinn learned of this distinction and, through training, is the first to maintain his consciousness after death as a Force spirit. He passes this information to Yoda on Dagobah and later to Obi-Wan Kenobi on Tatooine. When near death, a Jedi who has been trained simply fades away, passing into the Force while leaving no body behind to be buried.

Force sensitives

A Force-sensitive individual is able to tap into the Force and learns its will due to midi-chlorians: microscopic, intelligent life-forms that communicate the will of the Force. They reside within the cells of all living organisms and form a symbiotic relationship with their hosts. Without midi-chlorians, life would not exist and the universe would have no knowledge of the Force. They are a gateway to knowledge of the Force and, through

their spiritual connection to the host, create an organic imprint on the individual that can be identified through a blood test. Through contemplative meditation, a powerful Force user can hear them in the Force. The higher the midi-chlorian count, the more prevalent the extraordinary abilities a Force user can wield.

Some non-sentient creatures, plants, and minerals in nature are also strong in the Force. The lightsaber, a weapon of a Jedi, contains a kyber crystal that is attuned to the Force and connects to its wielder on a deeply personal

Fear is the path to the dark side.
Yoda

level. It is an extension of each Jedi's Force awareness and helps them find their center in combat or meditation. Kyber crystals do not take on a specific color until attuned to a Jedi and are primarily blue or green, although there are rare exceptions. The uneti tree is native to Ahch-To, and also contains a strong connection to the Force. The most well-known example, the Great Tree, grows at the Jedi Temple on Coruscant and is particularly strong with the Force.

The Light Side versus the Dark Side

Two of the main groups to have dedicated themselves to studying the Force are the Jedi and the Sith. Each of these groups perceive the Force to have two parts: the light and the dark sides of the Force. The Jedi seek the will of the Force and are devoted to the light side, choosing to use their gifts selflessly. They are galactic peacekeepers, using the Force for knowledge and defense, never attack. For a Jedi, attachment is forbidden, because it can lead to the potential for greed.

Defeated one Grievously wounded by Obi-Wan Kenobi, Darth Vader is saved by his master, who turns him into a cyborg being to keep him alive.

A Jedi communes with the Force when he or she is calm, finding peace and stability through meditation.

The Sith worship the dark side, and do not seek the will of the Force. The Sith want power and control, harnessing its power for evil. Anger, fear, and aggression are the tools a dark side user wields, with great suffering as the result. A true Sith can never find fulfillment because they perpetually look for more power. Darth Plagueis and Darth Sidious, in particular, seek to find control over death and subvert the natural order of things in the ultimate act of manipulation of the universe and the will of the Force.

The Chosen One

The Jedi have long spoken of balance in the Force, but it is unclear what that might mean for the galaxy. For some, balance could be equal light and equal darkness. For others, the light side may be the natural state of the Force, with the

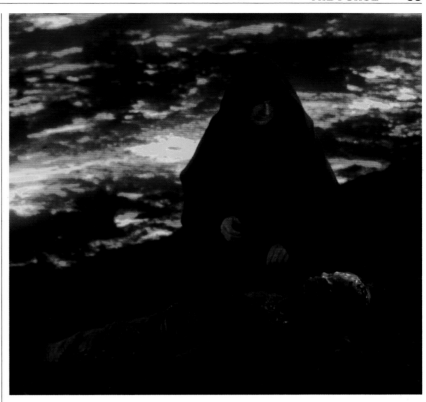

dark side creating imbalance. According to an ancient Jedi prophecy, there is one individual who will bring balance to the Force. Jedi Master Qui-Gon Jinn believes Anakin Skywalker, a vergence in the Force, is the Chosen One, but other Jedi are not as certain. Like so much of the Force, there is much unknown, and much to learn. ■

World between worlds

In Lothal's Jedi temple, there is a mystical gateway that lies behind an ancient painting of the mythical Mortis gods. This world between worlds contains paths and doorways that can instantly grant a traveler the ability to see and affect any place and point in history. This power is highly coveted by Emperor Palpatine. However, he is not able to gain access to the mysterious dimension through the living Force.

Jedi Padawan Ezra Bridger, a Lothal resident with a strong connection to the living Force, enters and sees a portal with Ahsoka Tano, thought deceased, in her duel to the death with Darth Vader on Malachor. Miraculously, Ezra reaches into the doorway and literally pulls her out of history, saving her life. After the two prevent Palpatine from gaining access, Ahsoka returns back to her timeline, but after Vader departs. Ezra then closes the entrance for good, preventing anyone from interfering with reality. Through the Force all things are possible.

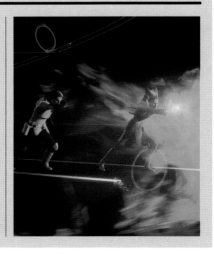

MY ALLY IS THE FORCE

FORCE ABILITIES

HOLOCRON FILE

NAME
The Force

NOTABLE ABILITIES
Telekinesis; enhanced senses; Force visions; mind tricks; mind probes; taming beasts; Force healing; Force lightning; Force choke; psychometry; Force bond

Force powers are extraordinary manifestations of a Force user's ability to connect with this mystical energy. Every Force sensitive can wield the Force, with some abilities being more instinctive to them, others requiring more focus and practice, and some being outside their range.

The Force also augments a user's natural abilities. Both Jedi and Sith have enhanced speed, stamina, athleticism, and agility, which is further honed through years of training and practice. Most Force sensitives can also unconsciously draw upon the Force to predict minor events before they happen. These skills are great boons

in combat. Master Yoda is 900 years old but is still capable of incredible feats during lightsaber duels.

Another ability bestowed upon some is Force visions, where the recipient is offered a glimpse of the past, present, or a possible future. Often convincing and all-consuming, these apparitions are the basis of many ancient Jedi prophecies. However in recent years, most Jedi distrust such manifestations, doubting their reliability. The Jedi Order condones the use of meditation to increase sensitivity to changes in the Force, but events on an unimaginable scale, such as the destruction of Alderaan, may be felt without focus.

Force sensitives can even manipulate the galaxy around them. Telekinesis, the ability to move objects with the Force, is common and can be used offensively in battle to push an opponent or weapon away. Others can telekinetically change their environment, much like when Grand Master Yoda lifts Luke Skywalker's X-wing out of a swamp on Dagobah. The Force can also be used to manipulate the atmosphere around a user, to

Shielding others Using the Force, the Jedi repel a harmful gas, ensuring that they protect themselves and Senator Amidala.

create a bubble to protect them and others from harmful environments.

Impacting others

Force sensitives can influence other sentient individuals. The Jedi may use mind tricks to manipulate weak-willed individuals to do, say, or forget something, without any pain or discomfort to the individual being tricked. While the Jedi would rarely go beyond this level of manipulation, other Force users, typically aligned to the dark side, have been known to use the Force to coerce others into following them or to even change an individual's memories. Force sensitives may also use mind probes to cruelly invade

> The ability to destroy a planet is insignificant, next to the power of the Force.
> **Darth Vader**

an individual's mind in order to learn information and discover secrets.

The Jedi are willing to influence creatures to a greater degree than sentient beings. Beasts can be temporarily tamed for use as mounts or in battle. Jedi Padawan Ezra Bridger shows a remarkable, natural aptitude for this ability, calling upon a pod of Purrgil to help him win the Battle of Lothal.

The Sith use the dark side of the Force to do harm to others, choking anyone that displeases them. The most powerful Sith Lords can unleash barrages of Force lightning that can wreak untold damage.

Rarer abilities

Some Force abilities require years of training, a form of instinctual aptitude, or a very strong connection to the Force to access.

A small number of Force users, including Rey and Cal Kestis, have the rare ability of psychometry, which allows them to learn about people or events by touching an object associated with them.

Ben Solo and Rey are dyads in the Force. This rare connection has not been seen for generations and means that the pair have a Force bond, allowing them to see and feel what the other is experiencing and even pass objects to one another over great distances through the Force.

Those in a dyad possess another unusual ability. They can use the Force to heal a wounded person or creature, but this act also requires that the healer transfer some of their Force energy, which can temporarily weaken them. After their battle with Darth Sidious, Ben Solo sacrifices his life and all of his Force energy to bring Rey back from the dead.

The greatest Jedi can use the Force in powerful ways. Grand Master Yoda is able to absorb massive amounts of energy, which he can either distribute harmlessly through his body or reflect back to the assailant. Luke Skywalker can project a lifelike image of himself across the galaxy, but the farther and more realistic the projection, the more it can take its toll.

Both the light and the dark side have abilities that impact life itself. Certain Sith Lords have the power to manipulate midi-chlorians in order to prolong or cheat death. Some even claim that Darth Plagueis had the ability to create life itself. Thanks to training from the mysterious Force

Healing wounds After giving Kylo Ren a grievous wound during a duel on Kef Bir, Rey draws upon her Force energy to heal him.

Loth-wolves

A select few creatures in the galaxy have Force powers that give them a mythic quality. One such animal is the Loth-wolf, a creature of legend, previously known only in ancient cave paintings.

While everything organic is connected to the Force, Loth-wolves act with purpose, guarding the light side of the Force on Lothal. These majestic creatures are able to speak basic but rarely opt to do so. Loth-wolves have remarkable Force powers and are able to mystically traverse great distances on their homeworld. Promising Jedi trainee Ezra Bridger is able to form a strong bond with the Loth-wolves, who aid him against the Empire.

Priestesses, some Jedi have the ability to retain their consciousness in the Force after death and interact with the physical world. While Qui-Gon Jinn can only manifest a disembodied voice, Luke Skywalker and Yoda are able to use the Force to interact with the physical galaxy after their deaths. ∎

GUARDIANS OF PEACE AND JUSTICE
THE JEDI ORDER

HOLOCRON FILE

NAME
The Jedi Order

KEY TEMPLE LOCATIONS
Ahch-To; Coruscant; Ilum; Lothal

NOTABLE EXAMPLES
Yoda; Obi-Wan Kenobi; Anakin Skywalker; Luke Skywalker; Rey Skywalker; Mace Windu; Ahsoka Tano; Leia Organa; Count Dooku; Qui-Gon Jinn; Avar Kriss

AIM
Peace; justice; balance of the Force

STATUS REPORT
Rebuilding

The High Republic The galaxy looked to the Jedi to peaceably settle disputes and render aid during the golden era of the High Republic.

An order of guardians as old as the Republic they are sworn to protect, the Jedi Knights are the foremost followers of the Force, a mystical energy field that binds all living things. For millennia they have upheld the ideals of the Republic, and their philosophy focuses on maintaining balance and harmony. Through the Force, they can achieve spectacular feats of agility, perception, telepathy, and telekinesis. A true mark of a Jedi is the ability to sense the connectivity and harmony of surrounding life, and root out causes of imbalance. But despite this advantage, they are nearly wiped out from existence by dark forces opposed to their philosophy.

Jedi devote their entire lives to the study of the Force, traditionally starting as initiates identified and brought into the Order at a very young age—infants and toddlers are the norm, with rare exceptions made for older children. The Jedi seek to steer impressionable minds away from fear, hatred, and other dark emotions that develop early. For most within the Republic, offering a Force-sensitive child to the Order is an incredible honor, but it is a heart-wrenching choice. The child—by Jedi doctrine—cannot know his or her birth family. Familial attachments are surrendered in service to the Order.

Circle of life
As Jedi younglings mature, they are placed into training groups called

Rise of the Jedi Order

C. 25,000 BSW4
Ancient beginnings
The Jedi Order is founded, possibly on Ahch-To.

C. 300 BSW4–C. 100 BSW4
Jedi glory
The High Republic and the Jedi enjoy an era of heroism.

24 BSW4
Start of the Separatists
Dooku leads the Separatist movement.

19 BSW4
Jedi in hiding
Order 66 eliminates most of the Jedi, and dark times begin.

15 ASW4
A new Order
Luke begins training his nephew, Ben Solo.

C. 1,032 BSW4
Rise of the Republic
Republic reformation comes after the Jedi "defeat" the Sith.

42 BSW4
Shock departure
Dooku departs from the Jedi.

22 BSW4
Galaxy at war
The Clone Wars begin.

3 ASW4
Dagobah instruction
Luke Skywalker trains under Jedi Master Yoda.

34 ASW4
The last Jedi?
Luke begins training Rey.

clans. These clans learn under the guidance of a single Jedi Master. In the middle of their teen years (biological equivalents for species other than human may vary), younglings are paired with a Master for more direct training. Padawan learners accompany their Jedi Masters on assignment, learning more about the galaxy at large through direct experience.

After a decade or so of apprenticeship, a Padawan is

Jedi Temple The Jedi Temple on Coruscant is an ancient structure that reaches deep beneath the city surface into the depths below.

subject to the trials. A Jedi trial is highly personalized, different for every apprentice, meant to specifically challenge a Padawan's blind spots and weaknesses. Upon successfully completing the trials, by verdict of the Jedi Council, the Padawan enters Knighthood. One of the greatest honors of a Jedi Knight is to take an apprentice, thus perpetuating the cycle of training and education. The Jedi Council often takes care to pair masters and Padawans who will learn the most from one another.

The next stage of a Jedi Knight's path is mastery, with a seat on the Jedi High Council the pinnacle »

> For over a thousand generations the Jedi Knights were the guardians of peace and justice in the Old Republic. Before the dark times. Before the Empire.
>
> **Obi-Wan Kenobi**

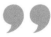

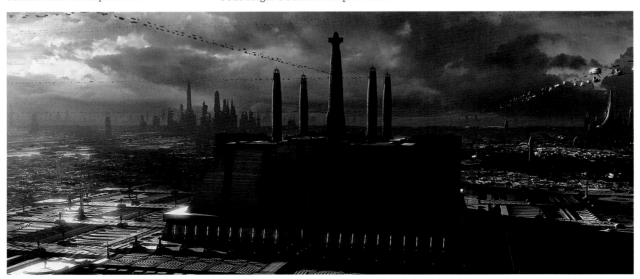

The Bear Clan A youngling clan learns from Jedi Master Yoda.

achievement. Twelve Jedi Masters serve this body, and even they still probe the mysteries of the Force, seeking new knowledge and insight.

The signature symbol of the Jedi, and their sole possession in a life devoid of attachments, is the lightsaber. Though the Jedi do not consider themselves warriors, it is a weapon: a blade of luminous plasma that can cut through nearly anything, except another lightsaber blade. Lightsabers are exceedingly rare, their construction only possible by those touched by the Force. Though anyone could conceivably wield one, only a trained Force user can achieve mastery of the difficult-to-control blade.

The Jedi Order has existed for so long that details of its origins are lost to time. The first Jedi temple—a place of training and contemplation—is found on an island on Ahch-To. More temples arise in time, often in places known as vergences—naturally occurring concentrations of Force energy.

Political prominence

As the Republic solidifies and stretches across much of the galaxy, the Jedi centralize on Coruscant, the capital world. The Jedi Order becomes an extension of the Judiciary branch of the Republic, answerable to the Senate. When disputes become particularly problematic, beyond the control of local law enforcement, or spill outside the borders of local space and become a truly inter-systems affair, the Senate dispatches Jedi to settle the matter through negotiation. The Jedi Council and most of the Order operate out of the Jedi Temple, an impressive, spired structure that stands above its surroundings.

I will not be the last Jedi.
Luke Skywalker

Millennia ago, the Jedi Knights and Sith Lords did battle, with the fate of the galaxy at stake. This era is the source of many Jedi legends, and sites such as Malachor are still scarred from these epic wars. A thousand years before its eventual fall, the Republic was challenged for its very survival in a conflict that saw the Sith ultimately destroyed. A thousand

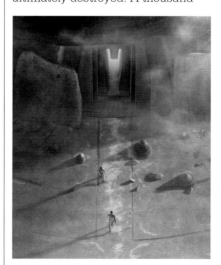

Lothal temple Ancient, forgotten temples still can be found on distant worlds.

years of peace begins that day, but it proves to be a ruse.

Little do the Jedi know that the Sith, in fact, survive, plotting in the shadows for their eventual revenge. The Jedi Order grows complacent and comfortable with its elevated place within the Republic power structure. Some Jedi grow disenchanted with such corruption. The most famous of these mavericks, Master Dooku, departs the Jedi Order. This precipitates a Separatist crisis that Dooku stokes, putting the Jedi on the defensive.

Twilight of the Jedi

The growing Separatist threat pushes the galaxy to the brink of war. The Jedi Order discovers that one of its own had secretly commissioned a clone army to deal with this foreseen threat. The Jedi, left with little choice, take up leadership of this army in time to defend the Republic as the Clone Wars erupt. It is the first full-scale war the galaxy has seen in a millennia, and the Jedi—who have long regarded themselves as peacekeepers—are battlefield commanders in the conflict.

The war is a complex plot hatched by Supreme Chancellor Sheev Palpatine to cement his power over the galaxy. He is, in truth, the Sith Lord Darth Sidious, and has planned a contingency hidden in the biology of the clone troopers. At a signal, they turn on their Jedi commanders, viewing them as traitors to the Republic. Thousands of Jedi are killed by their clone soldiers. His greatest enemies defeated, Palpatine declares himself Emperor, and any surviving Jedi as outlaws.

In the dark times that follow, scant few Jedi exist, hunted down by the Emperor's agents like Darth Vader and the Inquisitorius. Jedi Masters Obi-Wan Kenobi and Yoda survive to train young Luke Skywalker, who carries the mantle of Jedi Knight as he helps bring an end to the Sith and the Empire. Although Luke Skywalker did pursue training a new generation of Jedi, the Order has not returned to its former heights. ∎

The Jedi Code

A series of rules governing actions and behavior, as well as tenets that embody ideals, the Jedi Code has evolved over centuries. Some elements in the larger Code deal with practical matters of training, such as a restriction denoting that a Jedi Master may only take one apprentice at a time. Other elements place strictures on personal relationships—though Jedi are encouraged to have compassion toward all life, romantic love is forbidden, for it treads close to the dangers of attachment and greed. A koan excerpt of the Jedi Code is recited as follows:

> There is no emotion;
> there is peace
> There is no ignorance;
> there is knowledge
> There is no passion;
> there is serenity.
> There is no chaos;
> there is harmony.
> There is no death;
> there is the Force.

The Jedi Path **Rank progression** The Jedi Code prescribes a set path of advancement in the ways of the Order.

Initiate
Toddler-aged inductees are measured for potential.

Youngling
As children, Jedi learn in classes called clans.

Padawan
Adolescent Jedi are paired to Masters or Knights.

Grand Master
The wisest of the Jedi Masters.

Master
Knights who have taken and trained a Padawan to Knighthood.

Knight
Adult Jedi who have undergone the Trials.

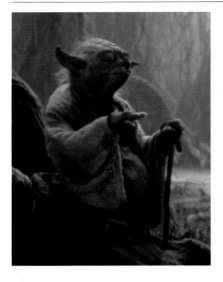

TEACHER AND LEARNER
YODA

HOLOCRON FILE

NAME
Yoda

SPECIES
Unknown

HOMEWORLD
Unknown

AFFILIATION
Jedi

ABILITIES
Enhanced Jedi reflexes; agility; combat skills; telekinesis; ability to see the future

AIM
Teach, learn, and protect

STATUS REPORT
One with the Force

Master Yoda is a legendary Jedi Master and perhaps one of the most influential teachers in the history of the Jedi Order. His small stature is in direct contrast to his power, wisdom, and the influence he has on his students, the Jedi, and the Republic. He is also widely considered the greatest Jedi duelist, although he rarely showcases this talent. Yoda always prefers a diplomatic solution, opting to pass on his insights through his distinct manner of speaking.

For eight hundred years, Yoda instructs countless Jedi and has taken on many Padawans, including Count Dooku and Luke Skywalker, during his final century. With his adaptive teaching style, Yoda is able to reach difficult students and bring out their best, knowing when to encourage and when to criticize. While he is certainly not reluctant to share his thoughts, he also has a playful sense of humor and is an excellent listener. These traits serve him well as the Grand Master of the Jedi Council.

When the Trade Federation blockades Naboo, Yoda's leadership is put to the test. He dispatches Master Qui-Gon Jinn and his Padawan, Obi-Wan Kenobi, to help settle the dispute. During the crisis, Yoda also learns that a vergence in the Force, a child named Anakin Skywalker, has been discovered, and that the Order's enemy—the Sith—have resurfaced. Yoda makes an exception to the rules and reluctantly agrees that recently knighted Kenobi can train Anakin, who is far older than a typical Order initiate.

Stoked by Yoda's former Padawan, now Sith Lord, Count Dooku, the Clone Wars challenges Yoda and the Council. Forced to take military posts in the Republic army, the transition from peacekeeper to warrior comes a bit too naturally for the Jedi, but with so many systems in need, there is no time for debate. In spite of this, Yoda's kind nature is evident in his treatment of the clones, his fellow Jedi, and those in need of help. He spends as much time on the battlefield as he does guiding others.

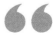

Judge me by my size do you?
Yoda

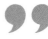

Much to learn, he still has

Even as Grand Master, Yoda's training never ends. Toward the end of the Clone Wars, Yoda hears the voice of Qui-Gon Jinn and fears the galaxy-wide conflict has taken its toll on his psyche. After a series of medical tests reveal he is healthy, Yoda receives another visit from the voice of Qui-Gon, who sends him to Dagobah, where he learns there are two aspects of the Force: the living Force and the cosmic Force.

Qui-Gon has learned how to maintain his consciousness after death and guides Yoda to do the same. Yoda faces a dark side version of himself on Dagobah and then travels across the galaxy, facing several spiritual trials. He realizes pride prevented him from avoiding the error of making the Jedi into warriors, and learns the secret of immortality through the Force, which he later passes on to Obi-Wan Kenobi.

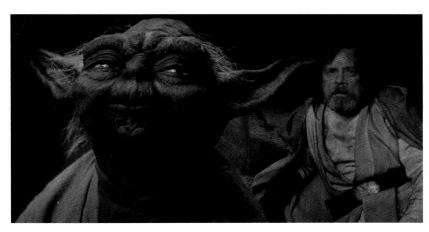

However, even with his powerful connection to the Force, Yoda is not able to predict that Supreme Chancellor Palpatine is actually a Sith Lord, or Anakin's turn to the dark side as he becomes Darth Vader. On Kashyyyk, Yoda senses the deaths of many Jedi during Order 66, and quickly kills the clones that attack him. Yoda confronts the now Emperor Palpatine, but barely escapes with his life. Realizing that the Sith cannot be defeated yet, Yoda exiles himself to the planet Dagobah. He decides to wait until he can train Anakin's children, who only a few know are alive, as Jedi.

One last lesson On Ahch-To, Yoda appears before his final student, Luke, to guide him.

It is a dark time, with few Jedi remaining. However, Yoda continues to inspire and guide Force sensitives, including Ezra Bridger and former Jedi Ahsoka Tano. Yoda learns to trust even more deeply in the will of the Force, and to let the way of things happen naturally. While the Jedi are nearly gone, Yoda has not lost his belief that good will always prevail.

When Anakin's son Luke visits Dagobah, Yoda trains the promising Jedi in the ways of the Force,

encouraging him to be mindful, patient, and confront his fears. While Yoda is disappointed that Luke wishes to cut his training short, he helps Luke recover his starfighter, using the Force to lift it out of a swamp.

At the end of his life, Yoda is visited once more by Luke and confirms the young Skywalker's lineage. He also reveals that there is another Skywalker—Princess Leia Organa. Yoda passes into the Force, maintaining his consciousness in the afterlife. As a Force spirit, Yoda watches the celebrations following the rebel victory at Endor.

There are still lessons for Luke to learn from his Master. Thirty years later, Yoda appears to a disenchanted Luke on Ahch-To, calling the self-exiled Jedi Master's bluff to burn the remaining sacred Jedi texts, even initiating the lightning strike himself. While Yoda may or may not be aware that Luke's final student Rey has taken the books already, he wishes to teach Luke one final lesson. Yoda has learned to trust in the Force fully and live in the moment, thinking for himself and not slavishly adhering to the Jedi doctrine that may have aided in the fall of the Jedi 53 years earlier. ∎

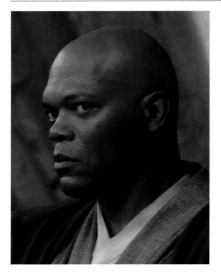

RULE-ABIDING JEDI
MACE WINDU

HOLOCRON FILE

NAME
Mace Windu

SPECIES
Human

HOMEWORLD
Haruun Kal

AFFILIATION
Jedi

ABILITIES
Force reflexes; agility; prophecy; superior lightsaber combat

AIM
Adhere to Jedi doctrine and defeat the Sith

STATUS REPORT
Deceased

Jedi Master Mace Windu is disciplined, steadfast, and unwavering in his commitment to the Jedi Order. He is second only to Master Yoda in lightsaber prowess, wisdom, and respect among his peers. While the Force is strong with him,

Mace is suspicious of anyone he perceives to be a threat to the Jedi teachings and traditions he holds sacrosanct. When maverick Jedi Qui-Gon Jinn introduces Anakin Skywalker to the Jedi Council, Mace mistrusts the boy, believing him too old to join the Order, and is skeptical of Qui-Gon's revelation that the Sith have returned.

The start of the Clone Wars overshadows his reservations. As a strategist and general in the galactic-wide conflict, Mace is a superior combatant, capable of defeating multiple enemies with his unique fighting style. He is a natural with his purple lightsaber in hand and an important figure in the Republic military. Mace is sometimes impatient with political dealings, preferring to take swift action, but is still an able negotiator, helping Twi'lek Cham Syndulla mediate a truce on Ryloth.

Throughout the Clone Wars, Mace holds fast to the rigid laws of the Jedi Order, but also becomes aware of some of its potential shortcomings. When Supreme Chancellor Palpatine seeks Anakin as his representative on the Jedi Council, Mace has grave doubts. He respects Anakin's skills but still

sees him as too emotional and is reluctant to believe the ancient prophecy that Anakin could bring balance to the Force.

Along with the rest of the Council, Mace does not perceive the real threat in front of them: Chancellor Palpatine is the Sith Lord Darth Sidious. When the moment comes, and despite believing that Jedi should not get involved with politics, Mace leads the Jedi's attempt to arrest Palpatine. He is shocked to see the dark side power unleashed by the secret Sith, but too late, and meets his end at Sidious' hands. ∎

Arrest interrupted Mace is doubly betrayed: first when Anakin shows his true Sith colors and turns on him, then when defenestrated by Palpatine.

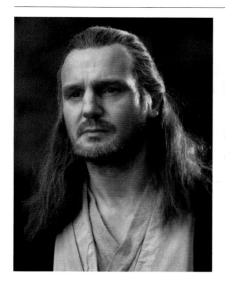

ENLIGHTENED MAVERICK

QUI-GON JINN

HOLOCRON FILE

NAME
Qui-Gon Jinn

SPECIES
Human

HOMEWORLD
Coruscant

AFFILIATION
Jedi

ABILITIES
Enhanced Force agility, speed, and reflexes; achieved capability to become one with the living Force

AIM
To commune with the living Force and learn its mysteries

STATUS REPORT
One with the Force

Possibly the only Jedi Master not to accept an invitation to sit on the Jedi Council, the esteemed Qui-Gon Jinn has a reputation for routinely going against the wishes of his allies in the Force. But he is not a contrarian. Rather, his belief is in the will of the living Force. He does not subscribe to the strict doctrine that can sometimes distract the Jedi from what Qui-Gon believes is their higher purpose. It is as Padawan to Count Dooku that Qui-Gon first learns to think outside the box and trust in his instincts, which sometimes causes tension for him when he comes to train his own Padawan, Obi-Wan Kenobi.

These philosophical differences reach a plateau when Qui-Gon meets a young boy, named Anakin Skywalker, who is unusually strong in the Force. Qui-Gon believes Anakin will bring balance to the Force and, despite the Jedi Council's wishes, takes the boy as his Padawan. Anakin's mentorship is cut short when Qui-Gon is killed by Darth Maul in a confrontation on Naboo. It is the fallen Jedi's dying wish for Obi-Wan to train Anakin, and the Council agrees, in spite of its initial reservation, out of respect for Obi-Wan's loyalty to his master.

Impossibly, Qui-Gon returns, maintaining his consciousness after passing through death and into the Force. He convinces Yoda that he has much to learn, and instructs him to go to Dagobah, a planet exceptionally strong in the Force. There, he informs the Grand Master about many undiscovered mysteries of the Force. He later teaches this lore to Obi-Wan on Tatooine during a mission to protect the young Luke Skywalker. ∎

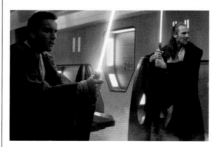

Side by side Qui-Gon and Obi-Wan may have differences in personality, but they fight well together.

Feel. Don't think.
Use your instincts.
Qui-Gon Jinn

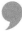

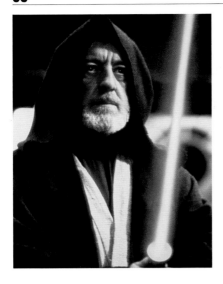

KEEPER OF THE PEACE
OBI-WAN KENOBI

HOLOCRON FILE

NAME
Obi-Wan Kenobi

SPECIES
Human

HOMEWORLD
Stewjon

AFFILIATION
Jedi

ABILITIES
Enhanced Jedi reflexes; telekinesis; expert lightsaber duelist

AIM
To watch over and train Luke Skywalker in order to bring balance to the Force

STATUS
One with the Force

O bi-Wan Kenobi is a promising Jedi in training, strong in the Force, and eager to prove himself to both his Master and the Jedi Council. From an early age, Obi-Wan is a natural leader, not reluctant to share his opinion, but always with respect. His adherence to the philosophy of the Order, along with his integrity, put him at odds early on with his Master, Qui-Gon Jinn, who is more likely to question the Council or established doctrines. However, the two Jedi form a powerful bond during their mission to protect the princess of the planet Pijal.

During a later mission to stop a blockade of Naboo and protect the planet's leader Queen Amidala, Obi-Wan and Qui-Gon encounter the young Anakin Skywalker, who is particularly strong in the Force. Qui-Gon believes Anakin to be the Chosen One—a prophesized figure who will bring balance to the Force.

Obi-Wan is skeptical of the prophecy and thinks that a ten-year-old child is too old to be trained as a Jedi. The two Jedi later face Sith Lord Darth Maul in a cataclysmic duel in which Qui-Gon is killed, and Obi-Wan dispatches the Sith Lord. For defeating the Sith, Obi-Wan is knighted.

Ironically, Qui-Gon's defiance seems to have been passed on to Obi-Wan, who honors his fallen master's wish to train Anakin despite the Council's reluctance. For ten years, Obi-Wan teaches Anakin, and the two do not always see eye-to-eye. When former Queen and now Senator, Padmé Amidala's life is in danger, Anakin is charged with protecting her, while Obi-Wan tracks down a lead on an assassin targeting the Senator.

Obi-Wan's investigation soon uncovers a secret plot to create a clone army on the planet Kamino, and eventually leads to a confrontation with former

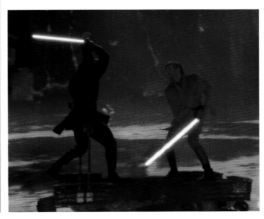

Duel on Mustafar During their epic clash on Mustafar, Anakin and Obi-Wan do not hold back.

Lifelong foes

One of Kenobi's chief adversaries throughout his life is Darth Maul, who was long believed dead following their duel on Naboo. However, Maul survived and returns to prominence during the Clone Wars. Maul is tireless in his pursuit of Obi-Wan, seeking revenge for his physical and psychological losses. The two battle on several occasions during the Clone Wars, with neither side getting a real advantage. Maul's obsessive bloodlust ultimately leads him to kill Obi-Wan's former love, Duchess Satine Kryze, devastating Kenobi. But unlike his dark-side antagonist, Obi-Wan refuses to give in to anger or hate, further cementing his reputation as a man of nobility and dignity.

While safeguarding Luke on Tatooine, Maul tracks down Obi-Wan, hoping to kill the older Jedi. But Kenobi guides his lightsaber to victory with one deadly blow, cradling the would-be assassin with compassion as Maul takes his last breath.

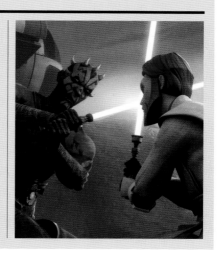

Jedi Count Dooku, the leader of the Separatists. Dooku imprisons Obi-Wan, unsuccessfully attempting to sway Obi-Wan away from the Republic. Anakin and Padmé attempt to rescue Obi-Wan, but they are also captured. The trio are due to be executed until the Republic launches a rescue mission. During the escape and ensuing battle, Padmé falls out of a Republic Gunship, and when Anakin wants to jump out and rescue her, Obi-Wan insists the two pursue Dooku instead, realizing that his capture could end the conflict. However, the two are unsuccessful in stopping the Count and the Clone Wars begin.

For three years, Obi-Wan, now a general in the Republic, leads many missions throughout the galaxy. His reputation as both a military leader and a negotiator grows rapidly, as does his friendship with Anakin.

But the galaxy is in constant turmoil and Obi-Wan does not realize the extent of the Sith's manipulations until it is too late. Obi-Wan is one of a few Jedi survivors of Order 66, when the clone troopers turn on their Jedi generals. He is shocked to realize that Anakin, who he sees as a brother, has betrayed the Jedi and joined the Sith.

Obi-Wan is forced to confront his former pupil on the lava planet Mustafar. A grief-stricken Obi-Wan grievously wounds Anakin. Seemingly incapable of bringing Anakin and the galaxy peace, the devastated Jedi Master leaves Anakin for dead, lamenting the nightmare that the galaxy has become with the end of the Jedi and the rise of the Empire. There is no time for sorrow, however, as fellow survivor Yoda tasks Obi-Wan with taking Luke Skywalker, one of Anakin's children who is believed to be dead, to Tatooine to be raised by

The Force will be with you. Always.
Obi-Wan Kenobi

his aunt and uncle. The Jedi believe that the infant may be their only hope to restore peace to the galaxy. On Tatooine, Kenobi takes on the moniker of Ben Kenobi. Nineteen years later, Obi-Wan saves the teenage Luke Skywalker from Tusken Raiders. He shares with Luke that he must learn the ways of the Force, to become a Jedi like his father.

Eventually, Darth Vader and Obi-Wan meet again, with Obi-Wan ultimately surrendering to the Force as Darth Vader strikes him down. His cloak billows to the ground, as he becomes one with the Force. Now a Force spirit, Obi-Wan believes Luke is the Chosen One, and instructs the burgeoning Jedi to seek out Yoda on Dagobah. Luke's headstrong ways are reminiscent of his father, giving Obi-Wan yet another strong-willed pupil. But with Obi-Wan and Yoda's guidance, Luke redeems his father and returns balance to the Force. Alongside Anakin's Force spirit, Obi-Wan watches the celebration on Endor following the Empire's defeat, grateful that peace has been restored to the galaxy and the Skywalker lineage. ∎

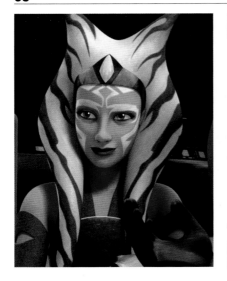

INDEPENDENT FIGHTER
AHSOKA TANO

HOLOCRON FILE

NAME
Ahsoka Tano

SPECIES
Togruta

HOMEWORLD
Coruscant (raised)

AFFILIATION
Jedi (formerly); rebels (formerly)

ABILITIES
Jedi training; piloting; mechanical aptitude

AIM
To challenge the dark side

STATUS REPORT
Last seen voyaging to the Unknown Regions

Ahsoka Tano spends her formative years in the Jedi Temple, brought there by Master Plo Koon. The Jedi Council apprentices her to Anakin Skywalker, seeing their relationship as useful to their development. Her Padawan status makes her a commander in the Clone Wars, while Anakin serves as a general.

Throughout the conflict, Ahsoka matures into a formidable warrior. She mirrors many of Anakin's attributes, such as his headstrong, impulsive approach to conflict and danger. When the duo investigates a shocking bombing of the Jedi Temple, they uncover evidence pinning the act on Ahsoka.

Anakin refuses to believe it; nevertheless, the Jedi expel Ahsoka from their ranks. She is nearly convicted for these crimes, but Anakin's dedicated detective work, with some help from surprising quarters, clears her name and spares her the death penalty. However, Ahsoka's faith in the Jedi Council is irreparably shaken. She walks away from the Order, leaving behind the only life she had ever known. She voyages to the lower levels of Coruscant to carve out a new existence.

The needs of the Clone Wars bring her back to the Jedi to carry out one last mission to capture Maul, the former Sith Lord wreaking havoc on Mandalore. As Emperor Palpatine seizes control of the Republic, Ahsoka goes underground, knowing that her past affiliation with the Jedi and her Force skills paint a target on her.

In the Outer Rim, Ahsoka tries to remain beyond the reach of the ever-expanding Empire and its deadly Inquisitors. She adopts many aliases and is ever mobile and often alone. Her actions organizing a local resistance on Raada draws the attention of Senator Bail Organa of Alderaan, who invites her to help the growing rebellion.

... Just when you think you understand the Force, you find out how little you actually know.
Ahsoka Tano

Ahsoka starts to work undercover facilitating communication across scattered cells and helping recruit candidates to the cause. She adopts an old Clone Wars-era code name

Morai the watcher

In the midst of the Clone Wars, Ahsoka, Anakin, and Obi-Wan Kenobi enter a vergence in the Force contained within a spacebound monolith in the Chrelythiumn system. This supernatural portal transports the trio into the realm of Mortis, a place that is a nexus and amplifier of the Force. In this realm are three godlike beings that are personifications of Force aspects: the Daughter is the light, the Son is the dark, and their Father is balance. Here, Ahsoka sees a glimpse of her future self, is possessed and killed by the Son, and then brought back to life by a transfer of Force energy from the Daughter.

If these events are real is unknown, but ever since, Ahsoka is often accompanied by a convor named Morai, thought to be a manifestation or representation of the Daughter in the mortal realm.

"Fulcrum" from insurgencies started to aid the Republic in the war effort. Ahsoka is the key point of contact for rebel Hera Syndulla and the crew of the *Ghost*, connecting them to the larger rebellion. As Inquisitors become more of a threat, Ahsoka is determined to stop them. This brings her and the Force-sensitive members of the *Ghost* crew—Kanan Jarrus and Ezra Bridger—to the ancient world of Malachor, where they seek some sort of advantage against the dark side.

It is within Malachor's ancient Sith temple that Ahsoka squares off with the Dark Lord, Darth Vader. In moments of close combat, she

Unhappy reunion Anakin is ruthless when facing his former Padawan on Malachor. In fact he blames her for leaving him when he needed her!

comes to realize that Vader was once Anakin Skywalker. She is heartbroken by her inability to sense anything of the Anakin she knew through the darkness. Vader attempts to slay Ahsoka without mercy, but is thwarted by the explosion of the temple that releases great torrents of Force energy. She disappears into a portal created at the temple's heart, slipping into the mysterious netherworld of the Force—a world between worlds.

Here, in this place beyond time, she meets a future Ezra Bridger who pulls her from Malachor. She learns of the future: that Vader's destiny lies along a path that does not include her. She returns to her time and place, finding Vader gone and the temple in ruins.

Ahsoka chooses to return to the *Ghost* crew after the fall of the Empire, joining Sabine Wren in a voyage into the Unknown Regions, now as part of a team. ∎

Fulcrum symbol A stylized representation of Ahsoka's facial markings is used as the symbol for Fulcrum agents across the galaxy.

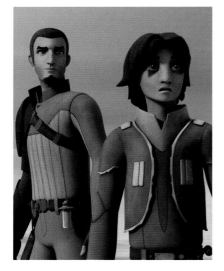

DARK TIMES
JEDI PURGE SURVIVORS

HOLOCRON FILE

NOTABLE INDIVIDUALS
**Kanan Jarrus; Ezra Bridger;
Cal Kestis; Cere Junda; Oppo
Rancisis; Coleman Kcaj;
Obi-Wan Kenobi; Yoda**

AFFILIATION
**Jedi; Republic;
Rebel Alliance**

POWERS
The light side of the Force

AIM
**Preserve the legacy
of the Jedi**

When Darth Sidious executes Order 66 at the end of the Clone Wars, few Jedi survive the initial ambush, and those who do are unprepared for the fight that lies ahead of them. Branded as traitors, they have little choice but to go into hiding, hunted by their clone troops and unable to trust anyone around them.

Leading the clone armies leaves the Jedi Council scattered throughout the galaxy when Order 66 is enacted. Many fall to their clone comrades, leaving the Jedi Order virtually leaderless. Masters Rancisis and Kcaj survive and go into hiding. Master Yoda manages to escape Kashyyyk, and Obi-Wan Kenobi evades his troops on Utapau, but they realize that the Empire has set a trap by way of a false message instructing the Jedi to return to the Temple. They undertake a dangerous mission to Coruscant to halt the dispatch, saving an undetermined number of survivors from Sidious' trap before ultimately withdrawing into exile.

During these dark times, the remaining Jedi live as fugitives, and a single sighting of their lightsaber is enough to draw the attention of the Inquisitorius. These Jedi targets either fall to an Inquisitor or Darth Vader's blade—including Jedi librarian Jocasta Nu—or face a worse fate: imprisonment and torture. Some captured Jedi are executed, like Jedi Master Luminara Unduli, but Jedi Padawan Trilla Suduri and others fall to the dark side, joining the Inquisitors.

Once proud Jedi resort to any work they can find. The Padawan of Depa Billaba, Caleb Dume, trades his saber for a blaster and his old name for a new one, Kanan Jarrus.

This is Master Obi-Wan Kenobi. I regret to report that both our Jedi Order and the Republic have fallen with the dark shadow of the Empire rising to take their place. This message is a warning and a reminder for any surviving Jedi. Trust in the Force. Do not return to the Temple, that time has passed and our future is uncertain. We will each be challenged: our trust, our faith, our friendships. But we must persevere, and in time, a new hope will emerge. May the Force be with you, always.

**Obi-Wan Kenobi's
message to the
surviving Jedi**

Fallen Jedi

While some Jedi survivors hold on to the principles of the Jedi Order, others fall under the influence of the dark side. One such Jedi is Taron Malicos, a Master known for his command on the battlefield. Though he escapes his troops, his ship crash-lands on the red planet of Dathomir. Whether due to the dark energies of the planet or Malicos' own anger at how the Order fell, he embraces the dark side. He rules over the Nightbrothers, scarred both physically and mentally, believing the Jedi had condemned themselves to being wiped out.

Jedi Padawan Ferren Barr wishes for the downfall of the Sith and has a Force vision of the Mon Calamari playing a role. While his aim is noble, Barr's methods are not, as he uses the Force to manipulate individuals. On Mon Cala, Barr coerces the Mon Calamari king and then kills the Imperial ambassador, leading the Empire to invade the planet. Barr strays from the Jedi doctrine in his quest, ultimately dying in a duel with Darth Vader. Regardless of his morality, Barr's actions ensure that the Mon Cala Exodus fleet escapes the planet and goes on to form an integral part of the Rebel Alliance Navy.

He struggles with the guilt of surviving Order 66, finding little comfort by drinking away his problems. He makes a life as a freighter pilot before joining forces with the rebellious Hera Syndulla, renewing his purpose in life.

Their insurgency on Lothal leads Kanan to discover a Force-sensitive orphan, Ezra Bridger. The headstrong teenager is an uncertain candidate to become a Jedi just as Jarrus is an unprepared teacher, but their shared desire to bring justice to the galaxy unites them as Padawan and Master. Kanan teaches Ezra everything he can about the Force, but often questions whether he has what it takes to be a teacher. Throughout their many missions on Lothal and beyond, each is tested and tempted, but in the end, Bridger grows into a fine Jedi. In their final mission together, Jarrus selflessly gives his life to save the rest of the crew. The loss of his Master weighs heavily on Ezra, whose greatest tests still lie ahead.

Exemplifying what it means to be a Jedi, he rebukes the temptation

of Darth Sidious and performs valiantly at the Battle of Lothal. In an attempt to save the Rebels from Grand Admiral Thrawn, Ezra is lost to an unknown destination in hyperspace. Though he vanishes, his sacrifice saves Lothal from the Empire forever.

Much like Kanan Jarrus, the young Jedi Cal Kestis takes up a new life after Order 66, hiding his identity while making a living in the Scrappers Guild on Bracca and cutting himself off from the Force. Using the Force to save a friend during an accident draws

Chartered craft Cal Kestis and Cere Junda travel aboard the *Stinger Mantis*, a yacht captained by Latero Greez Dritus.

the attention of both the Inquisitors and new allies. Another former Jedi, Cere Junda, welcomes Kestis to her crew. They race to find a Jedi holocron containing the names of Force-sensitive children before the Empire. Cal reconnects with the Force, but Junda's past traumas leave her without such a connection. Together they obtain the list and destroy it before the Empire can find the younglings. ∎

UNLIMITED POWER

THE SITH ORDER

HOLOCRON FILE

NAME
The Sith Order

KEY TEMPLE LOCATIONS
Exegol; Coruscant; Moraband; Malachor; Ashas Ree

NOTABLE EXAMPLES
Darth Sidious; Darth Vader; Darth Tyranus; Darth Maul; Darth Plagueis; Darth Tanis

AIM
Eternal conquest and control

STATUS REPORT
Defeated

The Sith are an order founded by a splinter group of Jedi who discover the raw power that can be achieved by devotion to the dark side. The Sith's focus on the dark side opens up powers that a Jedi dare not wield, such as the ability to corrupt the Force through focused rage to launching deadly lightning from their fingertips. While the Jedi follow a code that controls their actions for the betterment of the many, the Sith believe in controlling the many for their own advancement. As the antithesis of the democratic, peacekeeping Jedi, they desperately crave power.

Because of their origin as an offshoot of the Jedi, the Sith superficially resemble Jedi Knights. Their robes and hoods show strong Jedi influences, and their weapon of choice is a lightsaber. The Sith pour their hate and rage into the kyber crystals that make up the core of their weapons. This act creates a red blade; a color not found among the Jedi.

Despite their number, the Sith fail to maintain a well-structured order akin to the Jedi. The driving philosophy of the Sith is ascension at any cost. Any rigid structure would inevitably collapse when ambitious Sith Lords vie for control. Coups and intrigue are common within their ranks.

The Sith Order Darth Shaa and Darth Momin are ancient Sith from a time where the Dark Lords openly vie for power and control.

This spells doom for the original Sith attempt to rule the galaxy a millennia before the modern era. Though they nearly succeed in conquering the Republic, in-fighting accelerates the Sith's demise, and they are defeated by the Jedi Order.

The Jedi assume their enemy are completely wiped out, but one Sith visionary, Darth Bane, devises a new strategy for conquest. Instead of building an army of Sith Lords to challenge the legions of Jedi Knights, the power of the Sith is instead contained in just two individuals: the Master, who embodies the power, and the apprentice, who craves it. When the apprentice is ready, they challenge the Master and either ascend to this position or die in failure. Following Bane's absolute Rule of Two allows the Sith to continue hiding for generations.

The Sith remain in the shadows as true phantom menaces for a thousand years. The ultimate heir to Darth Bane's conspiracy, Darth Sidious, formulates a complex plan to topple the Republic and destroy the Jedi. In his common guise as the ambitious Sheev Palpatine, he becomes a congenial senator representing his homeworld of Naboo. He then becomes a beloved chancellor, navigating the Galactic Republic through times of conflict.

Ancient alphabet The runic Sith alphabet stems from the Old Tongue, a long-extinct language. The translation of Sith runes was made illegal by decree of the Galactic Republic.

But the public are unaware that he has engineered these conflicts to earn their trust. At the Republic's height, and with its citizens »

Darth Bane A fiery spectral image of Darth Bane said to haunt his tomb— Bane reconstituted the Sith Order for survival.

The history of the Sith Order

C. 5000 BSW4
Battles with the Jedi
An era of great conflict against the Jedi begins, including the Battle of Malachor.

32 BSW4
Ascent to power
Sheev Palpatine, secretly Darth Sidious, becomes Chancellor.

19 BSW
End of the Clone Wars Darth Tyranus is defeated, and Darth Vader rises.

35 ASW4
The Sith cult
The Final Order and the Sith Eternal are defeated.

C. 1032 BSW4
Rule of Two The Sith are seemingly destroyed; however, Darth Bane survives, continuing the order.

32 BSW4
Battle of Naboo
Darth Maul is defeated, and the Jedi come to learn the Sith still exist.

4 ASW4
Battle of Endor
Darth Sidious is defeated, though the secret Sith cult continues.

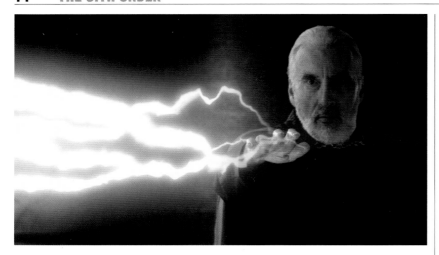

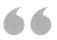

willingly relinquishing their freedoms to his authority, he declares himself Emperor and brands the Jedi traitors. After a thousand years in the shadows, the Sith finally have their revenge on the Jedi Order that defeated them generations ago.

The Sith Eternal

Darth Sidious rises to rule the galaxy with Darth Vader as his apprentice. The Jedi are all but destroyed, killed by clone troopers carrying out Order 66. Surviving Jedi are hunted down by Vader and the Inquisitorius.

Evil powers Darth Tyranus wields Force lightning, a dark side ability favored by the Sith Lords.

For all their power, there is an enemy the Sith cannot defeat: mortality. The Rule of Two requires the apprentice to slay the master, ensuring only the most powerful and cunning ascend. Darth Sidious in particular is not prepared to die to ensure the continuation of the Sith. He probes the secrets of the dark side for ways to cheat death, inspired by the unnatural experimentations of his master, Darth Plagueis the Wise.

With his position as Emperor Palpatine secure, Sidious largely disappears from public view, leaving the running of his regime to underlings. This allows him to focus on Sith arcana, and the building of a hidden power base on Exegol, the Sith throneworld in the Unknown Regions. Through a variety of dark sciences and advanced cloning technology, Sidious seeks to unlock the secrets of immortality. Upon his command, the Imperial military cracks down on any subversives that could challenge his rule of the Galactic Empire. This leads to the rise of the Rebellion and the outbreak of the Galactic Civil War.

Emperor Palpatine's demise comes at the Battle of Endor. The Empire is shattered by the Rebel Alliance and democracy is restored to the galaxy. But Sidious' multi-layered contingency in the event of such catastrophe sees his spirit reawaken in a cloned body on Exegol, attended to by his Sith Eternal cultists. The processes are far from perfected, and Darth Sidious' cloned body rapidly

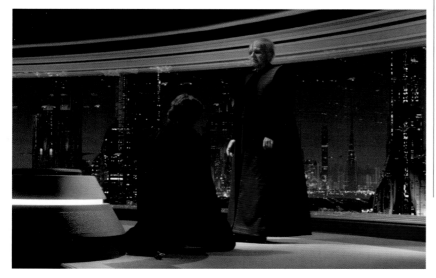

Complete corruption Anakin Skywalker kneels before the ascendant Darth Sidious to receive his Sith title: Darth Vader, Dark Lord of the Sith.

Foreboding furniture The jagged Throne of the Sith is reserved only for the most powerful Sith Lords on ancient Exegol.

deteriorates, trapping him on Exegol as his frail form is unable to leave. In the confines of his recuperative sanctuary, he plots the next phase of ultimate Sith vengeance, and the final defeat of the Jedi.

In the decades that follow the Battle of Endor, the First Order emerges as a serious threat to the galaxy. Unknown to the general public is that the First Order is but the tip of a spear that reaches all the way to Exegol, and it is Darth Sidious who wields it. Supreme Leader Snoke, a genetically engineered proxy for Sidious, appears to command the First Order. Though Snoke uses the dark side of the Force, he has no outward affiliation to the Sith. Through Snoke, Sidious corrupts young Ben Solo—grandson of Darth Vader—who serves Snoke as the vicious Kylo Ren. Imperial scientific research gives way to First Order superweapon technology capable of destroying entire star systems, in the form of Starkiller Base. In the secret shipyards of Exegol, a vast fleet of *Xyston*-class Star Destroyers equipped with planet-shattering superlasers is accumulated over decades. This is the Final Order: the culmination of Darth Sidious' dream to cow any dissent and create a galaxy without conflict in which he can live forever.

An ultimatum demanding that all worlds surrender broadcasts from the Unknown Regions, revealing to a disbelieving galaxy that the Emperor has returned. This time, he makes no secret of his Sith affiliation. Rey—granddaughter of Palpatine—and Ben Solo—grandson of Darth Vader—travel to Exegol and challenge Sidious. In the end, Rey channels the Force—bolstered by the spirits of Jedi past—to finally vanquish Sidious and the Sith, ending his dreams of immortality. ∎

Sith minions

Even when the Sith Order had many members, Sith still contracted agents to carry out assignments. When the Rule of Two is enacted, it becomes necessary to have underlings and allies carry out overt acts against the Jedi and the Republic, while keeping Sith involvement a secret. Similarly greedy individuals, like the corporate barons of the Trade Federation, or bounty hunters and assassins, like Cad Bane or Ochi of Bestoon, carry out Sith dirty work, often unaware of the nature of their clients and the dark agenda they are serving.

When a minion is strong in the Force, they risk becoming too powerful, and unsettling the balance of the Rule of Two. When Sith assassin Asajj Ventress, a servant of Darth Tyranus, becomes a threat to her master at the height of the Clone Wars, Darth Sidious decrees her a rival to power. As a test of his apprentice's loyalty, Sidious orders Tyranus to kill Ventress.

THE PHANTOM MENACE
DARTH SIDIOUS

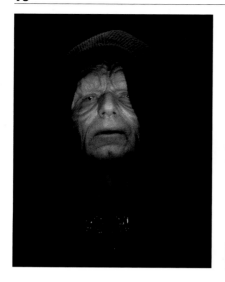

HOLOCRON FILE

NAME
Sheev Palpatine

SPECIES
Human

HOMEWORLD
Naboo

AFFILIATION
Sith; Galactic Senate; Empire

ABILITIES
Political scheming; Sith training; arcana (including lightning)

AIM
To rule unchallenged forever

STATUS REPORT
Destroyed on Exegol

Darth Sidious' origins are secrets he has taken to the grave more than once. It is not yet known when he began learning the ways of the dark side from his mentor, Darth Plagueis, but by Sith tradition, he kills Plagueis before ascending to master.

Sidious inherits Plagueis' studies: in-depth research into the biological underpinnings of life in an attempt to cheat death.

Sidious is better known to the galaxy as Sheev Palpatine, the senator from Naboo. In this role, he rides a tide of sympathy caused by the Trade Federation's occupation of Naboo, winning an election to become the Supreme Chancellor of the Republic. What no one in the Senate knows at this time is that the occupation was orchestrated by Sidious to achieve these ends.

While Sidious stays hidden, his apprentice Darth Maul is more often his outward agent. Sidious claims Maul when he is a child, taken from Mother Talzin of the Nightsisters of Dathomir. As Maul matures, he serves as a stealthy assassin, eager to finally claim vengeance against the Jedi.

Maul is defeated by the Jedi Obi-Wan Kenobi during the Naboo blockade and believed dead, so Sidious takes another apprentice, Darth Tyranus, once a former Jedi Master called Count Dooku. Together Tyranus, as the public face of a Separatist movement, and Sidious trigger the Clone Wars. This galaxy-wide military conflict cements Palpatine's chancellery for the duration of the emergency—well past full-term limits. Tyranus dies in the Clone Wars, to be replaced by Sidious' next apprentice—Darth Vader—formerly the Jedi Knight Anakin Skywalker. At the end of the Clone Wars, Palpatine declares himself Emperor and orchestrates the systematic elimination of the Jedi.

Obsessed with immortality, Palpatine withdraws from public view so he can probe the secrets of the dark

Smiling politician
Palpatine is a political mastermind who is beloved by the Republic in times of crisis.

> Your feeble skills are no match for the power of the dark side.
> **Emperor Palpatine**

side. In the Unknown Regions, he readies the ancient Sith throne of Exegol to be his permanent seat of power. His cultist underlings experiment with cloning technology to extend his life. When Sidious is defeated at the Battle of Endor, he transfers his consciousness through the Force to a waiting cloned body. The process is imperfect, resulting in his mind being trapped in a rotting corpse.

Treason Palpatine refuses to relinquish war-time power, revealing his Sith side to an arresting party of Jedi Masters.

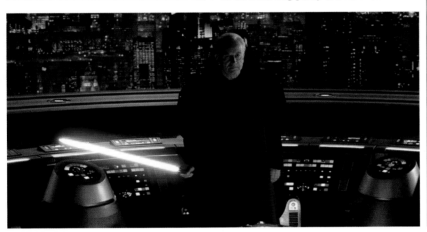

Over the ensuing decades, Sidious continues his obsessive explorations into rejuvenation. Clone offshoots from this process include his "son," who flees Exegol in an attempt to live a life apart from darkness. Another genetic construct becomes Snoke, an underling whom Sidious installs as Supreme Leader of the emergent First Order. Through Snoke, Sidious manipulates Anakin's grandson, Ben Solo, and lures him to the dark side. Sidious senses the Force awakening within Rey, the offspring of his cloned son and is determined to capture her.

Sidious lures Ben Solo and Rey to Exegol, revealing to the galaxy at large his continued existence and the military resources at his disposal. Sidious at first plans to take over Rey's body as a receptacle strong enough to hold his spirit, but is surprised to discover that Kylo and Rey are a dyad in the Force of great strength. By drawing upon their power, he can revivify his body. But Rey and Ben thwart his plan, with Rey channeling the power of the Force and the Jedi spirits of beyond to finally destroy Sidious, both body and soul. ∎

The pathway to immortality

Sidious' master, Darth Plagueis, thought the pathway to immortality lay in the sciences. He could coax midi-chlorians—the microscopic symbionts present in all body cells that channel the Force—to create new life. His experiments were incomplete but encouraging.

Sidious covets any and all vergences in the Force, for such concentrations of power are needed to break the rules that govern life and death. One Force nexus in particular draws his attention: the legend of a gateway beneath the ancient Jedi temple on Lothal. The Emperor's agents excavate this relic, finding markings that align with the Force netherworld between worlds. Sidious cannot open the passageway, and tries to compel Ezra Bridger—who can open it, possibly due to his Lothal heritage—to do so, but the young Jedi refuses.

Exegol is home to the most promising experimentations. Modified cloning technology and the dark side concentration of the Sith throneworld stave off death for a time, but eternal life eludes the Dark Lord.

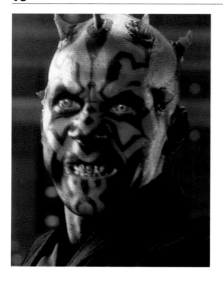

AGENT OF CHAOS
DARTH MAUL

HOLOCRON FILE

NAME
Darth Maul

SPECIES
Dathomirian Zabrak

HOMEWORLD
Dathomir

AFFILIATION
Sith; Shadow Collective; Crimson Dawn

ABILITIES
Criminal plotting; Sith training; lightsaber combat

AIM
To rule unchallenged

STATUS REPORT
Killed by Obi-Wan Kenobi on Tatooine

In their pursuit of power, Sith Lords will cling to life, surviving grievous injuries to claw onto miserable existence. Darth Maul is a tragic example of one whose path was rarely of his own choosing, manipulated by those with greater power and dark agendas. Despite this, he refuses to accept the hand that fate deals him.

Maul is born to Mother Talzin, leader of a coven of witches on the dark world of Dathomir. The Sith Lord Darth Sidious takes Maul from his home to train him as his Sith apprentice. Talzin vows vengeance for what she sees as thievery, though it would take decades for her plans to coalesce.

Maul learns martial skills through practice with droid opponents, and Sidious teaches him treachery, scheming, and the power of the dark side. Maul is deeply indoctrinated in Sith dogma, and longs to step out of the shadows and strike against the Jedi. He gets his chance when Sidious' plot to blockade Naboo attracts Jedi negotiators. Maul battles two Jedi opponents, slaying Jedi Master Qui-Gon Jinn first. However, Jinn's apprentice, Obi-Wan Kenobi, defeats Maul by slashing him in two.

Cyber spider The primitive apparatus that Maul scavenges at least allows him to walk again.

By all rights, Maul should have died. His Dathomirian physiology, Nightsister magicks, and Sith tenacity keep him grasping to life even as he loses his grip on his sanity. His broken body is dropped onto the junk planet of Lotho Minor, where he instinctively constructs for himself a mechanical arachnid form and lives as a carrion scavenger. After more than a decade of this pitiable life, he is found by his brother Savage Opress, sent on a retrieval mission by Mother Talzin.

The Shadow Collective

The Sith's historic inability to peacefully share power necessitates the Rule of Two. Maul and his brother Savage Opress know that they need to someday challenge Sidious, the reigning Sith master, but it will not be easy. Maul masterminds the creation of a powerbase in the criminal underworld, uniting the Hutts, the Pykes, Black Sun, the Mandalorian Death Watch, and Crimson Dawn into the group known as the Shadow Collective. Maul's takeover of Mandalore tips the scales, bringing him to Sidious' attention. Sidious arrives to war-torn Mandalore to do battle. The Sith Lord kills Savage and captures Maul.

For all his power, Maul is but a pawn in a larger game. His resurrection by Mother Talzin is a ploy to draw out Sidious so she can exact revenge. His capture by Sidious is likewise a lure to Talzin. Sidious and Talzin clash, and Sidious emerges victorious. Maul escapes once more to return to his criminal enterprises.

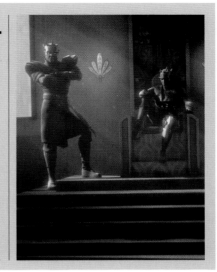

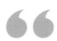

> At last we will reveal ourselves to the Jedi. At last we shall have our revenge.
>
> **Darth Maul**

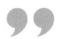

Opress brings Maul to Talzin, who heals his mind and equips him with humanoid, mechanical limbs. Maul vows vengeance against Obi-Wan, and plots to build a powerbase in the criminal underworld, taking advantage of the cover of the Clone Wars. His criminal enterprise allows him to take control of Mandalore for a time. During the Siege of Mandalore, former Jedi Ahsoka Tano apprehends Maul, but the chaos of Order 66 and the rise of the Empire allow him to escape.

Old rivals Kenobi honors Maul after defeating him by burning his body on a funeral pyre.

Over the years, Maul's obsession becomes two-fold. He longs for vengeance against Obi-Wan Kenobi for the injuries that ended his path as a Sith Lord. Second, he wishes to topple Darth Sidious. He knows to not underestimate either nemesis, so scours worlds such as Malachor and Dathomir to give him the advantage he needs. Maul even coerces young Jedi initiate Ezra Bridger into helping him. With a Sith holocron and a Jedi holocron combined, Ezra and Maul are able to peer into the Force to find answers.

A fleeting glimpse of a world with twin suns eventually draws both Ezra and Maul to Tatooine, where Obi-Wan Kenobi lives in hiding. Ezra rushes to warn Kenobi, but the old Jedi knows what hunts him. Kenobi and Maul square off once more, and Kenobi quickly dispatches Maul. Maul's desire for vengeance finally sated, Kenobi cradles his old enemy's body in death, giving him at least the peace of mind that there will someday come a hero who will end Darth Sidious' rule. ∎

BETRAYER OF THE JEDI

COUNT DOOKU

HOLOCRON FILE

NAME
Count Dooku/Darth Tyranus

SPECIES
Human

HOMEWORLD
Serenno

AFFILIATION
Jedi (formerly); Sith; Separatists

ABILITIES
Force lightning; telekinesis; agility

AIM
To destroy the Jedi and the Republic

STATUS REPORT
Deceased

Born to Count Gora and Countess Anya on Serenno, Count Dooku grows up not knowing about his aristocratic heritage. Disturbed by his son's latent Force abilities, his father abandons him outside his palace, where he is discovered and brought to the Jedi. Training under Master Yoda, Dooku shows considerable promise and advances to the rank of Jedi Master, taking Qui-Gon Jinn as his Padawan.

Upon learning the truth about his birth, Dooku discovers he has a sister, Jenza, and maintains correspondence with her, despite the fact that for Jedi such attachments are forbidden. This tears at Dooku's already wavering loyalties. His quest for power, fascination with dark-side artifacts, and his growing frustration with the Republic lead to him leaving the Jedi Order. He claims his family title and commands his sister's death, becoming the secret apprentice of Darth Sidious, replacing Darth Maul. The Jedi Council dismisses Dooku as a political idealist, not realizing there is a more sinister side to him: that of a Sith Lord.

Under his new master's guidance, and with the new name Darth Tyranus, Dooku becomes a lethal scourge of the galaxy, taking many lives in his role as a Separatist leader, effectively starting the Clone Wars. He takes on an apprentice of his own, Asajj Ventress, and cruelly molds her into his assassin. However, he is loyal to his master

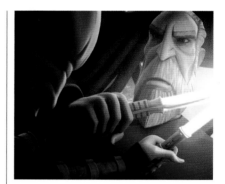

Sith assassin Dooku fails to destroy Ventress, but faces her once more when she returns to assassinate him. She is thwarted before she can complete her mission.

and tries to kill Ventress at the request of Sidious, who believes she is becoming too powerful.

During the Clone Wars, Dooku plays many roles. He is a politician, overseeing the war efforts of the Separatists and recruiting thousands of star systems. He is a legendary swordsman and dark-side disciple and engages the Jedi in combat many times. Yet in the end, Sidious orders Dooku's death in order to take young Anakin Skywalker as his apprentice instead, furthering the legacy of Sith betrayal. ∎

ASSASSIN REDEEMED

ASAJJ VENTRESS

HOLOCRON FILE

NAME
Asajj Ventress

SPECIES
Dathomirian

HOMEWORLD
Dathomir

AFFILIATION
Sith; Separatists; Nightsisters; bounty hunter

ABILITIES
Force telekinesis; enhanced agility and reflexes; dual-lightsaber proficiency

AIM
Stop Dooku's destructive path and find purpose

STATUS REPORT
Deceased

I am not your kind. I do not feed off vengeance.
Asajj Ventress

Asajj Ventress is many things throughout her life: Nightsister, enslaved individual, Jedi Padawan, Sith assassin, Separatist general, and bounty hunter. Turmoil is a constant for her: as a baby she is taken from the Nightsisters on her home planet of Dathomir by the pirate Hal'Sted. When he is killed, she is found by Jedi Master Ky Narec, who trains her until his untimely death, after which she falls under the influence of Count Dooku.

The Sith Lord capitalizes on her lifetime of pain and loss, torturing and manipulating her while training her in the dark side of the Force. Excelling at intimidation and infiltrating enemy territory, she becomes Dooku's assassin in the Clone Wars, ruthlessly hunting down Jedi and serving as a commander in the Separatist droid army. When Darth Sidious decides she is a threat, he orders Dooku to destroy her. Dooku is unsuccessful, but she is once again abandoned.

Injured and plotting vengeance, she flees home to Dathomir, where her sisters accept her with open arms. During a Rebirth Ritual, Asajj rejoins the coven's ranks. Their leader, Mother Talzin, lends resources to Asajj to exact her revenge. To further her aim, Asajj trains a vicious Nightbrother, Savage Oppress, but her conspiracy fails, bringing Dooku's wrath down upon the entire clan. Her people seemingly wiped out, Ventress seeks purpose by becoming a bounty hunter. She joins Boba Fett and his team of bounty hunters on a mission to Quarzite and even an old adversary, Obi-Wan Kenobi, on one occasion. When Jedi Ahsoka Tano is framed for murder, Asajj helps her find justice—showing there is still good in her.

Her new life also leads to an alliance and emotional attachment with Jedi Quinlan Vos. Learning he has been tasked with killing Dooku, Ventress agrees to help him, training him in the dark side of the Force. When Vos is attacked by Dooku, Asajj gives her life to save him, and in doing so finally knows peace. ∎

DAUGHTERS OF DATHOMIR
THE NIGHTSISTERS

HOLOCRON FILE

NAME
Nightsister

SPECIES
Dathomirian

HOMEWORLD
Dathomir

AFFILIATION
Neutral

POWERS
Magicks

The Nightsisters are an ancient order of witches living on the mysterious planet of Dathomir. Drawing strength from their dark planet, the Nightsisters can use the mystical energies they call magicks, an aspect of the Force that manifests in green-colored energies, to gain unnatural powers. They live in a strictly matriarchal society, surviving on their harsh planet in villages and underground caverns. Outsiders are rarely allowed to step foot on the planet, where they will be met by a team of Nightsisters ready to defend themselves with energy bows, razor-sharp swords, and poison darts. But their most common deterrent is simply their sinister reputation, as few offworlders would dare visit Dathomir at all.

With their magicks, the Nightsisters can conjure refreshing blackroot drinks and heal broken bodies, but their

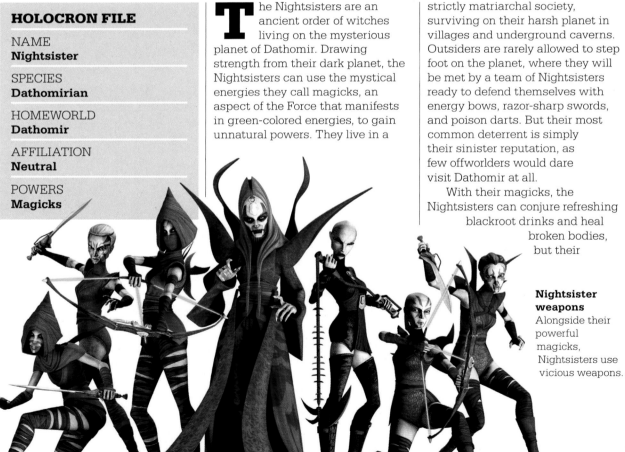

Nightsister weapons
Alongside their powerful magicks, Nightsisters use vicious weapons.

Nightbrothers

On the far side of Dathomir, the males of their species live in tribes among primitive villages. Led by Brother Viscus, the Nightbrothers are merciless, ferocious warriors identified by their horned heads and marked skin. The Nightsisters keep them at a distance, but occasionally they issue them orders.

In a series of deadly games, Asajj Ventress identifies one Nightbrother, Savage Opress, to become an assassin to carry out her vengeance on Dooku. Mother Talzin transforms him into a hulking beast whose final test is to kill a fellow Nightbrother. While the mission fails, Savage survives the encounter and later unites with his brother Maul, long thought dead. Together, the two Nightbrothers terrorize the galaxy until Darth Sidious kills Savage. The Nightbrothers are not targeted by Grievous and later join Maul's Shadow Collective on Talzin's orders.

abilities go beyond just restorative powers. This dark ichor allows them to conjure invisibility potions, enchanted blades, create illusions, form energy shields, use teleportation and more. Their most powerful machinations occur in dark rituals performed upon an altar, where green mists rise forth as they chant incantations known only to the sisters.

The Nightsisters are led by Mother Talzin, a powerful elder matriarch blessed with unnaturally long life. She forms an alliance with Darth Sidious to mix the power of the dark side with her magicks in hopes that he will allow her to rule

> Nadee, mah, reez, ven, doo, la, tren.
> **Nightsister potion conjuring chant**

Dark recollections Activating a lightsaber, Merrin remembers the day her sisters fell to Grievous' blades.

by his side. The Sith Lord betrays Talzin and steals her son, Maul, to train as a Sith. She must sell other Nightsister children to protect the clan, including a sister named Ventress whose return many years later brings with it an opportunity to take revenge on the Sith. Talzin helps Ventress attempt to assassinate Count Dooku—an ill-fated decision that has terrible repercussions for the coven.

Dooku's revenge

After Ventress' attempts on his life, Count Dooku orders General Grievous to lead a battle droid army to Dathomir and exterminate the Nightsisters. Faced with invasion, Talzin calls upon the aid of an elder, Old Daka, who resurrects fallen Nightsisters to fight as zombies and bolster their ranks. While the Nightsisters fight fiercely against the droids, even an undead legion is not enough to repel the onslaught, and there are few survivors. Talzin escapes, but only temporarily. In her final battle, now against Sidious, Grievous, and Dooku, she sacrifices herself to save her son Maul. As Grievous strikes her down, the magicks rush out of her body once and for all.

A survivor of Grievous' massacre is the Nightsister Merrin. Just a child at the time, she grows up vowing to take vengeance for her sisters' deaths. She matures into a powerful witch with excellent control of magicks and commands the Nightbrothers. She finds a curious understanding with Jedi Cal Kestis, also a young survivor of the war. After aiding him in his fight against fallen Jedi Taron Malicos, Merrin joins the crew of the *Mantis* on their mission to secure the future of the Jedi in hopes of leaving her unhappy life on Dathomir behind. ∎

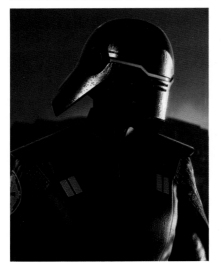

CRUEL HUNTERS
THE INQUISITORIUS

HOLOCRON FILE

NAME
Inquisitorius

SPECIES
Varied

HEADQUARTERS
Fortress Inquisitorius, Nur

AFFILIATION
Sith; Empire

POWERS
The dark side of the Force

AIM
Hunt down the last of the Jedi

While Order 66 is successful at destroying most of the Jedi Order, some Jedi survive the initial betrayal. Clones prove to be an effective weapon when they have the element of surprise, but the surviving Jedi are better prepared. Hunting down the remaining survivors requires an organization that can tackle the Jedi face to face, lightsaber to lightsaber. Sidious tasks his enforcer, Darth Vader, with tracking down the Jedi survivors, aided by Imperial Intelligence and a newly founded order of Force-sensitive agents known as the Inquisitors.

Believing that there is no one better to find a Jedi than one of their own, the Inquisitorius sources its members from the ranks of the Order. Whether by corrupting them or through torture, they lead these Jedi survivors to embrace the dark side and then equip them to hunt down their former associates. The new Inquisitors shed the symbols of their past, giving up their names to become just a number alongside their new brothers and sisters. They trade their Jedi robes for dark armor, uniquely built to each Inquisitor's new tastes. As their Jedi sabers are no longer suitable, they adopt double-bladed sabers with a ringed emitter, ideal for throwing, spinning, and combating Jedi who will not be used to such weapons. They train in secret facilities on Coruscant and their Fortress on Nur, a moon in the Mustafar system not far from Darth Vader's own castle on the nearby volcanic planet.

Aiding the Inquisitors are the Purge Troopers, the final batch of Kaminoan clone troopers who are

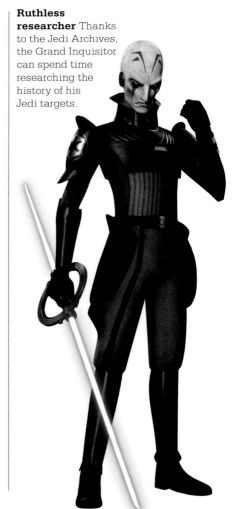

Ruthless researcher Thanks to the Jedi Archives, the Grand Inquisitor can spend time researching the history of his Jedi targets.

> The Jedi are dead, but there is another path: the dark side!
> **The Grand Inquisitor**

clad in black armor and are specially trained to deal with lightsaber-wielding foes. While the average Imperial stormtrooper offers little help in a fight against the Jedi, the Purge Troopers are valuable assistants to the Inquisitors.

Adding to their mysterious nature, Inquisitors reveal very little about themselves to outsiders, even keeping the size of their order a secret. The Inquisitors respond to all credible reports of Jedi activity, including a suspicious sighting on the scrap world of Bracca. There the Second Sister and Ninth Sister begin their hunt for the former Padawan Cal Kestis. After Cal defeats the Ninth Sister on Kashyyyk, the Second Sister

Sinister streak The Inquisitors tend to mistrust each other and are extremely competitive.

lures the young Jedi to Fortress Inquisitorius. For failing to stop the Jedi there, Vader strikes the Second Sister down.

Hunting Spectres

Atop the order is the Grand Inquisitor, a Pau'an and former Jedi Temple Guard who reports directly to Vader. He falls in battle to Kanan Jarrus, the former Jedi Padawan he hunts on Lothal. Though he fails that day, two Inquisitors, the Fifth Brother and Seventh Sister, take over the search. They make a

frightening pair, as the Fifth Brother's anger and strength is matched only by the Seventh Sister's cunning and agility. They are joined by the Eighth Brother on Malachor, who was assigned to hunt the former Sith, Maul. The three Inquisitors are surprised to be outnumbered by Force users. Former Jedi Ahsoka Tano, Padawan Ezra Bridger, and Jarrus form a tenuous alliance with Maul. These four would make a prodigious catch for the Inquisitors, who are overconfident in believing they can apprehend so many. These foes prove to be too much for the three Inquisitors, who perish on the ancient battlefield of Malachor that day. ∎

Project Harvester

Just one of Darth Sidious' secret plans, Project Harvester aims to identify and capture Force-sensitive children and turn them into agents of the dark side. Operating from the planet Arkanis, the children are raised in the care of Sidious' agents. His ultimate vision is to train an army of Force-sensitive spies to use their powers to see events hidden across the galaxy. The Emperor believes that by peering into events, he can find and destroy anyone who opposes him.

One target of Project Harvester is the newborn child of former Jedi Master Eeth Koth, who shares her father's potential to connect with the Force. Other possible members, including Lothalite Dhara Leonis, are found through cadet academies, which identify Force potential and then transfer the children to Arkanis.

SUPREME LEADER

SNOKE

HOLOCRON FILE

NAME
Snoke

SPECIES
Genetic strandcast (artificial)

HOMEWORLD
Exegol

AFFILIATION
Sith (proxy); First Order

ABILITIES
**Force perception;
telekinesis; Force lightning**

AIM
Galactic conquest

STATUS REPORT
Slain by Kylo Ren

For much of its history, the First Order lurks in the shadowy edges of the Unknown Regions. Its leader is a towering humanoid with a broken build, a scarred being known only as Snoke. Though a Force user of impressive power, he denies any Sith lineage. In fact, only scant details exist regarding his origins.

It's possible Snoke himself may not know his true nature. Snoke is a strandcast—an artificial genetic construct concocted by the resurrected Darth Sidious to be his proxy in power. Snoke has free will, but his actions and goals are still orchestrated by Sidious.

Snoke senses the coming of Rey as an awakening in the Force. He is disappointed by First Order leader Kylo Ren's inability to stop her. He goads Ren, all to push the darkness in him. Snoke— who is ordinarily extremely cognizant of Ren's thoughts and motives—doesn't foresee that Ren will outmaneuver him.

Clone brothers On Exegol, Emperor Palpatine holds many genetic copies of Supreme Leader Snoke in a vat.

> There has been an awakening. Have you felt it?
> **Snoke**

Through Snoke, Sidious sidesteps the tradition of a dark-side apprentice slaying his master to ascend, which happens when Kylo Ren betrays Snoke and slices him in two. Ren then assumes the mantle of Supreme Leader of the First Order. Ren's examination of Snoke's past turns up more mysteries and dead ends. Ren fully expects the dark voice that he has heard in his head for years to disappear once Snoke dies, but it persists. This points to someone manipulating Snoke, and Ren's search for answers uncovers the presence of the Emperor, who was believed deceased, on Exegol. There, in a laboratory deep in a Sith sanctuary, are other Snoke bodies, resting in nutrient fluid. ∎

MASKED MARAUDERS
THE KNIGHTS OF REN

HOLOCRON FILE

NAME
Knights of Ren

HOMEWORLD
Mobile

AFFILIATION
Independent

ABILITIES
Unarmed and armed combat; slight Force abilities

AIM
Chaos and violence

STATUS REPORT
Slain by Ben Solo on Exegol

A group of marauders that prey on vulnerable targets in the lawless stretches along the Unknown Regions, the Knights of Ren are touched by the dark side, but have no adherence to any Force disciplines. There are seven in total: Vicrul, the scythe-man; Cardo the heavy gunner; Ushar, who wields a club; Trudgen, the vibrocleaver; Kuruk, the rifleman; Ap'lek, the axman; and Ren, their leader, who carries a lightsaber. The Knights prowl the loosely settled worlds of the Unknown Regions in their brutish looking starship, the *Night Buzzard*.

Luke Skywalker and Ben Solo encounter the Knights of Ren on Elphrona during their travels, when Ben is still an apprentice to Skywalker. Though Skywalker easily defeats the Knights (while sparing their lives), unimpressed by their basic use of the dark side, their lawlessness and power appeal to Ben, and he thinks of them for years to come. When Ben first pledges himself to Supreme Leader Snoke, Snoke points him toward the Knights of Ren, so he can learn valuable skills from them.

As part of his initiation, Ben Solo slays Ren, and adopts his title. He becomes Kylo Ren, leader of the Knights of Ren, and fashions a look and weapon that reflects both himself and his leadership. Upon his ascendancy to Supreme Leader of the First Order, Ren dispatches his Knights to track down the scavenger Rey; they pursue her and her friends to Pasaana and Kijimi.

After Ben Solo's abandonment of his title, he does battle with the Knights of Ren in the depths of Exegol, and succeeds in dispatching all six of his former followers with his lightsaber. ∎

Striking terror The Knights intimidate wherever they go—whether hunting for Rey on Kijimi or aboard Star Destroyers.

Ghouls.
First Order stormtrooper

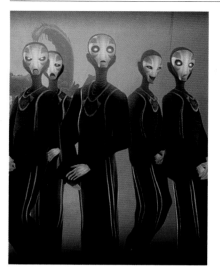

MORE THAN JEDI OR SITH
FORCE USERS

HOLOCRON FILE

NAME
Force users; Force sensitives

KEY LOCATIONS
Force vergences; ancient worlds across the galaxy

NOTABLE EXAMPLES
The Father, the Son, and the Daughter; the Bendu; Force Priestesses

AIM
Force cultivation

STATUS REPORT
Time will tell

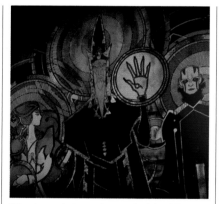

Moving picture A mural of the Mortis gods acts as a portal from Lothal's Jedi Temple to the world between worlds.

The use of the Force extends beyond just the Jedi and the Sith. Scattered across the galaxy are other, less easy to define, Force users and Force sensitives. These beings tend to align with either the light or the dark side, but usually position themselves outside the rules of either Order, or follow their own paths. Like the Force, many of these entities are enigmatic and mysterious, for the most part unknown to the galaxy at large.

Even when knowledge of such beings is gained, it can be hard to retain. During the Clone Wars, Obi-Wan Kenobi, Anakin Skywalker, and Ahsoka Tano answer an ancient Jedi distress call and find themselves in an uncharted region of space called Mortis. In this shifting, paradise-like place, three powerful, Force-wielding entities exist: perpetually in conflict, battling for supremacy. The Father maintains the balance between the Son—who is the physical embodiment of the dark side—and the Daughter, the Son's light-side counterpart.

Sensing that his time is coming to an end, the Father hopes to recruit Anakin to take his place, believing the Jedi to be the prophesized Chosen One. Anakin's presence throws off the trio's balance. The Son kills the Daughter and tries to manipulate Anakin to turn to the dark side. Anakin receives terrible visions of the atrocities he will one day commit as Darth Vader, but resists, at this time, the pull of the dark side. The Mortis gods die (restoring the balance of the place), and the visitors' memories of the experience fade away.

Jedi Grand Master Yoda himself learns more of the stranger aspects of the Force when the spirit of Qui-Gon Jinn sends him to a glowing land known as the Force planet, inhabited by five supernatural Force Priestesses. These mystical beings personify the connection between the living Force and the cosmic Force. Their home is the birthplace of midi-chlorians and is not found on any map. The Priestesses identify as Serenity, Joy, Anger, Confusion, and Sadness and test Yoda with the goal of teaching him the larger meaning of the Force and how to maintain consciousness in the living Force after death.

The Force be with you Awareness of the Force and the ability to harness it for oneself varies on a spectrum from person to person and group to group.

Frangawl Cult
Dark side cult that worships Malmourral, Bardottan demon of war.

The Ordu Aspectu
Extinct Jedi group; sacrificed Padawans in the hopes of discovering immortality.

Jedha Pilgrims
Devoted believers in the Force seeking spiritual guidance. Others on Jedha, such as Chirrut Îmwe, teach about the Force's powers.

Orphne
Whimsical nymph from Aleen; longs for balance in the Force on her world.

Lasat Prophecy
Survivors of Lasan use the "Ashla" (their word for the Force) to guide them to their new home, Lira San.

The Bendu

Aligned to the middle ground between the light and the dark sides of the Force is the Bendu, never straying to one or the other. This gigantic being lives on the planet Atollon, resting peacefully amongst the rocky terrain. Bendu does not interfere in the ways of the Jedi or Sith, but is interested in training Force sensitives to overcome their fears and internal conflict through personal trials. His connection to the Force is great, as is his power. The Bendu can sense the emotions of others, disappear and reappear, create storms, and see the future. He is also ancient, and has accumulated countless knowledge over the years as he meditates in the Force.

Bendu calls out to Kanan Jarrus, helping him make peace with his blindness, overcome his insecurity, and reconnect with the Force. When the Empire invades Atollon, the Bendu causes both Rebel and Imperial ships to be damaged, refusing to take a side. He later disappears.

Walking their own path, but forging an uneasy relationship with the rigid Jedi Order are the Dagoyan Masters. These Force users from Bardotta emphasize meditation and passively connect to the Force. They are not warriors and prefer to use their connection with the Force to sense intuition, harmony, and knowledge. Neither do they use the Force to affect the physical world. Their way establishes a much more personal connection in which they are not interested in either the light or the dark side. All Bardottans are educated at a Dagoyan school and learn the art of meditation there.

Malevolent influences

On the dark side there are Force sensitives who wreak their own brand of havoc in the galaxy. The Zeffo are one such group, who started out as a peaceable culture, but fell to the dark side. This ancient species from the planet Zeffo refer to the Force as "Life Wind." Those strong in the Force, and able to connect to it, were originally referred to as sages. However, led by Kujet, one of the esteemed sages fallen to evil, they established a place of power on Dathomir. After Kujet's death, the remaining Zeffo left for the great unknown in the hope of finding peace.

Deep in the Unknown Regions of the galaxy, on the remote planet Exegol, Sith Eternal cultists occupy an ancient Sith citadel. These robed figures are slavishly devoted to Palpatine and are fanatical in their adherence to his resolutes. Hungry for the return of the rule of the Sith, and almost void of a will of their own, they lie in reverent wait for Palpatine to be restored to full power. The number of their army, including Sith troopers and other military forces, may be many, but their individual Force abilities are unascertained. ∎

> My children and I can manipulate the Force like no other.
> **The Father**

THE
SKYWAL

ERS

Perhaps the most influential family in the history of the galaxy, the Skywalker family is forever connected to some of the most pivotal moments in the annals of the Jedi Order, the reemergence of the Sith, and the affairs of the Republic. The Skywalker name is synonymous with great power, prestige, and sometimes chaos, ultimately restoring peace to the galaxy.

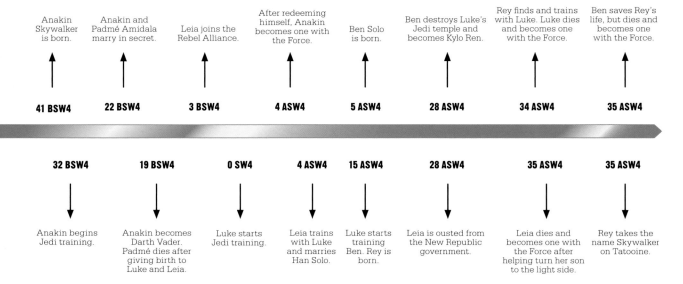

Anakin Skywalker is born.
41 BSW4

Anakin and Padmé Amidala marry in secret.
22 BSW4

Leia joins the Rebel Alliance.
3 BSW4

After redeeming himself, Anakin becomes one with the Force.
4 ASW4

Ben Solo is born.
5 ASW4

Ben destroys Luke's Jedi temple and becomes Kylo Ren.
28 ASW4

Rey finds and trains with Luke. Luke dies and becomes one with the Force.
34 ASW4

Ben saves Rey's life, but dies and becomes one with the Force.
35 ASW4

32 BSW4 Anakin begins Jedi training.

19 BSW4 Anakin becomes Darth Vader. Padmé dies after giving birth to Luke and Leia.

0 SW4 Luke starts Jedi training.

4 ASW4 Leia trains with Luke and marries Han Solo.

15 ASW4 Luke starts training Ben. Rey is born.

28 ASW4 Leia is ousted from the New Republic government.

35 ASW4 Leia dies and becomes one with the Force after helping to turn her son to the light side.

35 ASW4 Rey takes the name Skywalker on Tatooine.

Spanning several generations, the Skywalker family takes a prominent role in history-defining conflicts, including the Clone Wars, the Galactic Civil War, and the rise of the First Order. The family is rarely united, with members taking leadership roles in the opposing factions during each period. Full of hope, tragedy, and renewal, the Skywalker family is strong in the Force and legendary across the galaxy.

Shmi Skywalker's son, Anakin, is a mysterious child as he does not have a father and perhaps was conceived through the will of the Force. The young child starts predicting events before they come to pass, which attracts the attention of Jedi Master Qui-Gon Jinn. The Jedi discovers that Anakin is incredibly strong in the Force and might even be the Chosen One, a prophesized figure who would bring balance to the Force. Qui-Gon agrees to train Anakin to be a Jedi. The brave youth risks his life to help Qui-Gon's mission to help Queen Padmé Amidala of Naboo free her planet from the Trade Federation.

When Qui-Gon falls in battle, Qui-Gon's former Padawan Obi-Wan Kenobi becomes Anakin's new master.

A decade later, Anakin and Padmé, now a senator, play pivotal roles in the Clone Wars. Anakin and Padmé also fall in love, an act forbidden for a Jedi, and they marry in secret. When Padmé discovers she is pregnant, both Anakin and Padmé are excited for the future. However, Anakin starts to fear Padmé will die in childbirth. This weakness is capitalized upon by Darth Sidious, hiding in plain sight as Supreme Chancellor Palpatine. When Anakin discovers the Chancellor's secret, he exposes the Sith to the Jedi who attempt an arrest. Rejecting an order to stay away, Anakin disrupts this critical mission, and is tempted by the Sith to join the dark side and turn on his allies. After helping to kill Master Windu, Anakin becomes a Sith Lord, named Darth Vader, and helps Sidious destroy the Jedi Order.

Padmé is horrified by Anakin's actions and fails to turn him from the dark side on Mustafar. Obi-Wan

then confronts his former Padawan, badly wounding him. While Vader is being saved by Sidious, Padmé gives birth to the next generation of Skywalkers, naming the twins Leia and Luke. Tragically, Padmé dies afterward. Obi-Wan and Yoda hope that these twins might have the potential to become Jedi like their father, so hide the children. Leia is adopted by Padmé's friends, Bail and Breha Organa, while Luke is taken in by Shmi's relatives, the Lars family, on Tatooine.

Tyrannical origins
With the Jedi Order annihilated, Palpatine reigns as Emperor with Vader as his lethal enforcer. Like their parents before them, Luke and Leia become central figures in the next period of turmoil, the Galactic Civil War. Both are unaware that they have a sibling. Leia becomes a capable and strong leader in the Rebel Alliance. Unwittingly flung into galactic events, Luke embraces the prospect of training to be a Jedi, learning from Obi-Wan and Yoda, and joins the Alliance. Alongside brash smuggler Han Solo, Luke and

Leia work well together from their first meeting on the Death Star.

In the middle of the conflict, Luke is horrified to learn from Darth Vader that the Sith Lord is his father. Vader had recently found out this information and wants to rule the galaxy with Luke at his side. The young Jedi rejects the offer and escapes with Leia, who senses Luke is in danger through the Force.

Just prior to the Battle of Endor, Luke realizes that Leia is his sister. After sharing this with Leia, Luke travels to the second Death Star to confront the Sith, while Leia takes part in the ground assault on the Forest Moon of Endor. Luke redeems his father with compassion during this confrontation, convincing Vader to become Anakin once more. Anakin then turns on Palpatine, appearing to kill him, and fulfilling his role as the Chosen One. After becoming one with the Force, Anakin witnesses the Rebels celebrating their victory.

Era of hope

Having ushered in a new era of peace, Luke and Leia turn their attention to maintaining it. Now a Jedi Master, Luke trains Leia for a time, until she has a feeling that her son will die at the end of her time as a Jedi. Leia then decides to focus on a political career in the New Republic. Leia and Han marry and soon after they have a son, who they name Ben Solo.

Like his grandfather, Ben has great power to go with a thirst for proving himself. Luke takes Ben as his Padawan, going on to form a small Jedi temple. From the shadows, Palpatine, who survived his supposed death, uses his agents to turn Ben to the dark side. The once-promising Jedi takes the name Kylo Ren and joins the Empire's successor, the First Order. Full of regret, Luke exiles himself, abandoning the galaxy.

When the galaxy learns that Darth Vader is Leia's father, she is cast out of politics. Leia then forms a small military, called the Resistance, to keep an eye on the growing threat of the First Order. Leia is distraught to hear of her son's fall to the dark side and her marriage breaks down. However, she remains undaunted in her dedication to maintaining peace.

As the First Order begins its rise to galactic dominance, Skywalkers find themselves on both sides of the conflict. A mysterious Force-sensitive scavenger named Rey becomes embroiled in the action, as does Han Solo, who takes Rey under his wing. Rey sees part of the map to Luke, so is kidnapped by Kylo Ren. After reuniting with Leia, Han leads a mission to rescue Rey from the First Order's Starkiller Base and destroy this powerful superweapon. While Rey escapes and the base is destroyed, Han is killed by Kylo, who wants to prove his allegiance.

Leia has little time to mourn as she must lead her forces to safety, while Rey finds Luke to aid the Resistance. After prompting from Luke, Rey is intrigued to learn more about the Force, and Luke begins to train her. When the surviving Resistance members are threatened by the First Order, Luke buys them time so Rey can save them. Luke's efforts leave him exhausted, and he becomes one with the Force. Having dispatched Supreme Leader Snoke, Kylo Ren rises to lead the First Order.

A year later, having rebuilt the Resistance and spent time training Rey, Leia reaches out to her son, losing her life from the effort. Leia's death, along with Rey using the Force to save Ben's life, work together to encourage Ben to return to the light. Rey and Ben both face Palpatine on Exegol, defeating him and the Sith once and for all. Ben's last act is to save Rey, bringing her back from the dead and ending the Skywalker bloodline. Ben and Leia then become one with the Force. Rey, now the last Jedi, takes the name of Skywalker as her surname, continuing on the legacy of bravery, sacrifice, and strength. ∎

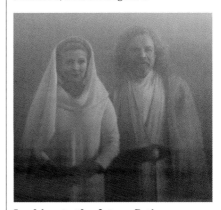

Looking to the future Both now one with the Force, Luke and Leia are proud that Rey will continue their legacy.

Skywalker family tree

THE CHOSEN ONE

ANAKIN SKYWALKER

HOLOCRON FILE

NAME
**Anakin Skywalker/
Darth Vader**

SPECIES
Human

HOMEWORLD
Tatooine

AFFILIATION
**Jedi; Republic;
Sith; Empire**

ABILITIES
**Enhanced Jedi reflexes;
speed; telekinesis; visions;
superior lightsaber combat**

SUCCESSIVE AIMS
**Become a Jedi; overcome
death; rule the galaxy**

STATUS REPORT
One with the Force

Born on the desert planet Tatooine, Anakin Skywalker spends his early days as an enslaved person alongside his mother, Shmi. Anakin is kind, attentive to his mother, and possesses a talent for repairing all manner of mechanical equipment. He also has the supernatural ability to see things before they happen, which he learns comes from his powerful connection to the Force.

Jedi Master Qui-Gon Jinn discovers the Force-sensitive nine-year-old and offers him the opportunity to travel the stars and be trained as a Jedi. This empowers the ambitious child, giving his life profound meaning and purpose. Anakin also meets Padmé Amidala, the queen of Naboo, who goes on to be an important figure in his life. To become a Jedi, Anakin must

Battle of Naboo Anakin accidentally joins the space battle and then proceeds to destroy a key enemy battleship, a critical moment in the battle.

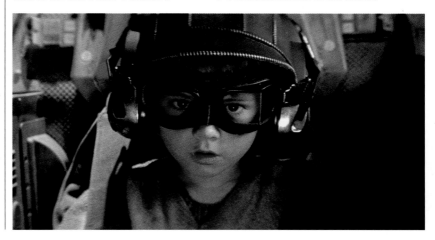

> Is it possible to learn this power?
> **Anakin Skywalker**

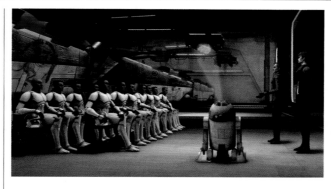

Jedi General
Anakin becomes a well-respected general, leading his 501st Legion to victory on many worlds, including Kamino and Teth.

leave his mother and journey to Coruscant, which tears at him internally. Qui-Gon believes Anakin is a vergence that will bring balance to the Force as the Chosen One, and Anakin's uncanny reflexes and staggering midi-chlorian count support this.

Jedi Knight
The Council is reluctant to train Anakin, particularly Masters Mace Windu and Yoda, who believe the boy is too old to start the training. However, the emergence of the Sith and Qui-Gon's conviction cause Yoda to agree. Anakin desperately wants to be a Jedi and is eager to learn from his new Master and accompanies him to Naboo. Sadly, Qui-Gon is killed by the Sith. Qui-Gon's former Padawan Obi-Wan

Kenobi becomes Anakin's master. Anakin has now lost two important figures in his life and is eager to find stability, which he gets with his new teacher.

For ten years, Obi-Wan trains Anakin in the ways of the Force. The duo forms a strong bond, becoming a powerful force for good. While there are moments of disagreement and tension, at the core is a brotherly bond built on trust.

When Padmé, who is now a Senator, is nearly assassinated, the Jedi Council appoints Obi-Wan and Anakin to protect her. Anakin and Padmé soon fall in love with each other. The two marry in secret and must keep their relationship in the shadows, due to the Jedi's rule forbidding attachment. This creates a unique challenge for the couple.

For three years, the galactic-wide Clone Wars sows discord, straining the Jedi Knights and blurring the limits of their role in the galaxy. While the Jedi do not know about Anakin's marital status, Yoda is aware that Anakin has difficulty letting go, as is the Jedi way, so assigns him a Padawan, Ahsoka Tano, in order to overcome this issue. Like her Master, Ahsoka is headstrong, but unlike Anakin, the Togruta Padawan is more centered, becoming a positive influence on Anakin. Throughout the Clone Wars, they grow individually and as a team, providing consistency for one another in an ever-changing galaxy enveloped in chaos. When Ahsoka is falsely accused of a crime and is not supported by the Jedi, she becomes disillusioned with the Order and walks away. Once again, Anakin loses an invaluable member of his inner circle and begins to have doubts about the Order. »

Anakin Skywalker's timeline

41 BSW4
Inexplicable birth
Shmi Skywalker gives birth to Anakin Skywalker on Tatooine.

32 BSW4
Jedi Padawan
Obi-Wan starts teaching Anakin.

22 BSW4
The Clone Wars
The Clone Wars begin, and Anakin marries Padmé Amidala.

19 BSW4
Lost Padawan
Ahsoka becomes disenchanted with the Order and departs.

19 BSW4
Lord Vader
Anakin turns to the dark side and becomes Darth Vader.

19 BSW4
Jedi hunter Vader begins to hunt down the remaining Jedi Knights.

4 BSW4
Reunion
Vader fights Ahsoka Tano in a Sith temple on Malachor.

4 BSW4
Siege of Lothal
Darth Vader goes to Lothal to stop a Rebel cell.

0 SW4
Battle of Yavin The Death Star is destroyed by the Rebel pilot Luke Skywalker.

3 ASW4
Family revelations
Darth Vader tells Luke Skywalker that he is his father.

4 ASW4
Return to the light
Vader saves his son and is redeemed in the Force.

> If you only knew the power of the dark side.
> **Darth Vader**

Ascent into darkness

Supreme Chancellor Palpatine, who is secretly the Sith Lord Darth Sidious, orchestrates the Clone Wars in order to destroy the Jedi Order and the Republic. Palpatine demands that his views are represented on the Jedi Council by Anakin. While the Council members acquiesce to this unprecedented intervention, they do not make Anakin a Master, which infuriates him and exacerbates his doubts about the Order. Anakin is at first overjoyed to learn that Padmé is pregnant. However, he begins to have visions that Padmé will die in childbirth. Palpatine preys on these fears to persuade the troubled Jedi that he can save Padmé from dying through the dark side of the Force.

Grim future On Mortis, Anakin is given a horrifying vision of his future as Darth Vader. Thanks to a powerful Force entity, Anakin forgets his experience.

With Palpatine's true nature revealed, Anakin is shaken to the core. The Chancellor has always been a mentor to Anakin, so he now feels deeply conflicted. He rushes to Mace Windu to inform the Jedi of this catastrophic turn of events, but when Palpatine is almost defeated, Anakin is tempted by the Sith's offer to save Padmé, so turns on Mace, cutting off his forearm. Palpatine then kills the Jedi Master. Anakin's inability to let go of what he fears to lose leads him to betray the Republic, the Jedi, and Padmé as he kneels in front of Darth Sidious and rises as Darth Vader.

The cost is dire to the galaxy and to the newly anointed Sith Lord. Vader leads the attack on the Jedi Temple, killing any Jedi he comes across. Both Padmé and Obi-Wan are horrified to learn of his actions and confront him on Mustafar, where Anakin wounds Padmé. Obi-Wan is shocked by Anakin's horrific transformation, and the two ferociously battle on Mustafar, leaving Anakin disfigured and severely burned. Palpatine encases him in black armor, saving Vader's life with an internal life-support system, but also removing the last remnants of his humanity. To punctuate the metamorphosis, Sidious tells Vader that in his anger, he killed Padmé—who in reality had died after secretly giving birth to twins. His unimaginable grief turns into an unquenchable rage, stopping Vader from seeing the light that once burned so brightly in him.

Man in the machine

Darth Sidious commissions a cyborg specialist named Cylo to build Vader's life-saving suit of armor. Vader likes to upgrade the armor himself.

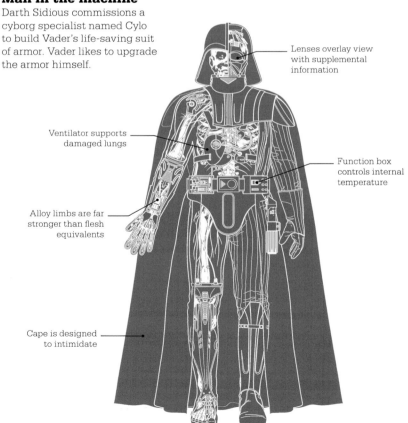

Lenses overlay view with supplemental information

Function box controls internal temperature

Ventilator supports damaged lungs

Alloy limbs are far stronger than flesh equivalents

Cape is designed to intimidate

For more than two decades, Vader hunts down Jedi survivors and rebel agents, bringing death and destruction at every turn. His savage hatred for himself and what he has become fuels his fury and aids him while he brings death as the Emperor's lethal enforcer.

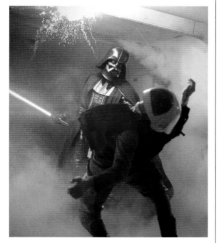

No mercy Desperate to retrieve the Death Star plans, Vader quickly cuts through Rebel troops aboard the Alliance flagship, the *Profundity*.

Vader shows no mercy, nearly killing his former Padawan Ahsoka Tano, who is willing to sacrifice herself and Vader, but she is rescued.

Vader slowly grows to despise Palpatine and his manipulative

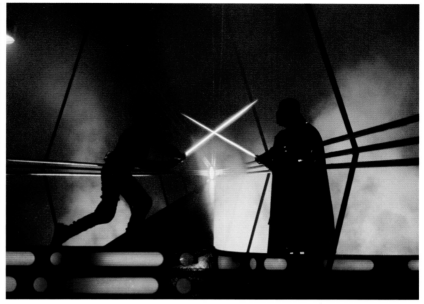

ways, so he starts plotting to destroy him. When Vader discovers that his child Luke Skywalker is alive, he attempts to recruit him to the dark side on Bespin. However, the attempt fails, and Luke barely escapes with his life.

Luke's internal strength and Jedi dedication leave an impression on Vader, gradually eroding his Sith convictions and self-loathing. A year later during a tense confrontation on the second Death Star, the Emperor sends Sith lightning coursing

Duel on Cloud City Vader is impressed by how much his son Luke has learned since their last duel on Cymoon 1.

through Luke's body. Vader now decides to act, picking Sidious up and throwing him down an elevator shaft to his supposed death. Redeemed through his actions, he becomes Anakin Skywalker again and passes into the Force. Reunited with Yoda and Obi-Wan as Force spirits, Anakin is a hero once more. ■

Shmi Skywalker

Living on the planet Tatooine, Shmi raises her son, the product of a mysterious pregnancy, to be kind and loving. She nurtures his curiosity and affinity for working on machinery—a trait she also possesses. Jedi Master Qui-Gon Jinn verifies her suspicions that her son is strong in the Force, and she gives her blessing that Anakin can leave and train to be a Jedi.

Shmi is an enslaved person until she is freed by Cliegg Lars. The two fall in love and marry, sharing many happy years together as moisture farmers. Sadly, Shmi is kidnapped by Tusken Raiders, who torture her. Her son returns to Tatooine and tries to save Shmi, but her wounds are too grievous. Mother and son briefly reunite and then Shmi dies, content that she has seen Anakin a final time.

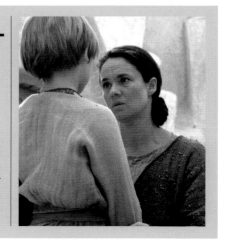

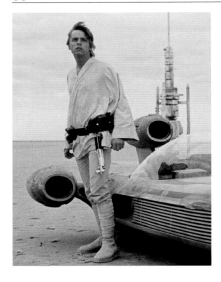

A NEW HOPE
LUKE SKYWALKER

HOLOCRON FILE

NAME
Luke Skywalker

SPECIES
Human

HOMEWORLD
Tatooine

AFFILIATION
Jedi; Rebel Alliance

ABILITIES
Force visions; enhanced Jedi reflexes; lightsaber dueling; telekinesis; Force projection; Jedi mind tricks

AIM
To resurrect the Jedi Order and restore freedom to the galaxy

STATUS REPORT
One with the Force

L uke Skywalker is raised on the desert planet Tatooine by his aunt and uncle, Beru and Owen Lars, with no awareness of who his parents really are. While he dutifully helps on their moisture farm, his sense of adventure has him looking to the horizon, dreaming of life beyond the stars. When he meets Ben Kenobi beyond the Dune Sea, his world is turned upside down as he learns about the Force and the Jedi. Ben used to be a Jedi who fought alongside Luke's father in the Clone Wars. Luke never knew

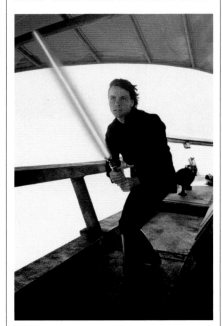

Jedi Knight While tested on Cloud City, Luke dedicates himself to his training and is a confident leader during the rescue of Han Solo from Jabba the Hutt.

his father, but meeting Ben further stokes his desire for adventure.

With Ben's encouragement, Luke agrees to learn the ways of the Force and become a Jedi like his father. When an errant message from Rebel leader Princess Leia Organa is discovered inside the astromech droid R2-D2, Ben hires smuggler Han Solo and his Wookiee copilot, Chewbacca, to take them to the planet Alderaan.

En route, they are captured by the Empire and held aboard the Death Star, and soon discover Leia is also onboard. They escape with the Princess and the plans to the space station, but Ben is killed in a lightsaber duel by the Dark Lord of the Sith, Darth Vader. With new hope and purpose, the Rebels mount an attack against the Death Star. In an X-wing, Luke receives guidance from the voice of Ben, trusts in the Force, and fires the one-in-a-million shot that sees the destruction of the Death Star. It is a momentous victory that ignites his legacy.

Following the Death Star's destruction, Vader is now aware of Luke's presence. To prepare Luke, Ben's Force spirit instructs him to go to Dagobah to learn from Jedi Master Yoda. Luke is trained by

Quest for knowledge

As the last remaining Jedi, Luke becomes a caretaker of the Order's legacy. After the Battle of Endor, he travels to many different worlds, gathering knowledge of forgotten Jedi lore. He discovers long-lost items, including ancient Jedi texts, artifacts, and Master Nu's holocrons, which contain a wealth of Jedi knowledge and history. One of his journeys takes him to the uncolonized planet Pillio where he discovers a Jedi compass the Emperor wanted to be destroyed. Luke also looks for Force sensitives who can become the next generation of Jedi. With his nephew and Jedi student, Ben Solo, and Lor San Tekka, Luke travels to Elphrona and encounters the Knights of Ren at an abandoned Jedi site. The structure proves to be a source of more knowledge for Luke, but also prompts Ben's interest in the Knights who use the dark side of the Force.

Yoda and shows great potential. However, his fear that his friends might die leads to his undoing. Despite the protestations of Yoda and Ben to continue his training, Luke leaves to confront Vader at Cloud City. He loses an arm in the duel and discovers a terrible truth—his father is actually Darth Vader.

Luke eventually learns to control his fear during the next year and faces Vader and Emperor Palpatine during the Battle of Endor. This time, Luke chooses love over aggression, redeeming Vader, who is restored to the light side of the Force. Vader dies protecting his son from the Emperor, throwing his former master to his believed death.

I am a Jedi, like my father before me.
Luke Skywalker

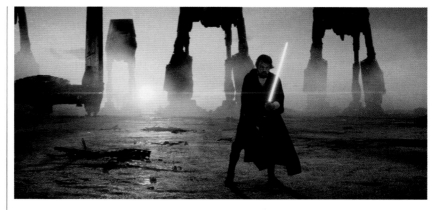

Reconnecting on Crait Luke's deception on Crait is a masterful display that fools the First Order.

The last Jedi

With the end of the Empire, Luke focuses on rebuilding the Jedi Order, training a small number of students at his temple. He also trains his sister, Leia. When Luke senses the dark side in his nephew, Ben Solo, he confronts him. This results in the destruction of Luke's Order and Ben fully turns to the dark side, taking the name Kylo Ren. Luke abandons everything, overcome with self-doubt and afraid he has let his family and the galaxy down. He exiles himself to Ahch-To, where he remains hidden from the galaxy.

The scavenger Rey soon seeks Luke out and requests Jedi training. He initially refuses to get involved in the latest galactic war, but Yoda reminds him again to confront his fear of failure. For his last act, Luke uses the Force to project himself across the galaxy to the planet Crait, where he confronts Kylo Ren to help the Resistance escape. After this act, Luke becomes one with the Force, but he continues to guide Rey to face her own fears to save the galaxy. Following her victory, Luke is pleased to watch Rey choose her own oath. ∎

ETERNAL HOPE
LEIA ORGANA

HOLOCRON FILE

NAME
Leia Organa

SPECIES
Human

HOMEWORLD
Alderaan

AFFILIATION
Rebel Alliance; New Republic; Resistance

ABILITIES
Force visions; enhanced Jedi reflexes; lightsaber dueling

AIM
To end oppression in the galaxy

STATUS REPORT
One with the Force

From Princess of Alderaan to New Republic Senator to General and leader of the Resistance, Leia Organa has been fighting for freedom in the galaxy for most of her life. She has become a symbol of lasting hope for her family, friends, and many thousands more.

Seeds of rebellion

Not learning until later in life that her father is Darth Vader, Leia grows up as the adopted daughter of Bail and Breha Organa and heir to the throne of Alderaan. She displays natural leadership qualities and hones her mind, body, and spirit to help those in need, secretly joining the Rebellion at an early age.

Fleeing the Battle of Scarif aboard her corvette, Leia carries the stolen plans to the Empire's ultimate weapon—the Death Star. Leia and her ship are captured by Darth Vader over Tatooine, but she manages to get the plans off the vessel. Soon after, Grand Moff Tarkin gives the order to destroy Alderaan before her very eyes, leaving her without family, home, and people. Her loss is catastrophic, but she doesn't let it deter her.

Not everyone shares Leia's convictions. One such example is the Corellian smuggler Han Solo, who she meets when he and Luke Skywalker arrive to rescue her from Vader and Tarkin. Leia helps Han see he has more to fight for than just himself. Through their wider combined efforts, the space station is destroyed, dealing a significant blow to the Empire.

Leia spends the next three years selflessly trying to restore galactic peace and democracy. She learns of an Imperial plot to hunt down Alderaanians and leads a mission to save the survivors. After this, she heads up rebel missions to Mon Cala, Cymoon 1, and countless other planets; her faith never waning.

Vader's relentless pursuit of the rebels leads to the capture of Han Solo on Cloud City. The smuggler is then sold to crime lord Jabba the Hutt. Bravely assuming a disguise, Leia, alongside Luke, Chewbacca, and Lando Calrissian, leads a mission to save Han from the vile criminal.

When the threat of a second Death Star looms, Leia is again

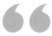

Don't tell me what things look like. Tell me what they are.
General Leia Organa

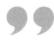

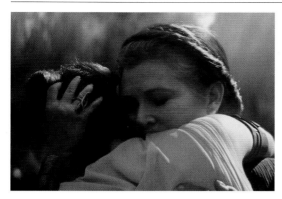

Sensing the light While Leia knows that Rey is descended from Emperor Palpatine, she never assumes that Rey will be evil.

instrumental in guiding the rebels. She befriends the native Ewoks on the moon of Endor and, with this alliance, ensures victory for the rebels. Her diplomatic skills and her compassion for all life continue to bring hope to the galaxy.

Strong in the Force
At the end of the Empire's rule, Leia learns she is actually Anakin Skywalker's daughter and Luke's sister. Her natural Force powers now make sense to her. Once, on Alderaan, she had survived a mudslide by intuitively using the Force—although she had not understood it at the time.

Undertaking Jedi training with Luke, Leia shows great potential, even defeating him in a lightsaber duel. However, she chooses to forego further training to instead help the galaxy in other ways— especially when a vision shows her that her child will die at the end of her Jedi career.

She marries Han and soon after, their son, Ben Solo, is born. Leia finds herself pulled in multiple directions when she suspects a new evil is rising—one that is a real threat to the democratic New Republic.

Despite the fact that Leia is held in high regard, many doubt the danger she is warning of. To subvert this, and despite her reservations, Leia puts herself forward for a new leadership role: First Senator. But when rival senator Ransolm Casterfo discovers Leia is the daughter of Darth Vader, Leia's reputation is destroyed, ending her candidacy. This, along with the discovery of a new military force, strengthens her belief that the galaxy is in peril.

Rise of the First Order
As the First Order emerges, Leia ignores the doubters and forms the Resistance. Her role becomes more difficult when her son Ben turns to the dark side and becomes Kylo Ren, driving a wedge between Leia and her now-estranged husband. Yet Leia continues to inspire, recruiting hotshot pilot Poe Dameron, among others, to build up the Resistance.

The drive of Kylo Ren and the First Order is relentless, but Leia refuses to give up on her son, believing there is still good in him. Her faith is rewarded with the arrival of Rey—who brings light to the Resistance. After Luke sacrifices himself to save their cause, it is Leia who continues Rey's Jedi training, becoming a mother figure, mentor, and master to her.

When Emperor Palpatine returns, Leia senses the conflict is nearing its end. She prepares her forces for the battle against the Final Order and her Padawan to face the supreme Sith Lord. In her last moments, she reaches out to her son. This acts as a catalyst for his return to the light, but the effort is too much for her mortal body. She dies, but does not pass into the Force until Ben joins her and the two enter the cosmic Force together, finding peace at last. ∎

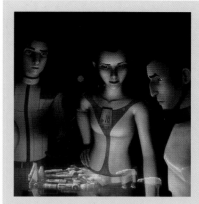

Freedom fighter
While Leia prepares to ascend to the throne of Alderaan, she learns that her increasingly absent parents are helping the Rebellion. She joins them and travels to systems needing aid from the oppression of the Empire, rapidly earning a reputation for adroitly using diplomacy to thwart the ever-growing might of the Empire. As a teenager, she journeys to Lothal. She meets members of Phoenix Squadron— including Hera Syndulla, Ezra Bridger, Garazeb Orrelios, Kanan Jarrus, and Sabine Wren—and helps them acquire three cruisers to bolster their fleet.

After the Battle of Endor, Leia travels to her biological mother's (Padmé Amidala's) homeworld to prevent Palpatine's posthumous Operation: Cinder from destroying the planet. It is there that she recruits Iden Versio and Del Meeko, who were part of the Imperial Inferno Squadron, but are now fighting for good. Like so many, Leia's acceptance of them is the affirmation they need to reach their potential.

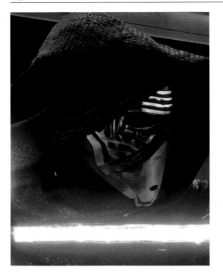

FROM DARK TO LIGHT
BEN SOLO A.K.A. KYLO REN

HOLOCRON FILE

NAME
Ben Solo/Kylo Ren

SPECIES
Human

HOMEWORLD
Chandrila

AFFILIATION
**Jedi; Knights of Ren;
First Order**

ABILITIES
**Force psychometry; healing;
enhanced agility and speed;
lightsaber prowess;
telepathy; telekinesis**

AIM
**Extinguish the light within
himself by any means
necessary**

STATUS REPORT
**Converted to the light
side and deceased**

The son of Han Solo and Leia Organa, Ben Solo is not just Luke Skywalker's nephew, but also his most promising Jedi student. Ben's strength in the Force is prodigious, but so is his internal conflict. With his parents often absent—Han habitually traveling the galaxy, never able to stay in one place, and Leia routinely occupied with senatorial duties—Ben is often left feeling alone. This loneliness becomes an easily exploitable weakness, making him vulnerable to the temptations of the dark side. His considerable Force abilities combined with his famous lineage mean he is the ultimate prize for Snoke and his creator, Darth Sidious, who is manipulating both of them without their knowledge.

Luke senses the growing darkness in his pupil and tries to intervene, but rashly. The tragic consequence is the destruction of his Jedi temple and the deaths of his other students. Feeling pushed away and misunderstood, Ben flees. Fully turning from the light, he joins the Knights of Ren, killing their former leader, Ren. Freed from pressure to live up to the Skywalker name, Ben takes on the new moniker Kylo Ren and is given the new, unrestrained purpose as the ultimate weapon of Snoke and the First Order. The destruction and loss of life caused by Kylo is matched only by the terrible legacy of his grandfather in the dark side—Darth Vader—giving Kylo deadly justification.

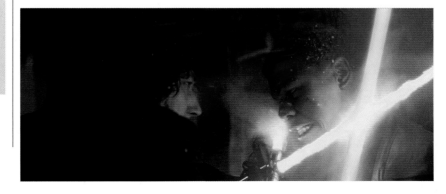

Dark-side warrior Kylo Ren
is a vicious and skilled fighter
on the battlefield.

When Luke disappears, Kylo Ren races to find him before Luke's allies do. On this voyage, he discovers Rey, a scavenger who is strong in the Force. She is able to resist his attempts to extract information from her mind and even defeats him in lightsaber combat, despite her lack of Force training. This incident is overshadowed by Kylo's final confrontation with his father on Starkiller Base. In an attempt to erase the goodness within himself and eradicate his internal conflict, he murders his father.

This act does not have the impact Kylo intended, instead causing him more pain and uncertainty. Continually at war with himself, and as lonely as he ever was before, he finds atypical solace communing with Rey, both unaware they form a prophesized dyad in the Force. He convinces her to join him on Snoke's Star Destroyer, the *Supremacy*, hoping to recruit her in his bid to shape the galaxy in his own twisted image. With Snoke distracted by torturing Rey, Kylo uses the Force to activate Rey's lightsaber and bisect Snoke. The pair then join forces to dispatch Snoke's Praetorian Guard. After the battle, Rey refuses to join Kylo's

cause, leaving him as Supreme Leader of the First Order.

Angry and vengeful, Kylo continues to hunt Rey down at the behest of his true master—the resurrected Emperor Palpatine—which also serves to further his insatiable fascination with her.

Knights no more In the end, Ben even turns against the knights he trained in order to bring down Palpatine.

There is still good in him

Amid the wreckage of the second Death Star on Kef Bir, after again dueling with Rey, Kylo Ren feels the Force presence of his mother, who reminds him of the goodness still

within him. Sensing his distraction, Rey runs him through with her lightsaber. Immediately horrified by her actions and the idea that she may be descending to his level, Rey uses the Force to restore him.

In a pivotal turn of events, Kylo faces the memory of his deceased father. Moved by the love of his parents and Rey's compassion, he hurls his unstable, red lightsaber into the ocean, renouncing darkness and becoming Ben Solo once more. His final act is to head to Exegol to help Rey face the Emperor. Together, the two defeat the Sith Lord. The effort drains Rey. Without hesitation, Ben transfers his life force to her, resurrecting her and sacrificing himself: redeemed at last. ■

I'm being torn apart. I want to be free of this pain.
Kylo Ren

A complicated history

While training to be a Jedi, Ben travels with his master, Luke, to seek out ancient secrets of the Force. Alongside Force historian Lor San Tekka, Luke and Ben encounter the Knights of Ren inside an ancient Jedi outpost on Elphrona. Ben protects Lor San Tekka while Luke dispatches the warriors without killing them. Their enigmatic leader, Ren, senses the dark-side potential within Ben and calls out to him. Ben is left frightened and intrigued by the dark-side user.

Luke is a kind master, but his attentions are divided by his students. Snoke uses this to seduce Ben, playing on his need for purpose and belonging. Years later, Luke senses Snoke's influence on his nephew, but fails to correctly interpret that Ben is still conflicted by both light- and dark-side teachings. When Ben does turn to the dark, he takes on the name Kylo Ren, and Snoke rewards him by gifting him the Knights of Ren for his own use.

FINDING HER IDENTITY
REY SKYWALKER

HOLOCRON FILE

NAME
Rey Skywalker

SPECIES
Human

HOMEWORLD
Jakku

AFFILIATION
Resistance; Jedi

ABILITIES
Force psychometry; healing; enhanced agility and speed; lightsaber prowess; Jedi mind tricks

AIM
Find her family and purpose to save the galaxy

STATUS REPORT
Jedi Master helping to restore peace

Growing up alone on the desert planet Jakku, the seemingly ordinary scavenger Rey lives out each day in relative isolation, waiting to be reunited with her parents. Despite not knowing if they will ever return, where she comes from, or even what her family name is, she remains resilient. Her natural talents as a pilot, mechanic, and fighter serve her well as she scavenges through wreckage from a war fought long ago. While she continues with this menial work for harsh boss Unkar Plutt, what she is really looking for cannot be found in a junkyard—a sense of belonging.

Her circumstances change at age 19 when she encounters orange astromech droid BB-8, renegade stormtrooper Finn, and war hero Han Solo. Rey was not looking to leave Jakku, but the war between the Resistance and the First Order has just begun. Rey and her new friends learn BB-8 has a map that leads to legendary lost Jedi, Luke Skywalker. In an effort to return BB-8 to the Resistance, the group travels to Takodana, where Rey feels a calling below Maz Kanata's castle. Here she has her first strong encounter with the Force, confirming what she has always known but not understood: there is untapped power inside her. The Force leads her to Luke's lightsaber and the instant Rey touches it she is flooded with frightening voices and visions.

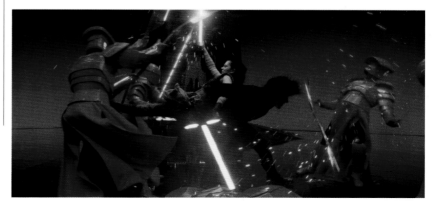

Dyad duel Instead of fighting each other, Rey and Ren unite forces to defeat Snoke. They instinctively fight back to back, sensing each other's next moves.

The mirror cave

Rey longs to discover who her parents are and find her place in the galaxy. She hopes Ahch-To might be the place to provide answers. Ahch-To's Jedi temple houses a concentration of the light side of the Force, offset by a sinister sea cave strong with the dark side. This cave speaks to Rey: promising knowledge. Despite Luke's warnings not to enter it alone, she steps into its depths.

Below the surface, she asks the Force to show her who her parents are. In answer, the cave reveals not a mother or a father but Rey's mirrored image, endlessly reflected. The cave plays upon her darkest fears, that she has always been, and will always be, alone. But it also helps her begin to see that maybe the only person she needs is herself. She is not defined by her parents, but by the choices she makes.

First steps

After Rey is captured by the invading First Order, leader Kylo Ren also senses something within her. He attempts to extract Luke's location from her using the Force. Rey is untrained but to both their surprise she is able to resist Ren. She escapes and defeats him, intuitively using Luke's lightsaber. General Leia Organa recruits Rey to find her brother, Luke, and bring him back from Ahch-To, home of the first Jedi temple. Rey is eager to help, and hopes Luke will train her in the ways of the Jedi. When found, Luke initially refuses. Rey is undaunted; she has felt the call of the Force all her life and hopes it will help her discover who she is.

Kylo Ren is also fascinated with Rey's identity, and the two find themselves attuned, connected in a unique dyad of the Force, able to communicate over great distances. She chooses to call him by his true name, Ben Solo, and he challenges her about her parentage, suggesting her parents were nobody special. The two unite to defeat Supreme Leader Snoke, but neither will turn from their chosen path. Rey escapes to return to the Resistance. She resumes her Jedi training with renewed purpose with her new master, Leia Organa, on Ajan Kloss.

Life forces Through the Force, Rey is able to heal the injured Vexis in the tunnels below Pasaana's surface.

Rey learns much, including the ability to heal through the Force.

When it is revealed that Emperor Palpatine has returned from the dead, Kylo again addresses Rey's

> I need someone to show me my place in all of this.
>
> **Rey**

origins, this time telling her she is Palpatine's granddaughter. Fearing that her quest to find her true self may lead her to the dark side, she sees an evil version of herself on Palpatine's throne. Like her first teacher, Rey flees to Ahch-To, afraid of what she could become. As a Force spirit, Luke advises her she must confront her fears in order to become a Jedi. Determined to forge her own identity, she goes to Exegol and battles Palpatine, nearly dying in the process. Having accepted all that she is, the voices of many legendary Jedi unite with her, inspiring her to rise and destroy Palpatine with the help of Ben Solo, now returned to the light. On Tatooine, Rey buries Luke and Leia's lightsabers and takes on the moniker Skywalker. Her choice, and not her lineage, defines who she is, bringing her peace and purpose. ∎

GALACTIC GOVERNME AND THEIR DISSIDENTS

TS

Throughout the ages, the balance of power swings between democracies and dictatorships. As each new government takes hold, another faction rises to contest it. Heroes and villains alike become legends as they clash in wars to determine the fate of the galaxy. These are the notable governments, key individuals, and groups who influence their fates.

Galactic Republic
Democracy declared
after the fall of the
Sith Empire.

Emergency powers
Palpatine uses the Clone
War crisis he created to
gain emergency powers
and establish Republic
forces under his control.

Organized Rebellion
The Alliance to Restore
the Republic is founded.

Rebel victories
The Rebel Alliance
secures its first major
victories at Scarif
and Yavin.

c. 1,032 BSW4 **22 BSW4** **2 BSW4** **0 SW4**

32 BSW4 **19 BSW4** **0 SW4**

Palpatine's election
Senator Palpatine—
secretly the Sith Lord
Darth Sidious—elected
Supreme Chancellor.

Galactic Empire
Palpatine declares himself
Emperor and enacts Order
66, leading to the execution
of most Jedi.

Council abolished
Palpatine dissolves the
Imperial Senate.

The Galactic Republic is among the greatest political achievements in the galaxy's history, unifying thousands of member planets into a single democratic government which represents the interests of trillions of beings. This Republic becomes the ruling government in the galaxy after the fall of the Sith Empire, but the machinations of the Sith do not end here. The balance of power in the galaxy swings between democracy and dictatorship thanks to the schemes of one Sith, Darth Sidious. He aims to destroy the Republic not through military force, but from within.

A thousand years before the Clone Wars, the Jedi Order defeats the Sith Empire, making way for the formation of the Galactic Republic. Most planets agree to unify under a single government in order to join the Republic. Those individual members gain representation in the Galactic Senate and appoint a senator to represent them, often with the help of a cadre of junior representatives, aides, and apprentice legislators. The city-planet of Coruscant serves as the Republic's capital, centered around the magnificent Senate Rotunda. There, thousands of senators debate legislation and collaborate in its many hallways and lobbies.

Peace reigns for millennia under the Galactic Republic, and when disputes do occur, it falls to the Jedi Order to keep the peace. Just as it served the Old Republic, the Jedi Order is a vital partner to the chancellery, working on the behalf of the Senate to solve disputes, negotiate treaties, and advise political leaders. In part due to the political stability and in part thanks to the effectiveness of the Jedi, the Galactic Republic has no standing army of its own. A small security force, alongside local defense authorities and private armies, are enough to defend the Republic from the threats that befall it.

>
> I will not let this
> Republic, which has
> stood for a thousand
> years, be split in two.
> **Supreme Chancellor
> Palpatine**
>

Fall of Palpatine
Emperor Palpatine
defeated at the
Battle of Endor

Fractured Republic
Worlds secede from
the New Republic, the
political beginning
of the First Order.

Unrestricted warfare
The First Order expands
across the galaxy with
only a small Resistance
to combat them.

4 ASW4 **29 ASW4** **34 ASW4**

4 ASW4 **5 ASW4** **34 ASW4** **35 ASW4**

Democracy returns
New Republic declared,
governed by a
new Senate.

Empire ends
The Imperial fleet
defeated at Jakku.
Remnants of the
Imperial fleet flee to
the Unknown Regions.

Starkiller Incident
The military strength of the
First Order revealed after
the destruction of the Senate
on Hosnian Prime.

Sith Eternal
Palpatine, having cheated death,
is revealed to be behind the First
Order. Resistance victory at
Exegol halts Palpatine's
resurgence. The First Order
falls across the galaxy.

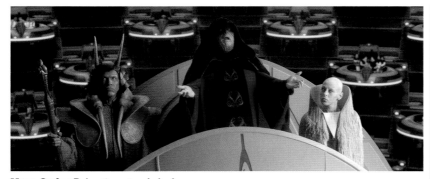

New Order Palpatine stands before
the Senate and declares himself the
new Emperor of the Galactic Empire.

At its peak during a period
sometimes referred to as the High
Republic, the government is a
shining example of prosperity
thanks to interplanetary cooperation
and trade. But in the final decades
of the Republic's rule, it is but a
shadow of its former self. Ineffective
committees, layers of bureaucracy,
overwhelmed courts, and deep-
seated corruption make the
Republic an incompetent machine.
Chancellor Finis Valorum is the face
of the Republic's decline, eventually
being replaced during the Naboo
crisis because of his inability to rein
in the power of the Trade Federation.
His replacement is Naboo's own
Sheev Palpatine— secretly a Sith
Lord named Darth Sidious—who
spends his time as Supreme
Chancellor covertly laying the
foundations of a galactic
dictatorship with him in control.

Palpatine's maneuvering stokes
unrest in the Outer Rim, leading to
a Separatist Crisis that threatens
to split the Republic in half. To
combat the dangers posed by the
Separatists, the Republic votes for
the creation of a Grand Army and
grants Palpatine unprecedented
emergency powers. War breaks out
with the Separatists who are led by
their own parliament, unaware that
the Sith are playing both sides.
As the Clone Wars rage, Palpatine
continues to centralize power in his
political position. At the Clone Wars'
end, he finally has what he needs to
destroy his enemy, the Jedi, declare
himself Emperor, and rule the
galaxy as a tyrannical dictator. »

Age of Empire

With Palpatine's plan complete, the Republic transforms into the Galactic Empire, handing unilateral power to the Sith Lord over both the government and expanding military. The legislature, now named the Imperial Senate, continues to operate, but as nothing more than a token relic of the previous regime. It passes legislation in lockstep with Palpatine's agenda and eventually is nothing more than a façade. Though it wields no real influence over the Empire, the Senate cultivates early seeds of Rebellion from within the government. Senators loyal to democracy, including Bail Organa of Alderaan and Mon Mothma of Chandrila, use the Senate to voice their opposition and secretly build a coalition of rebel sympathizers.

With the completion of the planet-destroying Death Star, Palpatine no longer needs the Senate to control his star systems. He disbands the legislature and hands power to the regional Moffs, believing that his new battle station inspires enough fear to discourage revolt. The government is now firmly in military hands reporting directly to Palpatine himself. Democracy is but a memory for most, and a hope of the Rebel Alliance.

New Republic

As Imperial atrocities mount, the Rebel Alliance grows stronger, leading to turning point battles at Scarif, Yavin, and Endor. With the Emperor killed at Endor and the Imperial fleet in shambles, the Rebellion follows through with its original promise: the restoration of the Republic. Styled as the New Republic, it adopts a structure similar to its predecessor. An elected Chancellor leads the newly reinstated Senate. Rather than Coruscant, it chooses to adopt an impermanent capital, with

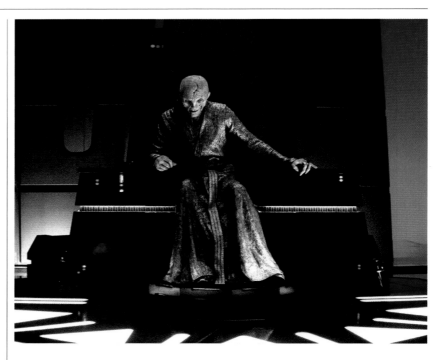

a member planet hosting the Senate for a period before moving to another. The new Senate, with Chancellor Mon Mothma to guide it, sees the New Republic through the final days of the war. It defeats the Imperial fleet at Jakku and the remaining Imperials sign the Galactic Concordance, officially ending the civil war between the New Republic and the Empire.

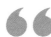

In order to ensure the security and continuing stability, the Republic will be reorganized into the first Galactic Empire! For a safe and secure society.

Emperor Palpatine

Supreme Leader Snoke, a powerful dark side Force sensitive, is the shadowy leader of the First Order. Even its members do not know that he is really a puppet of a more sinister force.

The return to democracy is not an easy one. The New Republic never reaches the size and influence of the Galactic Republic and the Military Disarmament Act ensures that the New Republic cannot wield the same military influence as previous governments. In the decades following the Galactic Civil War, the centrist faction of the government begins pushing for a stronger executive and increased military strength, much in the fashion of the Empire. This debate divides the Senate between centrist and populist factions, eventually making way for the centrist systems to leave the New Republic. The centrists prefer power with dictatorial tendencies, so join the First Order, with Supreme Leader Snoke at its head. The New Republic, however, acts too slowly

Outer Reaches

Though the Old Republic, the Empire, and the New Republic represent the largest governments in the galaxy, their influence never takes hold across all planets. Their presence is centralized in the galaxy's Core regions, where the rule of law has more precedent. In the further reaches of the galaxy, such as the Outer Rim territories, membership is less common. Those Outer Rim planets that are part of the Republic regularly claim that the Core receives favoritism, in part creating the strain that leads to the Separatist Crisis.

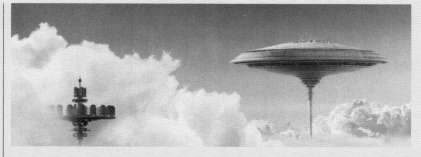

Many planets outside the Core operate under the eye of criminal syndicates, the Hutt cartel, independent monarchs, or local councils. Though the Empire expands its territorial claims during Palpatine's reign, the lawless nature of some planets is such that they never feel the pressure of the Empire.

They become a respite for independently minded beings who seek freedom (and unencumbered profits) to be gained outside a centralized government. Citizens wanting respite from bureaucracy find it in places such as Cloud City, a metropolis too small to attract the Empire's attention.

upon this threat, not realizing that the First Order has been making preparations for years from deep within the Unknown Regions.

First and Final Order

By the time the New Republic realizes just how dangerous the First Order is, it is too late. With a single strike from its Starkiller superweapon, the First Order wipes out the Hosnian system, the Galactic Senate, and most of the New Republic fleet. A Resistance, led by former Senator Leia Organa, destroys the superweapon but cannot face the First Order alone.

The First Order styles itself much like the Empire from which it grew. Its weapons, soldiers, and leadership structure are modern incarnations of their Imperial predecessors and many former Imperials remain in service as senior officers. Behind it all is none other than Palpatine—Darth Sidious himself. Thanks to a contingency plan he set in motion before his defeat at the Battle of Endor, the Sith Lord secretly

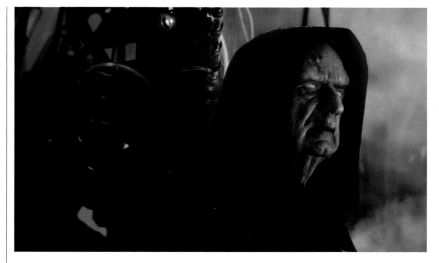

survives. The First Order is just the primary step of his plan to return the galaxy to rule under the Sith Empire, also known as the Final Order. From the planet Exegol, deep in the Unknown Regions, he prepares to unleash his vengeance on the galaxy by deploying a secret fleet of *Xyston*-class Star Destroyers. This Final Order might have been successful if not for the timely

Evil Reborn Emperor Palpatine cheats death at the Battle of Endor, biding his time to return to the galaxy for his final revenge.

arrival of the Resistance and a fleet of newfound allies who crush the Sith-led resurgence. The Battle of Exegol caps a thousand-year struggle between Sith dictatorship and galactic democracy. ∎

A MORE CIVILIZED AGE

THE GALACTIC REPUBLIC

HOLOCRON FILE

NAME
The Galactic Republic

CAPITAL
Coruscant

PROMINENT WORLDS
**Alderaan; Corellia; Naboo;
Chandrila; Eriadu; Ryloth**

AIM
Democratic governance

STATUS REPORT
**Defunct; transformed into
the Empire**

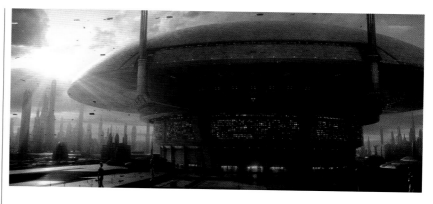

The Galactic Republic is the democratic system of government that peacefully maintains order in the galaxy for a thousand years before it is supplanted by the Galactic Empire in the fallout of the Clone Wars.

Before the Galactic Republic, its predecessor has been called "the Old Republic," a civilization that extends even further back.

This earlier era was not a peaceful and tranquil time. It was in this older period that the Jedi first defeated the Sith, leading the Sith Lords to remain in the shadows for a millennium.

A democratic body of representatives selected from member worlds, the Galactic Senate governs the Republic. Member worlds convene regularly to debate policy and pass legislation within the massive Senate Rotunda, in the Federal District of Coruscant. The Galactic Senate is itself chaired by the Supreme Chancellor, a position

Senate Rotunda The dome-shaped structure dominates the skyline in the Federal District of Coruscant.

elected from within the body of the Senate. The Supreme Chancellor serves for a four-year term before the position must be opened for election again. If reelected, the Chancellor may serve for a second, consecutive term but that is the extent of term limitations. Should a Chancellor fall out of favor, a senator with enough political allies can call for a vote of no confidence, triggering an immediate election.

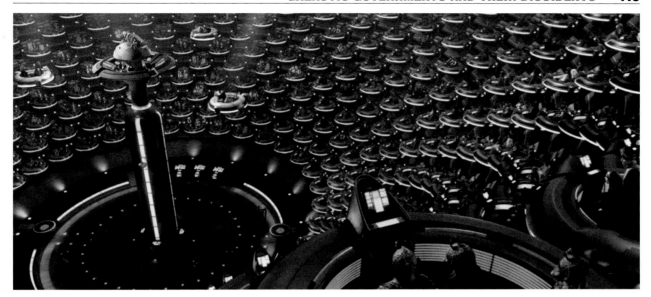

The Galactic Senate consists of worlds, systems, and sector representatives; differing populations and ranges of political power amid the constituents are what account for the variance in type. In the latter years of the Republic, certain titans of commerce grow so influential as to be afforded Senate representation. The Trade Federation, the Commerce Guild, the Corporate Alliance, and the InterGalactic Banking Clan, for example, are all able to shape legislation to their favor by presiding in the Senate.

These big businesses are adept at stalling progress and sniffing out loopholes in government codes that allow them to further profit. They line the coffers of many a corrupt senator to suit their needs. The lethargic bureaucracy of the Galactic Republic is ill-equipped to stop these robber barons; the few senators who are not on their payrolls are unable to stop such blatant avarice. Peace fosters comfort, comfort fosters complacency, and complacency fosters corruption.

Maintaining the peace of the Republic is the Jedi Order. In earlier eras, the Republic did have a standing military to deal with overt aggression from outlying systems not part of its fold. But as time passes, so does the need for such »

Grand Convocation Chamber
Hundreds of senatorial repulsorlift pods line the curved interior of the chamber.

I am the Senate.
Supreme Chancellor Palpatine

The Republic Era

~25,000 BSW4
The Old Republic
The Old Republic is formed.

232 BSW4
Starlight Station
The Starlight Station is launched as an Outer Rim beacon.

24 BSW4
Separatist schism The Separatist crisis begins.

19 BSW4
End of the Republic The First Galactic Empire is declared.

1,032 BSW4
Fall of the Sith The Sith are vanquished and the Republic is restored.

32 BSW4
Corrupting influence Supreme Chancellor Sheev Palpatine rises to power.

22 BSW4
The Clone Wars
War breaks out between the Republic and the Separatists.

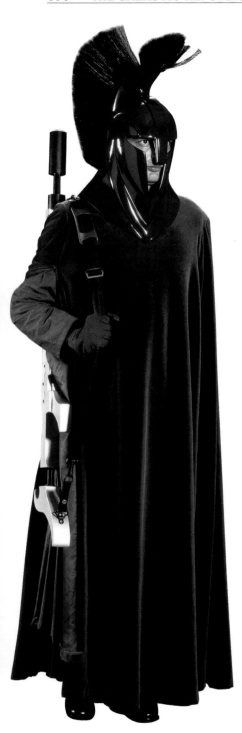

Senate guard The ornately helmed security sentries of the Galactic Senate stand at rigid attention.

Republic insignia During the Galactic Republic's final years, the government uses two logos across much of its estate and equipment.

Great Galactic Seal
The logo of the Galactic Senate adorns the Chancellor's podium in the Senate Chamber.

Galactic Republic symbol
The Galactic Republic symbol is prevalent across society, in both military and civilian contexts.

forces. Local star systems and sectors manage the protection of their territories. When needed, they petition the Senate for guidance and assistance from the Jedi Order, who favor negotiation and peacekeeping rather than aggression.

The coming of a Separatist crisis and the availability of droid armies prove to be great threats to the Republic, leading to the formation of a Grand Army of the Republic. The Military Creation Act is controversial, and many fear that war is inevitable. Their concerns are soon justified.

Fall of the Republic
About a decade prior to the Clone Wars, Jedi Master Sifo-Dyas secretly commissions the cloners of Kamino

It is clear to me the Republic no longer functions.
Queen Amidala

to develop an army for the Republic. When this fact is exposed years later, it comes as a surprise to the Jedi. There is no record of this agreement, and Sifo-Dyas is long dead, unable to clarify his actions. In truth, it is the machinations of Sith Lords Darth Tyranus and Darth Sidious that result in this ready-to-implement army to create a conflict that would allow the Sith to take control of the galaxy.

Bounty hunter Jango Fett serves as the genetic template of the clone army. His DNA is the foundation for millions of soldiers who will share his face, voice, and fighting prowess. The clones are genetically altered to make them easier to train and control, and they are age-accelerated to grow to adulthood within a decade. Jedi Knight Obi-Wan Kenobi discovers the clones on distant Kamino while on another assignment. When the Senate comes to learn of the existence of a clone army, senators concerned with the Republic's safety immediately petition for its use against the Separatist forces.

Fate would end this debate, as Obi-Wan Kenobi also discovers the Separatists are building armies of their own—endless battle droids ready to strike. The Senate votes

Holding office Beneath the Senate is the Chancellor's holding office, occupied here by Emperor Palpatine.

to give Supreme Chancellor Sheev Palpatine emergency powers to immediately activate the army, and then to manage the resulting war. These are powers he will never relinquish, all in the name of safety and security.

Some in the Senate, like Padmé Amidala, Bail Organa, and Mon Mothma, favor a peaceful, negotiated settlement to the war. Amidala even makes secret envoys to Separatist senators. The war risks bankrupting the Republic, to the point where Palpatine seizes control of the InterGalactic Banking Clan to keep the economy moving. Palpatine's power is such that he is able to select a Jedi Knight—Anakin Skywalker—to represent his interests in the Jedi Council.

Amidala and her allies in the Senate present Chancellor Palpatine with the Petition of 2,000—like-minded senators deeply concerned with the Chancellor's accrual of power and challenge to procedure. When Palpatine ignores their worries, these Senators form the seeds of what will eventually become a rebellion. Palpatine refuses to hand over his authority after the defeat of Separatist leaders Count Dooku and General Grievous, prompting the Jedi to move to arrest him. However, Palpatine turns the tables on the Jedi Order, claiming to the Senate that there has been an attempted coup. He activates Order 66, a secret contingency encoded in the biology of the clones that makes them attack their Jedi generals.

With the Clone Wars now over, the Separatists defeated, and the Jedi "rebellion" exposed, Chancellor Palpatine is at his political height. He uses this momentum to declare sweeping reformations to the Republic's structure and truly cements his position as its ruler. He declares himself Emperor, and the Galactic Republic is no more. Most in the Senate enthusiastically applaud this move—either believing in his promise of peace and security or profiting directly from the winds of change so as not to concern themselves with this stealthy rise of authoritarianism. ∎

The Senate

The Senate Rotunda is an immense domed structure that houses the auditorium wherein galactic representatives convene. Lining the walls of the circular chamber are 1,024 delegate pods—floating disks with seats and podiums where each delegation sits. Should a senator wish to speak, the pod detaches from its moorings and floats to the open space. At the center of the chamber is a spire atop which sits the Supreme Chancellor and his aides. The spire retracts into a holding chamber beneath the Rotunda, which serves as a secondary office for the Supreme Chancellor.

After the coming of the Empire, the Senate continues to function—though the role of Supreme Chancellor is no more—and most Senatorial sessions are overseen by the Grand Vizier, Mas Amedda. With the finalization of the Death Star, the Emperor decides to dissolve the Senate, and assigns his selected Regional Governors to represent the star systems.

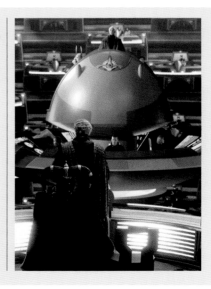

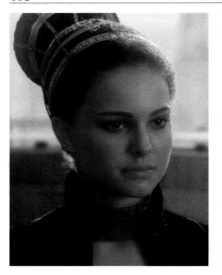

NOBLE VISIONARY
PADMÉ AMIDALA

HOLOCRON FILE

NAME
Padmé Amidala

SPECIES
Human

HOMEWORLD
Naboo

AFFILIATION
**Royal House of Naboo;
Galactic Senate**

TALENTS
Diplomacy; leadership

AIM
**Peace and prosperity for
the galaxy**

Whether as a royal or a politician, Padmé Amidala leads a life dedicated to serving others. Born Padmé Naberrie on the serene Mid Rim planet of Naboo, her penchant for public service emerges at an early age. As a young girl, she joins her father and a family friend, Onaconda Farr, on a mercy mission to save the population of Shadda-Bi-Boran, an Outer Rim world, from ecological disaster. She also holds the role of Apprentice Legislator for Naboo, representing her home planet on the galactic capital, Coruscant, amid other politically minded youth from systems across the galaxy.

Her civic experience leads to her eventual election as queen of the Naboo at the age of 14, making her the youngest person to ever hold the seat. As is tradition, she adopts a new name—Amidala—and tirelessly serves Naboo during one of the most trying times in the planet's history. During her reign, the Trade Federation blockades and later invades the world to force a settlement over trade routes. Amidala negotiates an alliance with the Gungans, Naboo's native species, to fight for freedom from the Federation. After centuries of tension between the Gungans and the human colonists, this cooperation forges a peace that lasts for decades.

Peaceful politician

After her term as queen ends, Amidala accepts an offer from the new queen, Réillata, to represent Naboo in the Galactic Senate. In opposition to the Chancellor, she

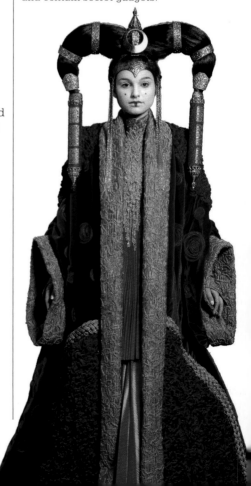

Battle garb Naboo royal gowns may look bulky but most are blaster-resistant and contain secret gadgets.

End of an era

Though she spends most of her life working for the good of people she doesn't know, in the end, Padmé falls victim to the evil of one closest to her. Her secret marriage to Jedi Anakin Skywalker ends in tragedy when her husband falls to the dark side of the Force. Anakin helps Darth Sidious destroy the Republic Padmé serves, effectively bringing to an end the very democracy she is fighting so hard to protect.

A pregnant Padmé is escorted to a medical facility by Anakin's former master, Obi-Wan Kenobi, where she gives birth to twins, whom she names Luke and Leia. Tragically, Padmé dies shortly afterward. Her funeral is attended by thousands of the Naboo who turn out to honor their former Queen and her myriad contributions toward peace and unity on their homeworld and across the galaxy.

aligns herself with Senators Bail Organa and Mon Mothma. The gifted leader gets to work quickly in her new role which allows her to serve not only her own people of Naboo, but also causes for individuals across the galaxy. Her first piece of legislation, the Mid Rim Cooperation Motion, saves millions on Bromlarch. She later acts as a member of the Loyalist Committee, helping to preserve the Republic from the growing threat of a Separatist Crisis. She is a vocal dissident against the creation of an army of the Republic. Padmé recognizes that the Military Creation Act will only bring strife. Ten years after the Trade Federation

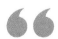

So this is how liberty dies. With thunderous applause.
Senator Padmé Amidala

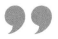

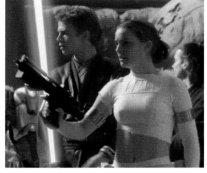

Aggressive negotiations Padmé will always try to seek a peaceful solution to a disagreement, but will resort to blasters if required.

crisis on Naboo, an unsuccessful attack on Amidala's life by notorious bounty hunter Zam Wesell reveals the true intent of the Separatists: the mobilization of a droid army to destroy the Republic. This sparks the beginning of the Clone Wars, paradoxically placing Padmé at the center of a war she has worked so hard to avoid.

A galaxy at war

Despite repeated attempts to assassinate her, Amidala boldly continues to serve in the public eye. Though she and Supreme Chancellor Sheev Palpatine hail from the same homeworld, their attitudes toward power are completely opposed. Whereas Padmé turns down an offer to amend the political process to allow her to stay in power as queen, Chancellor Palpatine embraces the additional authority handed to him by the Republic Senate.

As the Clone Wars rage endlessly on, Amidala is outwardly wary of Palpatine's unprecedented tenure and unyielding emergency powers. Despite her heroic service to the Senate on missions across the galaxy, her peace-seeking puts her at odds with pro-war Senators, including the Kaminoans who profit from the production of clone troops. Undeterred, she attempts to find diplomatic solutions to end the conflict with the Separatists, including direct negotiation with war-weary politicians in the Separatist government. However, peace always falls just outside her grasp, as she is unaware that her attempts are secretly undermined by Palpatine himself. When he finally declares himself Emperor, Amidala correctly sees the situation for what it is: the end of longstanding democracy in the Republic. ∎

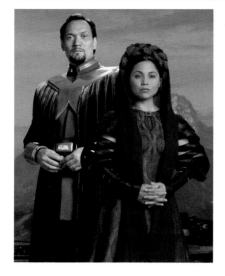

REBEL ROYALTY
BREHA AND BAIL ORGANA

HOLOCRON FILE

NAME
Breha and Bail Organa

SPECIES
Human

HOMEWORLD
Alderaan

AFFILIATION
**Royal House of Alderaan;
Republic; Rebel Alliance**

AIM
**Peace and freedom for
the galaxy**

STATUS REPORT
**Killed with the destruction
of Alderaan**

In contrast to some others in the ruling elite, Breha and Bail Organa break the mold because they are equally committed to their own people and to the trials and tribulations of the wider galaxy. These deeply compassionate leaders of Alderaan provide uncommon leadership through the waning days of the Republic and the dark times of the Empire. While Breha attends to affairs on their home planet, Bail represents Alderaan in the Galactic Senate and later becomes a leading political figure in the Rebel Alliance. During the final days of the Republic, he is a frequent friend to the Jedi Knights. Bail harbors Yoda and Obi-Wan Kenobi after Palpatine declares all Jedi traitors, allowing the Jedi Masters to escape the purge of Order 66. The Organas also agree to adopt Leia, daughter of their deceased friend Padmé Amidala and the recently anointed Darth Vader.

During the Imperial era, Bail and Breha secretly organize many rebel cells into a unified Alliance, recruiting them with the help of agents known as "Fulcrum" or inviting potential allies to banquets at their palace. Breha is also in charge of her planet's finances and secretly funnels money to the various rebel cells and sends aid to any planets suffering under Imperial rule. Their tireless work to organize and fund the groups that will become the Rebel Alliance is critical to their future victories. Though they are killed when the

Princess of Alderaan The Organas
raise Leia to be a dutiful future monarch.

Empire destroys Alderaan, Bail and Breha's rebellious spirit lives on in Leia. Statues are erected in their honor after their passing, but the Rebel Alliance they helped build and Leia are their lasting legacies. ■

Do you think they'll finally accept that the Empire will only be defeated through direct action?
Breha Organa

REBEL POLITICIAN
MON MOTHMA

HOLOCRON FILE

NAME
Mon Mothma

SPECIES
Human

HOMEWORLD
Chandrila

AFFILIATION
Republic; Rebel Alliance; New Republic

AIM
Restoration of democracy

STATUS REPORT
Retired New Republic Chancellor

Leading a rebellion is full of danger and uncertainty, but Mon Mothma's lifelong commitment to peace and unwavering morality provides a solid foundation upon which to build a formal opposition to the Galactic Empire. Throughout the entire existence of the Rebel Alliance, she is a beacon of principled political leadership that guides the Rebellion to its eventual victory.

As a Senator in the Galactic Republic, Mon Mothma pushes for a peaceful resolution to the Clone Wars and works as an active member of the Loyalist Committee dedicated to maintaining the democracy that Chancellor Palpatine so insidiously erodes. She serves in the Imperial Senate until she is branded a traitor for denouncing the Empire's role in the Ghorman Massacre. While on the run, Mothma makes a public statement officially forming the Alliance to Restore the Republic. Though she advocates fighting back, she is wary of unrestricted warfare, putting her at odds with the more militaristic wings of the Rebellion. With the death of Bail Organa, she serves as the primary political leader through the Galactic Civil War until the Emperor's defeat at the Battle of Endor.

Chancellor Mothma
With the Emperor gone, the Alliance declares itself the New Republic and elects Mon Mothma Supreme Chancellor to oversee the tumultuous period and establish order in the aftermath of the war. She pushes for demilitarization and the automation of the remaining military. Mothma also urges leniency for former Imperials and signs the Galactic Concordance, a peace treaty between the New Republic and the Imperial Remnants. Motivated by the hope that the new government won't become as tyrannical as the one defeated, Mothma serves as an elected leader until illness forces her to step down.

Ultimately, it can be argued that her idealistic commitment to peace and the demilitarization of the New Republic left the government unprepared to face the First Order years later. Unfortunately, the beliefs that helped her win the Galactic Civil War contributed to the rise of the First Order. ■

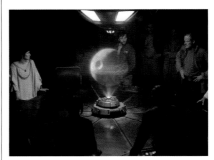

Tough decisions Facing an Imperial superweapon, the Alliance leaders decide the fate of the galaxy.

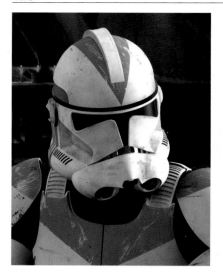

LEGIONS OF MIGHT
CLONE TROOPERS

HOLOCRON FILE

NAME
Various identification numbers (some clones take nicknames)

SPECIES
Human (clone)

HOMEWORLD
Kamino

AFFILIATION
Republic; Empire

ENHANCEMENTS
Rapid aging; combat training

DNA SOURCE
Jango Fett

For much of its thousand-year history, the Republic has no standing army of its own. With Jedi peacekeepers helping with law enforcement and facing no large-scale military threats, there is no need for a centralized force. But the government changes its stance during the Separatist Crisis when it discovers a fully formed clone army is ready to serve.

Supposedly ordered by Jedi Master Sifo-Dyas, the cloners of Kamino grow these fine soldiers at an industrial scale in their state-of-the-art facilities in the far reaches of the galaxy. Though they are often outnumbered by the mechanical armies of the Separatists, the clones prove that their superior intelligence and training outperforms the programming of battle droids.

Building a better army

Purpose built for combat, clones receive extensive training that includes physical fitness, battlefield tactics, and marksmanship. Each clone is physically identical to the host sample, the bounty hunter Jango Fett. Thanks to modified DNA, the clones grow at twice the rate of a normal human, allowing them to be combat ready twice as fast. By the time of the Clone Wars, the first batch of clones has received 10 years of full-time training.

Despite using the finest cloning technology, genetic mutations do occur, but clones with desirable mutations are pressed into specialized service. As the war rages on, it becomes clear that while the clones share the same DNA, they exhibit a surprising amount of individualism, taking on nicknames and modifying their appearance to reflect their personalities.

One feature that separates the troopers of the Grand Army of the Republic from other militaries of the era is the white armor worn by its foot soldiers. Encased almost entirely from head to toe, the armor protects clone troops from harsh environments, reduces exposure to the vacuum of space, deflects many melee weapons, and protects against glancing blaster bolts. Standard issue small arms come from the DC-15 series of blaster rifles and carbines, a weapon platform that proves to be both

Look around. We're one and the same. Same heart, same blood.
CT-5555 aka "Fives"

Ranks and commanders

With Jedi serving as leading generals in the Grand Army of the Republic, the clone troops have their own rank hierarchy. Clone sergeants typically command squads of nine troopers, while clone lieutenants lead a platoon comprised of multiple squads. Those platoons follow the orders of a captain, who reports to the clone commander, generally the highest-ranking clone in a unit known as a legion. Throughout the long campaigns of the Clone Wars, clone commanders often develop trusted relationships with their Jedi generals.

As leader of the 212th Attack Battalion, Commander Cody served alongside Master Obi-Wan Kenobi for the duration of the conflict, including the Battles of Christophsis, Teth, Ryloth, Saleucami, Utapau, and the second invasion of Geonosis. Commander Wolffe of the 104th Battalion served Master Plo Koon, and Commander Bly led the 327th Star Corps for Jedi Knight Aayla Secura.

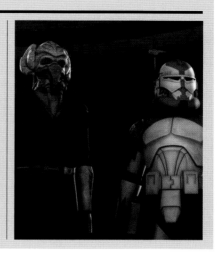

adaptable and dependable. For more specialized tasks, some clones receive dedicated training and equipment, such as anti-vehicle weaponry or climate-specific armor. The most talented clones are drafted into special service, taking roles as Advanced Recon Commandos (ARC troopers) or even Republic Commandos. They work in small units to carry out critical missions.

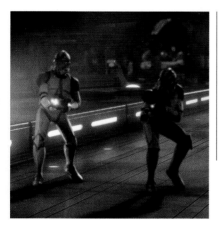

Heartless order During the attack on the Jedi Temple, two troopers mercilessly gun down a Jedi Padawan.

The Republic outfits these unique units with specialized armor to reflect their uncommon position.

Order 66

At Darth Sidious' behest, each clone has an inhibitor chip placed into them when they are embryos. This action is kept secret as the chips have a nefarious purpose. When called upon, the clones are programmed to betray their Jedi commanders. The direction, known as Order 66, is activated at the end of the Clone Wars. Almost instantaneously the clones destroy the Jedi Order, enabling Sidious to declare himself Emperor.

In Imperial service, clones continue to be the backbone of the army, and some even serve as Royal Guards protecting the Emperor. However, due to their rapid aging and the influx of natural-born recruits enticed by Imperial propaganda, clone troops are phased out after the Clone Wars. No longer needed for the only job they were ever trained to do, most quietly enter retirement. But their legacy is not soon forgotten, as the stormtroopers that replace them are a common sight across the galaxy. ∎

Armor redesign The Kaminoans introduce a new, redesigned armor partway through the Clone Wars.

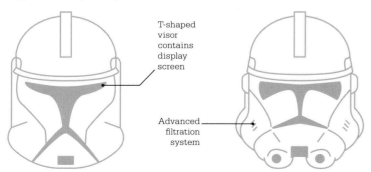

T-shaped visor contains display screen

Advanced filtration system

Phase I helmets Inspired by the armor of Jango Fett, Phase I clone trooper helmets contain life-support systems.

Phase II helmets Phase II clone trooper helmets are more comfortable and customizable than their predecessors.

CLONE COMMANDER
CAPTAIN REX

HOLOCRON FILE

NAME
CT-7567 "Rex"

SPECIES
Human (clone)

HOMEWORLD
Kamino

AFFILIATION
Republic; Rebel Alliance

NOTABLE TRAITS
Skilled leader; highly trained warrior

How is it that some clones, among millions born alike in every way, grow to stand above the rest? Some do it with their leadership or combat skills. For others, it is the bravery they inspire in their troops or the relationships they form with other leaders. For Rex, it is all of these things.

During the Clone Wars, Rex is a Captain in Jedi General Anakin Skywalker's 501st Legion, forming a close relationship with the Jedi and his Padawan, Ahsoka Tano. He serves with merit at the Battles of Arantara, Christophsis, Anaxes,

Saleucami, and many more. At Umbara, Rex leads a coup to arrest the treasonous Jedi General Pong Krell, protecting his men from useless slaughter.

During the war's final days, Rex reunites with Ahsoka, who has since left the Jedi Order, to end Maul's rule over Mandalore. Rex leads the 332nd Company, formed out of the 501st, to fight alongside Ahsoka during this difficult battle. The unit even paint their helmets to honor her. When Order 66 is issued aboard their Star Destroyer, Rex turns on Tano, but she incapacitates him and removes his inhibitor chip. Rex and Tano then work together to escape the ship. After faking their deaths, they escape into exile.

Rebellion
Years later, Rex comes out of retirement, hunting monstrous joopas on Seelos, to once again serve with Ahsoka, now a rebel recruiter. He joins Phoenix Squadron and takes part in the Liberation of Lothal and later the Battle of Endor. Rex

Still got it Years after the Clone Wars end, Rex rejoins an army. His tactical knowledge and martial skills are sorely needed by the rebels.

proves time and again that despite rapid aging, the old clone's loyalty to Tano and his dedication to fighting an honorable fight has not faded over the years. ■

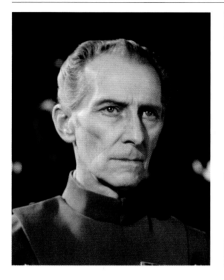

IMPERIAL RUTHLESSNESS
GRAND MOFF TARKIN

HOLOCRON FILE

NAME
Wilhuff Tarkin

SPECIES
Human

HOMEWORLD
Eriadu

AFFILIATION
Republic; Empire

AIM
Bring order to the galaxy through fear and military strength

STATUS REPORT
Perished at the Battle of Yavin

Born to a wealthy but hardened family, Wilhuff Tarkin faces survival tests on his homeworld from an early age and has to protect his planet from lawlessness. Tarkin quickly learns that callousness is a useful tool to thrive in a dangerous galaxy. He first encounters future Imperial Emperor Sheev Palpatine during the Eriadu Trade conference. Palpatine suggests the capable

Tarkin transition into politics. Heeding his advice, Tarkin serves as Eriadu's governor for a time. When the Clone Wars begin, Tarkin joins the Republic military, quickly rising to the rank of Admiral.

In the early days of the Empire, the Emperor makes Tarkin a Moff, responsible for overseeing a galactic sector. With characteristic ruthlessness, Tarkin applies himself to crushing insurrections, quashing rebellions on Mon Cala and Antar 4, and founding the Tarkin Initiative, a group devoted to creating superweapons. Tarkin is eventually named Grand Moff of the Outer Rim Territories for dealing with Berch Teller's rebel cell. He then oversees an ambitious plan to expand Imperial control across the Outer Rim. The insurgent activity on Lothal is a dark spot on his nearly flawless record, for it is there that his brutal methods are not effective at snuffing out rebellion.

Tarkin is a staunch believer in the Death Star program, though he maintains just enough distance from the project so as not to be blamed for its many delays. Once he has proof that the station's superlaser works, Tarkin assumes control and takes the credit. With the weapon,

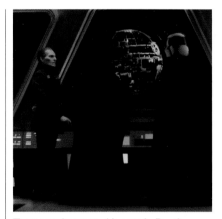

Emperor's trust Alongside Darth Vader, Tarkin is a vital member of Emperor Palpatine's inner circle.

he hopes to crush all defiance and expand the Empire through fear.

In the end, Tarkin's hubris is his downfall. He refuses to evacuate the Death Star when it falls under attack by the Rebel Alliance at Yavin, believing his triumph against the Rebellion is at hand. His ruthless rise ends with the destruction of the Death Star, leaving Imperial leaders debating for years to come if Tarkin's doctrine of consolidated power is flawed. Regardless of their concerns, a second Death Star is fully operational within four years. ∎

POLITICAL REBELS
THE SEPARATISTS

HOLOCRON FILE

NAME
Confederacy of Independent Systems

HEAD OF STATE
Count Dooku

CAPITAL
Raxus

AIM
Separation from the Republic

STATUS REPORT
Defeated in the Clone Wars and absorbed into the Empire

Separatist leaders Count Dooku, flanked by Poggle the Lesser and Nute Gunray, oversees the Petranaki arena on Geonosis at the start of the Clone Wars.

The greatest threat to the Galactic Republic comes in the form of discontented member systems, inspired by the promise of freedom and prosperity touted by former Jedi Master, Count Dooku of Serenno. The Confederacy of Independent Systems—also known as the Separatists—attempts to break away from the Republic to form its own government. Little does it know that its attempt to gain independence will lead to a war it cannot win and give rise to a far more unforgiving regime which will eventually replace the Republic it sought to escape.

While it's easy to solely attribute the creation of the Separatist crisis to the machinations of the Sith, the criticisms lodged by the Separatists against the Republic are genuine. Ineffectual government, heavy taxes, and the perception that the Core Worlds receive favoritism over their Outer Rim counterparts make countless systems receptive to Count Dooku's promise of a new government. Discontent brews for decades and Dooku merely seizes on the opportunity to turn their dissent into disloyalty. His Raxus Address, a scathing speech outlining his

Council in hiding Upon the death of Count Dooku, the Separatist Council goes into hiding on Utapau under the protection of General Grievous.

critiques of the Republic, rings true for many, rallying thousands to his cause. System after system pledges loyalty to Dooku in the lead-up to the Battle of Geonosis and their exit causes multiple reactions in the Republic Senate. While the Loyalist Committee tries to find a peaceful resolution to the crisis, more militaristic factions call for the creation of an armed force to defend against the possible Separatist

And as my first act with this new authority, I will create a Grand Army of the Republic to counter the increasing threats of the Separatists.
Chancellor Palpatine

threat. Such talk of war only serves to fan the flames even further, eventually leading to all-out conflict between the Separatists and the Republic, known as the Clone Wars.

While most of the Separatists identify with their star systems, the Confederacy of Independent Systems is unique; it includes a disproportionate number of business entities including the Corporate Alliance, Commerce Guild, InterGalactic Banking Clan, Techno Union, Retail Caucus, and Trade Federation. Attracted by the lack of regulation that will lead to greater profits, the corporations »

Separatist timeline

42 BSW4
Fallen Jedi
Dooku leaves the Jedi Order to become Count of his homeworld, Serenno.

22 BSW4
Battle of Geonosis
The Clone Wars begin with an assault on the droid factories on Geonosis.

21 BSW4
Invasion of Kamino
Separatists attempt to disrupt the Republic's clone production.

24 BSW4
Raxus Address
Dooku's impassioned speech inspires systems to leave the Republic.

21 BSW4
Negotiations Undermined
Senators Amidala and Bonteri begin peace talks, but are undermined by Dooku.

19 BSW4
War's End
Dooku, Grievous, and the Separatist Council betrayed by Sidious who ends the war with a single command.

pledge their vast resources to the cause. The Confederacy is dependent upon its considerable private security forces, whose armies of battle droids, fleets of starships, and hordes of armor prove to be a formidable rival to the Republic's clone army. For some of these corporate entities, their support for the Confederacy of Independent Systems is an open secret. Throughout the war, the Trade Federation officially remains loyal to the Republic, retaining a seat in the Galactic Senate by declaring neutrality despite the obvious deployment of its battle droid armies for the Separatists.

In the end, all of the Separatists suffer for their choice. Little do they know that the war is orchestrated by Darth Sidious—Chancellor Palpatine—and Dooku, also known as the apprentice Darth Tyranus. Once Sidious assumes complete control of the Republic, he ends the war and forces the Separatist systems back under his control. While some Separatists on the fringes of the galaxy continue to resist and others eventually join the Rebellion, most Separatists become reluctant citizens of the Empire, accepting their fate having already suffered so much for so very little.

Military forces

Upon declaring the Confederacy, the Separatist military is prepared for war thanks to the use of existing droid security forces from its corporate backers. Foundries from Geonosis to Akiva and beyond produce droids by the millions, heavily outnumbering their clone adversaries. On the ground, B1 battle droids made famous by the Trade Federation fill the ranks. Though not the most capable soldiers individually, in large numbers they can overwhelm clone units or even Jedi Knights. More capable, specialized droids such as

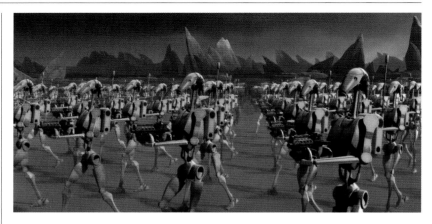

B2 battle droids, droideka destroyer droids, and commando droids are produced at a higher cost, albeit in limited numbers. Other corporate entities deploy their units in turn, including the Techno Union's tri-droid, the Commerce Guild with its spider droids, the Banking Clan's hailfire droids, and the Corporate Alliance's NR-N99 tank droids. Though a small fraction of the overall army, biological soldiers from local militias and defense forces such as those on Umbara and Geonosis also rally to the Separatist movement.

Military strategy is overseen by Count Dooku, who recruits the vicious, experienced General Grievous to lead the droid army. Other high-ranking posts are filled by non-droid officers including

The Commerce Guilds are preparing for war. There can be no doubt of that.
Bail Organa

Battle of Malastare The droid armies outnumber the Republic's clones, overwhelming their enemies at Malastare and beyond.

General Whorm Loathsom at Christophsis, Admiral Trench of the navy, Riff Tamson at Mon Cala, and Lok Durd who has a keen interest in special weapons development. Tactical droids assist with battlefield analysis and fill leadership roles where biological officers are not available.

Political leadership

Throughout the war, Count Dooku is the public head of the Separatist movement, while secretly answering to his Sith master, Darth Sidious. Shrewd and charismatic, Dooku actively manages both the political and military direction of the movement. Dooku's alter ego as a Sith Lord is not widely known, but he is compelled on many occasions to personally step in to influence the war with his lightsaber, should his underlings fail.

Officially, the Confederacy elects a Parliament to legislate issues impacting its member systems with Dooku presiding. But out of view, he heads a council of key Separatist leaders. The corporations who secretly fund his war gain prized seats on the council, as do early supporters like Po Nudo of Ando and Tikkes—a Quarren from Mon Cala.

Separatist Parliament

Though the Confederacy of Independent Systems is dissatisfied with the inefficiency of the Republic, it chooses to replicate its representative system by establishing one of its own. The Separatist Parliament operates much like its Republic counterpart, allowing representatives from its member worlds to debate and vote on legislation and motions—albeit without the layers of bureaucracy, existing treaties, and corporate meddling that plagues the Galactic Senate.

Count Dooku presides over the Parliament, with the assistance of Separatist Congress Leader Bec Lawise, a principled representative who is unaware of Count Dooku's sinister plots. Many of the senators are experienced veterans of the Republic and some support negotiation with their old colleagues for a peaceful resolution to the Clone Wars. The resolution is put forward by Mina Bonteri of Onderon, a friend and mentor of Padmé Amidala, but Dooku has her killed in order to prevent the peace negotiations from succeeding.

To further create unrest in the Republic, Dooku makes alliances with some of the galaxy's more dubious factions, including a clan of pro-war Mandalorians known as Death Watch and the Zygerrian Slave Empire. Death Watch hopes that their alliance will bring an end to the rule of pacifist Duchess Satine Kryze on its planet of Mandalore, while the Zygerrians yearn for a return of slavery, currently outlawed by the Republic within its borders.

Downfall of the Confederacy

After years of conflict, the Separatists' hopes for winning the war begin to diminish. They stage a desperate attack on the Republic capital in an attempt to capture the Supreme Chancellor to force a settlement. During the battle, Count Dooku is killed, betrayed by his master who has been controlling both sides of the conflict. Darth Sidious then betrays General Grievous and the Separatist council and orders the droid army to deactivate. The Clone Wars end without the need for a treaty, a dissatisfying conclusion for the Separatist systems who have little choice but to fall under control of the newly pronounced Empire. The corporations that make up the droid army largely continue under the new regime and the relics of their former glory, the battle droids, linger in droid workshops or in the service of pirates and partisans for decades to come. ∎

Separatist symbols The corporate members of the Confederacy attempt to hide their contributions to the war by replacing their own marks with the icon of the Separatist Alliance.

Confederacy of Independent Systems
This hex icon adorns the equipment and starships united under the Separatist banner.

Techno Union Led by Wat Tambor, this guild of technology firms helps arm the Confederacy with battle droids.

Trade Federation Once associated with commerce and shipping, this icon becomes synonymous with the war.

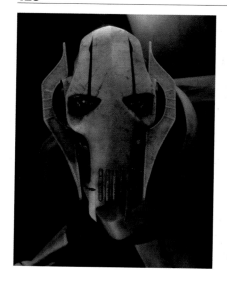

CYBORG TYRANT
GENERAL GRIEVOUS

HOLOCRON FILE

NAME
General Grievous

SPECIES
Kaleesh

HOMEWORLD
Kalee

AFFILIATION
Separatists

ABILITIES
Duranium alloy body and cybernetic upgrades provide augmented reflexes; four mechanical arms; magnetic feet

AIM
Destruction of the Jedi

O f all the fearsome combatants of the Clone Wars, perhaps none strikes terror into the hearts of Republic soldiers quite like General Grievous, the cunning and ruthless military leader of the Separatist droid army, and dedicated hunter of Jedi Knights.

This Kaleesh warlord gradually trades his biological parts for upgraded mechanical ones until only his original vital organs, brain, and eyes remain. These augmentations turn an already capable warrior into a nearly unstoppable killing machine on the battlefield, giving him capabilities beyond those of a normal soldier.

Though he does not use the Force, Grievous' heightened senses, the precision of his mechanical limbs, and the training he receives from Sith Lord Count Dooku allow him to employ lightsabers in combat. His two arms can split into four, so the general can use up to four sabers at once. Unlike his Jedi foes, he also wields a DT-57 blaster, taking advantage of every piece of technology available to him.

However, his abilities are not just physical. Behind Grievous' mask lies one of the shrewdest military strategists of the era— one who is not afraid to retreat should the odds turn against him. The general regularly avoids capture by the Republic, slipping away to fight another day.

While Count Dooku deals with matters of state for the Confederacy of Independent Systems, General Grievous focuses on matters of military execution. His motivations seem purely personal, whether it be pride in leading the largest droid army the galaxy has ever seen or his lust for killing Jedi. He regularly commands naval engagements from his flagship dreadnought, the *Invisible Hand*, but his combat experience and brutality shine in hand-to-hand combat. He often leads from the front lines, using his enhanced physical capabilities to attack enemy troops.

Grievous is often displeased with the droid army's failure to meet his exacting standards, and he is not afraid to demonstrate his frustration through cruel physical punishment.

I will rest when the Jedi are dead.
General Grievous

Frequent foes

Throughout the Clone Wars, the wise and tactical Jedi General Obi-Wan Kenobi is a frequent nemesis of General Grievous. The two cross sabers multiple times, including a duel aboard Grievous' superweapon battle cruiser, the *Malevolence*; aboard the cruiser *Steadfast* in the Saleucami system; on Kenobi's command ship near Florrum; and above Coruscant at the end of the war.

Though the general comes close to defeating Kenobi multiple times, in the end it is the Jedi who gets the best of the Separatist on Utapau. Following a dramatic chase through Pau City, Kenobi uses Grievous' own blaster against him in their final duel, landing a precise shot to the general's vital organs—what little remains of Grievous' original body eventually proves to be his undoing.

Murderous streak

Grievous believes himself to be a superior warrior to all Jedi and seeks to prove himself in combat. By the end of the war, he is rumored to have captured or killed dozens of Jedi, including Jedi Master Neebo and the newly knighted Nahdar Vebb, who locates Grievous' personal fortress on Vassek 3, but falls to the general's hidden blaster during their duel. The Jedi consider such devious tactics to be cowardly, but Grievous holds no such notions of honor. Instead, he takes pride in his growing collection of war trophies: the lightsaber blades of his defeated foes and the braids of Padawans struck down before their prime.

His vicious streak extends beyond the Jedi, as he personally slays Gungan General Tarpals on Naboo, and massacres the Nightsisters of Dathomir. There, he shows no mercy as he wipes out an entire clan of witches, with only a couple of Nightsisters surviving.

After years of seemingly unstoppable terror, the general's murderous streak comes to an end when Darth Sidious betrays his hiding spot on Utapau to the Jedi, wanting to tie up a loose end. Cornered by Master Obi-Wan Kenobi when attempting to flee in his starfighter, the *Soulless One*, Grievous finally meets his match. ■

Bold one After descending from a gangway high above, the brave General Kenobi duels Grievous.

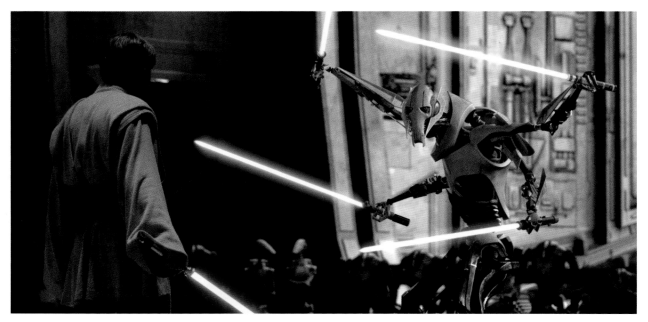

GALAXY AT WAR
THE CLONE WARS

HOLOCRON FILE

NAME
The Clone Wars

LENGTH
3 standard years

PARTICIPANTS
The Republic vs. the Confederacy of Independent Systems

INCITING EVENT
Battle of Geonosis

The largest and most destructive conflict to face the galaxy in a millennium, the Clone Wars rage in systems big and small. War erupts on land and sea, in the sky and space, pitting Republic clones born for battle against hordes of Separatist war droids. After three years of brutal conflict, the war ends with the downfall of both the Republic and Separatist governments, clearing the way for the rise of the authoritarian Galactic Empire.

The seeds of war begin 10 years before the armed conflict. Sifo-Dyas, a Jedi Master gifted with precognition, has a vision of war. He secretly orders a human army from the cloners of Kamino without the knowledge of the Republic or the Jedi Council. As the commissioned clones grow into fighting shape, their existence is discovered by Darth Sidious, who recognizes their value in his plan to destabilize the Jedi and the Galactic Republic.

In the lead-up to war, the threat of former member systems leaving to unite under Count Dooku's Confederacy of Independent Systems results in a debate over the creation of a large army to defend the Republic. As soon as the Senate votes for the establishment of an army, one is ready for battle, thanks to the clone legions ordered in secret years before.

Rising tensions boil over when the Separatists capture Jedi Obi-Wan Kenobi, Anakin Skywalker,

Clone Wars timeline

32 BSW4
Clone Army Conception Unknown to the Republic, Sifo-Dyas orders a clone army.

22 BSW4
Secret Weapons Separatist heavy cruiser *Malevolence* terrorizes the Republic fleet.

21 BSW4
Second Battle of Geonosis The Republic retakes Geonosis in a costly reinvasion.

22 BSW4
Battle of Geonosis Discovery of droid factories on Geonosis sparks war.

21 BSW4
Battle of Malastare The Republic tests a new anti-droid bomb while retreating from battle.

20 BSW4
Zygerrian Alliance The Separatists form a secret alliance with the slavers of Zygerria.

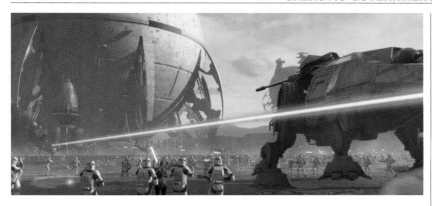

Battle of Geonosis The Clone Wars begin at the first Battle of Geonosis where clone troopers, backed by AT-TE vehicles, engage the droid army.

and Senator Padmé Amidala on Geonosis. There, they discover the Confederacy manufacturing millions of battle droids and witness the arrival of the Jedi-led clone army, which ignites war across the galaxy. The Battle of Geonosis is the first time the Republic fields its new soldiers, and the clones perform valiantly in battle. The Separatists are routed and its leadership flees.

Though the droid factories on Geonosis are shut down, at least temporarily, the Separatists gain an early upper hand in the war after quickly seizing control of the major hyperspace lanes. The strategy separates the Republic from the majority of its clone army, leaving them unable to gain a foothold in the Outer Rim. This back-and-forth arrangement continues throughout the war, with each side gaining the upper hand only to lose it once again. With each new superweapon, campaign, and scheme, it looks as if each side might finally win, but the conflict merely stretches on. The never-ending war nearly bankrupts the Republic, forcing the Senate to deregulate the banks to open ever increasing lines of credit. Fiscal and moral responsibility takes a back seat to more debt, more troops, and more conflict.

Near the end of the war, a series of engagements known as the Outer Rim Sieges turn the tide in favor of the Republic. Fearing defeat on the battlefield, Separatist leadership mounts an attack on the Republic capital of Coruscant in a bid to capture the Supreme Chancellor and force a truce. The gambit fails, leading to the death of Count Dooku and a series of events that brings about the end of the war. Ultimately, Darth Sidious' plan works. With the army he uses to fight the war he masterminds, he now has the power to destroy the Jedi. War-weary citizens are ready to embrace order in any form, allowing Sidious to declare himself Galactic Emperor.

The effects of such a widespread conflict linger for decades. In some parts of the galaxy, the memory of the Jedi fades. For aiding the Separatists during the war, the Empire cuts wages and lowers safety standards for the Scrapper Guild, just one example of such reprisals against Separatist systems. While physical relics of the war waste away in scrapyards like Reklam Station and Bracca, the physical and mental scars of the war linger upon citizens and soldiers for the rest of their lives.

The politics of this war are not as black and white as I once thought they were.
Ahsoka Tano

No analysis of the Clone Wars is complete without considering the clones after which it is named. The Kaminoans are rightly proud of their creation, which is so well trained and equipped it hands the Republic its first victory over the droid armies almost immediately after its discovery. Mentally superior to »

19 BSW4
Outer Rim Sieges
A series of battles begins to turn the war in the Republic's favor.

19 BSW4
Battle for Anaxes
The Confederacy aims to capture vital shipyards.

19 BSW4
Siege of Mandalore
The Republic fights a third front against underworld factions united by Maul.

19 BSW4
Bracca Invasion
Separatists attempt to wrest away control of the material-rich world with help from the local guild.

19 BSW4
Battle of Coruscant
First military attack on Coruscant in 1,000 years.

19 BSW4
Battle of Utapau
Droid General Grievous killed by Jedi Obi-Wan Kenobi.

Secret structure Officially, the Confederacy is led by Count Dooku, but few know that Darth Sidious is the real mastermind of the Separatists and the Republic.

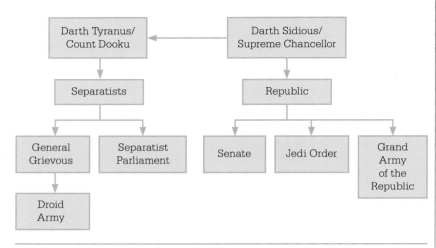

droids, technology augments the clones' physical conditioning to improve their chances of survival against never-ending waves of Separatists. A clone is expected to serve the entirety of the war with little respite, as their sole purpose is fighting. The troops develop real animosity for their enemies, adopting derogatory slang such as "clankers" (when referring to the battle droids of the Confederacy). Some clones go so far as to collect droid parts as war trophies. Long after the war, clones and many citizens alike hold onto deep-seated resentment for droids of all kinds.

Naval power

The Clone Wars are notable for their naval battles. This is one of the few times in recent galactic history that two powers' armadas are so evenly matched and so sizable. The Republic's fleets, staffed by clones under the command of natural-born officers, go head-to-head with the

Battle over Coruscant Above the city-planet, the Republic's ARC-170 starfighters and Jedi starfighters approach a Separatist *Providence*-class dreadnought to rescue the chancellor.

Separatist navy. Battle droids fill most stations on board, while biological officers command fleet movements and strategy. Even the Separatists' starfighters are droids who use overwhelming numbers to their advantage when facing Republic starfighters and their clone pilots. Realizing the importance of fleet engagements, the Republic quickly adopts *Venator*-class Star Destroyers to accompany its more lightly armed *Acclamator*-class assault ships that transport clones

to the battlefield. General Grievous uses his agile fleets to his advantage throughout the war, disrupting the Republic with attacks on planets such as Falleen and Dorin. Unable to calculate where the droid general will strike next, the Republic becomes distracted and leaves previously conquered worlds open to Separatist control. This is the case at the Second Battle of Geonosis, where the Republic must reinvade the planet at great cost of life after Archduke Poggle the Lesser reopens his droid factories.

Throughout the war that spans the entire galaxy, intelligence on enemy positions, troop strength, and capabilities is a fundamental asset for both sides. Each invests in listening posts, such as the Republic's on Pastil and the Rishi Moon or the Separatists' stations at Vanqor and Skytop Station.

Neutral parties

Not all systems rally to war, indeed some actively avoid it. Around 1,500 parties unite under the leadership of Duchess Satine Kryze to form a Council of Neutral Systems. While some systems are morally opposed to the war, remaining neutral also

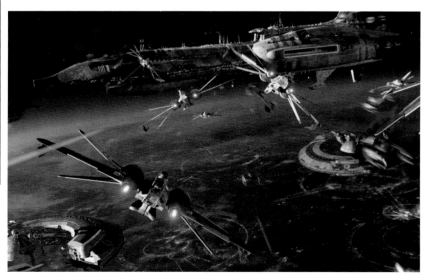

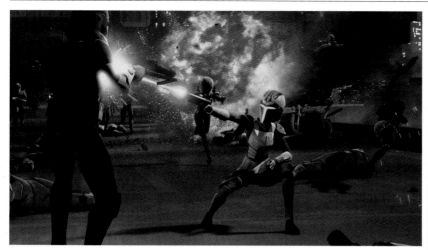

Siege of Mandalore
Led by Ahsoka Tano, the Republic's 332nd Division besieges Maul's Mandalorian warriors. The combatants clash in Mandalore's capital—Sundari.

For almost three standard years, this war has raged. We can barely even count the numbers of the fallen.
Master Plo Koon

allows for trade and transportation to both sides. Some pacifists seek to hide during this time, hoping that strict isolationism might insulate them from conflict. For the Lurmen colonists of Maridun, they would have no such luck and learn that even the most remote outpost has strategic value as a military testing ground.

The underworld also seizes upon the opportunities created by war. Bounty hunters find employment on both sides, either as instructors or carrying out assignments that fall outside of the rules of war.

The Hutts seek to control the hyperspace lanes during the conflict, reaping profits or striking deals with the two sides who need to pass through their territory. A collection of syndicates and criminals unite under the former Sith apprentice Maul. Known as the Shadow Collective, they hope to capitalize on the chaos to gain a foothold on Mandalore and beyond. ∎

Jedi generals

After the fortuitous creation of the clone army, it falls upon the Knights of the Jedi Order to lead it in battle. The Jedi Council oversees most matters of military strategy for the Republic and also leads the attack from the front lines. For generations, the Jedi had been peacekeepers for the Republic, but acting as officers in a drawn-out conflict is an unfamiliar role for the Order. War leaves little time for the more esoteric responsibilities of a Jedi. Padawans, typically given time to find their way under the careful guidance of their masters, are pushed into combat at a young age.

The Jedi Knights' role as military leaders also creates a strain between the Order and those it swears to protect. Many Separatists perceive them as evil, while some in the Republic question whether they truly seek an end to the war.

Distracted and weakened by perpetual conflict, the Jedi are not prepared when they discover Supreme Chancellor Palpatine is secretly a Sith. When he declares that the Jedi are traitors of the Republic, the galaxy is willing to accept his lies. Despite one thousand years of service to the Republic, and loyalty shown during the events of the war, the Clone Wars bring about the downfall of the Order.

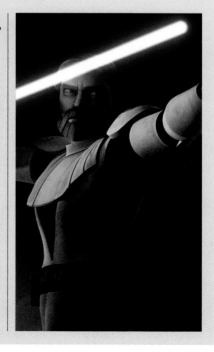

IMPERIAL MIGHT

THE GALACTIC EMPIRE

HOLOCRON FILE

NAME
The Galactic Empire

CAPITAL
Coruscant

LEADER
Emperor Palpatine

AIM
Order and security

STATUS REPORT
**Succeeded by
the New Republic**

Fear will keep the
local systems in line.
Fear of this battle station.
Grand Moff Tarkin

After years of war, many in the galaxy are willing to accept peace at any cost, even if it means handing over all power to a dictator. When Supreme Chancellor Palpatine declares himself Emperor, the Senate celebrates the New Order with thunderous applause. But with order and security also comes abuse at the hands of Imperial officials, and as the Empire tightens its grip on the galaxy, it becomes clear that the much longed-for peace is fleeting.

In the transition from Republic to Empire, some relics of the old system remain. The Senate continues as a largely symbolic organization, and Palpatine makes his Palace in the Jedi Temple on Coruscant. The Republic's clones are the first Imperial stormtroopers, serving in the early days of the Empire until new recruits replace them. A steady feed of propaganda, often portraying an undeformed version of Palpatine, fills the Imperial HoloNet—a wide-ranging communication system. Such broadcasts must be played in designated public spaces by legal decree. This propaganda proves so effective that the Empire no longer needs to purchase cloned troopers from Kamino, as millions enlist to serve the Emperor.

Corruption and greed are ever-present in the New Order. Military officers vie for increasing rank and power at all costs. Wealthy citizens and local politicians forsake their star systems in order to curry favor with the Empire or increase their personal wealth. Meanwhile, the unlucky citizens of those planets face dispossession, starvation, and forced labor. The Empire subjugates entire species to slavery, deforests parts of Kashyyyk in search of raw materials, strip-mines worlds like Lothal, and initiates excavation projects for ancient relics on worlds

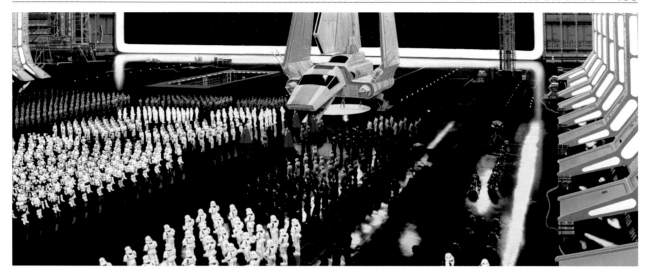

Emperor's visit Stormtroopers, officers, Moffs, and Darth Vader await Palpatine as he alights the Imperial Shuttle.

like Zeffo. Such harsh measures against the populace are deemed necessary as the Empire locks down control over its territories and expands into more Rimward sectors of the galaxy. The Outer Rim, long overlooked by the Republic, becomes the target for Imperial expansion. Palpatine also takes a personal interest in the galaxy's furthest expanses: the mysterious Unknown Regions.

A growing military is vital to expansion and to return order to unruly systems. Imperial cruelty incites scattered rebellion, though the Empire initially writes off such efforts as local partisan activity. As the rebel cells begin to unite, Palpatine continues his investments into more powerful superweapons.

Displays of power ultimately prove ineffective against rebel activity. Aided by subversives within the Empire, the Rebel Alliance destroys the Death Star at the Battle of Yavin. The Emperor devotes much of his attention for the following four years to crushing the Rebellion, but is himself undone at the Battle of Endor. Palpatine's apparent death is a major turning point in the Civil War, but it is not the end of his regime. Following Endor, the spiteful tyrant exacts revenge on the galaxy for another year through his proxies. At the Battle of Jakku, his enemies win a decisive victory against the remaining Imperial fleet, forcing the political leadership to sign a peace treaty—the Galactic Concordance—with the New Republic. On the fringes, some Imperials establish themselves as warlords overseeing local territories, but rarely hold wider power. Most Imperials are simply absorbed into the New Republic. But in the furthest reaches of the galaxy, select Imperials reside in the Unknown Regions, determined to carry on the legacy of the Empire as the First Order.

Though the Clone Wars end, military production does not slow when Palpatine pronounces the Empire. Shipyards at Kuat, Corellia, Fondor, and others meet strict quotas that fill the galaxy with fleets of Imperial warships, using expanding might to bring order to the once-divided galaxy. The Imperial military is as ruthless as it is efficient, from lowly technicians to Grand Admirals and Grand Generals at the top. »

Rise of the Empire

19 BSW4
New Order
Palpatine transforms the Republic into the first Galactic Empire.

0 SW4
Ultimate power undone
Shortly after testing its turbolaser on Jedha, Scarif, and Alderaan, the Rebel Alliance exploits a weakness to destroy the Death Star.

5 ASW4
Defeat at Jakku
The remnants of the Imperial fleet fall at Jakku. A Galactic Concordance treaty ends the war.

18 BSW4
Empire Day
The galaxy celebrates the first anniversary of the Empire, becoming an annual tradition known as Empire Day.

4 ASW4
Emperor's fall
Emperor Palpatine is apparently dead following the battle that destroys the second Death Star.

Imperial propaganda An entire division of government is devoted to creating and distributing propaganda.

An enduring symbol of the military are the Imperial stormtroopers, the faceless, white-clad soldiers of the New Order. Stoked by persuasive propaganda or the guarantee of a better life than can be found on downtrodden planets, the ranks of the stormtroopers are filled by volunteers. Recruits are cheaper than clones and a fanatical soldier proves to be just as loyal. Training at Arkanis, Carida, and Skystrike Academy, among others, the most promising cadets become pilots in the Imperial Navy. The very best serve in elite squadrons, including the famous Shadow Wing, Titan, or Vixus squadrons. Subordination, or simply average ability, may see a cadet funneled into the stormtrooper corps as infantry. The Empire employs droids in a variety

of roles, often performing training, security, maintenance, and administrative functions to free up biological service members for more pressing duties.

Among the Empire's massive fleet, the Star Destroyer and TIE fighter become icons of Imperial naval superiority. The capital ships are larger and more powerful than their Republic predecessors, while the economically produced TIE gives its Starfleet a numerical advantage with which to outnumber their enemies in combat.

Supplementing these common technologies is an array of special weapons projects led by Imperial research and development. The Empire invests trillions of credits into Death Star superweapons, Super Star Destroyers the size of cities, and formidable TIE defenders. The regime takes special interest in the application of kyber crystals, establishing mining operations to source these rare stones on Jedha and Ilum. Project Celestial Power gathers top scientists to study and apply kyber technology to Imperial

weapons and shields, including the Death Star.

With such a massive military, terror weapons, and fanatical servicemembers, the Empire commits numerous atrocities. Brutalities on Mon Cala, Lasan, Ghorman, and Alderaan are meant to establish order, but merely encourage greater rebellion.

Imperial logo An adaptation of the Republic's logo, the Empire's sigil is omnipresent in Imperial society.

Governing the Empire

Emperor Palpatine has the final say in all matters relating to the Empire, but he delegates authority to high-ranking Governor-Generals to enforce his will and maintain order across the star systems. For a time, Palpatine allows the Imperial Senate to continue, but the puppet legislature is formally abolished upon the Death Star's completion. His sector governors, known as Moffs, are given absolute authority to manage their systems. Under the guidance of the Moffs, planetary governors provide political leadership and local security, while high-ranking military officers oversee movements of the military fleets that operate across systems. A number of advisors assist Palpatine, including the politically shrewd Grand Vizier Mas Amedda and a small advisory council. Among them is Yupe Tashu, a Sith cultist who facilitates the Emperor's

Everything that has transpired has done so according to my design.
Emperor Palpatine

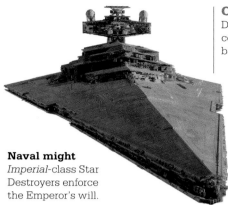

Naval might
Imperial-class Star
Destroyers enforce
the Emperor's will.

Organization of the Empire
Designed by Sheev Palpatine, the
convoluted Imperial hierarchy is
based on infighting and mistrust.

The Emperor

Advisors
high-ranking
bureaucrats

Moffs
rank held by the
Sector Governors

Grand Moffs
Governors of
Oversectors

ISB
Imperial Security
Bureau performs
functions
of intelligence
and security

Ubiqtorate
leadership of
Imperial intelligence

Planetary Governors
Both politicians and
Imperial Military
commanders (with
limited powers)

COMPNOR
(Commission for
the Preservation of
the New Order)
responsible for
promotion of New
Order ideology

personal interest in the arcane.
Palpatine's Sith apprentice, Darth
Vader, serves as the Emperor's
enforcer, tasked with hunting down
any remaining Jedi with the aid of
Force-sensitive Inquisitors. While
tribunals deal with smaller matters
of discipline, the Imperial Security
Bureau performs functions of
intelligence and security. ISB agents
seek out insurgency and disloyalty.

Following the Emperor's
apparent demise, a power vacuum
forms as various Imperial leaders
vie for control of the fragmented
Order. The chaos leads to infighting,
as officers attempt to eliminate their
rivals or declare themselves in
command. After the Battle of Jakku,
authority resides with Mas Amedda
to execute the Imperial Instruments
of Surrender, thereby formally
ending the war and Imperial rule. ■

Contingency

Even after his losses at Endor,
Darth Sidious' schemes do not
end. Similar to the complex
machinations that bring him
to power, his plans in the event
of his defeat are a complicated
series of actions of which only
he knows the full scope. With
his Contingency, Palpatine
seeks both vengeance and
self-preservation in three parts:
exact revenge on the Empire
for failing him, strike down the
Rebellion, and gather critical
resources in the Unknown
Regions to rebuild his Empire
ready for his eventual return.

Almost immediately
following Palpatine's demise,
sentinel messenger droids relay
his wishes to loyal Imperial
leaders. They conduct Operation:
Cinder, an attempt to punish
worlds like Abednedo, Naboo,
and Vardos using satellites that
ravage the ecological balance
of the target planet, although
Naboo is saved by the Rebellion.

Sidious' protégé, Gallius Rax,
is ordered to gather critical forces
in the Unknown Regions, while
the rest of the Imperial fleet is to
muster at Jakku. Grand Admiral
Rae Sloane undermines the plan
by killing Rax, and despite the
Imperial defeat at Jakku, she and
several select loyalists escape
to the Unknown Regions. They
are the seeds of the First Order
military, though even they do
not know of Sidious' ultimate
plan to cheat death at Exegol.

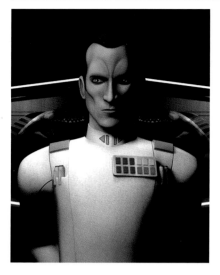

THE INTELLECTUAL
GRAND ADMIRAL THRAWN

HOLOCRON FILE

NAME
Mitth'raw'nuruodo (Thrawn)

SPECIES
Chiss

HOMEWORLD
Csilla

AFFILIATION
**Chiss Ascendency;
Empire**

FLAGSHIP
**Imperial Star Destroyer
*Chimaera***

STATUS REPORT
Missing in action

Mitth'raw'nuruodo, also known as Thrawn, is an atypical Imperial officer, not just because he is an alien and an outsider from the far reaches of the galaxy, but because of his unique approach to war and its politics. Rather than blind loyalty or unyielding ambition to attain more power, Thrawn's strength is his fierce intellect. Thanks to his ingenuity, he captures the attention of Darth Vader, Grand Moff Tarkin, and Emperor Palpatine, becoming one of the fastest rising Imperial officers. Thrawn is a student of war and culture. Through careful analysis of history and art, he gains personal insights into his enemies, which he can exploit in battle. In so many cases, this calculating leader seems to be at least one step ahead.

A member of the Chiss Ascendancy, a secretive government in the Unknown Regions, Thrawn is tasked with discovering if the Galactic Republic is a potential ally in its fight against a threat growing in its region of space. During an encounter with Jedi

Worthy opponent Thrawn carefully studies the history of his frequent enemy, rebel leader Hera Syndulla.

Knight Anakin Skywalker, Thrawn finds the Republic lacking. However, he is more impressed by its successor, the Galactic Empire, and joins the Imperial fleet, rising to become Grand Admiral.

Thrawn is acutely aware of the dangers a unified Rebel Alliance poses to the Empire and gives much thought to its defeat. While Grand Moff Tarkin and other Imperial officials put their faith in a single Death Star superweapon, Thrawn's analysis points to a different approach. He believes the TIE Defender project to be the superior platform to combat the rebel threat, believing a better-equipped TIE would wreak havoc on the Rebellion's prized starfighter squadrons. His appraisal is likely correct, considering one-man starfighters prove to be the downfall of the Death Star. In the end, Thrawn is not around to see the Death Star or the TIE Defender project through, as he is lost to an unplanned hyperspace jump at the Battle of Lothal. While his whereabouts aren't discovered, his knowledge of the Unknown Regions proves to be useful to the Imperials who flee at the end of the war to form the First Order. ∎

THE ARCHITECT
DIRECTOR ORSON KRENNIC

HOLOCRON FILE

NAME
Orson Krennic

SPECIES
Human

HOMEWORLD
Lexrul

AFFILIATION
Empire

AIM
Recognition for his leadership over the Death Star project

We were on the verge of greatness. We were this close to providing peace and security for the galaxy.
Director Krennic

The manipulative, ambitious Orson Krennic might seem perfectly suited for Imperial leadership. His unrelenting drive pushes him forward through his career to become the Director of the Imperial Military Department of Advanced Weapons Research, overseeing the construction of the Death Star. While secretly building a moon-sized battle station is a feat unto itself, the project truly hinges on the development of a planet-destroying armament. Kyber crystals could provide the basis for such a weapon, but harnessing the power requires the genius of scientist, and Krennic's old university friend, Galen Erso.

For a time, Krennic is able to manipulate Erso into applying his work to the research program, but the scientist flees upon learning of the project's ultimate goal. Krennic learns that ambition alone is not enough to complete the weapons, and he must press Erso back into service. In the process, the director orders Erso's wife killed and separates the scientist from his daughter, showing that he will to do whatever it takes to succeed.

Upon completing the weapon, Grand Moff Tarkin assumes control

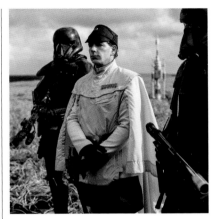

High-ranking officer As a critical member of the Empire, death troopers relentlessly guard Krennic.

of the station, citing delays and a lapse in security that threatens to reveal the station to the galaxy prematurely. Krennic is outraged that his triumph is so easily robbed and sets out to tie up all loose ends. In the end, Krennic's ambition is his downfall. He is so afraid of failure that he tries to take control of the situation personally. He is unable to stop the Rebel Alliance from stealing the Death Star's technical readout and is caught in a blast from the battle station, killed by his own greatest achievement. ∎

SEEDS OF REBELLION
EARLY REBEL FACTIONS

HOLOCRON FILE

NAME
Rebel cells

SPECIES
Mixed

NOTABLE EXAMPLES
Spectres; Phoenix Squadron; Massassi Group; Mon Calamari Exodus Fleet

AIM
Fall of the Empire

STATUS REPORT
Integrated into the Rebel Alliance

While the Empire faces resistance from the moment it is pronounced, early rebel cells do not yet reflect the full-fledged Rebel Alliance that ultimately wins the war. In those earliest years, the Empire succeeds in squashing smaller insurgencies, but when the splintered factions begin to unite, they pose a real threat to the Emperor's rule.

While these fledgling rebel cells all share the same ultimate goal, they have no central leadership or military structure. Bail and Breha Organa are among the first leaders to see the potential of uniting the smaller factions, but must work carefully not to attract the attention of the Empire before they can gather critical mass. The Organas use trusted agents who adopt the codename Fulcrum to identify and recruit individual cells into the burgeoning alliance. Former Jedi Ahsoka Tano and the intelligence officer Cassian Andor both use the codename. Among the recruited cells are Jun Sato's Phoenix Squadron and Hera Syndulla's Spectres, who operate as a small unit before being absorbed into the Massassi group led by Jan Dodonna from Yavin 4.

While the rebels aligned with Mon Mothma or Bail Organa take a principled approach to their rebellion, not all follow the same tactics. Saw Gerrera's Partisans use torture, assassination, and invasive interrogation on their enemies. In their ruthless attacks on Imperial operations, they ignore collateral damage, leading other cells to label them as violent extremists. Such tactics might do damage to parts of the Empire, but they also provide it with fodder for anti-rebel propaganda.

Family ties Despite differing approaches, Cham Syndulla and his daughter, Hera, both resist the Empire.

Saw Gerrera

Fierce, independent, and uncompromising, Saw Gerrera spends most of his life fighting tyrants and learns firsthand that rebellion is a dirty business. During the Clone Wars, he fights alongside his sister Steela to unseat a corrupt monarchy aligned with the Separatists. Steela's death during the uprising forever shapes Saw's approach to rebellion. As the Republic becomes the Empire, Saw refocuses his energies to fight the new dictatorship using whatever means necessary.

On Kashyyyk, he organizes a band of freedom fighters to disrupt the Empire and later arranges the bombing that kills Moff Panaka on Naboo. Saw relentlessly searches for clues on Geonosis in pursuit of an Imperial secret, sacrificing many of his own soldiers and betraying fellow rebels in the process. Saw's search eventually takes him to Jedha, where he and his Partisans attack cargo shipments. He learns that the secret he has been chasing is the Death Star, which targets the planet moments later. Though he dies that day, some of his Partisans continue the fight, carrying forward his hard-nosed, extremist tactics.

Cloud-Riders Enfys Nest takes up the mantle of rebellion after her mother dies.

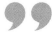

We're allies and the war has just begun.

Enfys Nest

Gerrera's experience teaches him that there are few rules when fighting a war. In that way, he has much in common with Cham Syndulla's Free Ryloth Movement. While Syndulla is a fanatical believer in the freedom of his own Twi'lek people, he has little interest in the wider rebellion. His severe tactics drive a rift between him and his daughter, Hera, who eventually convinces him that his cause is better served by supporting the Rebellion outside his own borders.

On the surface, the Cloud-Riders appear to be simple marauders, but their true motives are to fight back against those who oppress them. This diverse band works under the leadership of Enfys Nest, having endured suffering at the hands of cartels like Crimson Dawn. They know that the syndicates, in league with the Empire, must be stopped, so they band together to steal vital supplies to fund the Rebel Alliance.

The Mon Calamari people also endure suffering that inspires them to rebel. After a battle for their planet, the Empire's occupation of Mon Cala and imprisonment of their king leads to a mass exodus when Mon Calamari leaders launch their city ships into space. Underwater structures that had once been government buildings rise from the planet to join the rebel fleet and be refitted as military ships. This instant flotilla proves critical to the war effort in subsequent years. ∎

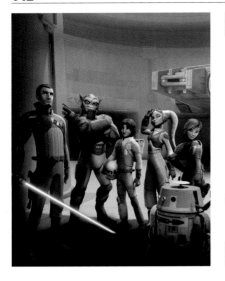

SPECTRE OF REBELLION
THE CREW OF THE GHOST

HOLOCRON FILE

MEMBERS
Hera Syndulla; Garazeb "Zeb" Orrelios; C1-10P "Chopper;" Sabine Wren; Ezra Bridger; Kanan Jarrus

SHIP
Ghost

MAIN BASE OF OPERATIONS
Lothal

AIM
Justice for the people of Lothal; end of the Empire

The crew of the *Ghost*, a small band of rebellious individuals who call themselves the Spectres, are all united by their desire to make things right. They're a diverse group from different corners of the galaxy whose struggles form them into an unlikely family.

Hera Syndulla is more than just the pilot and owner of the *Ghost*; she is the team's leader whose vision and grace under pressure holds them together as dangers and tensions rise. The daughter of Twi'lek freedom-fighter Cham Syndulla, Hera knows what's at stake when fighting against oppressors who forcibly occupy a planet.

Zeb Orrelios, a Lasat, provides the crew's muscle. His people's seeming destruction at the hands of the Empire inspires him to fight back as the last of the Lasat. Mandalorian, artist, and explosives expert Sabine Wren is haunted by her past. Before joining the Spectres, she unknowingly creates a weapon for the Empire that can be used to specifically target her people's armor and incinerate the wearer. Sabine's missteps see her banished from her home. The cantankerous astromech, Chopper, or C1-10P, is an older model that once served in the Republic. While he is more troublesome than any droid should be, he is ultimately loyal and trustworthy. Along with Jedi survivor Kanan Jarrus and his newfound Padawan, Lothalite Ezra Bridger, each of the Spectres has reason to rebel.

Rebels rising
Their struggle against the Empire is modest at first, focusing on fighting injustices on Lothal. While Hera is secretly communicating with the mysterious agent Fulcrum, aka former Jedi Ahsoka Tano, the rest of the crew are unaware that they are connected to a wider, embryonic rebel movement. Raiding supply convoys attracts the attention of the Imperial Security Bureau (ISB) and one of its agents, Alexsandr Kallus. They manage to evade him, but the presence of Kanan and Ezra draws the attention of the Empire's Inquisitors—fallen Jedi who now hunt their former brethren—and eventually Imperial Grand Moff Tarkin. When Tarkin captures Kanan, the Spectres launch a rescue and are assisted by fellow rebels.

The rest of the crew realize that their fight isn't just a personal one. They now have a role to play

Whatever it takes, this Rebellion is worth it.
Hera Syndulla

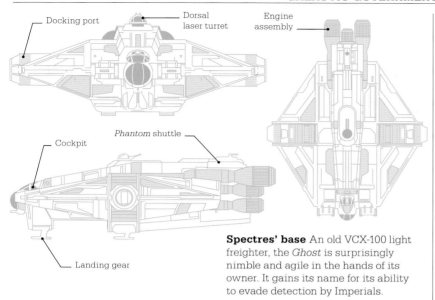

Docking port

Dorsal
laser turret

Engine
assembly

Phantom shuttle

Cockpit

Landing gear

Spectres' base An old VCX-100 light freighter, the *Ghost* is surprisingly nimble and agile in the hands of its owner. It gains its name for its ability to evade detection by Imperials.

in the galactic struggle against tyranny. Their efforts attract the attention of Darth Vader, who besieges Lothal. Forced to flee their home, the Spectres join a rebel cell called Phoenix Squadron and turn their attention toward other worlds, such as Ibaar and Garel. They are even entrusted with a vital mission: transporting rebel Senator Mon Mothma to the planet Dantooine. From the *Ghost*'s cockpit, the inspiring leader formally announces the birth of the Rebel Alliance.

By the time the crew return to Lothal, they find the situation has deteriorated even further in their absence. Led by the cunning Grand Admiral Thrawn, Imperials strip the planet of its resources and press its people into servitude to fuel the growing war machine. With the support of the Alliance, the Spectres launch a final attack to free Lothal, breaking the Imperial grip on the planet. The victory is not without its costs, as Kanan gives his life to save his family, and Ezra is lost in space.

Family portrait Created by Sabine, this mural of the *Ghost* crew adorns a wall in Ezra's old home on Lothal.

A lifetime of service
Though the Spectres came together as individuals, it's their commitment to others that is their lasting legacy. With Lothal liberated, Hera, Zeb, and Chopper continue to serve the Rebellion for years to come. Hera flies the *Ghost* at the Battle of Scarif and the Battle of Endor. She also raises her and Kanan's son, Jacen. After the war's end, Zeb leads Lasat survivors to a new homeworld. To honor Ezra, Sabine remains behind to protect Lothal until the Empire falls. She then joins Ahsoka in her search for their wayward friend. ■

Blade Wing

Desperate to break the Imperial blockade of Ibaar, Hera undertakes a high-stakes mission to Shantipole. There, a Mon Calamari named Quarrie has developed a heavily armed fighter prototype called the Blade Wing. This fighter gives the rebels the edge they need to save Ibaar, but it falls to Hera's piloting skills to convince the reluctant engineer to hand over his ship. With Hera at the controls, the well-armed and agile craft lives up to expectations.

After Hera defeats the blockade, the proud designer is so impressed with her flying that he agrees to aid the rebels in the mass production of his prototype. Thanks to Quarrie and Hera, the B-wing becomes a vital part of the Alliance fleet. Later models serve the Resistance, including at the Battle of Exegol.

AGAINST ALL ODDS
THE REBEL ALLIANCE

HOLOCRON FILE

NAME
The Rebel Alliance

HEADQUARTERS
**Various hidden bases
including Yavin 4**

AIM
**Defy the Empire to
restore democracy**

STATUS REPORT
Victorious

From humble beginnings, the Rebel Alliance grows into a political and military faction so well organized and equipped that it becomes the greatest hope for restoring democracy to the galaxy. Through much of the ensuing war, the Empire is confident of its power and consistently underestimates the capabilities and resolve of the Alliance, whose members are willing to risk everything for freedom. Despite a series of trying events, they secure victories against all odds, thanks to a handful of individuals who turn the tide.

Much of the Rebellion's success hinges on the actions of a few notable heroes. At the Battle of Scarif, Jyn Erso and her team—known as Rogue One—succeed in a risky mission to infiltrate a secure Imperial records facility on Scarif to steal the plans to the Death Star. Through teamwork they succeed, though the team sacrifice their lives. Their bravery allows Princess Leia Organa to deliver the plans to the Rebel Alliance in R2-D2's memory bank. But the Rebellion is not always so lucky. Losses at Vrogas Vas, Mako-Ta, and Hoth are a reminder that the Rebels are regularly outgunned and outnumbered.

Through carefully managing its resources and steady recruitment, the Alliance executes a crucial strike at the Battle of Endor. It throws everything it has at the second Death Star in an attempt to take down the new battle station—

Rebel starbird The Rebel Alliance's insignia becomes synonymous with freedom and resistance to oppression.

and the Emperor with it. Thanks to the bravery of Leia, Luke Skywalker, Han Solo, Lando Calrissian, and many others, the Rebels pull off a momentous victory that sparks a galaxy-wide celebration. The Alliance now stands a chance of restoring democracy, rallying more support in the leadup to the final battle against the Empire at Jakku. There, the Alliance wages a climactic battle that cripples

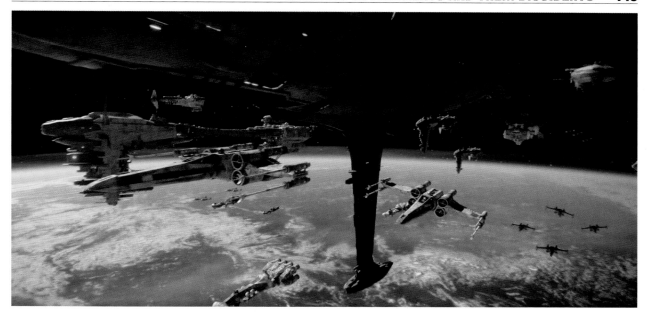

> You are part of the Rebel Alliance and a traitor. Take her away!
>
> **Darth Vader to Leia Organa**

the Imperial fleet, making way for decades of peace.

Strong leadership

The Rebel Alliance's victory on Endor is the culmination of years of careful organizing and strategizing. Multiple rebel factions have been united into a single Alliance with shared goals and command structure. Overseeing the Rebellion is the Alliance High Command and its foremost leader, Mon Mothma. Senator Bail Organa is an instrumental partner until his

Rebel fleet The Alliance fleet gathers at Scarif, led by Admiral Raddus on the flagship, *Profundity*.

death, at which point his daughter, Princess Leia, steps into an even larger role. The council hosts both political and high-ranking military leaders, such as General Jan Dodonna and Admirals Raddus and Ackbar. They provide vital guidance as the fleet grows and squadrons are formed.

As the war draws to a close, Mon Mothma works hard to ensure »

Rise of the Rebellion

2 BSW4
Alliance Unified
Senator Mon Mothma announces the formation of the Alliance to Restore the Republic.

0 SW4
Battle of Yavin
The destruction of the Death Star is a major victory, but puts the Rebellion on the run looking for a new base.

3 ASW4
Battle of Hoth
The Rebels retreat from their hidden base on Hoth, under siege from Darth Vader.

4 ASW4
New Allies
The Rebellion grows after Palpatine's defeat as new supporters join and Imperials defect.

0 BSW4
Liberation of Lothal
Rallying to the aide of the Spectres, the Rebels oust the Empire from the Outer Rim world of Lothal.

0 BSW4
Rogue One The Alliance debates a large-scale strike against the Empire. The Battle of Scarif is its first significant victory.

4 ASW4
Bothan Spies Rebel spies deliver information about a new Death Star and Palpatine's presence there.

5 ASW4
New Republic The Imperial fleet is defeated at Jakku and the New Republic is officially formed.

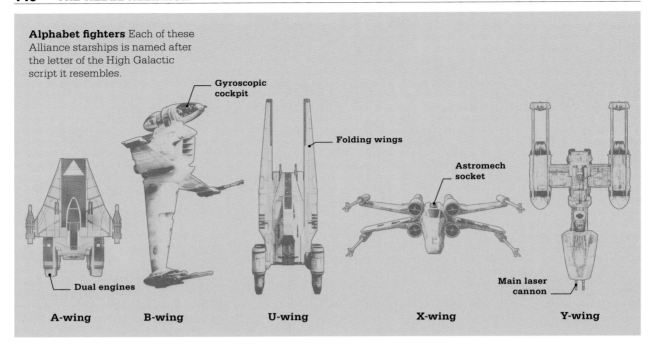

Alphabet fighters Each of these Alliance starships is named after the letter of the High Galactic script it resembles.

Gyroscopic cockpit

Folding wings

Astromech socket

Dual engines

Main laser cannon

A-wing **B-wing** **U-wing** **X-wing** **Y-wing**

that the Rebellion follows through with its goal to restore the Republic. She rightly fears the organization becoming the tyrannical rulers that they are trying to destroy, and endeavors to ensure a smooth transition. While the Rebels share an unwavering determination to prevail, they wish to do so without collateral damage, reprisals, or war crimes. These values live on with the formation of the Resistance three decades later, where once again a small band of rebels find themselves outnumbered by the successor to the Empire.

Though the Rebel Alliance's ultimate aim is to restore peace to the galaxy, it believes waging war against the Empire to be a necessity. The Alliance maintains a number of strike teams, pathfinder regiments, extraction squads, and infantry companies to combat its enemies on the ground. Its soldiers come in the form of individual recruits or security details from sympathetic worlds like Alderaan. They may be willing, but these

soldiers can never achieve the uniformity found in the Empire's stormtrooper corps.

The Alliance spends much of its limited resources on building and maintaining its starfighter squadrons. While the Y-wing is an older craft model left over from the Clone Wars, the X-wing is a modern starfighter that can outperform

Everything I did, I did for the Rebellion, and every time I walked away from something I wanted to forget, I told myself it was for a cause I believed in.
Cassian Andor

virtually all Imperial counterparts. Armed with four cannons, torpedo tubes, and an astromech droid, the X-wing gives the Rebellion's limited pool of volunteer pilots many technological advantages over their Imperial contemporaries. Alongside speedy A-wings, heavily armed B-wings, and versatile U-wings, the Rebellion relies heavily on its fighter squadrons.

As the Alliance attempts to stay one step ahead of the Empire, it employs a number of blockade runners, frigates, and transport craft to remain mobile. Mon Calamari cruisers, recruited to the Rebel cause after Imperial crackdowns on their home planet, serve as capital ships and mobile command centers for much of the war. Mon Cal volunteers prove to be a vital part of the Navy, both as senior officers and crew. In the final months of the war, the Nadiri Dockyards turn the Empire's own weapons against it by reconstructing Imperial Star Destroyers into formidable

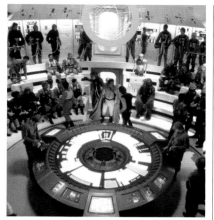

Mobile command Frequently on the run, the Alliance uses Admiral Ackbar's flagship, *Home One*, as a mobile command center.

Starhawk-class battleships, providing the Rebel fleet with a level of firepower it had not possessed early in the conflict.

Spies and intelligence

As it will never have a numerical advantage over the Empire, the Rebellion depends on a network of spies, intelligence officers, and sympathetic allies. Working in the shadows, they help identify new rebel cells, prevent Imperial detection, and determine viable targets. Leaders like General Cracken and General Draven oversee operatives across the galaxy, aiding them to avoid detection at all costs. The nature of their work is often messy and leaves little room for idealism, making the best field operatives the ones who are willing to do whatever it takes to succeed. Cassian Andor is one such officer. His work before the Battle of Yavin is critical to the discovery of the existence of the Death Star, but it requires him to take steps he would rather not. Spying is a dangerous game, certainly for the Bothans who provide the intelligence that leads to the Battle of Endor. Their knowledge of the location of the Death Star II and Palpatine's presence there is essential, but many give their lives.

Deception is a practical strategy for the Alliance. During Operation Yellow Moon, the Rebels exploit the high profile of Leia Organa to distract the Empire from the Rebel fleet assembling before the Battle of Endor. The Empire turns its attention to Organa, unaware that she is a decoy. The Alliance also regularly makes use of stolen Imperial transponder codes and stolen vehicles such as at the Battles of Scarif and Endor.

A generation after the Rebellion's war ends, its values, tactics, technology, and bases provide the foundation for the Resistance. Leia Organa's past experiences prepare her to stand up to the First Order. ∎

Heroes of the Rebellion Luke Skywalker, Chewbacca, and Han Solo are recognized for their heroics at the Battle of Yavin.

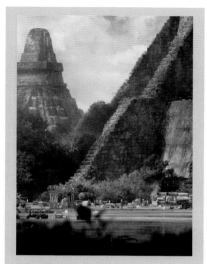

Hidden bases

The Rebel Alliance ensures its survival by utilizing hidden bases on remote planets. Because building is both unaffordable and impractical due to the Alliance's frequent relocation, it instead makes use of existing structures. On Yavin 4, the rebels move into the ancient Massassi temple, which provides enough space for a proper command center, crew quarters, and starfighter hangar. On Hoth, Echo Base is dug out of the existing underground ice caves, expanding upon what little already exists on the desolate snow planet.

Aside from these larger bases, the Rebellion establishes smaller outposts on Tierfon, Horox III, and Crait amongst others. The abandoned site on Crait proves useful three decades later when the Resistance attempts to outrun the First Order. The Resistance also continues the Rebellion's legacy of using hidden bases at D'Qar and Ajan Kloss.

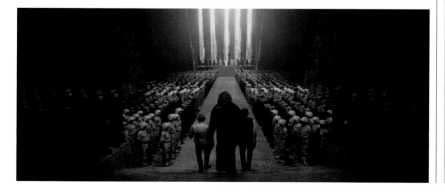

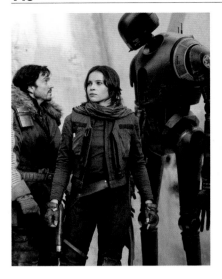

REBELS RISING
ROGUE ONE

HOLOCRON FILE

MEMBERS
**Jyn Erso; Cassian Andor;
Chirrut Îmwe; Baze Malbus;
Bodhi Rook; K-2SO**

SPECIES
Human (except K-2SO)

AFFILIATION
Rebel Alliance

AIM
**Stealing the technical
readouts to the Death Star**

STATUS REPORT
Killed in action on Scarif

I n the galactic struggle against the forces of tyranny, the Rebel Alliance finds hope in unexpected places. After chasing mysterious activity for years, Rebel intelligence learns that rumors of an Imperial superweapon are true. Named the Death Star, this technological marvel has not only enough power to destroy a planet—it could wipe out the burgeoning Rebellion in short order. An Imperial defector has more information on the superweapon and was sent by a person named Erso. Believing this Erso to be none other than Imperial scientist Dr. Galen Erso, the Alliance finds his dissident daughter, Jyn Erso, hoping she might be able to assist them.

A former child soldier, Cassian Andor knows conflict from a young age. In his twenties, Cassian defies the Republic's successor, the Galactic Empire, by joining the Rebels and rising to the rank of Captain. As part of Rebel Intelligence, he operates on the fringes alongside his reprogrammed Imperial droid, K-2SO. While the droid's personality has been reprogrammed, his Imperial appearance allows him to blend in. K-2SO helps rescue Jyn Erso from Imperial captivity. While Jyn has little desire to join a larger rebellion, she must help them if she wants to reconnect with her father.

The vital intelligence that they seek comes from an unexpected ally: an Imperial cargo pilot named Bodhi Rook. The pilot's assignment has him transporting kyber crystals from his homeworld, Jedha, to the Imperial research labs on Eadu, making him complicit in the pillaging of Jedha. He defects due to the influence of Galen Erso.

Now on Jedha, Jyn, Andor, and K-2SO cross paths with two former Guardians of the Whills, Chirrut Îmwe and Baze Malbus. Once the protectors of Jedha's most holy site, the pair remain committed friends in these dark times, though they have grown apart ideologically. Îmwe maintains his stout belief in the Force, while Baze becomes stubbornly pragmatic.

Death Star gambit
During the mission to Jedha, Jyn learns that her father has designed a weakness into the Death Star's plans. Jyn, always hopeful that her

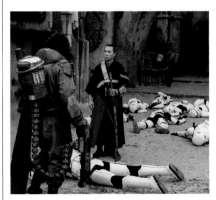

Guardians When all hope looks lost, Baze and Chirrut rescue Jyn and Cassian from an Imperial patrol.

Rogue operative

Jyn Erso is not born into a life of Rebellion. The daughter of scientists Galen and Lyra Erso, her early childhood is a happy one. But as a child, she is unaware of the pressure put on her father by the Empire. Galen attempts to take his family into hiding, living a quiet life as farmers.

After their hideout is discovered, Jyn is left alone. A longtime family friend, Saw Gerrera, takes Jyn into his band of rebels, called the Partisans, where she grows up among fugitives. By the age of 16, some of her fellow fighters begin to suspect who she is, forcing Gerrera to abandon her on a mission to Tamsye Prime. This betrayal leaves Jyn to survive on her own, relying on a deep-seeded rebellious streak that puts her on the wrong side of Imperial law. By the time the Rebel Alliance finds her, she is wanted for multiple crimes, is serving a sentence of hard labor at an Imperial labor camp on Wobani, and holds little hope for the future.

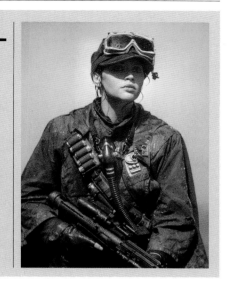

father hadn't fully turned to the Imperial cause, urges Alliance leadership to make a bold strike to retrieve the station's plans from an Imperial base on Scarif for further analysis. Unwilling to risk open war with the Empire and doubting Jyn's information, the council initially refuses the gambit, but her impassioned message of hope inspires Admiral Raddus to deploy his fleet in support of Jyn's unsanctioned covert mission. With her newfound allies by her side and using the code name Rogue One, these unlikely rebels infiltrate the seemingly impenetrable Imperial world of Scarif.

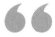

> **"** I'm one with the Force, the Force is with me.
> **Chirrut Îmwe**
> **"**

While Rogue One is the Rebellion's best hope, the odds are against its members. Gaining access to the plans requires a sufficient distraction outside the Citadel, one that ultimately takes the self-sacrifice of Chirrut, Baze, Bodhi, and their outnumbered strike team of Rebel commandos. As Jyn and Cassian gain access to the all-important data tapes, K-2SO makes a similar sacrifice to hold off the Imperial guards. Jyn transmits the vital plans to the Rebel fleet above, but she and the rest of the troops cannot escape before the Death Star enters Scarif's orbit and promptly obliterates the planet's surface.

The sacrifices aren't made in vain. Jyn's transmission makes its way into the hands of a hopeful Princess Leia Organa, and eventually back to Rebel command at Yavin 4. Even with the peril of a planet-killing superweapon at large and the sacrifice of many brave Rebels, Rogue One's bold plan gives the Rebellion more than just the technical readouts to the station; it gives the Alliance its best hope that it might one day restore freedom to the galaxy. ■

Path of the plans
During the Battle of Scarif, Rebel ingenuity is necessary to transmit the plans from the Citadel's data vaults.

Rogue One infiltrates the citadel tower and locate the Death Star schematics.

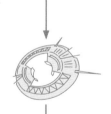

Rebel Alliance navy destroys the Imperial shield gate above, allowing the newly acquired data to be transmitted to orbit.

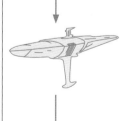

Admiral Raddus' flagship, *Profundity*, receives the data. Rebel soldiers download the plans and pass them to the docked *Tantive IV*.

Princess Leia Organa escapes with the plans aboard *Tantive IV*.

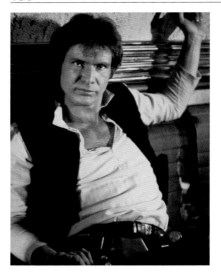

STAR PILOT
HAN SOLO

HOLOCRON FILE

NAME
Han Solo (last name adopted during escape from Corellia)

SPECIES
Human

HOMEWORLD
Corellia

AFFILIATION
Rebel Alliance; Resistance

ABILITIES
Piloting; playing sabacc

SHIP
Millennium Falcon

FAMILY
Leia Organa (spouse); Ben Solo (son)

O n the surface, Han Solo might seem like a self-interested smuggler, but his history as a scrumrat, legendary pilot, rebel general, and finally Resistance fighter suggests that this scoundrel cares more than he lets on. Orphaned at a young age on Corellia, he lives as child thief and con artist in the White Worms gang.

Han is often in over his head and eventually gets caught playing both sides in a negotiation and stealing valuable hyperfuel. With his partner-in-crime, Qi'ra, Han attempts to flee by bribing his way offworld. The ruse fails, forcing Han to abandon Qi'ra and enlist in the Imperial Navy.

Though Han's skills as a pilot are unquestionable, he never truly believes in the Imperial cause and gets creative with orders. As punishment, he is transferred to the infantry where he fights on Mimban. Empathizing with the local militia and fed up with the Empire, Han defects, joining a crew of scoundrels with a newfound Wookiee ally Chewbacca, aka Chewie.

Led by the experienced rogue Tobias Beckett, the group works for the infamous criminal syndicate Crimson Dawn. Han wants to see himself like Beckett—mercenary and cavalier—but reuniting with Qi'ra, now a Crimson Dawn lieutenant, proves that Han still cares for others. To make up for a botched heist, Beckett, Solo, and the rest plan a mission to steal unrefined coaxium hyperfuel from the planet Kessel. Qi'ra joins their crew at the behest of crime boss Dryden Vos, and

promptly recruits flashy smuggler Lando Calrissian.

When the mission goes awry, it's up to Han to pilot the crew's ship, Lando's *Millennium Falcon*, on a record-breaking Kessel Run. Before handing the fuel over, Han learns that the criminal coaxium trade inflicts suffering on innocents, so has a change of heart and offers the fuel to a band of rebels. This act ultimately leads to Beckett betraying him. After being forced to kill Beckett in a standoff, Han is abandoned by Qi'ra, leaving him and Chewie to start anew.

Smuggler and rebel
After winning the *Falcon* from Lando in a game of sabacc, Han embraces a smuggler's life alongside his copilot Chewie and frequently works for crime lord Jabba the Hutt. Years later on Tatooine, Han negotiates a private charter to Alderaan, thinking that transporting Ben Kenobi, Luke Skywalker, and some droids will be enough to pay off his debts to Jabba. Little does Han know that these passengers will change his life. When they are all captured by the Empire, Han helps them rescue Rebel Alliance leader Leia Organa and escape.

Captain Solo

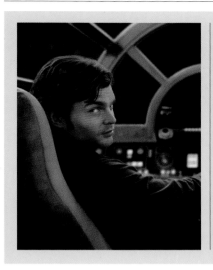

Han Solo is many things, but foremost he is a pilot. Having honed his skills on Coruscant and flown Imperial ships as a cadet, he is confident behind the stick of almost any craft.

On a mission to Kessel, he becomes enamored of Lando Calrissian's *Millennium Falcon*. It's on that fateful journey that he takes the captain's seat for the first time, successfully surviving a life-threatening passage through the maelstrom that surrounds the planet. He gambles away his meager earnings from that job to win the ship in a hand of the card game sabacc. Over the years, Han modifies the vessel to match his own personality and needs. Rough around the edges and always in need of repair, the *Falcon* is one of the fastest ships in the galaxy. It, like Solo, becomes a legendary icon of the Rebellion whose exploits take on a life of their own.

Having received a handsome reward for his efforts, Han later returns to fight the Empire during the Battle of Yavin, becoming a rebel hero. Han insists that he isn't part of the cause, but nevertheless joins many Alliance missions. Yet Han is never far from his old life, taking smuggling jobs or entering dangerous starship races.

After fleeing the Battle of Hoth with Leia and Chewie in a damaged *Falcon*, Han decides to visit his old friend Lando on Cloud City to repair his ship. When the Empire is already there and captures the rebels, Han misreads the situation, unaware that Lando has no choice but to hand them over. Encased in carbonite by Darth Vader, Han is

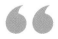

You know, sometimes I amaze even myself.

Han Solo

then delivered to Jabba by bounty hunter Boba Fett. Han is rescued by his friends, at which point he becomes more dedicated to the rebels' plight and is promoted to general. Tasked with leading the ground attack during the Battle of Endor, Solo's scoundrel wits serve him well as he tricks the Imperial garrison into a mistake that is critical to the rebel victory.

Following the Battle of Endor, Han and Leia marry and have a child, named Ben Solo. The youngling shows incredible potential as a Jedi and is trained by his uncle—Jedi Master Luke Skywalker. But Ben is also a troubled youth. Manipulated by sinister figures, Ben turns to the dark side of the Force and destroys Luke's Jedi Order. Now known as Kylo Ren, Ben's horrific actions cause a rift in Han and Leia's marriage. Feeling guilty, Han flees and returns to a smuggler's life alongside Chewie.

By the time of the First Order's rise to power, Han has lost the *Falcon* and is on the run from his debts. When he once again finds the *Falcon*, with it he discovers the scavenger Rey. The elder smuggler takes her under his wing. When Rey is captured by the First Order, Han leads the Resistance ground strike on the superweapon Starkiller Base to rescue her and destroy the installation. The mission brings him face to face with his estranged son, whom Han tries to persuade to come home. Han's attempt fails as Kylo strikes down his father, ending the life of one of the galaxy's most improbable yet greatest heroes. ∎

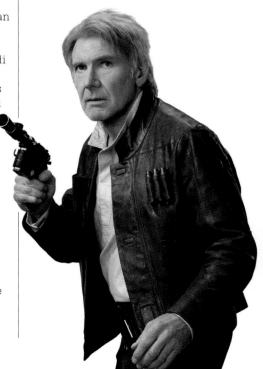

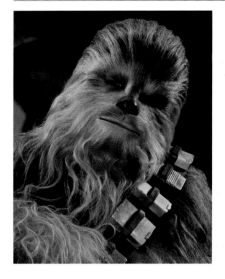

STANDING TALL
CHEWBACCA

HOLOCRON FILE

NAME
Chewbacca aka "Chewie"

SPECIES
Wookiee

HOMEWORLD
Kashyyyk

AFFILIATION
Republic; Rebel Alliance; Resistance

AGE
230+ years at the time of the Starkiller Incident

It's not wise to upset a Wookiee.
Han Solo

Some know him as a rebel and others as a smuggler. He's been a tribe member, Republic warrior, slave, mechanic, pilot, husband, father, and friend. In his more than 200 years of life, Chewbacca has been many things to many beings. No matter the role he plays at any given point, there is seemingly always more to this Wookiee than meets the eye.

Born on his species' homeworld of Kashyyyk two centuries before the formation of the Rebel Alliance, Chewbacca lives a proud existence marked by periods of strife and pain.

During the Clone Wars, he is captured by a band of Trandoshan hunters and sent to Wasskah to serve as live prey. The Trandoshans underestimate the noble Wookiee, who teams up with a group of Jedi Padawans to evade their hunters. Chewbacca surprises the Jedi with his technological skills by fixing a transmitter that leads to their rescue. Later in the Clone Wars, he defends his homeworld from

Meeting on Mimban Both prisoners, Chewie and Han Solo's legendary partnership starts in a mud pit.

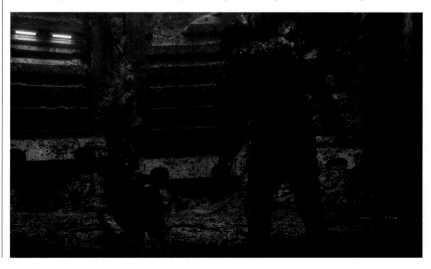

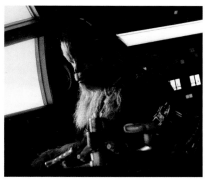

Natural flyer Chewie, a natural pilot, is quite content to be the copilot aboard the *Millennium Falcon*.

Separatist invasion. Chewbacca works alongside some of the most prominent galactic figures of this era, the Wookiee Chief Tarfful and Jedi Master Yoda—whom Chewie helps escape Order 66.

The fall of the Republic brings anguish upon the Wookiees, who toil as slaves under the occupation of the Empire. Chewbacca finds himself an Imperial prisoner on Mimban, where he is thought to be little more than a ferocious beast caged in a muddy pit. He partners with reluctant Imperial Han Solo to stage a clever escape, allowing them to flee captivity with a crew of scoundrels. During their mission to Kessel, Chewbacca exhibits his skills as a pilot, surprising the crew by stepping into the copilot chair of the *Millennium Falcon* during its famed Kessel Run. The mission forges a lasting bond between Chewie and Solo, who stick together for decades to come. They begin work as smugglers, including employment for the infamous gangster Jabba the Hutt and famed relic hunter Dok-Ondar.

Making a rebel

Chewbacca's days as a smuggler don't last, thanks to a fateful mission to Alderaan with Ben Kenobi and his mentee, Luke Skywalker. When he and Han finally deliver them, along with Princess Leia Organa, to the Rebel Alliance for a steep reward, it's Chewbacca who urges Han to help at the ensuing Battle of Yavin. This heroic Wookiee always wants to help a fellow underdog, and he continues to serve the Rebel Alliance until the declaration of the New Republic. At this point, Chewie returns to his homeworld to help free the planet from the brutal grasp of Grand Moff Lozen Tolruck. The mighty Wookiee commandeers the Star Destroyer *Dominion*, using its weapons to force the Empire to surrender. Afterward, Chewie reunites with his freed family—his wife Mallatobuck and their son Lumpawaroo—but he still joins Han on the occasional adventure.

Age of Resistance

Decades after the fall of the Empire, Han and Chewbacca return to their life as smugglers. Chewie stays by Han's side, even after a series of bad business deals and the loss of the *Falcon*. The rediscovery of their beloved ship soon brings the pair back into a war alongside Leia against a new threat—the First Order. Soon after, Chewie has to deal with the devastating loss of Han, but he gains a new ally in the aspiring Jedi Rey. He accompanies her as her copilot to the planet Ahch-To to find Luke Skywalker. Afterward, Chewie and Rey join the Battle of Crait, saving a scant number of individuals that comprise Organa's Resistance.

In the following year, Chewie helps rebuild the group. Just prior to the Battle of Exegol, he works with old ally Lando to rally a fleet to back up the Resistance. Without these critical reinforcements, it would have lost the battle. Of all the heroes that have become legends in galactic history, few can be counted as more savvy, loyal, or compassionate than Chewbacca. ∎

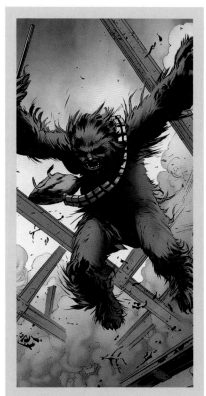

Brave warrior

Standing 2.3 meters (7 ½ feet) tall and possessing famous Wookiee strength, Chewie is a capable warrior and veteran of many conflicts. The Rebel Alliance puts his expertise—and muscle—to use on many occasions. After crash landing on Andelm IV alone, he fights alongside local miners against oppression. His fight for subjugated beings continues later on Cymoon 1, where he helps free the slaves powering one of the Empire's vital factories. His role in the capture of the Imperial Star Destroyer *Harbinger* brings him up against an elite stormtrooper from Task Force 99, ending in a hand-to-hand fight to the death.

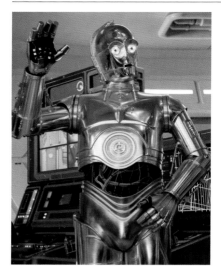

POLISHED BRAVERY
C-3PO

HOLOCRON FILE

NAME
C-3PO

TYPE
Protocol droid

MANUFACTURER
Anakin Skywalker

AFFILIATION
Republic; Rebel Alliance; Resistance

PRIMARY FUNCTION
Speaks and translates more than 7,000,000 forms of communication

Throughout his half century of faithful service to the Republic, the Rebellion, and later the Resistance, C-3PO proves that bravery comes in many forms. While not programmed for heroism or outfitted for adventure, this gold-plated protocol droid finds plenty of both.

As an assistant to Senator Padmé Amidala throughout the Clone Wars, C-3PO often finds himself in dangerous situations.

He works with Representative Jar Jar Binks on Rodia providing a much-needed sense of calm around the calamitous Gungan, and valiantly survives capture by the Separatists. While on a mission to Aleen, he saves the Mid Rim planet from a natural disaster that threatens to destroy it.

In service to the Rebellion, he gallantly joins R2-D2 in an escape pod to Tatooine to deliver a secret message to Obi Wan Kenobi, and his quick thinking saves the duo from Imperial capture in Mos Eisley. While on the Death Star, C-3PO's creative lies allow the pair to escape again when they are discovered by a stormtrooper. He later serves General Leia Organa, organizing a spy ring of droids who provide critical intelligence to the Resistance, including the location of Han Solo, Rey, Finn, and BB-8 on Takodana.

Translator
Etiquette and protocol have little use on a battlefield, but C-3PO's ability to translate over seven million languages proves to be a crucial addition to the cause of the Rebellion. He communicates with the *Millennium Falcon*'s computer to make repairs to the ship after the Battle of Hoth, translates Huttese during the rescue of Han Solo from crime lord Jabba the Hutt, and deciphers the Ewok's unique dialect when the rebels arrive on the Forest Moon of Endor, saving his friends from becoming the main course of a celebration feast.

When Rey finds a Sith relic on Pasaana that could lead to a vital clue about the hidden planet Exegol, 3PO is able to decipher the ancient text inscribed upon it. Unfortunately, his programming prevents him from sharing the script. Knowing that it will result in a memory wipe, C-3PO bravely agrees to an operation by a droidsmith so the mission can be a success—a courageousness which cannot be denied. ∎

We're doomed!
C-3PO

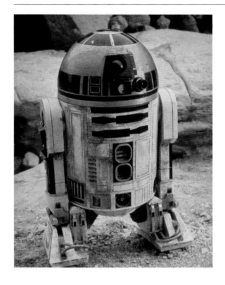

HABITUAL HERO
R2-D2

HOLOCRON FILE

NAME
R2-D2

TYPE
Astromech droid

AFFILIATION
Royal House of Naboo; Republic; Rebel Alliance; Resistance

NOTABLE APPENDAGES
Data probes; utility arms; scanning arrays; holoprojectors; rocket thrusters

Astromech droids are designed to be adaptable assistants and no matter the situation, R2 always seems to be the right droid for the job. Perhaps because he has never had a full memory wipe, the industrious droid frequently saves the day by using one of his many tools in a clever way to help out a friend in need.

R2-D2 begins his service life aboard Queen Amidala's royal starship. During an attempt to break through the Trade Federation's planetary blockade, he is called on to fix the ship's shield generator. The deed saves the entire crew, including the queen herself, and is only the first time he heroically serves royalty.

Decades later, Princess Leia calls on the droid to carry the stolen Death Star plans to Obi-Wan Kenobi. It is on this mission that his quick thinking saves the princess and her companions from being crushed to death in a trash compactor. During the rise of the First Order, he remains by Leia's side. After a period of semi-retirement, R2-D2 powers up in time to share a vital starchart that leads the Resistance to Luke Skywalker.

Jedi companion

Across multiple generations, R2-D2 serves by the side of great Jedi. He accompanies Padawan Anakin Skywalker to Geonosis at the outbreak of the Clone Wars, sticking with him through Knighthood and most of the war. At the Battle of Coruscant, R2 cleverly combats battle droids to save Anakin and Obi-Wan Kenobi on their mission to rescue the Republic Chancellor. He is the personal droid of Luke Skywalker during the Galactic Civil War and beyond, fixing the *Millennium Falcon*'s hyperdrive at Cloud City to allow his rebel friends to escape Darth Vader.

Many years later, R2-D2 persuades his old master to train Rey in the ways of the Jedi by replaying an old message stored deep in his memory banks: the hologram of Princess Leia saying, "…You're my only hope," convinces Luke to give Rey a chance, forging a future for the Jedi in the galaxy. ∎

Jet-setter R2-D2 has rocket boosters built into his legs but they are damaged at some point after the Clone Wars.

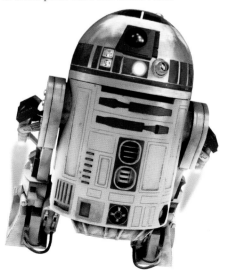

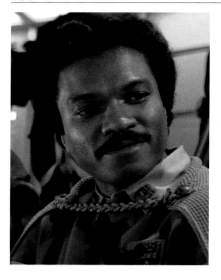

HERO BUSINESS
LANDO CALRISSIAN

HOLOCRON FILE

NAME
Landonis Balthazar Calrissian

SPECIES
Human

HOMEWORLD
Socorro

AFFILIATION
Independent; Rebel Alliance; Resistance

OCCUPATION
Entrepreneur; Baron Administrator; hermit

ABILITIES
Charisma; style; schemes

From his beginnings as a pilot to his triumph at Exegol, Lando Calrissian's life is a series of gambles. Even though some hands don't go his way, those who bet on this smooth-talking sabacc player learn that good fortunes never elude Lando for long. That's because this serial entrepreneur has a knack for making his own luck and always finds a way back in the game.

As a younger man, Lando makes a living as a smuggler and captain for hire aboard his pride and joy, the *Millennium Falcon*, a Corellian freighter that he heavily modifies to reflect his own refined tastes. He can recount tales of adventure on Felucia, exploits in the Rafa system, run-ins with the notorious bounty hunter Aurra Sing, and raiding the sacred temple of Sharu to name a few. Though he attempts to retire from the more dangerous gigs, a job hauling weapons to Kullgroon lands his prized ship in Imperial impound, leaving him little choice but to accept a job from Qi'ra of the criminal gang Crimson Dawn. She and a scoundrel crew, including Han Solo and Chewbacca, seek transportation to the Kessel system. After the trip nearly destroys his beloved ship and facing even more trouble on Savareen, Lando decides to fold his hand, abandoning the rest of the crew. Lando's luck fully runs out when he loses the *Falcon* to Solo in a sabacc game.

Galactic entrepreneur

The loss of his favorite ship does not slow him down for long, as Lando finds ever more creative ways of making credits. From smuggling puffer pigs on Lothal to dealing in military-grade hardware, he always has a card up his sleeve. These small jobs pale in comparison to Lando's ultimate commercial pursuit as the Baron Administrator of Cloud City, a beautiful mining colony hovering in the upper atmosphere of the gas giant Bespin.

Hunk of junk
Ever since Lando first set his eyes on the *Millennium Falcon*, the ship has been upgraded and modified many times.

Auxiliary ship between mandibles

Extensive damage

Lando's *Falcon*

Post-Kessel Run *Falcon*

Han's *Falcon*

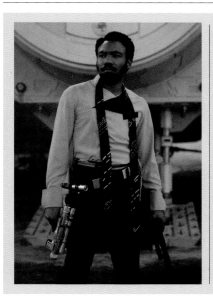

Lando's associates

Through the decades, Lando forms long-standing partnerships with a few close allies whose trust in Calrissian brings with it both triumph and tragedy. While owning the *Falcon*, Lando's copilot is the droid L3-37. This "self-made" automaton is independent, resourceful, and possesses unparalleled navigational skills. After inspiring a droid uprising on Kessel, L3 is hit by blaster fire. Lando uploads L3's programming into the *Falcon*'s own computer, allowing the crew to navigate a record-breaking Kessel Run.

Lando also partners with a cybernetically enhanced human named Lobot. Wearing cybernetic implants from his former job as an Imperial analyst, Lobot is a skilled tactician. On one fateful job, Lando attempts to steal a valuable artifact from the *Imperialis*, unaware that the yacht belongs to Emperor Palpatine himself. The mission goes awry, and Lobot is injured. In his weakened state, Lobot's implants take over his mind, forever altering his personality.

Just when his fortunes are at their highest, Han reenters Lando's life, bringing with him unwanted Imperial attention. Lando must hand Solo over to Darth Vader, but risks his own life to save Han's friends—Chewbacca and Princess Leia. After their escape with Jedi Luke Skywalker from Bespin, Lando joins the Rebellion, earning the rank of general for his participation in the mission to rescue Han from Jabba the Hutt. During the Battle of Endor, Lando is tasked with piloting the *Falcon* and leads the successful attempt to destroy the Death Star II.

After his days in the Rebellion, Calrissian settles down and starts a family. However, his young daughter is kidnapped. Her disappearance is a mystery, yet it becomes clear later that his only child was targeted by the First Order, as the group had abducted the kids of other former Alliance leaders. Lando joins Luke Skywalker's mission to track down the rumors of Sith agents, and when the trail runs cold on Pasaana, Lando decides to remain on the planet, living a quiet, restful existence as a hermit. His time as a hero has not yet passed, however.

Everything you've heard about me is true.
Lando Calrissian

Rejoining the fight

Returning to Leia Organa's side, Lando once again takes up the mantle of rebellion, joining her Resistance in the final days of its struggle against the First Order. In the *Falcon* alongside Chewbacca, Lando recruits a massive fleet to their cause, arriving at the Battle of Exegol just in time to secure victory for the Resistance. As the Final Order crumbles around the galaxy, Lando looks ahead to his next play. He offers to join the former stormtrooper Jannah in her search for her family, hoping that together they can find their long-lost relatives, even if the odds are against them. ∎

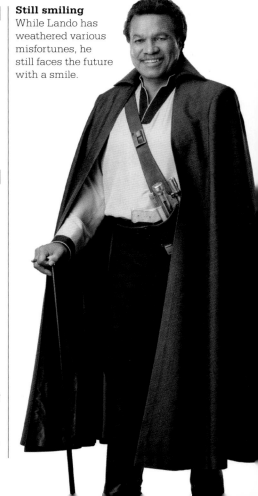

Still smiling
While Lando has weathered various misfortunes, he still faces the future with a smile.

RESTORING DEMOCRACY
THE GALACTIC CIVIL WAR

T he Empire's heavy-handed rule is bound to sow insurrection. But prior to the Battle of Scarif, rebel actions are modest or localized. After years of small-scale revolts across the galaxy, news of a planet-destroying weapon forces the Rebel Alliance to strike before it is ready. The creation of the Death Star—a space station intended to crush any resistance—sparks the beginning of the Galactic Civil War. On Scarif, like many battles that follow, the Rebellion is mere moments away from failure, yet manages to emerge victorious against a much more formidable foe.

Crash course Thanks to Rebel ingenuity and sacrifice, two Imperial Star Destroyers collide into each other. The debris destroys the Scarif shield gate.

The Battle of Scarif
The Empire goes to great lengths to ensure that the galaxy does not find out about the Death Star, but when Alliance Intelligence receives confirmation of its existence it

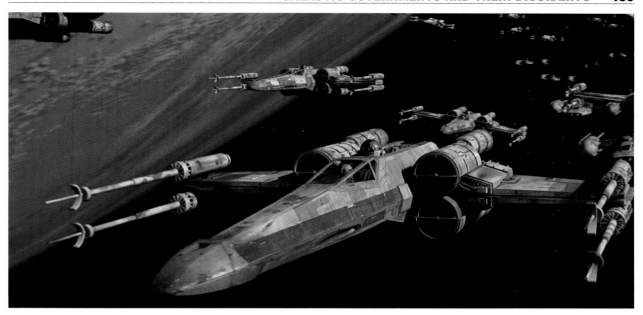

Red Five During his first time in an X-wing cockpit, new Rebel Luke Skywalker joins the assault on the Death Star.

sparks debate within the Alliance leadership. Some recognize that such a weapon spells the end of the Rebellion, whose supporters will have no choice but to fall into line or face the total destruction of their planets. In the final days of the Death Star's construction, a team known as Rogue One mounts a suicide mission to steal the station's blueprints. As they infiltrate the Citadel Tower on Scarif, the Rebel Fleet—led by Admiral Raddus—arrives to support them. Though the ground team successfully locate the plans, an orbital shield gate prevents them from being transmitted to the fleet above. An improvised but coordinated attack between Alliance Y-wing bombers and a Hammerhead corvette sends a defending Imperial Star Destroyer crashing into the gate, allowing the waiting Rebel fleet to intercept the plans. But just as they have successfully transferred the data to the Rebel flagship, the *Profundity*,

the Death Star arrives in orbit alongside Darth Vader's flagship, the *Devastator*. The station fires on Scarif, killing Rebels and Imperials alike, while Vader boards the *Profundity* above. He is just steps behind as Princess Leia Organa escapes with the plans aboard the previously docked *Tantive IV*.

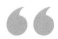

The Emperor has made a critical error, and the time for our attack has come.
Mon Mothma

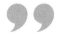

The Battle of Yavin
Organa's mission to deliver the Death Star plans to the Alliance is successful, and technicians at the

Rebel base on the moon Yavin 4 locate an exploitable weakness in the station's design. Imperial leader Grand Moff Tarkin tracks the Rebels to their base and prepares to obliterate the entire moon with the Death Star, ending the Rebellion once and for all. Using two squadrons of starfighters, the Rebel pilots attempt daring attack runs on the battle station's weakness, having limited time before it fires on the base. The final Rebel pilot, Luke Skywalker, takes aim with mere seconds remaining, landing a fatal blow to the entire station.

However, celebrations are short-lived, with the Rebellion having little time to enjoy its victory. Though the Death Star is destroyed, the Empire's resolve is unwavering, and Darth Vader is eager to exact revenge for the embarrassing failure of his troops to stop the Alliance.

The Rebels scatter far and wide in search of a new headquarters, but the Imperial fleet employs extensive resources to hunt them down. Probe droids are deployed to scour the most remote parts of the galaxy. »

The Battle of Hoth

The Empire's tireless search for the Rebels' new base proves fruitful when a probe droid detects them on an icy, uninhabited planet in the Hoth system. Darth Vader's personal armada, the Death Squadron—under the command of Admiral Ozzel—descends on the planet. But Ozzel's choice to exit hyperspace within sensor range of the base gives the Rebels time to activate their planetary shield and prepare an evacuation. This miscalculation costs the Imperials dearly, and Ozzel pays with his life at the hands of Darth Vader. Unable to conduct an orbital bombardment, the Empire instead launches a ground invasion using AT-AT and AT-ST walkers against which the Rebels have no defense. They improvise tow cables to trip some of the vehicles, slowing down the assault long enough to allow most of the rebels to evacuate. The Alliance transport ships make it out of the system thanks to the ground-based v-150 ion cannon that temporarily disables the Imperial Star Destroyers waiting in orbit. Once again, the Empire is so close to crushing the Rebellion but a

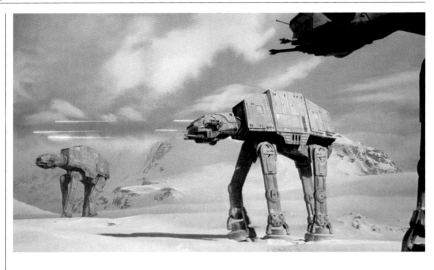

critical error by leadership—and the creative thinking of the Rebels—thwarts its efforts.

The Battle of Endor

The Rebellion's discovery of a second Death Star with Emperor Palpatine onboard provides the perfect incentive to strike. Believing the Imperial fleet is spread throughout the galaxy and that the weapon system is not yet operational, the Alliance sends everything it has in the

Imperial assault Led by General Veers, a trio of AT-ATs assault the Alliance shield generator.

attack. Its plan relies on a strike team, led by General Han Solo, landing on the Forest Moon of Endor to disable the energy shield that protects the orbiting station. The cruisers are to protect the perimeter while General Lando Calrissian's fighters penetrate the station and destroy the main reactor. Little do they know that the intelligence they received is all a lie, provided by Emperor Palpatine himself to lure the Rebellion into a final battle.

The Alliance fleet arrives at Endor to find the shield generator still operational, a giant Imperial fleet, and the Death Star's weapon fully functional. The rebel fleet suffers heavy losses in space as the strike team below is captured. Just when it seems all hope is lost, a local tribe of sympathetic Ewoks come to the Rebellion's aid, using primitive weapons in a surprise attack that confuses the Imperial garrison. Solo's team detonates the shield just in time for Calrissian to carry out his strike on the reactor. Due to his own miscalculations, the Emperor is defeated and his Death Star is destroyed.

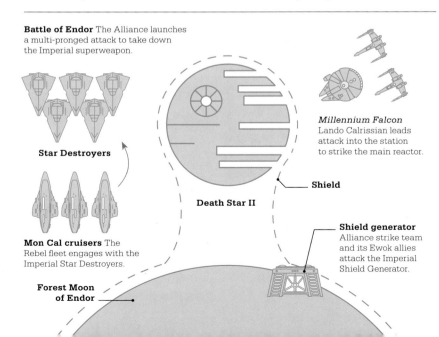

Battle of Endor The Alliance launches a multi-pronged attack to take down the Imperial superweapon.

Star Destroyers

Mon Cal cruisers The Rebel fleet engages with the Imperial Star Destroyers.

Forest Moon of Endor

Death Star II

Shield

Millennium Falcon Lando Calrissian leads attack into the station to strike the main reactor.

Shield generator Alliance strike team and its Ewok allies attack the Imperial Shield Generator.

Scoundrels at war

When civil war descends upon the galaxy, some parties who seek to stay out of the fray are caught up in the fighting. That includes a number of smugglers, scoundrels, and bounty hunters. Smugglers Han Solo and Chewbacca's fates change when they join the Battle of Yavin. Though he initially refuses the calling, Han's status as a war hero makes it hard to outrun the Empire. He also brings the Imperials down upon his old associate, Lando Calrissian, who hoped to avoid notice on his beloved Cloud City. Having betrayed the Empire to help his friends, Lando too finds little choice but to aid the Alliance.

For Doctor Chelli Aphra, her interest in personal fortune lands her in the middle of the Civil War when the archaeologist is recruited by Darth Vader. Though she has no loyalty to anyone's cause, her entanglements with the Sith Lord lead her to play both sides in order to survive.

Final fight

With the Emperor believed to be dead, the Imperial fleet is left in a state of disarray. For the first time, the Rebellion and the Empire appear to be on equal footing. With its chances of victory seemingly improving, more individuals are recruited to join the Alliance's cause. Meanwhile, the Empire begins to fracture under the strain of infighting and defection.

The war continues at a frenzied pace leading up to a final fierce confrontation at Jakku. Against the Rebellion's newly-built

Starship Graveyard Following the climactic Battle of Jakku, wreckage of Rebel and Imperial craft litter the planet.

Starhawk-class battleships, the Empire does not stand a chance of victory. With its fleet destroyed, civil unrest erupting within its borders, and many of its promising leaders vanishing into the mysterious Unknown Regions, the Empire agrees to sign the Galactic Concordance treaty to officially end the Galactic Civil War. The Rebellion, now known as the New Republic, emerges victorious and restores the democratic Senate. However, some Imperial remnants ignore the newly signed declaration and continue to operate. ∎

The Galactic Civil War

0 BSW4
Battle of Scarif
A team of Rebels steal the technical readouts to the Death Star in search of a weakness.

0 ASW4
Battle of Vrogas Vas
The Empire, led by Darth Vader, wins a victory against the Rebel fleet.

4 ASW4
Battle of Endor
The majority of the Rebel fleet gathers to attack Palpatine on the second Death Star. This defeat scatters the remaining Imperial fleet.

0 SW4
Battle of Yavin
Rebel starfighters strike a massive blow to the Empire, destroying its planet-killing Death Star.

3 ASW4
Battle of Hoth
Echo Base is discovered by the Empire. The Imperial attack scatters the Rebellion.

5 ASW4
Battle of Jakku
The Imperial fleet is defeated at Jakku, ending the Galactic Civil War.

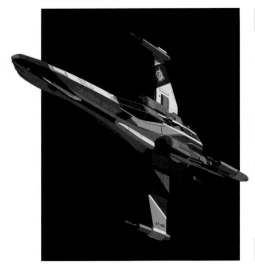

FROM THE ASHES OF THE EMPIRE
THE NEW REPUBLIC

HOLOCRON FILE

NAME
The New Republic

HOMEWORLD
Mobile, with Chandrila and Hosnian Prime as its past capitals

AIM
Peaceful galactic unity; democratic governance

STATUS REPORT
Destroyed by the First Order

After the Clone Wars and the Galactic Civil War that follows, the leadership of the victorious Rebel Alliance makes a pledge not to repeat past errors. The New Republic will by necessity require restrictions to keep any individual from accruing the power that Palpatine had held. The new government creates a decentralized structure, giving worlds more of a say on galactic matters. Among the first steps is the signing of the Galactic Concordance, officially ending the Galactic Civil War.

The New Republic is spread thin trying to stop opportunistic criminal elements from taking advantage of the chaos of the revolution. Furthermore, the last great war prior to the Empire was one driven by separatism, with worlds not wanting to be part of the Republic. Convincing them that things will be different is a difficult challenge.

The Military Disarmament Act leads to the New Republic eliminating fleets and armies that can be fielded on a galactic scale. The stripped-down New Republic fleet is small in comparison to the Imperial or Galactic Republic fleets

Is the world more peaceful since the revolution? I see nothing but chaos and death.
The Client

that preceded it, but sets a new standard. Indeed, the New Republic itself is smaller than the Galactic Republic and Galactic Empire before it. More and more systems and sectors opt to "go it alone."

Despite peace, the New Republic is not the promised unity heralded by the defeat of the Empire. The lack of cohesion leads to a breakdown of essential services and a lapse in vigilance toward dangerous trends. Many worlds question the value of Republic membership and depart. Rather than risk draconian overreach, the Republic lets them leave. Into this uncertain atmosphere, agents of the secret First Order sow discontent, promising a more effective and efficient government through centralized power.

After over two decades in power, the New Republic faces a great question about its future. As a potential solution, the concept of a First Senator is floated, to act as a sort of authority over the Senate. It is a controversial move, especially to those who remember Palpatine's slippery road to authoritarianism. A political impasse on this question, peppered with violence orchestrated by First Order operatives, leads to a

Imperial remnants

A year after the Battle of Endor, Mon Mothma of the New Republic and Mas Amedda of the Galactic Empire signed a treaty bringing an end to the Galactic Civil War. On the fringes of the galaxy, Imperial holdouts refused to go quietly or recognize the agreement. In the Anoat sector, Moff Adelhard closes his borders and attempts to rule his own private fiefdom, decrying any reports of the former Emperor Palpatine's death as propaganda.

Other Imperial warlords unwittingly carry out Darth Sidious' contingency plan to create a secret foothold of power in the Unknown Regions. Some simply accrue wealth and power for their own ends. One notorious warlord, whose full agenda is unknown, is Moff Gideon. His agents on Nevarro seek out a Force-sensitive child for nefarious reasons, a task that a bounty hunter, called the Mandalorian, carries out before second thoughts make him an enemy of Gideon's Imperial forces.

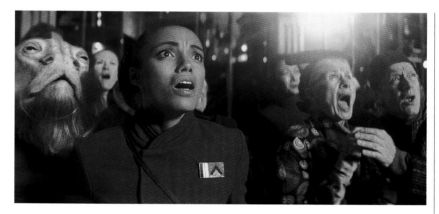

Symbols of hope During its 30-year tenure, the government of the New Republic has used different symbols.

Starburst insignia This New Republic government sigil depicts an inspiring starburst behind the Rebel Alliance phoenix crest.

new Separatist crisis. Worlds advocating centralized rule secede from the New Republic, opting instead to carve out their own power structure within their borders. Senator Leia Organa is one of the few in the New Republic who voices her objections to this course of action, recognizing that the centrist worlds need to be kept in the fold if only to monitor their development. But Leia is politically compromised by scandal at this time, and is forced to step down.

The New Republic continues in this new configuration for five more years, weathering cold war tensions with the centrist systems that have

Republic's end From the capital of Hosnian Prime, terrified New Republic citizens witness the Starkiller blast.

become known publicly as the First Order. In between is the Resistance, running unaffiliated recon missions on the First Order while attempting not to risk galactic warfare. Leia's instincts prove correct. The First Order has been amassing military power for decades, with the aim of obliterating the New Republic. Its goal is achieved with the firing of its Starkiller Base weapon that wipes out the New Republic's capital, Hosnian Prime, and the bulk of the Republic's fleet. ∎

Roundel insignia A more understated New Republic sigil features stars representing unity. It is found among security forces.

BOW BEFORE ITS MIGHT

THE FIRST ORDER

HOLOCRON FILE

CAPITAL
Mobile, with Exegol as a major world

AIM
Destruction of the New Republic; imposition of military law; the crushing of all subversives so that the Sith Eternal can rule unchallenged

STATUS REPORT
Defeated

From the ashes of the Galactic Empire emerges the First Order, a direct continuation of Darth Sidious' plot to rule the galaxy for eternity. The scope of Palpatine's plotting and contingencies were well hidden deep in the shadows, undetected until it was far too late to stop his ambitions.

The First Order is the grand culmination of several conspiracies intended to continue the Empire after the destruction of the second Death Star and the defeat of the Emperor at the Battle of Endor. Militarily, it continues through the escape of surviving Imperial warships into the Unknown Regions, and the funneling of resources from major corporations to hidden shipyards. Politically, it continues through a push for centralized authority in the New Republic Senate that culminates in a political impasse, and a breakaway coalition of worlds that brands itself as the First Order. Spiritually, it continues with the rise of the Sith Eternal cult on the hidden world of Exegol, which uses dark sciences to resurrect Palpatine. These three branches combine to describe the First Order menace.

After the Battle of Endor, the Empire fragments as there is no clear plan of succession in place should the unthinkable—the apparent death of the Emperor—occur. Regional governors and fleet admirals vie for supremacy, while individual worlds long under Imperial rule rise up in

Hexagonal sigil The First Order symbol denotes an explosive force pushing against attempts to contain it.

a rash of revolutions that spread like fire across the galaxy. It is a highly tumultuous time, as the New Republic tries to rein in the chaos. Automated systems put in place by the Emperor trigger Operation: Cinder, an orbital bombardment campaign meant to scour the Emperor's secrets, keeping them from being discovered by his enemies and successors.

A few Imperials are aware of fragments of the Emperor's master plan, but no one has the entire picture. Fleet Admiral Gallius Rax, Grand Admiral Rae Sloane,

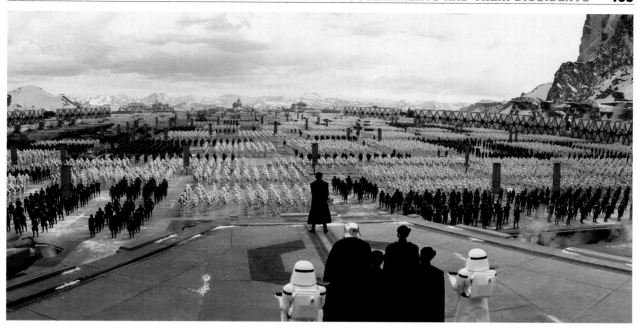

General Brendol Hux and others lead the push of a major remnant of Imperial survivors into the Unknown Regions after the Battle of Jakku. After years of hardship blazing through poorly mapped systems, they find more secure footing in worlds secretly charted by Imperial efforts. On Coruscant, Mas Amedda is left the de facto head of Imperial state and signs a treaty with the New Republic, thus officially ending the Galactic Civil War. The New Republic sets to work

trying to build a more egalitarian system of government while trying to avoid the missteps of the past.

To hinder the outbreak of galactic warfare, the New Republic imposes limitations on militarization among its member worlds, and throttles the output of major weapons manufacturers. These powerful corporations find ways to work around such restrictions, spinning off subsidiaries in independent territories that continue to produce war material

Starkiller assembly General Hux speaks to First Order forces stationed at the Starkiller before it is unleashed.

and funnel their output into the growing First Order. In this manner, the TIE fighters and Star Destroyers of the Imperial generation evolve over the years to much more modern incarnations, though their roots are unmistakable.

Though the First Order fleet is nowhere near the size of the Imperial one at its height, it is »

Rise of the First Order

4 ASW4
Battle of Endor
The Imperials suffer defeat at the hands of the Rebel Alliance.

22 ASW4
Parnassos
The Imperial fleet survivors arrive at Parnassos.

34 ASW4
Return to power
Starkiller Base destroys the New Republic capital in the Hosnian system.

5 ASW4
Battle of Jakku
After losing the battle, Grand Admiral Rae Sloane leads some of the surviving Imperials into the Unknown Regions.

29 ASW4
Centrist schism
The political schism in the New Republic creates the political core of the First Order.

35 ASW4
End of an era
The Final Order is destroyed.

Today is the end of the Republic! The end of a regime that acquiesces to disorder!
General Armitage Hux

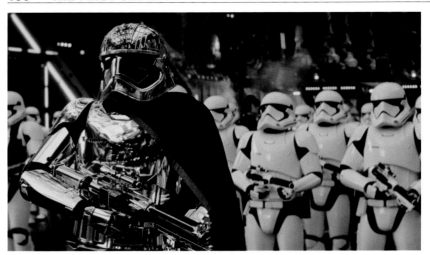

nonetheless the most formidable assembly of battleships in a galaxy that has scaled down its military production. Massive *Resurgent*-class Star Destroyers are nearly twice the size of *Imperial*-class vessels. These in turn are dwarfed by massive *Mandator IV*-class planet-searing dreadnoughts. But none are larger than the *Supremacy*; one-of-a-kind, the wing-shaped flagship of the mysterious Supreme Leader Snoke has an expansive 60 kilometer (37 mile) span. For its smaller pursuit craft, the First Order

Precision forces Captain Phasma commands First Order stormtroopers who loyally obey her command.

fields newer TIE/fo fighters that include shields and, in some variants, hyperdrives. Newer TIE classes like Silencers, Special Forces models, Echelons, bombers, and whispers give versatility to the First Order starfighter corps.

Like the Empire that preceded it, the standard infantry soldier of the First Order is the stormtrooper, a white armored shock trooper

trained and well-equipped for combat. General Brendol Hux formulates a training program based on theories he developed at Arkanis Academy. Young candidates are rigorously indoctrinated to strip away individuality. First Order troopers often begin as children taken from conquered planets, and are given numbers for names.

The most destructive of the First Order's cutting-edge weapons is Starkiller Base. An evolution of Death Star-era research into the weaponization of kyber focusing crystals, the Starkiller is not an artificially constructed space station but rather a dwarf planet carved and transformed into a weapons platform. Raw kyber crystalline deposits at the heart of the planet once known as Ilum power an unthinkable hyperspace cannon that draws energy from a sun and directs its destructive energy across the galaxy at a distant target. The Starkiller fires only once, and with it, destroys the entire Hosnian system—home of the New Republic government.

Worlds that already sided with the First Order see its unparalleled power in action. Systems that

The Sith fleet

Forged in shipyards hidden beneath the surface of Exegol are thousands of warships that comprise the Final Order fleet. These *Xyston*-class Star Destroyers are larger than the traditional *Imperial*-class, and a significant portion of their reactor output is channeled to the planet-cracking superlaser suspended beneath its hull.

As a terrifying display of its might, a single advance Star Destroyer launches from Exegol to Kijimi and destroys

the planet for harboring fugitives. In addition to the Sith Star Destroyers, Exegol launches specialist Sith TIE fighters (called TIE daggers) and red-armored Sith stormtroopers that, while not capable of wielding the Force, are loyal to the dark aims of the Sith Eternal cult.

Some in the First Order are uncomfortable with the

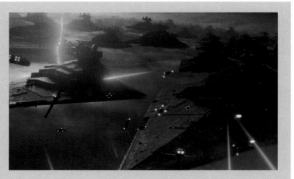

revelation of these new allies, preferring the trappings of technology and military precision to the mystical, occult nature of the Sith agenda.

attempt to stay neutral capitulate in the face of such a demonstration. With one shot, the First Order displays its dominance, forcing the galaxy to bow to its power. This would prove to be only the initial phase of its grand plan of conquest.

Supreme Leader Kylo Ren, having usurped the title from his

> **"** All remaining systems will bow to the First Order and will remember this as the last day of the Republic!
> **General Armitage Hux**
>

master Snoke by murdering him, uncovers a hidden layer to the First Order's structure, a Sith agenda previously unseen in its inner workings.

From the depths of the Unknown Regions comes a proclamation from the resurrected Emperor that the day of revenge, the day of the Sith, is at hand. Ren pieces together enough information to uncover an ancient Sith wayfinder that points the way to Exegol, deep in the Unknown Regions. There, he finds the Final Order fleet—enough Star Destroyer-style warships to increase the power of the First Order fleet ten-thousandfold. And within an ancient citadel, Ren finds the resurrected form of Darth Sidious, who reveals that the First Order was all his doing, and he is on the verge of realizing his ultimate goal—to destroy the Jedi Order once and for all, and to cheat death and live up to the aims of the Sith Eternal cult. ■

First Order stormtroopers

Stormtrooper The standard infantry soldier of the First Order, trained from early childhood.

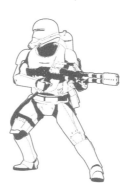

Flametrooper An incendiary assault soldier with flamethrower and specialized armor.

Snowtrooper Cold assault troopers are equipped with environmentally-appropriate, climate-ruggedized gear.

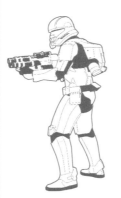

Jet Trooper Jetpack-equipped soldiers launch short range aerial assault on targets.

Mountain Trooper Flexible armor and extended survival gear is suited for the terrain.

Executioner Trooper Standard troopers are rotated into punishment duty.

Scuba Trooper Underwater demolitions and assault troopers are deployed in aquatic environments.

First Order Raider Elite specialist troopers, skilled in hunting down Force relics for their Supreme Leader.

Treadspeeder Pilot The flexible armor is better suited for driving the swift treadspeeder vehicles.

BITTER RIVALRY
ARMITAGE HUX

HOLOCRON FILE

NAME
Armitage Hux

SPECIES
Human

HOMEWORLD
Arkanis

AFFILIATION
First Order

AIM
Destruction of the New Republic; personal power atop the First Order

STATUS REPORT
Executed for treason

From the ashes of the Empire rises the First Order, upholding its predecessor's traditions of fighting and rivalry within its leadership ranks. General Armitage Hux's career in particular is marked by grudges, jealousy, and conflict.

The illegitimate son of Imperial Commandant Brendol Hux, Armitage dedicates his life to First Order service. The pair have a difficult relationship due to Brendol's callous treatment of his son, which leads to Armitage plotting with Phasma to orchestrate Brendol's assassination. His only request is that she make it untraceable. This allows Armitage to take his father's place overseeing the First Order's stormtrooper training program.

Hux's most enduring rivalry is with Supreme Leader Snoke's apprentice, the fallen Jedi Kylo Ren. Snoke regularly plays Kylo and Hux against each other, using Hux's victories to stoke jealousy in Ren. But it is Hux who resents Kylo's position at Snoke's side. After Snoke's death, Ren assumes the role of Supreme Leader, putting Hux under his authority. Kylo further emphasizes his dominance when he uses the Force against Hux.

Kylo's ascension and the appointment of Allegiant General Pryde atop the First Order military leads Hux to take drastic measures in order to see Ren fail. He becomes a double agent, maintaining his role in the First Order while passing vital intelligence to the Resistance. He even frees captive enemy agents in order to undermine Ren, but it is a step too far. The move reveals his treachery to General Pryde, who executes him on the spot. Armitage Hux is so close to the top, but his own insecurities and jealousy prove to be his—and ultimately the First Order's—undoing. ∎

Bow to the First Order From Starkiller Base, Hux proclaims the end of the New Republic and orders the superweapon to destroy the Hosnian system.

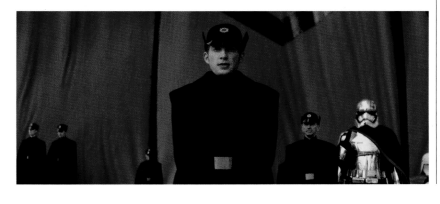

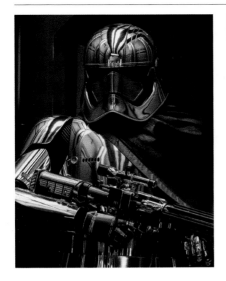

MASKED BETRAYAL
CAPTAIN PHASMA

HOLOCRON FILE

NAME
Phasma

SPECIES
Human

HOMEWORLD
Parnassos

AFFILIATION
First Order

AIM
Unshakable training of First Order stormtroopers

Final moments Armed with her quicksilver baton, Phasma engages her well-trained former underling.

As a leader, Captain Phasma demands unwavering loyalty from her troops, despite her own past being littered with acts of great treachery.

Growing up on the desolate planet Parnassos, Phasma's early life is a constant fight for survival against the predatory Scyre clan. She schemes to murder her parents in an attempt to secure her and her brother, Keldo's, safety as part of the Scyre. However, this protectiveness doesn't last, and she later turns on Keldo and the Scyre when First Order Commandant Brendol Hux crash-lands on their homeworld. Hux recruits her to his stormtrooper corps, but her loyalty to him is also fleeting. She colludes with Armitage Hux—Brendol's son—to poison his father: a treachery she deems necessary to ensure her ascension in the First Order.

Phasma is a steadfast comrade of General Armitage Hux for many years while overseeing the training of First Order stormtroopers. She favors indoctrination despite the potential for increased brutality among the troops. At Jakku, FN-2187 fails to follow her orders and defects: a desertion Phasma takes personally.

You are a bug in the system!
Phasma to Finn

Now known as Finn, FN-2187 returns to the superweapon Starkiller Base and forces Phasma to lower the base's planetary shield—a betrayal that leads to the station's complete destruction. However, she manages to escape, and plots to kill anyone with knowledge of her error.

Finn and Phasma battle a final time after he is caught infiltrating Snoke's capital ship, the *Supremacy*. After a short but ferocious duel, Finn strikes down Phasma by delivering a single blow to her head. It is a fitting end that someone whose past is filled with such ruthless treachery is herself killed by a traitor. ∎

THE SPARK THAT LIGHTS THE FIRE
THE RESISTANCE

HOLOCRON FILE

NAME
The Resistance

LEADERSHIP
**General Leia Organa;
General Poe Dameron;
General Finn**

KNOWN BASES
**D'Qar; Crait (temporary
encampment); Anoat
(temporary encampment);
Batuu (recruitment outpost);
Ajan Kloss**

AIM
Stopping the First Order

STATUS REPORT
Victorious

The years of peace following
the Galactic Civil War
comes with a lapse of
vigilance on the part of the New
Republic. Efforts to prevent the
centralization of authority that led
to the rise of the Empire has the

unintended consequence of
making the New Republic
ineffective at stemming the rapid
rise of authoritarianism in systems
plagued with lawlessness. As a
Senator within the New Republic,
Leia Organa attempts to address
this, but is most often branded by
her political opponents as being
needlessly alarmist, or even an
outright warmonger. When a rival
senator, Carise Sindian, exposes
Leia's familial connection to Darth
Vader, a scandal erupts, and Leia
finds her ability to work within
the system compromised.

She steps down from office,
but Leia is not done fighting.
Instead, she calls upon old allies
earned over a lifetime of freedom-
fighting, and together they create
a paramilitary force—the
Resistance—that exists outside
of the New Republic structure.
Though she hopes it will not come
to war, she recognizes all the signs
that war may be inevitable. At its
start, the Resistance is primarily
designed for information-gathering
during a time of "cold war" tensions

General Organa Leia brings decades
of experience to her leadership of
the newly established Resistance.

between the New Republic and the
burgeoning First Order. Outright
aggression in First Order territories
risks the outbreak of war, so the
Resistance must tread carefully.

Leia builds the Resistance to
resemble the structure of the Rebel
Alliance, and resumes her old rank
of General. Her long-serving protocol
droid C-3PO serves a vital function
in the early Resistance as the
coordinator of a network of spy
droids spread across the galaxy.
Rebel veterans of the Galactic Civil

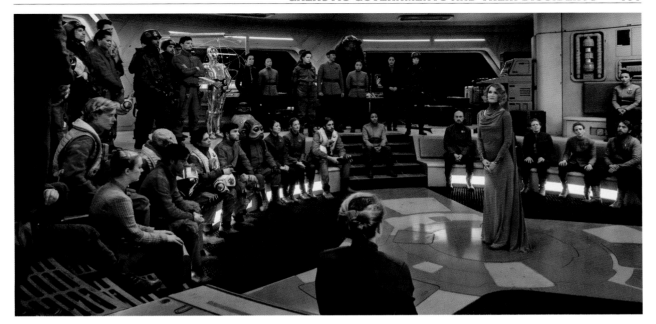

War, including Admiral Gial Ackbar, Major Caluan Ematt, Admiral Ushos Statura, and Vice Admiral Amilyn Holdo are among the first to join Leia in developing ground and space strategies. The Resistance are forced to make do with starfighters a generation removed from the cutting edge. Still, young pilots eager to make history join her cause. These include Poe Dameron, Temmin "Snap" Wexley, Stomeroni Starck, Tallie Lintra, and Jaycris Tubbs.

The Resistance space forces consist of a meager amount of capital ships, the largest being the *Raddus*, a decommissioned Mon Calamari cruiser from the New Republic fleet. Other vessels include old Corellian corvettes, bunker busters, and escort- and cargo frigates. The starfighter arsenal grows to include X-, Y-, B-, and A-wing fighters of outdated design. MG-100 StarFortress heavy bombers give the Resistance explosive firepower, with Cobalt and Crimson Squadrons the foremost among these specialist units.

The Resistance is chronically understaffed, requiring its personnel to cover multiple diverse roles—as was the case in the early Rebellion.

Aboard the *Raddus* Vice Admiral Amilyn Holdo briefs the survivors of the D'Qar evacuation during one of the Resistance's most harrowing trials.

Technicians serve as infantry should circumstances require it. Though the organization of the Resistance is by necessity loose, there is a clear military command hierarchy. Officers wear rank badges reminiscent of the ones used in the Rebellion, with red denoting army service and blue indicating the navy, even though the Resistance is small enough that the terms "army" and "navy" are clearly aspirational. **»**

Rise of the Resistance

28 ASW4
Political revelations
Leia is ousted from New Republic politics by lineage scandal.

33 ASW4
The Resistance prepares
The Resistance is staffed to operational levels; Leia begins her search for Luke.

34 ASW4
Battle of Crait
Near routing of Resistance at Crait.

29–34 ASW4
Cold War The cold war begins between the New Republic and the First Order.

34 ASW4
Battle of Starkiller Base The Resistance succeeds in destroying Starkiller Base.

35 ASW4
Battle of Exegol
The galaxy rallies around the Resistance at the Battle of Exegol.

Leia pieces together that long before the First Order was known to be a threat, its agents had been behind a number of covert operations that either removed old Rebel leaders through assassination, or inflicted tragedy in their lives that would prevent them from being an effective opponent. Years earlier, Lando Calrissian suffered the disappearance of his daughter. Leia also suffers heartbreak with the fall of her son, Ben Solo, and the disappearance of her brother, Luke Skywalker. With the emergence of Supreme Leader Snoke and his student, Kylo Ren, in command of the First Order, she realizes how desperately she needs Luke's help.

General Organa tasks pilot Poe Dameron with finding Skywalker. She cites Lor San Tekka, a scholar and old friend of the family, as someone who is likely to know Luke's whereabouts. Before that, Poe has been helping extend the Resistance's spy network by recruiting a New Republic flier, Kazuda Xiono, to keep an eye on

Castilon, a watery planet bordering First Order territory. Poe abandons this assignment to focus on San Tekka, who gives him a partial map to the first Jedi temple on the planet of Ahch-To, believed to be where Skywalker can be found.

It is during this quest that the First Order makes clear its dark intentions, firing the Starkiller Base superweapon in a terrifying display of power that destroys the New

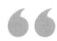

The First Order wins by making us think we're alone. We're not alone. Good people will fight if we lead them.
General Poe Dameron

Republic capital. This leaves the fledgling Resistance as the sole military force that stands poised to challenge the First Order. Before the Starkiller can destroy the Resistance base on D'Qar, General Organa scrambles X-wing starfighters in a mission to destroy the weapon. Dameron successfully blasts a vulnerable oscillator on the Starkiller's surface, letting the titanic energies within the dwarf planet destroy itself.

Though the Resistance enjoy a brief victory, it comes at a terrible personal cost. General Organa's husband, Han Solo, is killed in the Starkiller mission, slain by their own son, Kylo Ren. The Resistance hurriedly evacuates D'Qar before it is destroyed by the First Order fleet that then doggedly chase them using relentless hyperspace tracking technology.

Final struggle Unorthodox tactics abound as the Resistance takes the battle to the enemy in one last push against the Final Order.

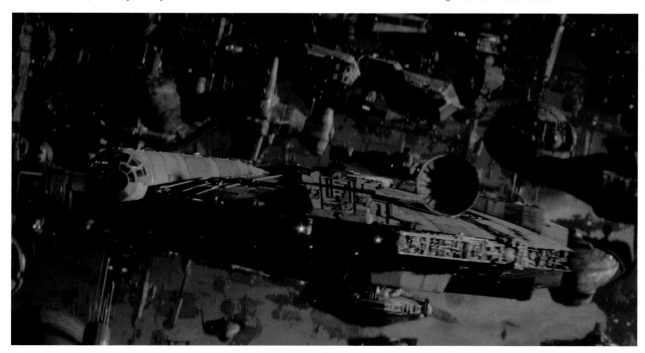

Sign of the times Though the Resistance has a far looser structure than even the ragtag Rebellion did, it still adopts a military hierarchy and rank system.

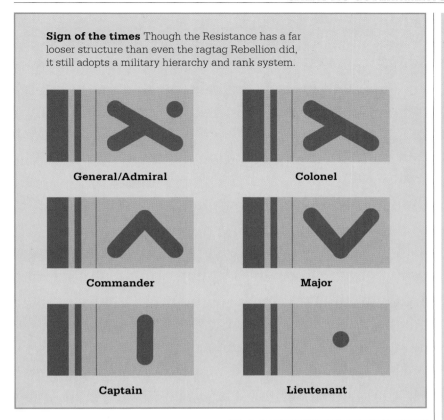

General/Admiral	Colonel
Commander	Major
Captain	Lieutenant

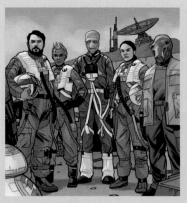

Black Squadron

In the early days of the Resistance, many special missions are undertaken by Black Squadron, a multi-discipline group of pilots under the command of Poe Dameron. The unit consists mostly of T-70 X-wing starfighters. Pilots in the squadron include Snap Wexley, Karé Kun, L'ulo L'ampar, Jess Pava, and Suralinda Javos. General Leia Organa tasks Dameron with leading the search for Lor San Tekka, an old explorer who helped Luke Skywalker uncover Jedi relics and temples in the years since the fall of the Empire.

Black Squadron's nemesis is a First Order Security Bureau officer named Terex, who is obsessed with bringing down these pilots who so flagrantly risk intruding in First Order territory and operations.

The starfighter units in the Resistance need to be flexible, and they are reassembled and renamed as needed. As such, several Black Squadron veterans fly as Blue Squadron in the attack on Starkiller Base.

The year that follows is one of pursuit and evasion. Though the Resistance is pared down to a single ship, the *Millennium Falcon*, it rebuilds in earnest. News of Luke Skywalker's spectacular sacrifice on Crait spreads, renewing hope in the galaxy. Worlds begin standing up on their own, forcing the First Order to concentrate on local subversives rather than the Resistance proper. General Organa and her young officers recruit help and supplies on the planets of Mon Cala, Batuu, Minfar, Tevel, and elsewhere to replenish the Resistance.

When the disturbing word of a resurrected Emperor begins to spread across the galaxy, General Organa sends out spies and agents to bring back solid intel. A Resistance contact in the Sinta Glacier Colony passes along shocking details of the Final Order fleet that threatens to wipe out not only the Resistance, but all free planets that don't swear fealty. Of vital help to the Resistance is word from a spy within the highest echelons of the First Order—General Armitage Hux, who wants desperately to see Kylo Ren fail.

General Leia Organa does not live to see the end of the conflict. Before passing into the Force, she leaves instructions for Poe and Finn—now promoted to generals—to carry on the fight without her. Using the example she has set to inspire new allies to the cause, the Resistance brings the fight to the First Order headquarters on Exegol, and rallies an ad hoc armada of civilian ships to follow. It proves victorious in the final push against the forces of darkness. ∎

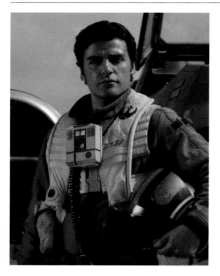

LEADERSHIP CALLS
POE DAMERON

HOLOCRON FILE

NAME
Poe Dameron

SPECIES
Human

HOMEWORLD
Yavin 4

AFFILIATION
New Republic; Resistance

ABILITIES
Ace pilot; inspirational leadership

This hotshot's natural talents carry him far as a pilot. But as his role in the Resistance changes, Poe learns the hard way that true leadership is more than just talent and bravado.

After a falling out with his father, the young, cocky Dameron joins the Spice Runners, a criminal gang on Kijimi, for a time, but he abandons this life to join the New Republic Navy. Poe excels in the cockpit, and is recruited by General Leia Organa, who appreciates his rash style, to command the Resistance's starfighter squadrons.

Leia entrusts Poe with a vital mission to find out where Luke Skywalker is located. Though Poe is captured, he entrusts the intel he discovers to his beloved astromech, BB-8. Poe later escapes First Order captivity thanks to the stormtrooper he names Finn, returning in time to lead his pilots into battle on Takodana and Starkiller Base. Fresh off his wins, Poe leads the defense of D'Qar, but disobeys orders, keen to try and take down a First Order dreadnought. Once again, Poe's fancy flying leads to victory, but he loses many squad mates, failing them and Leia when he is needed.

With Leia temporarily out of the fight, the recently demoted Poe comes into conflict with the new leader, Vice Admiral Amilyn Holdo, not realizing that his penchant for combat risks lives. It's only at the Battle of Crait that Poe finally learns when to stand down, spearheading the Resistance evacuation in order to fight another day.

Leading up to the final battle against the First Order, Poe

Desperate attack Although the odds appear insurmountable, Poe leads his navy into battle against the Sith fleet.

struggles with the responsibility he bears as the acting general alongside Finn after Leia's passing. But having learned the hard lessons of his past, Poe commands the air attack at Exegol, not as a selfish flyboy, but as an inspirational leader. ■

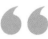

We are the spark that'll light the fire that'll burn down the First Order.
Poe Dameron

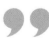

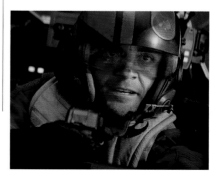

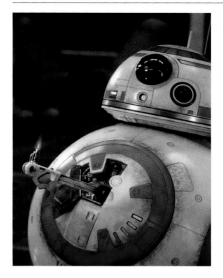

DROID COMPANION
BB-8

HOLOCRON FILE

NAME
BB-8

TYPE
Astromech droid

PLANET OF CONSTRUCTION
Hosnian Prime

AFFILIATION
New Republic; Resistance

AGE
4 years old at the time of the Starkiller Incident

ABILITIES
Swappable tool-bay discs feature multiple tools

He's a BB unit, orange and white. One of a kind.
Poe Dameron

Whether distrusted or simply dismissed, most droids operate unnoticed by their organic neighbors, yet some droids attract more attention. BB-8 is one such automaton whose loyal, dependable, and loving demeanor makes him a true friend to his allies. Like most astromech droids, BB-8's primary function is in starship repair and navigation, providing his pilot Poe Dameron with many helping hands. Recruited alongside Poe into the Resistance, BB-8 is a trusty companion to the pilot when spying on the First Order, on their fateful mission to Jakku, and during the harrowing attack on Starkiller Base.

At the Battle of D'Qar, BB-8 voices his concerns over the odds of attacking a dreadnought head on, but his quick thinking saves the duo from certain death. For proof of Dameron's friendship with the droid, look no further than the affection Poe displays for him when they reunite after time apart.

BB-8's loyal friendship extends to Rey, who takes special care of the droid after discovering him on the planet Jakku, and to former stormtrooper Finn who encounters the pair. This meeting changes Rey and Finn's lives, leading them to the Resistance where BB-8 becomes friends with them both. BB-8 works alongside Rey, Poe, and Finn on a number of Resistance missions. After the Battle of Exegol, BB-8 accompanies Rey to Tatooine. ■

Loyal copilot Without BB-8, Poe might not have survived the defense of D'Qar.

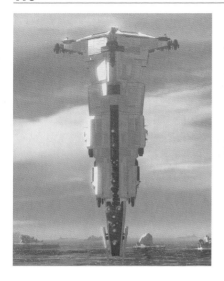

MORE THAN MEETS THE EYE
THE COLOSSUS

HOLOCRON FILE

NAME
Colossus

DESCRIPTION
Spacecraft-turned-refueling-platform

NOTABLE RESIDENTS
Imanuel Doza; Jarek Yeager; Kazuda Xiono; Tam Ryvora; Neeku Vozo

The ocean planet Castilon borders Wild Space on the far edge of the Outer Rim. Few call this world home, but many from around the galaxy visit its massive ex-Imperial refueling platform, the *Colossus*, for fuel, supplies, and community. In the planet's deep ocean trenches live shoals of strange fish and tentacled creatures. But above the water, the *Colossus* is protected by the Aces, elite pilots who entertain the fueling station's residents, but who are also capable of repelling invaders—such as Kragan Gorr's pirate gang. One of

the mechanics, who is also a skilled pilot, is a bumbling, albeit kind-hearted and loyal newcomer named Kazuda "Kaz" Xiono. Kaz is actually a spy for the Resistance, recruited by General Leia Organa and Poe Dameron. The Resistance becomes suspicious when the First Order shows a marked interest in the *Colossus*. Poe and Leia hope to gather intelligence and prevent the First Order from using the base to further its plans.

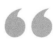

We are the
Resistance now.
Kazuda Xiono

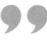

No place like home
The *Colossus* is an active platform and functions like a floating city. There is a market, where produce is sold, a popular tavern run by Aunt Z—where pilots and travelers can

relax and blow off some steam—and a repair shop run by retired pilot Jarek Yeager, among many other points of interest. Yeager enjoys the peace and quiet he has earned after a lifetime of fighting the Empire during the Galactic Civil War. He is the only person on the *Colossus* who knows about Kaz's role as a spy and serves as a kind of reluctant mentor for the young rebel.

Yeager has a strong working relationship with the *Colossus* captain, Imanuel Doza, who keeps the resident population at arm's length, aware that the First Order is a real threat. The galaxy's bullies continue to find ways to explore Doza's bustling platform, creating tension and anxiety for those who live and work on the *Colossus*.

Into space
Kaz befriends Tam Ryvora, a fellow mechanic who longs to be a pilot and racer. When she learns of Kaz's espionage mission, she begins to think he cannot be trusted. The First Order occupation does not bother Tam as much as Kaz keeping secrets from her and so she joins the First Order when Security Bureau Agent Tierny promises her she can be a pilot.

Harbinger of Hosnian Prime

The best pilot in the Resistance, Poe Dameron, sees something in Kazuda "Kaz" Xiono beyond his clumsy, accident-prone ways. Kaz is an excellent pilot and wants to help the Resistance defeat the First Order. In his early days undercover, the two receive a distress call during a training exercise and discover a damaged ship attacked by pirates. They are ambushed by a large Kowakian monkey-lizard and manage to escape.

On a separate adventure, the pilots discover Station Theta Black, which the First Order destroys. The two agree the First Order is hiding something. However, nothing prepares them for the discovery of the planet Najra-Va, which has been drilled completely through, or for the fact that the system's sun has vanished. Poe has to leave for a critical mission on Jakku, but both pilots believe that something unprecedented and evil is about to happen.

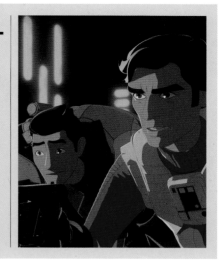

Kaz, however, finds there is no time to dwell on the loss of his friend, as the First Order invasion begins. In a fortuitous moment, Kaz and his friend Neeku Vozo, a Nikto mechanic, inadvertently discover that the *Colossus* has a hyperdrive, and with a few adjustments, can actually fly, although it has been almost 20 years since this was last tested. In a daring move, and with the permission of Captain Doza, Kaz and Neeku get the hyperdrive operational and drain the water from the ship to flush out the remaining First Order and allow for the platform to launch into space once again. They blast into hyperspace to start a new chapter.

Time for change

No longer stationary, the *Colossus* is now an active spacecraft, being piloted by the crew of the massive vessel. Upon leaving Castilon behind and pulling the *Colossus* out of hyperspace, Kaz sets coordinates for D'Qar to reunite with the Resistance. But once there, they find evidence of a huge battle, and seemingly no survivors. Desperate for supplies and the coaxium fuel that the station needs to fly, Kaz and his friends travel to different worlds

in the hopes of finding aid as they continue to stay one step ahead of the First Order. Kaz tries to contact Tam, hoping she will come to her senses, but she is still not ready to trust him. Her continuing training and exposure to the First Order's methods have placed even more confusion in her heart.

Neeku and Kaz infiltrate a First Order refueling station. Tam notices her friends, but secretly allows them to escape. Kaz ultimately returns to Castilon and is reunited with Tam, who deserts the First Order. Tired of the continual failures, Supreme Leader Kylo Ren orders the *Colossus* destroyed by Commander Pyre's Star Destroyer. Kaz and his friends are captured in the Star Destroyer's tractor beam, but escape, with CB-23 disabling the shield generator as the First Order warship and its inhabitants are destroyed. Kaz and his friends reunite on the refueling station in Aunt Z's Tavern.

However, this respite is short-lived. After receiving a distress signal from Lando Calrissian, the Resistance ships and the *Colossus* join the Battle of Exegol, hoping to end the tyranny of the First Order once and for all. ∎

The Aces

Each of the Aces pilots a heavily customized ship, tailored to their personal flying style.

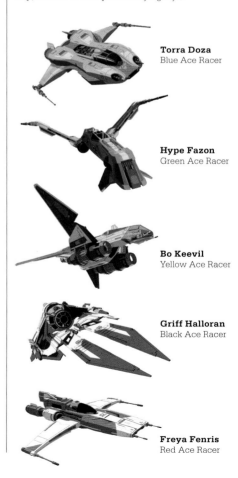

Torra Doza
Blue Ace Racer

Hype Fazon
Green Ace Racer

Bo Keevil
Yellow Ace Racer

Griff Halloran
Black Ace Racer

Freya Fenris
Red Ace Racer

STORMTROOPER TURNED

FINN

HOLOCRON FILE

NAME
Finn (formerly FN-2187)

SPECIES
Human

HOMEWORLD
Unknown

AFFILIATION
First Order (formerly); Resistance

STATUS REPORT
Named General of the Resistance before battle of Exegol

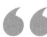

> I was raised to fight. For the first time I have something to fight for.
>
> **Finn**

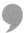

Few individuals have wrestled with such personal change as Finn. Along the way, he grows from a faceless soldier to General of the Resistance. But his path is not a straight line, as he continually struggles with his conflicting loyalties, whether to the First Order, himself, his friends, or the cause of the Resistance.

Like other First Order stormtroopers, FN-2187 is taken from his family as an infant and spends his childhood training to be a soldier. Shaken by the horrors of war, Finn grows aware of the atrocities committed by the First Order and the suffering he witnesses on Jakku motivates him to defect. Focused on his own survival and afraid of capture by the First Order, he lies to the scavenger Rey and Rebel hero Han Solo about his past and attempts to desert them. Seeing Rey captured by Kylo Ren changes his mind, and he is determined to rescue his new friend even if he is not interested in joining the Resistance.

After the Battle of Starkiller Base, Finn attempts to flee the Resistance in hopes of saving Rey but is caught by the ever-loyal Rose Tico. By the Battle of Crait, their adventure together shows Finn that believing in a higher cause is a way to save those you love.

Following the Resistance's near destruction at Crait, Finn is now fully committed his friends and works tirelessly to replenish the Resistance's arms and forces.

At the Battle of Exegol, Finn proves himself to be a selfless leader. His heroics there, and his willingness to sacrifice his own life in order to destroy the Final Order fleet, bring his journey full circle. He survives the battle and is hailed among the great heroes of the Resistance. ∎

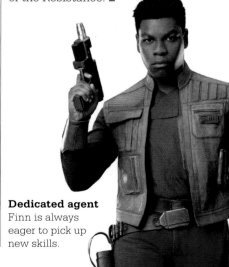

Dedicated agent
Finn is always eager to pick up new skills.

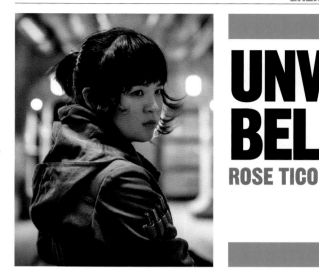

UNWAVERING BELIEF

ROSE TICO

HOLOCRON FILE

NAME
Rose Tico

SPECIES
Human

HOMEWORLD
Hays Minor

AFFILIATION
Resistance

ABILITIES
Mechanical skills; schematic & systems analysis

AIM
Saving the galaxy from the First Order

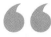

I work behind pipes all day. Doing talking with Resistance heroes is not my forte.

Rose Tico

From her upbringing on the impoverished Hays Minor to the dark moments at the Battle of D'Qar, Rose Tico's greatest strength is her unshakeable belief in the cause. Rose's road to the Resistance begins on her homeworld, a planet stripped of its resources to fuel the First Order's ravenous military rearmament. She joins the Resistance with her sister, Paige, in hopes that they might save other planets from similar fates.

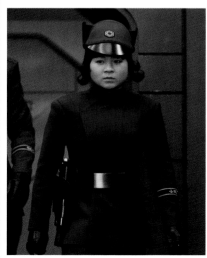

Rebel spirit Desperate to help her Resistance allies, Rose goes undercover on the First Order *Supremacy.*

Reeling after Paige's death at the Battle of D'Qar, Rose remains dedicated to the Resistance and guards the escape pods aboard the *Raddus* where she stops deserters from jumping ship. Included among the would-be deserters is Finn, who she joins on a last-ditch mission to Canto Bight in search of a Master Codebreaker who can help the Resistance escape the First Order. There she teaches Finn a valuable lesson in the importance of fighting corruption in all of its forms.

At the Battle of Crait, Rose and Finn pilot ski speeders in the ground battle to delay the First Order's advance. She stops Finn from foolishly sacrificing himself, reminding her friend that they will ultimately defeat evil by saving those they love.

Rose's unyielding faith in the forces of good eventually pays off. Now leading the Engineering Corps, Rose prepares the Resistance for the Battle of Exegol during General Organa's final days. After participating in the ground assault, Rose finally sees the end of the First Order. Though she has sacrificed so much and lost so many friends along the way, she never loses faith and is a model of what it means to resist. ∎

UNLIKELY ALLIES

JANNAH

HOLOCRON FILE

NAME
Jannah

SPECIES
Human

HOMEWORLD
Kef Bir

AFFILIATION
Company 77; Resistance

ABILITIES
Orbak rider; skilled archer

AIM
A life free from the First Order

Once known as TZ-1719 of First Order stormtrooper Company 77, Jannah escapes to live a life of freedom and self-reliance. She was snatched from her parents as a child and indoctrinated into obeying the First Order. However, Jannah and her company mutiny at the Battle of Ansett Island, refusing to target innocent civilians. The group flees and eventually settles on the oceanic moon Kef Bir in the Endor system. Jannah becomes the group's leader, overseeing their lives taming orbaks and scavenging among the remains of the Death Star II on their adopted homeworld.

When Resistance heroes Rey, Finn, and Poe land on Kef Bir, Jannah aids their search to find a Sith Wayfinder. Finn, also a First Order defector, is unaware that others made the same choice as him. Jannah quickly bonds with Finn over their similar pasts, and later they make an ideal team during the Battle of Exegol. Jannah leads Company 77 atop their orbaks into battle against the newly created Final Order, where the well-trained warriors give the Resistance a fighting chance at disrupting the enemy's fleet deployment.

With the battle won, Jannah accepts galactic legend Lando Calrissian's offer to travel the galaxy in search of her family. He empathizes with her as his own child had been kidnapped years before. Jannah, an improbable ally to the Resistance, has found an unlikely ally of her own. ∎

They told us to fire on civilians. We wouldn't do it. We laid down our weapons.
Jannah

Innovator
Alongside her company, Jannah adapts to life on Kef Bir, crafting new gear from material found in the ruins of the Death Star II.

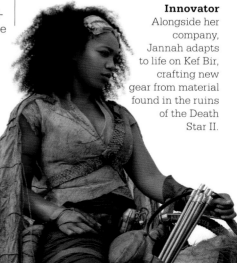

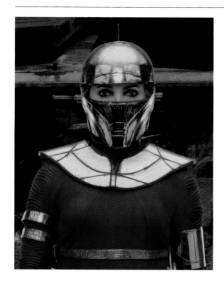

CHOOSING SIDES

ZORII BLISS

HOLOCRON FILE

NAME
Zorii Bliss

SPECIES
Human

HOMEWORLD
Kijimi

AFFILIATION
Spice Runners of Kijimi

SHIP
BTA-NR2 Y-wing (modified)

So long, sky trash.
Zorii Bliss

Living in the criminal underworld since she was a teenager, Zorii Bliss isn't a typical hero. An agile combatant and talented pilot, the young Zorii puts her skills to use extorting locals and pirating spice. She joins the Spice Runners of Kijimi alongside fellow rebellious teen Poe Dameron. Some time after Poe's acrimonious departure from the gang, Zorii rises to lead the crew.

When the First Order expands its control across the galaxy, the Spice Runner's autonomous and mercenary ways are threatened. Much like other criminals without political convictions, Zorii must eventually choose a side after a long and lucrative life operating on the fringes of legality.

Bliss is forced to decide when Poe, now a Resistance hero, returns to Kijimi, hunting for the hidden planet Exegol. Zorii confronts him for leaving Kijimi, but reluctantly assists his mission by leading him to expert droidsmith Babu Frik. Zorii also gifts Poe a critical asset: a First Order officer transit data-medallion, which enables the Resistance to rescue their ally Chewbacca from the orbiting First Order Star Destroyer *Steadfast*.

Old friends Poe and Zorii's lives have diverged dramatically since their time together as teenagers, where they taught each other essential skills.

When the First Order's reborn leader Emperor Palpatine decides to make an example out of a planet, Kijimi is targeted due to the help the Resistance received from Zorii. Alongside Frik, Zorii manages to escape Kijimi's destruction by a Sith Star Destroyer. They answer the call of Resistance hero Lando Calrissian when he assembles a fleet to fight the Final Order at the Battle of Exegol. Flying alongside other notable scoundrels and criminals, including Zulay Ulor and Sidon Ithano, Zorii risks everything to prevent the rise of the Sith and restore freedom to the galaxy. ■

CIVIL WAR RENEWED
THE FIRST ORDER/RESISTANCE WAR

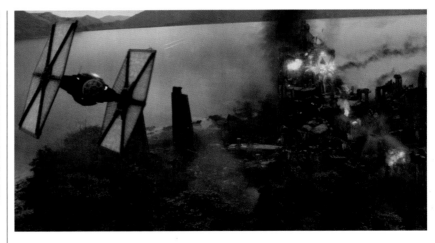

Supreme Leader Snoke orders the last Jedi to be found and destroyed, lest he stand in the way of the First Order's plans for galactic domination. An aggressive attack is launched on a civilian encampment on the remote planet of Jakku. Searching for clues that will lead to Luke Skywalker, fearless Kylo Ren cuts through anyone who stands in his way. The First Order captures Resistance pilot Poe Dameron, who reveals that he has hidden a partial map to Luke Skywalker's whereabouts in

the memory systems of his droid, BB-8, who now roams the deserts of Jakku alone.

The First Order dispatches forces to locate BB-8, but he is found first by a local scavenger, Rey, and then a deserter stormtrooper named Finn. Rey and Finn escape First Order pursuit aboard a battered freighter that they later discover is the *Millennium Falcon*. While attempting to reach the Resistance base, the ship is

Battle of Takodana The First Order's swift strike on Maz's castle on Takodana leaves it in ruins.

captured by the *Eravana*, a cargo freighter operated by former General Han Solo and his Wookiee copilot, Chewbacca. Rey and Finn are prepared for a battle with the First Order, but instead come face-to-face with Solo and Chewie. A delighted Han reclaims his beloved ship but is surprised to learn that Rey and Finn

are trying to return BB-8 to the Resistance. He agrees to help the pair, even though he risks crossing paths with his estranged wife, General Leia Organa.

Han pilots the *Millennium Falcon* to Takodana where he makes contact with the old pirate Maz Kanata—an ally of Leia's. While on the Mid Rim planet, they witness the destruction of the distant Hosnian system by the First Order's Starkiller Base weapon. With one blast, the First Order declares war and destroys the New Republic Senate, leaving the Resistance to take up the fight. First Order and Resistance spies positioned in Maz's castle inform their respective leaders that the droid they seek— BB-8 and his prized data—is on Takodana. The First Order launches an attack on the planet, razing Maz's castle to the ground. Kylo Ren successfully locates and captures Rey. Determined to find the information he seeks, he takes her back to Starkiller Base for interrogation. The Resistance chases off the First Order stragglers and safely returns Han, Finn, and BB-8 to the Resistance base on D'Qar.

The Resistance closely examines intelligence data of Starkiller Base. Aided by inside information from former stormtrooper Finn, the

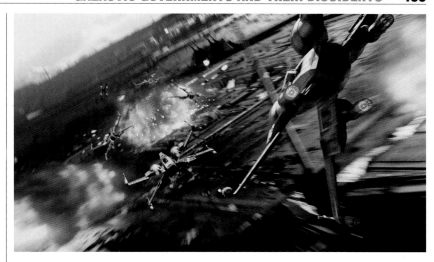

Assault on Starkiller Base Decades after the desperate Rebel assault on the Death Star, the Resistance's pilots mount a similar operation.

That's how we're gonna win. Not fighting what we hate, saving what we love.

Rose Tico

Resistance leaders plot an attack on the weapon. Meanwhile, Finn focuses on rescuing Rey from Kylo Ren's clutches. The *Millennium Falcon* successfully penetrates Starkiller's shields, thanks to some harebrained and hazardous piloting only possible by General Han Solo. From inside the base, Han, Finn, and Chewbacca are able to lower its shields. They are reunited with Rey who has managed her own escape by channelling her Force abilities.

A squadron of Resistance X-wings launch an aerial strike on Starkiller Base's oscillator station. The starfighters eventually penetrate its armor and trigger a cascade reaction that destroys the planet. »

The First Order/Resistance War

34 ASW4
The Hosnian cataclysm
The First Order wipes out the Hosnian system.

34 ASW4
Battle of Starkiller Base The Resistance destroys the First Order's Starkiller weapon.

34 ASW4
Battle of Crait The Resistance is saved from annihilation by the last Jedi.

35 ASW4
Battle of Exegol The final battle is won by the Resistance and allies hailing from across the galaxy.

34 ASW4
Battle of Takodana
On Takodana, the First Order and the Resistance attempt to capture BB-8, who carries a map to Luke Skywalker.

34 ASW4
Battle of D'Qar On D'Qar, the Resistance desperately flees its base following a First Order counterattack.

34 ASW4
Battle of Batuu Resistance agents infiltrate and heavily damage Kylo Ren's Star Destroyer.

Escape from D'Qar On Poe Dameron's orders, Resistance bombers attempt to take out a First Order dreadnought.

Han confronts his son, First Order leader Kylo Ren, and pleads with him to reject the dark side. But Ren refuses, and kills his father. Ren then battles Rey, who is able to heavily wound him and escape aboard the *Millennium Falcon*. The Starkiller Base threat is eliminated, but the war against the First Order has only just begun.

Though the Resistance destroys the imminent threat posed by Starkiller Base, the location of its headquarters on D'Qar is known to the First Order. This necessitates hasty evacuation from the system. Poe Dameron launches a daring strike against a First Order dreadnought. It is a costly victory, as Poe's insistence on following the attack through to its end results in significant casualties. Nonetheless,

one last Resistance bomber succeeds in emptying its explosive payload onto the dreadnought's reactor housing, destroying the fleet-killing warship.

The small Resistance fleet escapes into hyperspace. But to everyone's surprise, it is pursued by the First Order fleet, including the command ship, the *Supremacy*. The First Order has cracked the secrets of hyperspace tracking, and the Resistance ships cannot flee into lightspeed.

General Leia Organa is injured during the escape from D'Qar, leaving Vice Admiral Amilyn Holdo to assume command of the fleeing military. Tensions escalate between Captain Poe Dameron and Holdo over how to handle the First Order pursuit. She undertakes a secret evacuation of Resistance personnel, transporting them to the nearby planet of Crait. To distract from the escape efforts, Holdo sacrifices herself and Leia's cruiser, the *Raddus*, in a spectacular hyperspace collision that splits the *Supremacy* in two.

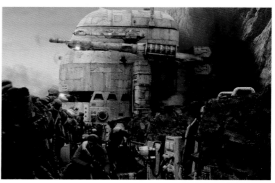

Trench warfare Hoping Leia's distress call will be answered, Resistance personnel man the trenches on Crait. If they can buy time, they might survive.

The few Resistance survivors touch down on Crait, a mineral planet that once housed a Rebel outpost. They hunker down while the First Order launches ground forces to hunt them. Kylo Ren, now Supreme Leader of the First Order after usurping Snoke, commands the attack. The miraculous appearance of Luke Skywalker on the battlefield draws Ren out and buys time for the

Desperate maneuver Some surviving Resistance fighters attempt to attack the First Order's forces in falling-apart ski speeders.

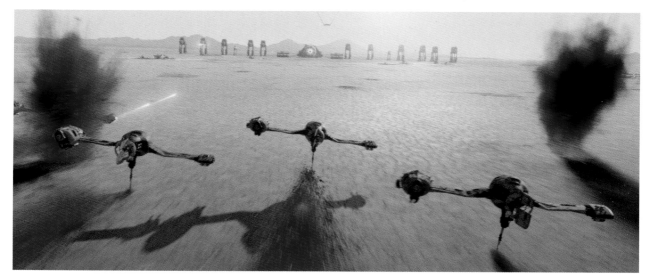

Rebels to escape Crait. Skywalker is in fact a Force projection—one that takes every living effort for Luke to create—that vanishes, leaving Ren empty-handed.

The Resistance retreats and rebuilds, eventually settling on the jungle moon Ajan Kloss. Intelligence gathered by its agents confirm the unbelievable—Emperor Palpatine not only lives, but is hours away from launching an enormous fleet capable of cementing his rule

over the galaxy. The Resistance scrambles to find answers to how the Emperor is alive, and a way to stop this fleet, which is vulnerable before it launches from its construction site on distant Exegol.

The fleet, known as the Final Order, is not only enormous, but powerful—each of the new Star Destroyers carries an axial superlaser capable of annihilating a planet. The chaotic atmospheric conditions of Exegol, exacerbated by the

unpredictable nature of the Unknown Regions, means the fleet needs extra assistance to launch. The very fog that keeps it hidden makes it vulnerable. A navigational tower transmits a path through the skies to a launch altitude, during which time, the fleet does not have its deflector shields active. This gives the Resistance a narrow window in which to strike.

General Poe Dameron leads the Resistance starfighter assault that covers a ground strike led by General Finn and fellow former stormtrooper Jannah. They ride orbaks along the surface of the First Order command ship, *Steadfast*, and destroy the transmission tower. General Lando Calrissian, aboard the *Millennium Falcon*, leads civilian craft from various systems in bringing down the Final Order warships. ∎

Battle of Exegol The orbak riders of Company 77 join the Resistance forces to attack the First Order's Star Destroyer *Steadfast*.

The Holdo maneuver

In an extremely unconventional maneuver, Vice Admiral Amilyn Holdo sacrifices the *Raddus* to destroy the *Supremacy* and severely damage several First Order Star Destroyers with a well-timed lightspeed jump. It is similar to a maneuver Anakin Skywalker undertook during the Clone Wars to destroy the *Malevolence* warship, by ramming it into a dead Antarian moon. For such a maneuver to work, the jumping craft must be sizable, making it a very expensive tactic. The *Raddus* is over three kilometers (two miles) in

length. The *Raddus'* jump distance must intersect its target while it is entering lightspeed, when jump collisions are most likely. This makes it a point-blank maneuver.

Holdo pays for the incredible results with her life. To honor her bravery, the maneuver now bears her name. It is also used to smash the First Order Star Destroyer that patrols Endor.

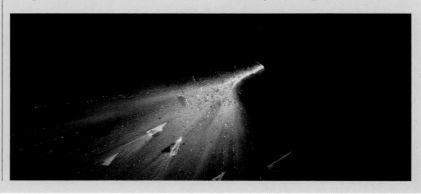

GALACT

DENIZEN

C S

The galaxy is home to diverse cultures, each with distinctive homeworlds, curious beliefs, and prominent figures. Some are drawn into the center of critical events—they choose to fight for a cause larger than any individual or even species. But others are more self-interested, opting to pursue their own ambitions, whether they be wealth, power, fame, or independence.

TOOTH AND CLAW
NON-SENTIENT SPECIES

Sentient dangers of Sith, stormtroopers, and politicians aside, the galaxy is also full of deadly, non-sentient creatures of all shapes and sizes. By definition they do not think or reason and are primal in nature, acting on instinct. Potentially dangerous if crossed, these beasts of prey are not to be taken lightly and have often become the stuff of legend. Perhaps most infamous are monstrous rancors. While there is debate as to where they originated from, these large reptilian carnivores are typically agreeable creatures, but are capable of great violence if provoked or treated badly. Rancors coexist peacefully on Felucia with their farmers, but,

unfortunately, due to their rows of sharp teeth and armored skin, are prized by crime lords such as Jabba the Hutt—who keeps one under his palace on Tatooine and feeds it with anyone who makes him angry.

The sarlacc is another, rare, favorite of Jabba the Hutt and is frightening from birth. After taking 30,000 years to mature, they bury themselves into the ground, often on sandy planets such as Tatooine. Then, they wait for helpless creatures to fall into their massive maws, sometimes pulling them in with long tentacles. A sarlacc injects its victims with neurotoxins, causing the unfortunate victim to digest slowly over 1,000 years. Whether the sarlacc is classified as an animal or a plant is still open for debate.

Similarly toothy, rathtars are cousins to the sarlacc and considered to be among the most dangerous creatures in the galaxy. These tentacled predators hunt in packs and are famous for their involvement in the Trillia massacre. They can roll up into balls and chase after their prey, gobbling them up in their massive jaws.

The gundark is a bipedal, ferocious predator that is the stuff of nightmares for even the toughest

scoundrels in the galaxy. A gundark has four arms, 16 claws, and excellent hearing, making it almost unstoppable to an unarmed foe. As an alpha predator, it is among the more advanced non-sentient creatures in the galaxy.

Another bipedal monster is the wampa, native to Hoth. While also possessing razor-sharp claws and fangs, the wampa relies on stealth, blending into the ice world's surroundings with its white fur. These tall beasts primarily live in caves, preferring to hang prey upside down until ready to feast.

A nexu is a four-legged, furry predator that is quick and

Pack hunters When three rathtars are accidentally released on Han Solo's cargo freighter, chaos ensues.

Non-sentient, domesticated species These beasts of burden, plus others, are the most tameable, nondeadly, non-sentient creatures in the galaxy, useful for work others cannot—or do not want—to do.

Tauntaun
Snow lizards of Hoth; thick fur; docile; useful for riding on patrol

Blurrg
Very loyal once won over; used by Twi'leks in battle on Ryloth

Luggabeast
Part animal, part machine; found on frontier worlds such as Jakku

Fambaa
Hauls immense weight on Naboo; utilized by Gungan Grand Army

Dewback
Slow but steady reptiles; used by stormtroopers on Tatooine's desert plains

Varactyl
Four-legged reptavian mounts native to Utapau system

Kaadu
Wingless, two-legged avians; very fast; tamed by Gungans

Bantha
Favored by Tatooine's Tusken Raiders, with whom they share a bond

Mairan
Semi-sentient empaths that read minds; one owned by Saw Gerrera on Jedha

Prehistoric size

Non-sentient species can evolve more freely under the galaxy's waters than above ground. Traveling to Naboo's core risks finding non-sentient sea-creatures such as the opee sea killer.

The opee is a silent hunter that patiently waits motionless on rocky overhangs and uses its long tongue as a projectile to reel in its food.

The colo claw fish, in comparison, is twice the size of the opee sea killer and has a much longer row of pointy teeth inside its triangle-shaped jaws. This fish prefers to wait in underwater tunnels and has a luminescent tail.

Scaling up, the sando aqua monster is a gargantuan creature lurking deep in the waters of Naboo, capable of eating its prey whole—including a Gungan sub or creatures unfortunate enough to cross its path. It appears to be fractionally more advanced in predatory instinct than Naboo's other sea creatures.

Space slugs, or exogorths, are among the largest in the galaxy, reaching up to 900 meters (3,000 feet). They burrow inside asteroids while unwitting pilots traverse their long gullets toward certain doom. ∎

aggressive, with quills popping out of its spine and a forked tail. Reeks are also quadrupeds and have a distinct horn on the top of their head. Typically herbivores, they will eat meat if they are starved. Their skin color changes depending on the world they inhabit. The acklay, meanwhile, is larger and much more dangerous. The six-legged creature has sharp claws and razor-like teeth and towers over its prey. It is equally at home on land and water. All three are similar in intelligence.

> 66
>
> There's always a bigger fish.
> **Qui-Gon Jinn**
>
> 99

The legendary Zillo Beast

In a particularly intense battle on Malastare during the Clone Wars, a fabled beast is awakened, bringing danger and destruction at more than 97 meters (320 feet) long. Known as the Zillo Beast, it was long believed to be extinct. Its thick, reptilian hide is impervious to weaponry— even lightsabers. The long tail of the creature has eight large spikes, which it uses to knock over buildings, ships, and other obstacles. It fights for survival when Anakin Skywalker and the clone troopers try to subdue it.

It is eventually put to sleep with gas and taken to Coruscant, where Supreme Chancellor Palpatine wants to clone the creature, taking a keen interest in its impenetrable hide, and subscribing to the growing belief that it appears to have increased sentience. It breaks free and wreaks havoc on the Republic capital until it is ultimately destroyed by poison gas deployed from Republic gunships.

CRIME CAN PAY
CRIMINALS

HOLOCRON FILE

NAME
Criminals

KEY LOCATIONS
All across the galaxy

NOTABLE EXAMPLES
Black Sun; Pykes; Hutts; Shadow Collective; Crimson Dawn; Crymorah; Tobias Beckett; Maz Kanata; DJ

AIM
Accumulate wealth and power

STATUS REPORT
Roaming free, unchecked

Behind the scenes of broader conflicts, crime flourishes across the galaxy. Often brokering deals with whoever has the most power or influence, criminals—whether alone or in syndicates—take advantage of a war-torn galaxy for selfish gain, often resulting in destruction and death. In the Republic's prime, the

Deals with Dryden Before Han Solo becomes a poster boy for the Rebellion, he is no stranger to crime.

Jedi are able to maintain some semblance of order, though many criminals still operate in secret. With the emergence of the Empire, crime is able to thrive, as long as the factions stay out of Palpatine's way.

Crime in the Clone Wars

The most prevalent criminal organizations vie for power and control. At one unique point in history, during the Clone Wars, a tenuous union forms as Maul seeks to reestablish his place of power in the galaxy and consequently unites Death Watch, Crimson Dawn, Black Sun, the Pyke Syndicate, and the Hutt Clan—forming the Shadow Collective on Mandalore. With this

union, Maul is able, for a time, to defy both sides of the war. However, a group of insurgents fights back, which precipitates a split of the factions and eventually leads to Maul having to abandon both the planet and his role as a crime boss.

Black Sun's prominence during the Clone Wars occurs because the Jedi are more concerned with military matters, and less with keeping the peace. The group operates mostly on Mustafar and Ord Mantell and its members are largely made up of the Falleen species. Black Sun is led by Xomit Grunseit until he is killed by Maul. The group then joins the former Sith.

The smuggler queen

Perhaps the best-connected smuggler in the galaxy, Maz Kanata's physical stature is not an accurate reflection of her clout and reputation in the underworld. She has lived for 1,000 years and has seen the best and worst the galaxy has to offer. Maz is no Jedi, but she feels the Force as it ebbs and flows. She has a gift for reading people and is always ready to help up-and-coming smugglers find their way.

Maz prefers to be apolitical during times of galactic conflict, remaining tucked away in her castle on Takodana. However when her old ally Han Solo unwittingly draws the First Order's attention to her location, she is not pleased to see her home destroyed. After this loss, Maz starts supporting the Resistance, becoming a close confidant and advisor of General Organa during her final days.

The Pyke Syndicate is a part of the spice cartel and is largely in control of the drug, as well as the planet it is mined from: Kessel. The group has a tenuous relationship with Black Sun, even during the time all five factions were a member of the Shadow Collective. The Pykes are also responsible for the death of Jedi Master Sifo-Dyas.

The Hutt Clan is one of the most powerful criminal organizations in the galaxy, with five major families to their name. At one time or other, the Hutts align themselves with the Republic, the Empire, and the Shadow Collective, depending on what benefits them the most. Jabba is the most respected and feared of all the Hutts. During the Clone Wars, the Hutts have major influence over hyperspace lanes.

Not all criminals are found in the major syndicates. Groups such as the Crymorah do not follow a code so much as their own amoral whims, while pirates like Hondo Ohnaka follow their own caprice. In fact, Hondo is just as likely to befriend as he is to betray if there is financial gain in it. His selfish nature, combined with his charm, makes him a confounding opponent. His path has crossed with Jedi, bounty hunters, and rebels alike.

Imperial illegality

During the reign of the Empire, five major criminal syndicates dominate the galaxy: Crimson Dawn, Black Sun, the Crymorah syndicate, the Hutt Clan, and the Pyke Syndicate. During this tumultuous time, Maul returns from a lengthy absence to take over Crimson Dawn. However, he chooses to keep his identity a secret and employs Dryden Vos as his figurehead. Vos has a reputation for ruthlessness if double-crossed or angry, and hires professional thief Tobias Beckett and his gang to steal coaxium from the Pykes.

Free spirits

Tempting fate and the wrath of Darth Vader, archaeologist Doctor Chelli Lona Aphra roams the galaxy, looking for ancient weapons and

Live free. Don't join.
DJ

Jedi artifacts. Highly intelligent, Aphra looks out for herself and has a tendency to change allegiances for survival or maximum profit. Hovering somewhere between a hero and a villain, she is as likely to help the Rebellion as she is the Empire, and is not to be trusted.

When the First Order rises, lone ranger DJ skulks in the background on Canto Bight—unimpressed with the greed on display, while fully embracing his own avarice. He refuses to join either the First Order or the Resistance, thinking both corrupt. DJ is cynical and apathetic to the greater struggle in the galaxy, ready to aid whoever pays the most and loan his skills as a slicer and con man to the highest bidder. His current whereabouts are unknown. ∎

Vader's apprentice Darth Vader hires Aphra for her skills, planning to kill her when she is no longer of use to him. He is therefore surprised when she outfoxes him and survives his attempt.

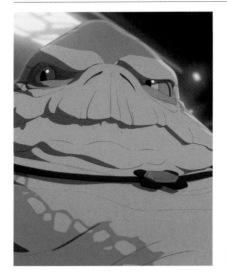

SLIMY CRIME LORDS
THE HUTTS

HOLOCRON FILE

NOTABLE MEMBERS
Jabba; Ziro; Marlo; Arok; Gorga; Oruba; Gardulla

BASE OF OPERATIONS
Nal Hutta; Tatooine

AIM
Gain power and control through manipulation and criminal enterprises

The governorship of the Hutt Clan is composed of Jabba, Marlo, Arok, Gorga, and Oruba. Jabba, the most dangerous of the lot, and descended from ancient Hutt elder Mama, rules from Tatooine, but he has a reach that far exceeds his desert planet. Like many of the Hutts, Jabba lives an opulent lifestyle, but rules with an iron fist.

Gardulla the Hutt is a cunning and clever crime lord also located on Tatooine, who is a confidant of Jabba. She temporarily holds Shmi and Anakin Skywalker during their time as enslaved people, but eventually loses them in a bet to Toydarian junk dealer Watto.

During the reign of the Empire, Jabba hires Boba Fett to capture

Han Solo, who dumped valuable cargo that belonged to the Hutt. Han is frozen in carbonite, thus becoming Jabba's favorite wall decoration. But this also puts Jabba on the radar of rebel heroes Luke Skywalker and Leia Organa. Taking advantage of Jabba's overconfidence and laziness, Leia strangles Jabba with a chain, killing him with the object by which he would degrade her. This leaves a massive void at the top of the Hutt Grand Council.

The Hutts are a giant, sluglike species from the planet Nal Hutta. They have a well-deserved reputation for being ruthless gangsters, involved in smuggling and countless other nefarious illegal activities. They are governed by the Hutt Grand Council: five Hutt members that are as likely to double-cross one another as they are one of their business partners, due to rampant infighting and constant scheming. They are primarily obese and unhealthy but can live for centuries.

Keeper of the court Jabba likes to be entertained and so enslaves dancers and musicians to do as he pleases—or face certain death. He keeps beasts for this grim purpose.

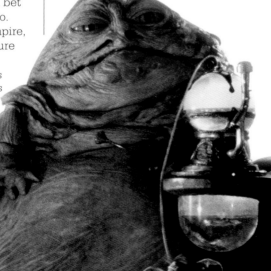

Hutt history

Jabba is not the first Hutt Luke has encountered. Four years earlier, Luke and his friends meet Grakkus the Hutt. Grakkus is different from other Hutts. He has cybernetic legs to help him get around and is also a connoisseur of Jedi artifacts. In his

On the move Possibly unique among the Hutts, mobile and muscular Grakkus has great physical strength, capable of smashing Luke to the ground.

possession are countless lightsabers and holocrons, plus other rarities outlawed by the Empire. Eventually, he is jailed for owning contraband and remains incarcerated for 30 years—until he cuts a deal with Resistance pilot Poe Dameron, who breaks him out in exchange for intel on historian Lor San Tekka.

Jabba's death leaves a massive void in the Hutt clan, eventually causing its members to lose their power. They are replaced in the criminal underworld by the Nikto crime cartels. The New Republic's two halves, the centrists and the populists, have always disliked the Hutts, aware of their history of duplicity, back-stabbing, and violence.

Hutt Grand Council leaders

Jabba the Hutt
Crime lord and ruthless leader of the Hutts; rules from his palace on Tatooine

Marlo
Co-leader of the Hutt Clan; dealer in Zygerrian slaves

Gorga
Accountant of the Council; Jabba's nephew

Arok
A member of the Hutt family during the Clone Wars; frequently found smoking

Oruba
Clothed Hutt; killed by Savage Opress after giving up the location to Jabba's palace

However, surviving Hutt Vranki the Blue is able to establish a profitable business as the proprietor of Vranki's Hotel and Casino. Vranki claims to be different to most Hutts but soon proves otherwise. When enemies of the First Order seek respite and a chance to make extra money for supplies, Vranki sets up a series of races but promptly cheats at every turn. Eventually, the racers figure out the algorithm that Vranki is using and are able to beat the Hutt at his own game. Proving himself different in this one regard, Vranki gives the victors their winnings and lets them go without fear of retribution. This is a far cry from the authority the Hutt Grand Council wielded during the Clone Wars. ■

Revenge for Rotta

The Hutt Clan is at the height of its powers during the Clone Wars and tries to avoid picking a side in the galaxy-wide conflict. Separatist leader Count Dooku finds this unacceptable and initiates a plan to kidnap Jabba's son Rotta the Huttlet and frame it on the Jedi, in the hopes of persuading Jabba to join his cause. However, Jedi Anakin Skywalker and his new Padawan, Ahsoka Tano, rescue the Huttlet and deliver him safely to Jabba, prompting the gangster to side with the Republic for a time.

It is soon revealed that none other than Jabba's uncle, Ziro the Hutt, is the mastermind behind his son's kidnapping. Jabba hires bounty hunter Cad Bane to break Ziro out of a Republic prison so that he can recover the Hutt records in Ziro's possession. Jabba also hires Ziro's former love, Sy Snootles, to murder his uncle, keeping the Hutts' duplicitous ways secret, and exacting revenge for Rotta's kidnapping. The message from these actions is clear: do not cross Jabba.

PREDATORS FOR HIRE
BOUNTY HUNTERS

HOLOCRON FILE

NAME
Bounty hunters

KEY LOCATIONS
All across the galaxy

NOTABLE EXAMPLES
**4-LOM; Aurra Sing; Beilert
Valance; Boba Fett; Bossk;
C-21 Highsinger; Cad Bane;
Dengar; Greedo; IG-88;
IG-11; Jango Fett; Latts
Razzi; Toro Calican;
Zam Wesell; Zuckuss**

AIM
Work for the highest bidder

STATUS REPORT
Still active, still lethal

Bounty hunters are guns for hire. They are often used as muscle by crime lords who pay well. But bounty hunters also serve law enforcement, by capturing bail jumpers and criminals that try to slip beyond the authority's reach. More often than not, though, bounty hunters are unscrupulous, deadly, and as dangerous—or more so—than their wanted targets.

A complicated profession
Bounty hunting during the time of the Republic or Empire requires proper certification to ensure the legal handling of a wanted quarry, and the delivery of a posted bounty by the issuing authority. Membership of the Bounty Hunters Guild expedites much of the bureaucratic hassle required to acquire the necessary permits.

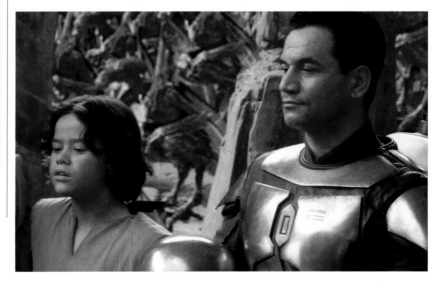

Like father, like son Jango and Boba Fett are perhaps two of the most notorious bounty hunters in galactic history.

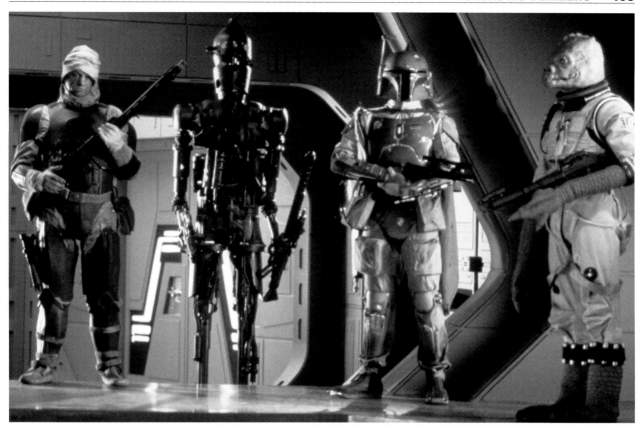

Most wanted When Darth Vader needs to hunt down Han Solo, he calls on a host of bounty hunters, to be led by Boba Fett.

A Guild hunter has access to bounties curated by a Guild representative, detailed as a posting in a Guild office, or as holographic pucks when operating remotely.

The puck or posting lists the details of the bounty: the amount offered, the circumstances (or crimes) that warranted the bounty, the operational jurisdiction allowed for pursuit, and specific conditions required to collect (for example, "dead or alive.") If the bounty hunter agrees to take on the assignment, he or she gets access to the target's chain code—an identification marker that describes certain biographical information. This code drives the parameters of a tracking

Bounty hunters.
We don't need their scum.
Admiral Firmus Piett

fob, a short-range sensor attuned to this biometric data. Upon the capture and delivery of a target, the Guild operative runs a sensor check on the body and compares it to the chain code data on the fob, confirming the identification of the acquisition.

After the collapse of the Empire, the bureaucratic infrastructure required to catalog legal bounties evaporates, leaving the Bounty Hunters Guild to be ultimate arbiter on the jobs distributed to hunters. »

Keeping watch Whether to complete a bounty or just to watch the race, Aurra Sing's reason for attending the Boonta Eve Classic has not been verified.

Notable bounty hunters

While there are many individuals in the bounty hunting profession, only a few rise to galactic prominence. Some are known for their skill, while others are just unlucky.

Toro Calican

A young hotshot, Toro Calican aspires to get into the Bounty Hunters Guild in the chaos following the Empire's fall, by bagging a quarry as capable as Fennec Shand. Recognizing Toro as dangerously inexperienced, the mysterious hunter known as the Mandalorian agrees to help Toro out in a brief but convenient partnership on Tatooine. Rather than split the reward, Calican takes out the quarry and attempts to nab the Mandalorian for the price placed on his head by the Guild. The Mandalorian is not one to be outsmarted, however, and blasts the loudmouth.

Aurra Sing

Striking in build and appearance, Aurra Sing is a notorious hunter in the last days of the Republic. An associate of Jango Fett, Sing takes the orphaned Boba Fett under her protection and tutelage. Rumor has it that gunslinger Tobias Beckett is responsible for ending her career permanently.

Bossk

A brawny Trandoshan, Bossk has been in the profession for decades, helped by his species' natural ability to regenerate damaged tissue. Trandoshans are big game hunters who have a storied dislike of Wookiees, and Bossk in particular wants to bag the bounty on Chewbacca.

Zam Wesell

Clawdite Zam Wesell is a shape-changer, a natural ability that serves her well as a bounty hunter and assassin. She attempts to kill Senator Padmé Amidala prior to the Military Creation Act, but is thwarted by Jedi Knight Obi-Wan Kenobi and his apprentice Anakin Skywalker.

Greedo

A bumbling hunter down on his luck for years, Greedo the Rodian tries to corner wanted smuggler Han Solo in the Mos Eisley Cantina and collect the bounty on his head, but fails to disarm Solo who blasts him under the table. This mildly inconveniences Jabba the Hutt.

IG-88

IG-88 is violent, lethal, and dedicated to perfecting itself as well as killing others. There are rumors that IG-88 killed its manufacturers soon after activation. In operation for decades, this droid displays a penchant for pyrotechnics and a patience unmatched by his organic counterparts.

Latts Razzi

An acrobatic Theelin, Latts Razzi is a tough hunter and is part of young Boba Fett's Krayt Claw hunter posse. She specializes in exotic weapons, such as the segmented armored boa she can wield effectively as a lariat. With this weapon, Latts can easily dispatch multiple foes.

IG-11

One of a number of IG-series assassin droids, IG-11 is a fully-fledged member of the Bounty Hunters Guild. His programming makes him a stickler for Guild rules and a fearless hunter. He works alongside the Mandalorian to collect a lucrative bounty on Arvala-7.

Beilert Valance

Imperial cadet Beilert Valance is rebuilt as a cyborg after sustaining grievous injuries. He applies his military skills to the bounty hunting profession, upgrading his cybernetic systems with each profitable reward, essentially remaking himself into a killing machine.

Dengar

Dengar is a Corellian bounty hunter who stays in his career far past his prime. While in fighting shape during the Clone Wars, he is much more battered and scarred during the Galactic Civil War. Years later, he is barely recognizable after undergoing cybernetic surgery to try and remain competitive.

Zuckuss

The Gand Zuckuss specializes in esoteric hunting rituals native to his people that seem to give him an extrasensory edge in tracking prey. Gands breathe ammonia, so Zuckuss requires a respirator to survive in atmospheres rich in oxygen. Zuckuss often teams up with 4-LOM on missions.

4-LOM

4-LOM is a droid that has become a bounty hunter, by purportedly rewriting his former programming. His past life as a protocol droid aboard a luxury cruise liner makes him better suited to tactics, analysis, and deduction rather than raw martial applications.

Cad Bane

A preeminent bounty hunter during the Clone Wars, Cad Bane is a tight-lipped, well-equipped Duros. After decades of experience, Bane gathers an arsenal designed to counter Jedi interlopers. His jet boots make him as agile as any leaping Jedi; his wrist-mounted flamethrower is impossible to deflect with a lightsaber. He proves his worth in going toe-to-toe with such Jedi as Obi-Wan Kenobi, Anakin Skywalker, Mace Windu, Ahsoka Tano, and Quinlan Vos during his career—and living to brag about it.

The Sith Lord Darth Sidious hires Bane to steal a Jedi holocron from within the very vaults of the Jedi Temple, a task Bane succeeds at. Bane takes an interest in young Boba Fett, and trains him in the ways of the hunt before all but disappearing from the underworld stage.

The Guild's neutral stance in the fallout of the war means that ex-Rebel, New Republic, ex-Imperial, and criminal bounties alike are all fair game, provided they follow the code of the Guild. Bounty hunters cannot hunt each other (or "jump a claim") by usurping an assignment after the hard work is complete. Neither could hunters renege on a deal, especially after payment has been delivered. To go against Guild rules such as these would be to invite the ire of hunters and acquire a hefty bounty in turn.

The Galactic Republic condones bounty hunting as a profession, provided it is done properly. In the lawless Outer Rim, however, with little to no monitoring, bounty hunters often amount to no more than paid assassins employed by crime lords. With the outbreak of the Clone Wars, the Separatist Alliance issues sizeable bounties on the heads of Jedi Knights and Republic senators—making any bounty hunters signing on for this hunt independent operatives.

The Empire has more official resources to focus on hunting fugitives—the heavily militarized regime has intelligence arms such as the Imperial Security Bureau

Fast shots Smuggler Han Solo is not intimidated by bounty hunters and is prepared to talk, or shoot, his way out of the situation.

and even exotic hunters like the Inquisitorius to bring in quarry. Still, even the Empire needs bounty hunters at times, especially since they often operate in the far fringes of the galaxy known to be hiding places of Rebel fugitives.

Regardless of the political system currently in power, there always appears to be a need for bounty hunters to track down individuals in such a large galaxy. ∎

I can bring you in warm. Or I can bring you in cold.
The Mandalorian

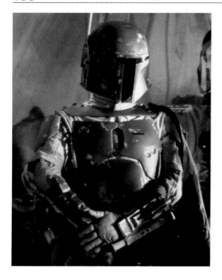

THE BEST IN THE BUSINESS

BOBA FETT

HOLOCRON FILE

NAME
Boba Fett

SPECIES
Human (Clone)

HOMEWORLD
Kamino

AFFILIATION
Bounty hunter

AIM
Find the next bounty

STATUS REPORT
Last seen in the Sarlacc

Bounty Hunter Jango Fett is hired to be the template for the clone army of the Republic and agrees, with one request: to be given one clone for him to raise. The Kaminoans agree, and Jango raises the clone, Boba, as his son. From an early age, Boba is trained to be a bounty hunter and proves he is a lethal combatant with extraordinary sharp-shooting abilities and complete dedication to the profession.

During the Battle of Geonosis, Boba witnesses his father's decapitation at Jedi Master Windu's blade. Now orphaned and with a burning hatred of Jedi, Boba joins a bounty hunter crew led by Aurra Sing to learn more and nearly kills Mace on a mission. When this attempt fails, Boba is imprisoned. Upon his release, the experienced young bounty hunter forms his own crew, named Krayt's Claw, and dons Mandalorian armor like his father's old suit.

During the Imperial Era, Boba becomes a legendary bounty hunter in his own right, proving himself cunning and ruthless with a grim penchant for adorning his suit of armor with trophies from his hunts. He frequently takes jobs from the crime lord Jabba the Hutt and Imperial leader Darth Vader. Two of Boba's most notorious missions for Vader include discovering the identity of the pilot who destroyed the Death Star, and tracking down the *Millennium Falcon* after the Battle of Hoth.

Cunning mercenary Having tracked the *Falcon* for Darth Vader, Boba captures Han to collect the bounty on the smuggler from Jabba the Hutt.

Boba is alongside Jabba when the rebels rescue Han Solo. Joining the fight to protect a lucrative client, Boba's jetpack is damaged and the bounty hunter loses control, falling into the monstrous Sarlacc's maw. Regardless of this unlucky and ignominious event, Boba is remembered as one of the best bounty hunters in the galaxy, with a reputation eclipsing his father's. ∎

He's no good to me dead.
Boba Fett

STAYING IN THE GAME

QI'RA

HOLOCRON FILE

NAME
Qi'ra

SPECIES
Human

HOMEWORLD
Corellia

AFFILIATION
**White Worms;
Crimson Dawn**

ABILITIES
**Skilled negotiator; master
of Teräs Käsi**

AIM
Survival

STATUS REPORT
Unknown

Resourceful, strategic, and quick-thinking, Qi'ra grows up on Corellia as a scrumrat who is part of Lady Proxima's White Worm gang, rising to the position of Head Girl in the group. Alongside fellow scrumrat and her partner Han, Qi'ra attempts to flee Corellia, hoping for a new life, free to make her own choices. However, Qi'ra is captured by the White Worms during the attempt. Outraged at the betrayal, Proxima sells Qi'ra into slavery, and she is eventually purchased by the public face of the criminal organization Crimson Dawn—the ruthless Dryden Vos.

Qi'ra's potential is recognized by Vos, who offers her a senior position in his gang for complete loyalty. She excels in the role, becoming one of Vos' top lieutenants and quickly picking up many valuable skills, including the martial art Teräs Käsi.

Now hardened by years with Crimson Dawn, Qi'ra inadvertently reconnects with the still-idealistic Han on Vandor. Dryden is furious that Han and his companions lost his valuable cargo to pirate leader Enfys Nest, so Qi'ra deftly brokers a deal between the two parties. She accompanies Han and his associates on their mission to steal coaxium from the Kessel spice mines for Vos.

Their mission would have failed without Qi'ra's skills and contacts. When they meet Vos on the planet Savareen, Qi'ra participates in Han's plan to bluff Vos. She betrays Vos—killing him with his own petar—and later Solo, leaving him on Savareen. Qi'ra travels to Dathomir to meet Maul, the secretive head of Crimson Dawn. Whether to protect Han, realizing that she cannot escape her life, or perhaps sensing a promotion opportunity, Qi'ra's true motivations are unclear. However, she remains an adaptable and capable realist, who now chooses her path. ■

Cunning operative
With a sword to Han's chest, Qi'ra appears to be poised to kill him. However, she turns on her crime boss.

KEEPERS OF THE WAY
MANDALORIANS

HOLOCRON FILE

NAME
Mandalorians

HOMEWORLD
**Mandalore; though now
scattered across the galaxy**

AIM
**Reclaiming of the
Mandalorian homeworld**

STATUS REPORT
In exile

A high-tech world with a prominent and diverse human culture, Mandalore has a proud warrior tradition and a long history of conflict. In the ancient past, Jedi Knights would tangle with Mandalorian warriors, who prove to be a challenge to even seasoned Masters. The expansion efforts of past Mandalorian regimes extend the culture's sway to over a thousand worlds within Mandalorian space.

Mandalorian society is ruled by the Manda'lor, who in turn is guarded by Protectors. The most important Houses—major families—report to the Manda'lor, with lesser clans divided among the Houses. The Mandalorian families often identify a key homeworld within Mandalorian space. House Kryze, for instance, is based on Kalavela, Wren on Krownest, and Vizsla on Mandalore itself.

The signature innovation of the Mandalorians is the mining and tempering of beskar, a metal found only on Mandalorian worlds. Beskar, in the hands of a proper armorer, can be forged into an impermeable battle-suit. The purest beskar can even briefly deflect a Jedi lightsaber blade. The storied legends of armored Mandalorian warriors would influence fighting forces the galaxy over, even including the clone trooper forces of the Grand Army of the Republic which would evolve into Imperial stormtroopers.

Over a battle-scarred history, Mandalorian houses engage in intrigue and the occasional open warfare. In the Mandalorian Civil War, the homeworld is devastated; most of Mandalore is left a blasted white wasteland with dome cities jutting out from the bleak expanses. Inside these domes, Mandalorians live in hermetic, cube-shaped, high-tech cities.

Civil war Disguised in beskar armor, Jedi Obi-Wan Kenobi witnesses the outbreak of clan warfare on Mandalore.

After this environmental disaster, a pacifist movement of Mandalorians attempts to reshape society by withdrawing from all galactic conflict and exiling its warriors to the verdant moon of Concordia. The warriors, however, become even more extreme, forming the Death Watch splinter faction. This faction takes over Mandalore during the Clone Wars, ousting the pacifist ruler Duchess Satine Kryze. Though Mandalore attempts to stay neutral in the war, the intervention of outside players—most notably the former Sith Lord Maul—drags the

The Darksaber

The Darksaber is a unique lightsaber constructed over a thousand years ago by the only known Mandalorian to ever enter the Jedi Order, Tarre Vizsla. After Vizsla's passing, the Jedi kept the blade secure in the Jedi Temple. During the chaos that saw the end of the Old Republic and extinction of the Sith, members of the Vizsla clan steal the Darksaber, returning it to Mandalore. A powerful symbol for House Vizsla, it becomes an instrument of unification among the many Mandalorian clans.

When Death Watch resurfaces during the Clone Wars, Pre Vizsla wields it. He loses it—and his life—in battle with Maul, who usurps command of Death Watch during his time ruling Mandalore. The blade is next found on Dathomir, where Sabine Wren claims it from Maul and returns it to Bo-Katan Kryze. After the fall of Mandalore to the Empire, Moff Gideon brandishes it.

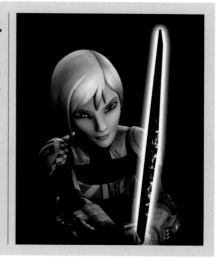

planet onto the galactic stage, requiring Republic intervention. Though Maul escapes capture, the Republic presence on Mandalore paves the way for a later Imperial occupation.

At first, Mandalorians like Gar and Tiber Saxon facilitate the Imperial presence by becoming high-ranking Imperial Mandalorians. Bo-Katan Kryze, aided by the rebel crew of the *Ghost* and Mandalorian Sabine Wren, tries to wrest control from the Saxons and unites the clans by brandishing the Darksaber, a symbol of Mandalorian rule. In time, though, the Empire cracks

> I'm a Mandalorian. Weapons are part of my religion.
> **The Mandalorian**

down on this rebellion, and in the resulting purge, many Mandalorians are killed or dispersed.

In the uncertainty of the New Republic era, the Mandalorians as a people are scattered. Small pockets of Mandalorian clans exist in so-called coverts hidden on various worlds, such as Nevarro in the Outer Rim. The Darksaber falls into the hands of an Imperial warlord, Moff Gideon, and the Mandalorians seem directionless in this era. The most orthodox adherents try to keep the Way in practice, a code of behavior and traditions that honor Mandalorian heritage. ∎

Mandalorian signets Mandalorian clans are often identified by shoulder signets denoting a worthy kill or conquest.

Kast
House Kast's serpentine vexis sigil

Eldar
The leonid sigil of Clan Eldar

Vizsla
A peacetime sigil of House Vizsla, predating the Death Watch coup

Mudhorn
A mudhorn sigil for a clan of two: Din Djarin and the Child

Mythosaur
A fabled beast often worn as a Mandalorian symbol

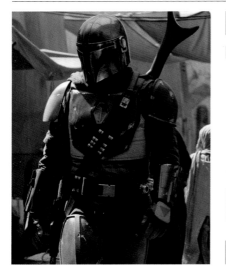

THE MANDALORIAN
DIN DJARIN

HOLOCRON FILE

NAME
Din Djarin

SPECIES
Human

AFFILIATION
Mandalorians; Bounty Hunters Guild

ABILITIES
Hand-to-hand combat; weapons use; piloting

AIMS
To make a living; to protect the Child

STATUS REPORT
Active during the early New Republic

The man known to most only as the Mandalorian, or Mando for short, walks a lonely path as a bounty hunter, a complicated profession particularly in the lawless times following the collapse of the Galactic Empire. Even in these tumultuous early years of the New Republic, he outshines his fellow bounty hunters, earning a reputation for success. Mando develops an amicable relationship with Greef Karga, a representative from the Bounty Hunters Guild. Greef shares in Mando's successes, providing him with bounties in exchange for collecting a finder's fee.

When not flitting from world to world in his gunship, the *Razor Crest*, Mando visits a Mandalorian covert hidden in the sewers of Nevarro. There, an Armorer keeps his beskar suit intact. Mando hands over a portion of his profits to the covert to ensure his people's future. This money is used to support any of the clan's foundlings—younglings in need of protection who are rescued and raised as Mandalorians. This seemingly incongruous act of selflessness comes as a salve for his own painful past.

Although now known as the Mandalorian, he was once a boy named Din Djarin. When his home, Aq Vetina, is assaulted by merciless battle droid forces, Din's parents hide him in a cellar, hoping to keep him safe. He survives, thanks to the intervention of Mandalorian forces. Armored warriors carrying the mark

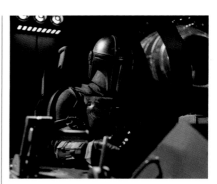

Ever mobile The Mandalorian at the helm of the *Razor Crest*, an antiquated gunship that serves him well.

of Death Watch take the abandoned child to be raised as a Mandalorian foundling. Din receives an orthodox Mandalorian upbringing so believes that he cannot ever take his helmet off in the company of another living being, lest he lose claim to his Mandalorian heritage.

The Mandalorian's adherence to the creed of the Bounty Hunters Guild is tested when he is assigned to bring in an unregistered quarry at the behest of a mysterious Imperial client. With very scant information, he tracks the target to Arvala-7, where he is surprised to find it is a child. The Mandalorian delivers the bounty, but has

The Mandalorian's armor
As he undertakes dangerous assignments, the Mandalorian upgrades his gear.

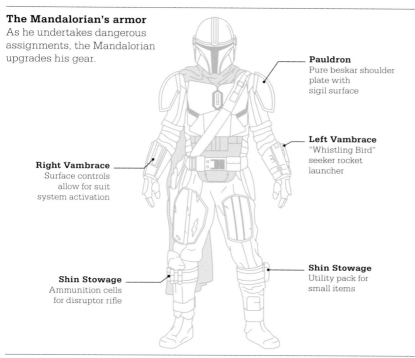

Pauldron
Pure beskar shoulder plate with sigil surface

Left Vambrace
"Whistling Bird" seeker rocket launcher

Right Vambrace
Surface controls allow for suit system activation

Shin Stowage
Utility pack for small items

Shin Stowage
Ammunition cells for disruptor rifle

allies such as Kuiil, an Ugnaught rancher and mechanic; Cara Dune, a former Rebel shock trooper; and IG-11, a reprogrammed assassin droid. Together with Greef Karga—who has had a change of heart—they conspire to settle the dispute with the Imperial client on Nevarro, short of handing over the Child. The Mandalorian plots to kill the client, but is beaten to it by the dangerous Moff Gideon, the client's mysterious benefactor.

The Mandalorian, Cara, Greef, and the Child barely escape the clutches of Moff Gideon, making the Imperial warlord their latest dangerous enemy. ∎

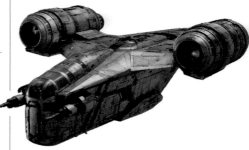

Razor Crest More than just a conveyance, the *Razor Crest* is the Mandalorian's home.

misgivings about turning over a foundling. He reneges on his deal and breaks into the Imperial remnant holdings, freeing the Child, and the pair become fugitives. As a consequence of breaking the Guild's creed, the pair are targeted by other hunters, including Greef Karga. Only cover flown by his covert brethren buys the Mandalorian the time needed to escape safely with the Child.

The Mandalorian lays low in a number of bolt-holes, including a farming village on the forest planet Sorgan, the spaceport of Mos Eisley on Tatooine, and a vapor farm on Arvala-7. He draws upon unlikely

The Child

Very little is known about the Child, the Mandalorian's target-turned-ward. He is found sleeping in a hovering pram in a safehouse on Arvala-7, guarded by Nikto henchmen. Where he came from is unknown.

According to a fragmented chain code, the Child is 50 standard years old, but has the look and behavior of a toddler. His species is unknown, but is a match for that of Yoda, the late Jedi Master. The wide-eyed youngling forms a strong bond with the Mandalorian and tries to protect his guardian with latent yet powerful Force abilities. With concentrated effort he is able to use the Force to stop a charging mudhorn in its tracks, lifting the beast aloft with telekinesis. But such displays exhaust the infant. The Armorer of the Nevarro Mandalorian covert claims that the Child and the Mandalorian form a clan of two, as they are devoted to each other's safety.

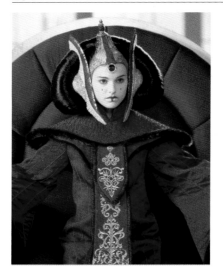

PACIFISTS AT HEART

THE NABOO

HOLOCRON FILE

NAME
The Naboo

SPECIES
Human

HOMEWORLD
Naboo

AFFILIATION
Republic

CAPITAL
Theed

GOVERNMENT
Elected monarchy

The people of Naboo, inhabitants of a serene and striking planet, play an unexpected role in the events that shape the galaxy during the final days of the Republic. This planet of pacifists exudes elegant styling stemming from their appreciation of art, architecture, and culture. It is therefore surprising that they should be caught up in so much unrest, first in the form of a Trade Federation blockade and later during the Clone Wars. It's even more shocking that the Sith Lord Darth Sidious hails from this place.

Unlike hereditary monarchies, the people of Naboo elect their ruler every two years. While virtually anyone could become the next queen or king, the people generally elect young women who exhibit the qualities they seek in a leader. Each monarch is limited to just two terms by the constitution, a law that is nearly amended to allow Queen Amidala to continue to serve after her exceptional leadership during the Trade Federation crisis. She declines the honor, passing on the throne to Queen Réillata, followed by Jamillia, Neeyutnee, and Apailana.

With the formation of the Empire, the monarchs that followed are largely ceremonial in nature, as the Imperial governor takes control of all issues of substance. Following the fall of the Empire, Queen Soruna valiantly flies an N-1 starfighter alongside rebel forces to protect Naboo from destruction.

Palace courtyard Some areas of Theed are destroyed during the blockade, but the Naboo rebuild. The new Palace Courtyard is one example.

From the magnificent Royal Palace in the capital city of Theed, the monarch is assisted by a cadre of councilors, handmaidens, and security. The Royal Naboo Security Force is a modest assembly whose sophisticated uniforms and handcrafted starfighters are a reflection of their society. Though outnumbered, they perform valiantly during the crisis with the Trade Federation, perhaps the most formative event in recent Naboo history. The crisis cements Padmé Amidala in her life of public service and thrusts Senator Palpatine into the position of Supreme Chancellor from which the secret Sith Lord will take over the galaxy. ∎

RISING UP FROM THE DEPTHS
THE GUNGANS

HOLOCRON FILE

SPECIES
Gungan

HOMEWORLD
Naboo

AFFILIATION
**Republic; previously
independent**

CAPITAL
Otah Gunga

GOVERNMENT
High Council

Though they share a planet with the Naboo, the Gungans are a distinct culture all their own, and even their language, a form of Galactic Basic, is a unique dialect. They follow their own gods and some practice a form of Gungan magic. This aquatic species lives in underwater cities, and its capital, Otoh Gunga, serves as home to the ruling council and its leader who holds the title of Boss. With the aid of advisors, the Boss has the ability to form alliances, oversee military strategy, issue punishments, and banish citizens.

The outspoken and bombastic Boss Nass leads the Gungans during the Trade Federation crisis. Like many Gungans, Nass is wary of the Naboo and feels that his people can survive by hiding. Thanks to the help of Gungan exile Jar Jar Binks and Naboo's leader Queen Amidala, Nass realizes that the two societies form a symbiotic relationship on their planet, and accepts the queen's proposed alliance to defeat the invaders. The Gungan Grand Army meets the Federation's mechanical droid army on the battlefield. The Gungan infantry, armed with booma energy weapons, and cavalry, atop kaadu mounts, hold out long enough to serve as a distraction while the conflict is won elsewhere.

Gungan homes Gungan cities are glistening spheres built from bubble-like plasma harvested nearby.

Fighting together brings about a new era of cooperation between the Naboo and the Gungans, who organize a victory parade to declare peace between their societies.

A decade later, Gungan hero Jar Jar Binks is a junior representative in the Republic's Senate. Standing in for Senator Amidala, Jar Jar innocently initiates a political bill to grant the Supreme Chancellor more powers to deal with a looming war. This bill eventually brings about the fall of the Republic. Despite his brave acts during the Clone Wars, Jar Jar is exiled by his people once more for his role in the fall of democracy. ∎

COMMERCIAL CLONERS
THE KAMINOANS

HOLOCRON FILE

SPECIES
Kaminoan

HOMEWORLD
Kamino

AFFILIATION
Republic; Sith (covertly)

INDUSTRY
Cloning

AIM
Profits

Hidden beyond the Outer Rim, the aquatic planet of Kamino is home to the sophisticated and secretive Kaminoans who are known for their excellence in the scientific field of cloning. Since the planet is prone to storms that turn its watery surface into crashing waves, the inhabitants create magnificent domed cities, built high atop platforms, to shelter them while they perfect the art and business of cloning. Their most notable client is the Galactic Republic, whose order for a clone army is a curious mystery but a fortuitous one when the troops are needed for the Clone Wars.

The Kaminoans take great pride in their work, using a single individual's DNA to create millions of living copies. Their process includes growing, training, and equipping the army in Tipoca City—some of which is subcontracted out to arms manufacturers or bounty hunters. Their work commands a high price, and while the war can be debated, the quality of their product cannot. Their motives, however, are questionable. On the surface, it seems as if the Kaminoans are simply fulfilling a business transaction, but their secret relationship with Darth Tyranus reveals their role in a more sinister plot. Despite working closely with the Jedi and earning a seat in the Republic Senate, they never disclose the true purpose of the inhibitor chips installed in each clone. The Kaminoans are complicit in Order 66, which helps explain why their planet and the clone army had been a secret for so long. The Sith actively conspire to hide Kamino from the Jedi until the time is right. After the establishment of the Empire, the Kaminoan cloning facilities are closed for business. ∎

Tipoca City During the Clone Wars, the Separatists launch a bold attack on Tipoca City. Thanks to some noble sacrifices, the clones defeat them.

These Kaminoans keep to themselves; they're cloners. Damn good ones, too.
Dexter Jettster

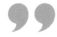

HIVE OF PRODUCTIVITY
THE GEONOSIANS

HOLOCRON FILE

SPECIES
Geonosian

HOMEWORLD
Geonosis

AFFILIATION
Separatists

ABILITIES
Manufacturing

STATUS REPORT
Virtually eliminated by the Empire

My Empire is forever!
Queen Karina the Great

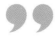

Mass produced The Geonosian battle droids are mechanical marvels, but they are inferior compared to the clone troops.

Though they create unique sonic energy weapons and sleek starfighters of their own, the Geonosians are best known for manufacturing weapons for others. Living and working underground in hives, they produce millions of battle droids for the Confederacy of Independent Systems. Maintained by Geonosian workers, the automated assembly lines are a marvel of mechanical efficiency, and as a reward for their labors, the Geonosians stage gladiatorial matches in the Petranaki arena. Witnessing combat to the death sends drones into an excited frenzy as they watch beings being executed while fighting imported beasts like acklays, reeks, and nexu.

Hive structure and history

The public face of Geonosis is an Archduke, a position filled at the time of the Clone Wars by Poggle the Lesser. He handles all external affairs while Queen Karina lays new eggs and leads the hive from deep within the catacombs. The queen's existence is a secret, guarded by winged warriors who protect the matriarch, while worker drones handle construction tasks. The drones must be given a steady workload or risk devolving into a state of civil war, battling each other in order to keep busy.

The Geonosians spark the beginning of the Clone Wars when the Republic discovers a Separatist droid factory on their planet. After the war, the Geonosian drones construct the early phases of the Death Star, built in part by using material from the Geonosis asteroid rings. In order to keep the existence of the station a secret once their work is completed, the Empire uses poison gas to sterilize the planet, exterminating the Geonosians. A single drone, caring for a queen egg, survives. Tragically when the queen matures, she cannot lay eggs. ■

WALKING CARPETS
THE WOOKIEES

HOLOCRON FILE

SPECIES
Wookiee

HOMEWORLD
Kashyyyk

CAPITAL
Kachirho

AFFILIATION
Republic; Rebel Alliance

LANGUAGE
Shyriiwook

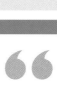

You will never have a deeper sleep than curled up in a Wookiee's lap.
Rio Durant

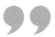

Tall, strong, and majestic, the trees of Kashyyyk are similar in many ways to the Wookiees who live among them. This wondrous yet dangerous world produces many unique life-forms and the Wookiees are no exception. Standing more than 2 meters (6 ½ feet) tall, they tower over most other species. Covered in fur and speaking in a series of powerful roars, a Wookiee has strength that is legendary. Yet they are also known for their loyalty, compassion, and industriousness. Living in elegantly crafted tree cities, they seamlessly blend natural materials with modern technology.

Wookiees have a special relationship with their native forests, whose wroshyr trees hold deep, spiritual meaning. The foremost example is the Origin Tree, an exceptionally large specimen that towers over the nearby Shadowlands. It is home to the shyyyo bird, an avian so rare some consider it merely a legend. Climbing the Origin Tree is a spiritual rite of passage for the Wookiees. In ancient times, a strong connection to the Force found on

Kachirho This coastal capital city becomes a key battleground during the closing days of the Clone Wars.

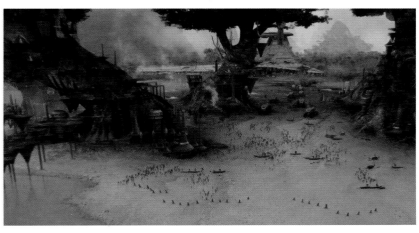

Chief Tarfful

The Chieftain of Kashyyyk's capital city of Kachirho, Tarfful is among the planet's most prominent Wookiees, thanks to his leadership during the tumultuous periods of the Clone Wars and Galactic Civil War.

When Kashyyyk faces Separatist invasion, Tarfful partners directly with Jedi Master Yoda on battlefield strategy and leads his Wookiee militia from the front lines.

His anti-Imperial stance makes him a wanted criminal during the Civil War, forcing him into hiding in the heavily-wooded Shadowlands. He works with Saw Gerrera's Partisans to mount a resistance at great risk to himself, narrowly avoiding Imperial capture that would surely see him executed as a traitor. As a symbol of freedom and pride, mere rumors of his survival are enough to inspire Wookiees to continue their revolt.

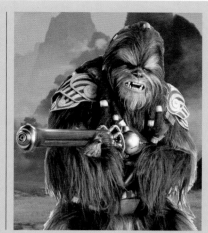

Kashyyyk attracts the Zeffo, a mysterious alien race of Force users. In more recent times, a young Wookiee named Gungi is accepted into the Jedi Order, a rare example of the species among the Jedi.

Living hundreds of years, the Wookiees have seen the rise and fall of many governments and been the victims of injustices throughout. Trandoshan slavers have long terrorized the Wookiees, sometimes hunting them for sport. Kashyyyk also produces a number of famous Wookiees, including the Rebel hero Chewbacca, the ferocious bounty hunter Black Krrsantan, the freedom fighter Choyyssyk, and the vigorous King Grakchawwaa who fights in the Clone Wars, accompanied by a warrior Wookiee named Alrrark.

During the Clone Wars, Kashyyyk falls under attack from the Separatists. The Wookiees remain allied with the Republic, fighting alongside the Jedi to defend themselves from droid invasion. Though they win the fight, their battle against one oppressor soon gives way to the next. Kashyyyk is still reeling when Order 66 is triggered, but the Wookiees remain loyal to the Jedi. They help Jedi Master Yoda flee the planet,

Oevvaor catamarans Normally used for fishing, these catamarans are repurposed for defense when necessary.

but soon find themselves hunted by the newly pronounced Empire. With their planet now blockaded, the Empire allows the Wookiees to be forced into captivity and slavery.

Freshly announced Imperial laws lead to immeasurable suffering as Wookiees are ripped from their families and shipped off the planet to carry out hard labor in the spice mines of Kessel, in the Outer Rim. To keep order, the Imperials install inhibitor chips in many Wookiees. The Empire deforests many of the

wroshyr trees to harvest their legendarily durable lumber and valuable sap. For a time, Saw Gerrera and his Partisans join the Wookiee Resistance, forming an alliance that frees many Wookiees and neutralizes the Imperial sap refinery. However, even after the Battle of Endor, Kashyyyk remains under Imperial control. Grand Moff Lozen Tolruck uses propaganda and a blockade to keep news of Palpatine's apparent demise a secret. His iron grip falters when Chewbacca and Han Solo lead a mass uprising, bringing about the Grand Moff's death and finally freeing the planet after decades of Imperial rule. ∎

SPIRITUAL WARRIORS
THE LASAT

HOLOCRON FILE

SPECIES
Lasat

HOMEWORLD
Lasan; Lira San

AFFILIATION
Royal family of Lasan

ABILITIES
Strength; agility; climbing

The story of the Lasat is one of pride, tragedy, and renewal. The galaxy knows them as a species hailing from Lasan, an Outer Rim world where the Lasat people thrived since before records were kept. They are especially proud of their warriors, whose physical strength and fearlessness in combat are legendary. The most esteemed are their High Honor Guard, a group tasked with protecting their royal family. Yet the Lasat also have a spiritual side, believing in the

Lost battle A captain in the High Honor Guard, Garazeb Orrelios feels personally responsible for the defeat.

energy of Ashla—known elsewhere as the Force—and decoding cryptic prophecies housed in ancient texts.

Unrest on Lasan brings down the Empire's wrath, culminating at the Siege of Lasan. Though the Lasat warriors fight bravely, the Imperials win by using brutal T-7 ion disruptors and a devastating bomb strike against the royal palace. The siege decimates the population, causing the Lasat to nearly go extinct in the known galaxy.

Rebel warrior Garazeb Orrelios believes he is the last survivor of his species and joins a rebel cell to fight back.

He is surprised to meet two other Lasat, Chava the Wise and Gron. The two survivors tell of a prophecy that will lead them to a mysterious planet called Lira San, the fabled original Lasat homeworld, but requires them to conduct a ritual to reveal a path to the new world. Zeb's weapon, a traditional bo-rifle with ancient lineage, is the key that leads them through an imploded star cluster in Wild Space where they discover the mythical planet. To their surprise, they discover an entire population of Lasat living there, ensuring that the species will carry on. Zeb goes on to lead any Lasat survivors to their new home. ∎

Lasan was not destroyed. It was transformed as part of the future destiny of our people.

Gron

FREEDOM FIGHTERS
THE TWI'LEKS

HOLOCRON FILE

SPECIES
Twi'lek

HOMEWORLD
Ryloth

AFFILIATION
Republic; Free Ryloth Movement

NOTABLE MEMBERS
Aayla Secura; Bib Fortuna; Cham Syndulla; Hera Syndulla

While Twi'leks hail from the Outer Rim planet of Ryloth, many can be found across the galaxy. They are most easily identified from other humanoids by their head-tails known as lekku. Some think of the Twi'leks as entertainers or dancers, professions that a number of Twi'leks practice, but this prominent people excels at far more than just the arts. The Twi'leks count among them pilots, smugglers, bounty hunters, gangsters, politicians, Jedi, and especially freedom fighters.

Twi'lek culture places great importance on family. One symbol of the Twi'lek family is the Kalikori, a hand-crafted heirloom passed down through the generations. Each new member adds their own piece to the relic depicting something of personal significance, chronicling the legacy of the family through unique artwork and inscriptions. The Kalikoris often capture the great suffering endured by the Twi'leks through the ages.

During the Clone Wars, Ryloth falls under Separatist attack. The invasion, bombings, and pilfering devastate the planet and its people, but the droids are eventually repelled thanks to an alliance between the Jedi and local freedom fighters led by Cham Syndulla. While Cham is considered a radical by his own government, his leadership continues until the next war when he founds the Free Ryloth Movement to fight back against Imperial occupation. They even attempt to assassinate Emperor Palpatine and Darth Vader.

Decades of fighting hardens many of the freedom fighters. But their reputation as warriors does not save all of them from harm, with many being forced into slavery.

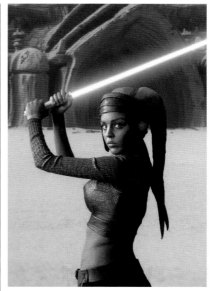

Jedi Knight Aayla Secura is one of the few Jedi to survive the Battle of Geonosis. She serves with distinction throughout the Clone Wars.

Following years of subjugation, Ryloth stays independent from the New Republic, though the rise of the First Order leads some to support the Resistance. Former Alliance member Yendor agrees to harbor his old friend Leia Organa's Resistance after the Battle of Crait, but this act incurs the First Order wrath. ∎

FURRY ALLIES
THE EWOKS

HOLOCRON FILE

SPECIES
Ewok

HOMEWORLD
Forest Moon, IX3244-A

AFFILIATION
Rebel Alliance;
New Republic

NOTABLE EXAMPLES
Wicket; Chief Chirpa;
Peekpa

LANGUAGE
Ewokese

Small as they are in stature, the Ewoks should not be underestimated. The Empire makes this mistake on the Forest Moon of Endor, believing them to be only primitive animals. Yet this band of diminutive, furry aliens plays a critical role in the downfall of the Empire when the Ewoks fight by the side of the Rebellion at the Battle of Endor. Though Ewoks fight with primitive weapons—spears, stones, bows, and catapults—their ingenuity and surprise attack turn the tide of the battle. Their simple traps prove deadly, taking down Imperial walkers and overwhelming armored stormtroopers. The Ewoks prove to be long-standing allies of the Rebellion, with some serving as emotional support companions for shell-shocked veterans seeking to cope with what they saw or did during the Galactic Civil War.

The Ewoks find their own spiritual peace in nature. Shamans serve as mystical guides, curating and interpreting their oral histories passed down through generations. They make their homes in treetop villages, high above the predators that roam the forest floor. Though generally content to live a simple life in the forest, contact with the outside world leads some Ewoks to leave the isolated villages behind. Peekpa, a technologically savvy Ewok, joins Rebels Han Solo, Chewbacca, and Lando Calrissian on their mission to stop the maniac Fyzen Gor from spreading a deadly droid virus.

Endor is also home to the Wisties, a tiny species sometimes known as Firesprites, who defend the forest and befriend the Ewoks. Warriors have occasionally weaponized the creatures, filling pouches with them and launching the frantic creatures at enemies as a distraction. ∎

Treetop dwellings Thanks to C-3PO, the Alliance strike team befriends the residents of Bright Tree Village.

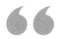

Well, short help's better than no help at all, Chewie.
Han Solo

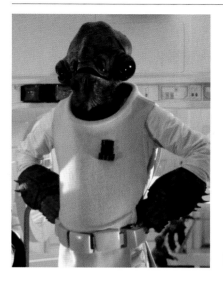

DEFENDERS OF PEACE
THE MON CALAMARI

HOLOCRON FILE

SPECIES
Mon Calamari

HOMEWORLD
Mon Cala

AFFILIATION
Republic; Rebel Alliance; New Republic

NOTABLE EXAMPLES
Admiral Raddus; Admiral Gial Ackbar; Jedi Knight Nahdar Vebb

Whether under the seas of their home planet Mon Cala, or fighting in the vastness of space, Mon Calamari are regular defenders of peace. Their aquatic planet is home to underwater cities, whose towering structures connect through a series of pressurized tubes to allow for high speed travel. A beloved monarch rules over them, aided by mayors and local bureaucrats spread across the planet. Mon Calamari share their homeworld with the Quarren, a species that has been both friend and foe over time.

During the Clone Wars, King Yos Kolina's suspicious death leads to Prince Lee-Char's ascension to the throne at a time of great unrest. The Separatists stoke Quarren discontent, fomenting a civil war. Backed by the Republic, Lee-Char leads the defense of Mon Cala from Separatist invasion with help from Captain of the Guard, Gial Ackbar.

During the early reign of the Empire, Lee-Char harbors the Jedi Padawan Ferren Barr and his followers, attracting the attention of the Empire. Suspecting the Jedi are there, the Imperials seize upon the first opportunity to invade. As the Empire occupies Mon Cala, the Mon Calamari respond by launching their underwater buildings into space and refitting them to become warships—armed with ion cannons, turbolasers, and tractor beam projectors. They prove to be a critical part of the Rebel Alliance fleet, providing much-needed

capital ships for the Alliance Navy led by Mon Calamari Admirals Raddus and Gial Ackbar.

It's a trap!
Admiral Ackbar

Decades later, the Mon Calamari again assist a rebel cause by allying with the Resistance in the war against the First Order. They provide valuable ships, crew, and pilots including Aftab Ackbar, son of Gial. Their support of the Resistance leads to First Order reprisals, once again putting the Mon Calamari in the crosshairs of invaders. ■

Ship design Mon Calamari ships have a more bulbous, organic appearance than their Imperial and First Order counterparts.

BRIGHT-EYED SCAVENGERS
THE JAWAS

HOLOCRON FILE

SPECIES
Jawa

HOMEWORLD
Tatooine

AFFILIATION
Neutral

KNOWN FOR
Scavenging

The Jawas of Tatooine hold many secrets. Though they are a common sight across the planet, few outside of their society even know what they look like beneath their tattered brown robes. From under their hoods peer glowing eyes, and high-pitched voices speak their native language of Jawaese. They live in towering sandcrawlers—tread-laden vehicles that serve as their home and roving warehouse. From this mobile workshop, they repair machines and droids that they sell to local farmers, traveling between homesteads, lining up their wares for sale. Other species can sometimes learn their language, though since speaking it involves using scent, it is notoriously difficult to master. The creatures default to the easier Jawa Trade Talk when striking deals.

The Jawas seem single-mindedly focused on technology. Where there is a lost droid or crashed starship, they are rarely far behind. They seize upon almost any opportunity to gather unattended tech, quickly dismantling anything of value and preparing it for resale. Using ion weapons cobbled together from scrap, they seek to steal—but never to destroy—their finds. Droids unlucky enough to be caught alone become the property of the clan. This behavior proves fateful for the rebel droids R2-D2 and C-3PO, whose capture by the Jawas and subsequent sale to Owen Lars on Tatooine sparks Luke Skywalker's journey to becoming a Jedi.

Though their exact movements are hard to track, it is believed that ships traveling to and from Tatooine enable some Jawas to leave their homeworld. Colonies exist on Arvala-7, Nevarro, and Vanqor, where they live much as they do on Tatooine: inextricably drawn to all forms of technology, often at the annoyance of their neighbors. ∎

> The Jawas steal.
> They don't destroy.
> **Kuiil**

Sandcrawlers These vehicles may be unarmed, but their robust armor plating protects Jawas from most threats.

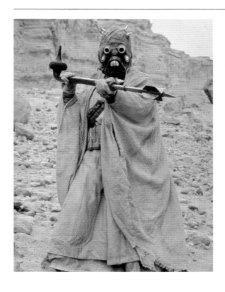

PEOPLE OF THE DESERT
TUSKEN RAIDERS

HOLOCRON FILE

SPECIES
Tusken

HOMEWORLD
Tatooine

AFFILIATION
Neutral

WEAPONS
Gaderffii sticks; cycler rifles

Surviving in the harsh wastes of Tatooine requires extreme knowledge of the landscape and unmatched physical toughness, traits that the Tusken Raiders certainly embody. Also known as Sand People, the Tuskens live in primitive tribes scattered across the desert wastes. They live their entire lives covered from head-to-toe in homespun cloth and facemasks, giving them a fierce appearance while also protecting them from the damaging rays of Tatooine's twin suns and ferocious windstorms. Few outsiders have ever seen what a Tusken looks like beneath their camouflaged robes.

The Tuskens' survival relies heavily on the herds of banthas that roam Tatooine. Riding them, Tusken Raiders cross broad swathes of desert in search of water, or to defend their territory from outsiders. Those passing through their lands must offer a trade in return for safe passage, as the Tuskens have an uncanny ability to identify trespassers. Their territorial nature brings them into conflict with Tatooine's settlers. One such victim is Shmi Skywalker—the mother of Anakin Skywalker—who is held captive by a tribe. Though he finds her, Anakin is too late to save his mother's life. In his rage, the young Jedi slaughters the entire tribe. Many years later, his return to Tatooine is an opportunity for Darth Vader to take even more vengeance upon the Tuskens. He wipes out an entire village, leaving one survivor. The slaughter draws the reverence of another village, who build a shrine to worship the memory of a powerful figure in black. ∎

Those Tuskens walk like men, but they're vicious, mindless monsters.
Cliegg Lars

Wrapped up Even Tusken children don full body outfits to protect them against the harsh desert conditions of Tatooine.

GLOSSARY

Alliance High Command
A council of political and military leaders who lead the Alliance to Restore the Republic.

Arkanis Academy
An Imperial facility on the planet Arkanis for training cadets, overseen by Brendol Hux in the final days of the Galactic Empire.

ASW4/BSW4
After *Star Wars* 4/Before *Star Wars* 4; a dating system used to describe the timeline of events in *Star Wars* stories. Indicates how many standard years before or after *Star Wars*: Episode IV *A New Hope* an event takes place.

axial
A term that describes a subsystem placement that runs parallel to a major axis of vehicular motion.

bacta
A prized substance with healing properties. Can be administered in bandages, sprays, or submersion tanks to rapidly repair minor to moderate surface wounds to organic life-forms.

bactaspray
A method of quickly dispensing bacta.

Baron Administrator
The title held by Lando Calrissian as the leader of Cloud City. He is responsible for the operation of the mining facility and ensuring the well-being of the floating station's inhabitants.

beskar
A prized metal with considerable blaster-resistant properties. Prized by Mandalorians, who forge the alloy into protective suits of armor.

bunker buster
A warship manufactured by the Corellian Engineering Corporation. It is used by the Resistance and is equipped to drop powerful plasma bombs.

centrist faction
A group of member systems in the New Republic favoring a strong central government and military. These systems eventually break from the New Republic to become the political beginnings of the First Order.

Chancellor
The elected political leader of the Galactic Republic and New Republic who presides over the Senate.

Chiss Ascendancy
An advanced civilization from the Unknown Regions. It is renowned for its military prowess and secrecy.

coaxium
Rare, combustible substance used to propel starships faster than the speed of light. It is tightly controlled during the Galactic Empire and commands a steep price on the black market.

corvette
A class of starship that serves multiple roles, including as diplomatic shuttles, light cargo ships, and small warships.

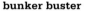

cruiser
A class of armed warship, typically smaller than a destroyer or dreadnought.

Death Watch
A faction of Mandalorian warriors infamous for their militaristic nature and opposition to the pacifist leader of Mandalore, Satine Kryze.

Department of Advanced Weapons Research
An Imperial organization tasked with developing advanced technologies including weapons, armor, droids, and the superlaser of the Death Star.

dreadnought
Among the largest warships in the galaxy, this class of vessel boasts armor, powerful weapons, and large crews.

droidsmith
A craftsperson specializing in the creation, repair, and modification of mechanical droids.

dyad
An exceedingly rare connection between two individuals strong in the Force. Kylo Ren and Rey share such a bond, allowing them to use the Force in ways unique to them.

Emperor
The powerful, autocratic leader of an Empire, such as the tyrannical Palpatine, who took control of the Galactic Republic and declared himself Emperor.

First Order transit data-medallion
An object given to ranking leaders of the First Order to allow free passage through controlled sectors of space.

First Senator
A position proposed to replace the Chancellor of the New Republic. The intention of the role is to unify a government divided between Centrists and Populists.

Galactic Concordance
The treaty signed at the end of the Galactic Civil War calling for the end of fighting between the shattered Galactic Empire and the New Republic.

Ghorman Massacre
A tragedy committed by Imperial troops that inspired Senator Mon Mothma to speak out publicly against the Empire's crimes.

Grand Moff
A high-ranking military official in the Galactic Empire charged with governing a large territory for the Emperor.

Guardian of the Whills
Sworn protectors of the Temple of Kyber on Jedha. Disbanded during the time of the Empire, Chirrut Îmwe and Baze Malbus were once members.

High Republic
An era of relative prosperity and expansion of the Galactic Republic at the height of the Jedi Order, approximately 200 years before the Clone Wars.

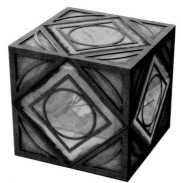

holocron
A device that contains data and messages that can only be accessed via the Force. The Jedi and the Sith each construct holocrons of their own designs.

holoprojector
A device that displays a three-dimensional image, such as maps and messages.

Imperial Commandant
An Imperial military officer who oversees the training of soldiers at academies. Often known for their punishing methods.

Imperial Remnant
Rogue members of the Galactic Empire who refuse to abide by the surrender of the Galactic Concordance and who operate from the fringes of space.

Imperial Security Bureau
The Imperial division responsible for security within the Empire. ISB officers investigate reports of disloyalty among citizens and the military alike.

Imperial Senate
Once the Galactic Senate, its Imperial successor is a mostly powerless governing body of senators from star systems in the Galactic Empire. The council is eventually disbanded entirely by Emperor Palpatine.

inhibitor chip
A device secretly implanted in the brains of the Republic's clone soldiers ensuring they will follow preprogrammed commands, including Order 66.

joopa
A species of large, predatory worms living below the surface of the planet Seelos that swallow their prey whole.

koan
A Jedi meditation on abandoning dependence on reason and instead embracing intuitive enlightenment in the Force.

lariat
A long, ropelike weapon used in a similar way to a whip, which can also be worn like a scarf.

Loyalist Committee
A political committee loyal to Supreme Chancellor Palpatine created to advise him during the Separatist crisis.

Mandalorian covert
A hidden location where Mandalorians can remain in secret, preserving their creed and way of life.

midi-chlorians
Microscopic life-forms that enable Force sensitives to connect with the living Force.

Military Disarmament Act
An Act proposed by Republic Chancellor Mon Mothma at the end of the Galactic Civil War. The aim was to significantly reduce the military size of the New Republic and promote peace.

Moff
A title held by regional governors during the reign of the Empire. Moffs can command military assets and intelligence, and are appointed by the Emperor or his advisors.

moisture farmer
Individual who operates a moisture vaporator to collect surplus humidity for water, particularly in excessively hot climates, such as Tatooine.

nebulae
A cloud of swirling dust and gas located in space, identifiable by its amorphous color pattern.

Old Republic
The galaxy-wide government that preceded the Galactic Republic. It existed many years before the Clone Wars and worked with the Jedi during various conflicts.

orbak
A horselike creature that can be domesticated in order to be used as a mount for warfare and travel.

oscillator
A device found on Starkiller Base that moves back and forth at regular intervals to generate an electrical current that prevents the planet from destabilizing.

pathfinder
A special forces unit in the Rebel Alliance that specializes in stealth and highly dangerous missions, also known as the SpecForce Pathfinders.

Phoenix Squadron
A rebel faction led by Commander Jun Sato that was instrumental in challenging the regime of the Empire prior to the Battle of Yavin.

populist faction
A political faction formed after the Galactic Civil War favored by Senator Leia Organa. It advocates for individual planets maintaining their own sovereignty, rather than the formation of a galaxy-wide government and a potent, centralized military.

psychometry
A Force ability where the Force user is able to touch an inanimate object and learn about the person or event where the item was previously discovered.

puffer pig
A small, plump animal that swells to three times its size when frightened, and is able to sniff out precious metals.

Representative
An elected government official that serves in the Republic senate as a voice for his or her respective world, and holds the title of senator.

Royal Guard
The formal role of a dedicated protector of a sovereign. Royal courts, such as Alderaan and Naboo, have such guards, as do Emperor Palpatine and Supreme Leader Snoke.

scoundrel
Anyone who makes a living by skirting regulations and breaking the law. Generally regarded as lowly by law-abiding citizens.

scrumrat
A slang term describing thieving street urchins in the urban slums of Corellia. One particular gang of scrumrats work for the White Worms in the capital city of Coronet City.

senator
A political representative of a world or sector within the Galactic Senate, during the time of the Galactic

Republic, Galactic Empire, and the New Republic. Some corporate entities are also influential enough to warrant senatorial representation.

sentient
A quality of self-awareness, abstract thinking, and higher reasoning possessed by some life-forms. Sentient species are afforded rights and protections, but enforcement of them is dependent on the ruling authority.

shock trooper
A specialized role within armed forces that emphasizes training and equipment for rapid strikes against high-value targets. The Grand Army of the Republic, Imperial stormtrooper corps, and Rebel Alliance had units classified as shock troopers.

Sith Empire
The ruling regime of the Sith in ancient times, thousands of years before the modern era. The Sith Empire ruled the galaxy until infighting and the efforts of the Jedi Knights led to its downfall.

smuggler
An independent starship operator who seeks to profit from the transport of contraband material. Smugglers often use illegally modified starships—built for speed, evasion, and cargo concealment—to carry out their work.

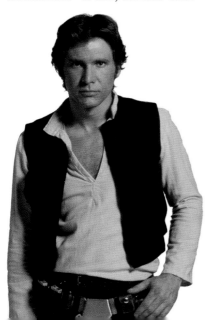

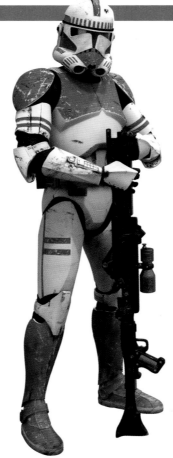

spice
A natural substance of high value that, when properly refined, can be turned into a medicinal agent or a powerful narcotic. Demand for spice, and governmental attempts to limit its distribution, has led to a lucrative and expansive criminal spice-smuggling trade.

spice runners
Criminals who transport illegal spice. As the name suggests, their operations favor speed and agility to avoid pursuit and interception from law enforcement or rival criminals.

strike team
A small team of commandos that operate deep within hostile territory.

Supreme Chancellor
An elected position within the Senate of the Galactic Republic that serves as the leader of the governing body, and

speaker of the senate, steering the agenda of governance. During the Clone Wars, the position undergoes significant modification to better handle the waging of the war.

Supreme Leader
Self-appointed title of ultimate authority within the First Order. Snoke held the title of Supreme Leader before his murder by Kylo Ren, who then adopted the title.

syndicates
Any of the major criminal organizations within the galaxy with a large sphere of operation. They are typically defined by territory or goods. Syndicates are led by crime bosses, with a layer of underbosses beneath them, and lesser soldiers further down the command chain. The five most influential criminal syndicates are the Crymorah, the Hutts, the Pyke Syndicate, Black Sun, and Crimson Dawn.

Trade Federation
A powerful interstellar shipping conglomerate in the Galactic Republic, responsible for the movement of goods across the galaxy. Run by Neimoidian business beings, the Trade Federation is wealthy and politically influential. Though outwardly neutral, it covertly backs the Separatists in the Clone Wars for the promise of unrestricted trade.

transponder codes
A signal broadcast by all legally operating starships in the galaxy that transmits essential data about the vessel—name, captain, port of registry, weapons profile, etc. It is a way for law enforcement to track wanted ships.

vapor farm
An agricultural settlement in worlds with harsh ecosystems where moisture must be drawn from the air with specialized condensers called moisture vaporators. A vapor farm is a type of moisture farm.

vergence
An unusual yet naturally occurring concentration of Force energy, localized around a place, object, or person. Proximity to vergences often triggers visions among Force sensitives.

INDEX

Page numbers in **bold** refer to main entries